GRAPHIC DESIGN SOLUTIONS

Delmar Publishers' Online Services
NEW! Desktop Cafe...offering an online arena for creative
discussions, tips & tricks, as well as industry news and events!
http://www.desktopcafe.com
To access Delmar on the World Wide Web, point your browser to:
http://www.delmar.com/delmar.html
To access through Gopher: gopher:// gopher.delmar.com
(Delmar online is part of "thomson.com", an Internet site with information on
more than 30 publishers of the International Publishing organization.)
For more information on our products and services:
email: info@delmar.com
Or call 800-347-7707

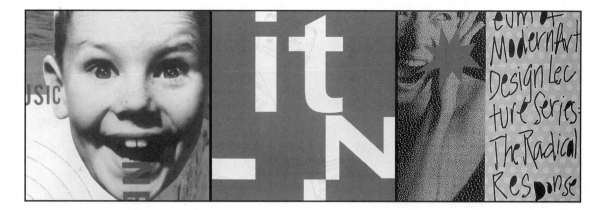

GRAPHIC DESIGN SOLUTIONS
Robin Landa

Delmar Publishers

I(T)P An International Thomson Publishing Company

Albany • Bonn • Boston • Cincinnati • Detroit • London • Madrid
Melbourne • Mexico City • New York • Pacific Grove • Paris • San Francisco
Singapore • Tokyo • Toronto • Washington

NOTICE TO THE READER

Cover Design: Denise M. Anderson

Delmar Staff
Publisher: Robert D. Lynch
Sr. Administrative Editor: John E. Anderson
Development Editors: Sheila Davitt, Barbara Riedell
Production Manager: Larry Main
Art/Design/Production Coordinator: Nicole Reamer

COPYRIGHT © 1996
By Delmar Publishers
a division of International Thomson Publishing Inc.

The ITP logo is a trademark under license

Printed in the United States of America

For more information, contact:

Delmar Publishers
3 Columbia Circle , Box 15015
Albany, New York 12212-5015

International Thomson Publishing Europe
Berkshire House 168-173
High Holborn
London, WC1V7AA
England

Thomas Nelson Australia
102 Dodds Street
South Melbourne, 3205
Victoria, Australia

Nelson Canada
1120 Birchmont Road
Scarborough, Ontario
Canada M1K 5G4

International Thomson Editores
Campos Eliseos 385, Piso 7
Col Polanco
11560 Mexico D F Mexico

International Thomson Publishing GmbH
Königswinterer Strasse 418
53227 Bonn
Germany

International Thomson Publishing Asia
221 Henderson Road
#05 -10 Henderson Building
Singapore 0315

International Thomson Publishing - Japan
Hirakawacho Kyowa Building, 3F
2-2-1 Hirakawacho
Chiyoda-ku, Tokyo 102
Japan

4 5 6 7 8 9 10 XXX 01 00 99 98 97

Library of Congress Cataloging-in-Publication Data

Landa, Robin
 Graphic design solutions / Robin Landa.
 p. cm.
 Includes bibliographical references and index.
 ISBN 0-8273-6352-4
 1. Commercial art. 2. Graphic arts. I. Title
NC997.L32 1996 95-20077
741.6--dc20 CIP

Dedication

To my very beautiful mother, Betty,
with love.

To the memory of my loving father,
Hy, who was my favorite
dance partner.

Table of Contents

Chapter 3 Overview of Graphic Design

Chapter 4 Designing with Type

Chapter 5 Layout

Chapter 6 Logos, Symbols, Pictograms and Stationery

Chapter 7 Posters

Chapter 8 Book Jackets and CD Covers

Chapter 9 Packaging and Shopping Bags

Chapter 10 Visual Identity

Chapter 11 Advertisements

Chapter 12 The Portfolio

Appendix A: Materials, Tools, and Processes

Foreword

Philip B. Meggs

Graphic design solutions. The title of this book addresses the essence of how graphic design has evolved as a discipline and profession. Graphic designers characterize themselves as problem solvers, and problem solvers by definition are hunters engaged in a search for solutions. Historically, designers have not always defined themselves in this way. Many graphic designers in earlier periods worked in the realm of handicraft. Their primary task was execution—hands for hire who laid out elements determined by a copywriter or client. Other designers made a more elaborate contribution by adding artistic attributes to the craft function, embellishing printed material with decorative qualities. As the machine age yielded to the information age, graphic designers working in recent decades have responded to the increased complexity of modern communications by forging a greater comprehension about all aspects of their work. This has resulted in a body of theoretical information concerning form, message, and the interface between the visual and communicative aspects of a graphic design.

Compared to earlier times when many designers were content to be executors or decorators, contemporary graphic designers are engaged in a multifaceted activity. Design is now defined as a process. Its progress and sequence of steps from problem assignment to final solution can be studied, evaluated, and amended. Graphic designers and design-education programs have achieved professional maturity in an effort to keep pace with the more demanding information environment and advanced electronic technology. A theoretical underpinning for design problem solving has emerged. This expanded base of knowledge and information has a direct application to a designer's work.

Factoring the design process into its component parts demonstrates the compound nature of the enterprise. Designers are by definition form-builders, individuals who create concrete, tangible objects that are prototypes for mass production. While product, fashion, and architectural designers create three-dimensional objects, graphic designers invent prototypes for messages that are delivered in diverse formats. These include two-dimensional surfaces; three-dimensional structures including packages, signage, and exhibitions; and four-dimensional media such as film, video, and computer animation.

Design prototypes are created by manipulation of physical attributes such as color, tonality, shape, spatial arrangements of elements in space, and texture. Graphic designers use the same visual language of two-dimensional design as painters and fiber artists, even when they veer into the three-dimensional world of the sculptor or the fourth-dimensional world of the musician and cinematographer. While the organization of forms in space is often a primary focus of fine art, it remains but one dimension of the overall problem confronting the graphic designer.

Form serves as a vehicle to convey meaning. All art has a communicative aspect, bearing intentional, implied, or even ambiguous messages. Graphic designers create specific messages; they use their culture's common communications currency—language, signs, and symbols—to forge a definite communication for a specific audience. This mandatory duality of form and message defines the essence of graphic design, separating it from traditional fine art.

The search for a design solution is a quest for synergy, the marriage of a distinctive visual arrangement with an appropriate message. Res-

olution occurs when form and message become interdependent and mutually supportive. Achieving this resolution is complicated by the need to bring unlike communicative elements such as words and pictures into a cohesive whole. Resolution is defined as emphasis, unity, and balance.

By writing this book, Robin Landa has attempted to address the complexity of graphic-design problem solving—or perhaps we should say solution finding—and reveal a cohesive body of knowledge to aspiring designers. This is a formidable task, for design fundamentals, communicative concepts, strategy, problem-solving processes, typography, and layout of the elements all must be clarified and explained. For practicing designers, comprehension of all of these aspects alone is not enough. This knowledge must be applied to the actual creative process used to find design solutions. To aid in this transformation of information into inspiration and production, Landa includes exercises and projects in every section of this book. These are tried and proven over a decade-and-a-half of design pedagogy.

The second half of this book scans a range of design categories—from symbols and visual identity to posters and advertisements—and discusses the unique issues and challenges inherent in each of these categories of design. Each category is illustrated by successful solutions created by many of America's most outstanding designers and art directors. These examples provide a demonstration of design excellence; they are imaginative solutions whose form and message answered the needs of a specific communications problem. Accompanying comments clarify the message and strategies for achieving an effective solution.

A most striking aspect of this book is author Robin Landa's ability to write with clarity, defining terms and concepts in language readily understandable by students just beginning their exploration of graphic design. Theory is linked to pragmatic solutions for typical graphic-design problems. This stands in marked contrast to arid theoretical concepts that are difficult for students to grasp because they lack any apparent connection to the real world of graphic-design problem solving. Landa's commitment and diligence as a design educator are apparent to the reader; her decision to document and publish her knowledge and experience is a fortunate event.

Preface

Graphic Design is the application of art and communication skills to the needs of business and industry. *Graphic Design Solutions* is about visual communications. It is based on the conviction that graphic design and advertising design are visual arts disciplines that can be taught and learned. This book has grown out of my experiences over sixteen years of teaching visual communications and foundation courses such as graphic design, advertising design and concepts, communication design fundamentals, two-dimensional design, color, and visual thinking. My courses and this book have four main goals: first, to provide students with a comprehensive foundation in design; second, to address basic problems and applications in graphic design and advertising; third, to encourage students to explore the discipline of graphic design; and fourth, to foster creativity and experimentation.

The approach of this book is significantly different from others in the field. It continually relates graphic design to the fundamental elements and principles of two-dimensional design. Recognizing that design is an active process, this book offers design problems for the reader to solve. This turns the reader into an active participant. Executing the projects yields high level work that can be used to compile a portfolio. Finally, this book integrates design, critical thinking, and communication skills, exploring the visual/verbal relationship in graphic design, covering advertising concepts and copywriting, and encouraging assessment. This text is based on the premise that when you learn *why* elements and principles are used as well as *how* they are used, you tend to retain knowledge. If you are encouraged to assess and question what you have learned, not just to accept it, then you will learn even more.

Graphic Design Solutions has been sequenced carefully, but it also is structured to allow instructors to adapt the text to the particular needs of their students and courses. In the first five chapters a foundation is laid with overviews of design fundamentals, the graphic design profession, type, and layout. The next six chapters explore various graphic design applications: logos, symbols, pictograms, stationery, posters, book jackets, album covers, packaging, shopping bags, visual identity, and advertising. The last chapter addresses the need and requirements for a professional portfolio. As examples, two entire portfolios are reproduced.

There are two types of hands-on activities in this text: Exercises and Projects. Both are interactive, allowing you to experience a design element or principle. All of the Exercises and Projects develop hand skills, and critical and visual thinking skills. The comments following the projects allow you to assess what you have learned.

The Exercises are so called because they are just that — a work out. Exercises are the kind of informal nudge you might need to stir your creative juices. The Exercises are intended to stimulate your imagination, develop your capacity for critical thinking, and foster an understanding of the creative process. Your first response should be to think about the idea rather than to fret over a finished piece. Exercises accomplish that.

Projects allow you to experience each topic in the text. The Projects provide a resource of experience and support your understanding of each design concept and principle. As stated earlier, nothing can replace hands-on experience in design. There are plenty of projects for instructors to choose from and most can be modified to accommodate each instructor's style and goals.

The format of this text is flexible. Successful execution of these projects will result in quality portfolio pieces. My colleagues and I have used all these Exercises and Projects in our classes over the years — they work, and work well.

Before you design logos, posters, CD covers, or advertisements that are meaningful, you must learn the basics of graphic design — two-dimensional design, layout, and designing with type. Only then can you focus on different graphic design applications. Like any other discipline, whether it's painting or music, there's a lot to learn. However, the learning process can be an exciting one that stimulates and challenges. Along with an instructor, a text should inspire you to work hard and to experiment — to try things that you ordinarily would not try. You should enjoy the design process and be excited by it. This book has a number of components that will accomplish this:

- Comprehensive review of two-dimensional design
- Comprehensive chapter on advertising design and copywriting
- Explanation of design procedure
- Explanations of *why* and *how* elements and principles are used
- Critique guides and methods of assessing work
- Objectives and suggestions for each topic
- Visual thinking concepts and principles
- Comments from professional designers about their work
- Creative Exercises
- Projects with comments

The information, explanations, concepts, critiques guides, suggestions, illustrations, exercises, and projects in this book will help you in many ways. This book will:

- Stimulate imagination and creative thinking
- Provide a friendly voice to encourage and coach you
- Develop your capacity for conceptual thinking
- Foster an understanding of the intellectual depth necessary for the subject
- Foster your willingness to experiment
- Provide many examples of contemporary and master works
- Provide a comprehensive foundation for further study
- Provide a wide range of portfolio pieces
- Prepare you for continuing professional and creative growth

Over the years, I have taught all types of learners, from the underprepared to the brilliant. What I found was that all students respond to accessible information and language, clearly stated goals, interesting exercises and projects, plenty of experimentation, good examples, clear challenges, and a positive atmosphere. The instructor and the text can provide this. People can be taught to be creative, to think visually, to think conceptually and critically, and to design well. This book is an attempt to package all these ideas in a coherent way.

Acknowledgments

There are three people to whom I am deeply indebted. Rose Gonnella, Martin Holloway, and Alan Robbins, my great colleagues and friends, provided assistance on a continuous basis, edited my writing, contributed to the book, helped to select illustrations, critiqued the manuscript, and provided very strong shoulders to lean on.

I sincerely appreciate the help and support from many individuals at Kean College. Leni Fuhrman read parts of the manuscript in its early stages and made helpful suggestions. In photographing the student work, Tony Velez and Dave Whitthum produced excellent transparencies for reproduction. Dr. Edward Weil, Dean of the School of Liberal Arts, and Dr. Robert Coon provided encouragement and collegial support. Janet Gallagher and Eileen Sleeper provided assistance which was beyond the call of duty. The Released Time for Research Committee supported this project.

To all my students and former students, whose passion and talent make teaching a joy, I offer my deepest gratitude. Special thanks to Denise M. Anderson, Chris Arrogante, Cassandra Cassell, Mary Ann Castillo, Tung Ho Jonathan Chao, Tony Ciccolella, Melanie Decker, David DeSantis, Shasta Donaldson, Colin Fuchs, Sean Gallagher, Lisa Gonnella, Teresa Genneralli, Ann Marie Gentile, Karin M. Hoffmann, Joseph Konopka, Susan Kneebone, Jean Laurianti, Mair Lewandowski, Danilo Medina, Jeannie Metz, Sam Ralson, Paul Renner, Spencer Rogers, Alicia Shillcock, Mary Alice Scola, Jerry Simon, Kim Steiert, Keith Van Norman, Tom Venner, Anna Villani, and Carrie Wagner.

Many gracious professionals, art directors,

creatives, designers, and writers, and their clients allowed me to use their work as examples of excellence in the field of visual communications. They are individually acknowledged in the credits. Special thanks to Thomas Courtenay Ema, Tom Geismar, Alexander Isley, and Mike Quon for their tips on type. Bob Mitchell, as always, was an inspiration. Special thanks to Denise M. Anderson and Nicole Reamer for designing the cover with me.

Several instructors and professionals reviewed this manuscript before it's publication. I wish to recognize and thank Dr. Thomas Schildgen, Shelle Barron, Ronald Norvelle, Marshall Williams, Paul Olsen, Michael Hataway, Randy Long, and especially Stephen Heller, who took time out of his busy schedule as art director for the New York Times and director of the American Institute of Graphic Arts.

At Delmar Publishers, Vernon Anthony and John Anderson, acquisitions editors, believed in and supported this project. Sheila Davitt and Barbara Riedell, development editors, carefully guided this project and made wonderful suggestions. Extra thanks to Barbara Riedell for carefully editing the manuscript. I am very grateful to have had Nicole Reamer as the art editor on this book; her thoughtful art direction made this book look great. Thanks to Stillwater Studio, who designed and typeset this book. Lori Hilfinger provided great assistance in obtaining permissions and made my life a good deal easier.

My very generous friend, William Stanke, kept asking if I needed assistance and then really provided it. Mel Paroff provided expert legal advice. My dear friends and family, Linda Butti, the late Morris Guralnick, (who is deeply missed), Martha and Richard Nochimson, Gary Rogers, and Rose and Roy Rogers provided good advice, encouragement, support, and were willing to listen to my troubles. A special thanks to Victor Esquillin who helped me focus my energy. Thanks to Nathan Hescock, for sharing his creative energy with me. Finally, my ever beautiful mother, Betty Landa, didn't mind that I worked on my manuscript when I visited her in Florida (but made me promise that this would be my last book because I work too hard).

Robin Landa

NOTES

Americas most predominant ART.

Defined as the application of art and communication skills.

- Market - sell products. services
- create visual identies
- environmentalgraphics / signage
- informational design

Graphic Designers Role

Visual - verbal expressions using word (type) pictures and other graphics elements (visuals) to communicate their message.

2 goals

1. communicate a message to a audience
2. create a compelling / pleasing design to enhance that message.

[The Design Procedure] Think like a designer!

- Restate the problem in your own words
- Do research
- Think with your pencil in hand!
- choose your 3 best thumb nails ~ do roughs!
- choose your best rough and develop a comp! [make it look like the real thing]

[The] Critique

- Restate the goals / objectives
- Did you fulfill those goals?
- is the solution properly executed
- is the solution appropriate
- did you create an informa hierarchy.
- does the solution communicate

Chapter 1
Introduction

Objectives
▌ to understand the purpose of graphic design
▌ to become familiar with the job of the graphic designer
▌ to learn the design procedure
▌ to learn to critique your work

Defining Graphic Design

Graphic design is America's most pervasive art form. We don't have to go to a museum or gallery to see graphic design—it comes to us. Everything from television commercials to the label on the ketchup bottle is designed by a visual communications professional. This art form, once called commercial art, is an integral part of contemporary society. Since graphic design plays a key role in the appearance of almost all print, film, and electronic media, it becomes a primary creator of the visual artifacts of our environment and popular culture (See Figures 1-1, 1-2, and 1-3). Imagine a world

Balance = Alignment
EMPHASIS - Contrast
Accents - Subhead
Rhythm - Repetition
Unity - Proximity

Figure 1-1
MTV: MUSIC TELEVISION
Logo used by permission.

Figure 1-2
"Fuel Gauge" Watch, 1988
Design firm: Drenttel Doyle
Partners, New York, NY
Designer: Tom Kluepfel

Figure 1-3
Print Craft Truck, October 1989
Design firm: Charles S. Anderson Design Company, Minneapolis, MN
Art director: Charles S. Anderson
Designers: Charles S. Anderson, Daniel Olson
Photograph: Dave Bausman
Client: Print Craft, Inc., St. Paul, MN

This is the vehicle application of our identity design, created to increase name awareness. It was intended to be so loud and over-powering that you couldn't help but notice it - even from half a mile away. (The 11 foot tall logo on the back was designed to be legible from a distance of 500 yards.) In fact, designers have been heard to say, "Print Craft? Yes, I've seen their trucks all over town," even though they have only one. If it weren't for design, we wouldn't be able to tell what anything was.

Print Craft

oral

he message?

1

Or buy a Volkswagen.

Volkswagen makes the 3 highest mileage cars in America: the Rabbit Diesel 5-speed, Rabbit Diesel 4-speed and the Dasher Diesels.
Rabbit Diesel 5-speed est 41 mpg, 55 mpg est hwy. Rabbit Diesel 4-speed, est 40 mpg, 50 mpg est hwy. Dasher Diesels est 36 mpg, 46 mpg est hwy. Compare these EPA est. to the est. mpg of other cars. Your mileage may vary with speed, weather and trip length. Hwy mileage will probably be less.)

Figure 1-4
Print Advertisement, "Or buy a Volkswagen," 1980
Agency: Doyle Dane Bernbach, New York, NY
Art director/artist: Charles Piccirillo
Writer: Robert Levenson
Client: Volkswagen

Figure 1-5
Founders Financial
Corporation Logo, 1990
Design Firm: Concrete,
Chicago, IL
Designers: Jilly Simons,
David Robson
Client: Founders Financial
Corporation

Founders Financial Corporation is the parent company for The Founders Bank. The logo was inspired by an Ionic column, which suggests strength; a Nautilus shell, referencing the Florida location of the company; and the initials of the company name (two lowercase f's).

Jilly Simons, Principal, Concrete

without television graphics or with blank compact disc covers; imagine all packaging looked the same. That would be a world without graphic design.

Graphic design can be defined as the application of art and communication skills to the needs of business and industry (which is why it was once called commercial art). These applications could include: marketing and selling products and services; creating visual identities for institutions, products, and companies; environmental graphics/signage; information design; and visually enhancing messages in publications. Mass communications media—print, film, and electronic—are the vehicles for these visual messages. Whenever you read an advertisement or see a logo, you are on the receiving end of communication through design (See Figures 1-4 and 1-5). A design can be so effective that it influences your behavior; you may choose a particular product because you are attracted to the design of its package or to its advertisement.

The Graphic Designer's Job

Graphic designers use words (type), and pictures and other graphic elements (visuals) to communicate. Their art is a visual-verbal expression. The graphic designer mediates between a

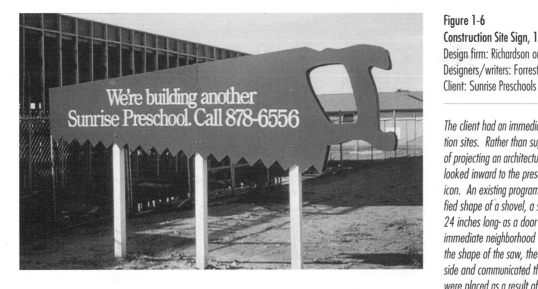

Figure 1-6
Construction Site Sign, 1988
Design firm: Richardson or Richardson, Phoenix, AZ
Designers/writers: Forrest Richardson, Valerie Richardson
Client: Sunrise Preschools

The client had an immediate need for a sign to identify new construction sites. Rather than supporting the usual, non-creative, approach of projecting an architectural image of the building, the design team looked inward to the preschool's marketing program for a related icon. An existing program by Richardson or Richardson used a simplified shape of a shovel, a saw, and a key - all die-cut cardboard about 24 inches long- as a door hanger direct delivery program to the immediate neighborhood where new schools were being built. Taking the shape of the saw, the designers simply turned the shape on its side and communicated the simple message. More than 600 calls were placed as a result of the coordinated sign and delivery program as both marketing and signage tied together to support a single image and identity.

Richardson or Richardson

Figure 1-7, Print Advertisement, "Confining," 1992
Agency: Chuck Ruhr Advertising
Art director: Randy Hughes
Writer: Bill Johnson
Photographer: Steve Umland
Client: Minnesota Department of Public Safety

Figure 1-8
Ads, Harley-Davidson
of Dallas, 1992
Agency: The Richards Group
Creative director/writer:
Todd Tilford
Art Director: Bryan Burlison
Photographer: Richard Reens
Client:
Harley-Davidson of Dallas

Warning: People don't like ads.
People don't trust ads.
People don't remember ads.
How do we make sure this one
will be different?

Why are we advertising?
To announce the introduction of
a clothing line to the Harley-
Davidson store in Dallas.

Who are we talking to?
Weekend rebels. Middle-class
men who are not hard-core
bikers (they may not even own
motorcycles), but want a piece
of the mystique.

What do they currently think?
"Harley-Davidson has a badass
image that appeals to me."

What would we like them
to think?
"Harley-Davidson now makes
clothing that reflects that wild,
rebellious image."

What is the single most per-
suasive idea we can convey?
Harley-Davidson clothing re-
flects the rebellious personality
of the Harley-Davidson biker.

Why should they believe it?
Harley-Davidson bikers shop for
their clothes at Harley-Davidson.

Are there any creative
guidelines?
Real and honest. Should be
viewed favorably by hard-core
Harley-Davidson bikers.

The Richards Group

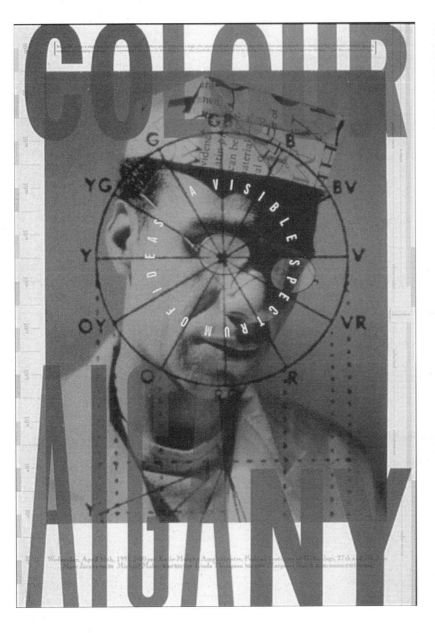

The perfect Philly pick up line "Yo, Steve!"

S. J. Cab Company

Steve's not the prettiest thing, but he does go all the way. Wherever you want to go.
215-850-4811

client with a message to send and the audience. Visuals and words are used by the designer on behalf of the client in order to inform, persuade, or sell (See Figures 1-6, 1-7, and 1-8).

Regardless of the specific task, the graphic designer has two interconnected goals. They are to communicate a message to an audience, and to create a compelling or pleasing design that will enhance the message (See Figure 1-9). Like other communicators, the graphic designer works to make the message clear and, like any other artist, the graphic designer is con-

cerned with aesthetics. Whether these goals are achieved depends on how well the designer understands the design medium and the design problem given.

Design is the arrangement of parts into a coherent whole. Graphic designers take parts—words, pictures, and other graphic elements—and arrange them into unified communications in formats such as advertisements or posters (See Figures 1-10 and Colorplate 1). Graphic designers, therefore, need to fully understand the fundamental elements and principles of design. These elements include: line, shape,

volume, texture, color, and format. These principles include: balance, emphasis, rhythm, unity, positive-negative space, and the illusion of three-dimensional space.

The fundamental elements and principles of design are the foundation of a design education—like understanding the basic parts of speech and the principles of composition before writing a novel. Ideally, these basics are studied before attempting practical applications. This book will cover the basics of graphic design.

The Design Procedure

The best way to learn design is to learn to think like a designer. You need to question and experiment. Why did the designer arrange the page like that? Why did this designer choose that color? Learn to constantly ask *why* and *how* about designs you see. It is equally important to learn to experiment with the creative process— to learn by doing. In the beginning of a design course, it's difficult to know how to begin to solve a design problem. The following procedure will help you.

Step 1: Restate the problem in your own words.

Understand the goal. If you don't understand the assignment or goal, your solution will not be on target. Write the goal or problem on an index card and keep it in front of you as you work on the solution.

Step 2: Do any research that needs to be done.

Do you need to know more about your topic? If you do, obtain information, photographs, and materials at this stage of the process. Go to the library. This is a crucial stage and most students mistakenly think they can do a good job without it. Researching your topic will provide many points of departure that might not have occurred to you off the top of your head. Finding photographs and visuals that relate to your assignment can be extremely useful.

It's a good practice to keep an "idea book," which is a collection of art reproductions, illustrations, photographs, advertisements, graphics, or any imagery you find stimulating and exciting. You can use this collection of materials as a source book because sometimes you may need references in order to create your design. Remember, an idea book is not for the purpose of plagiarism—it is for inspiration and reference.

Step 3: Think with your pencil or mouse in your hand!

Sitting and thinking is not enough most of the time. Draw something. Doodle. Sketch. One visual leads to another. It doesn't matter how good or bad your first sketch is—just sketch. Thumbnail sketches are preliminary, small, quick, rough designs or drawings of your ideas. Create many of them. Judging your sketches at this stage may inhibit your creative energy, so just keep sketching. Thumbnail sketches allow you to think visually. Coming up with many thumbnail sketches may be frustrating at first, but the process will become more natural. (Unfortunately, many beginners are happy with their first and, often, only solution.) Thumbnails should be done to scale, if possible, and in the right proportion. For example, if your finished design solution will have to fit into a rectangular space, do your thumbnails in proportional rectangles. Whether you're thinking with a pencil, marker, mouse, or light pen in your hand, create lots of thumbnails.

Step 4: Choose your three best thumbnail sketches and turn them into roughs.

Roughs enable you to visualize your ideas more realistically. Roughs are sketches that are larger and more refined than thumbnails and show the basic elements in a design. Roughs allow you to test ideas, methods, techniques, tools, and colors. (Although some designers go directly from thumbnails to comps, it is better for students to work out their ideas more fully before going to a comp.) If the thumbnails you have chosen to turn into roughs do not work, go back over your other thumbnails and turn some of them into roughs. Here's a tip: Working on tracing paper will enable you to combine ideas by tracing parts of different roughs onto another page. Working on a computer will allow you to do the same, and also allows you to change typefaces and colors in an instant.

It is a good idea to wait a day or so between creating roughs and creating comps. The time in between will give you a fresh perspective on your work.

Step 5: Choose your best rough and turn it into a comp.

Make it look like the real thing. A **comp** or **comprehensive** is a detailed representation of a design. Type, illustrations, photographs,

paper stock, and layout are rendered closely enough to the finished product to convey an accurate impression of the printed piece. The term mock-up is used to describe a facsimile of a printed three-dimensional design piece.

A comp is important—it is your solution to the design problem. This artwork must be extremely clean and accurate, as it represents both you and your work. You want people to notice your idea, not your fingerprints or uneven cut marks. Very often the comp is used as a guide or "blueprint" for the printer.

Critique Guide

A **critique** is an assessment, an evaluation of your project. Assessing your solution maximizes your learning because it forces you to re-examine the problem, to evaluate the way you went about solving the problem, to determine how well you used the design medium, and to see if you fulfilled your objectives. Most design instructors hold a critique or critical analysis after students create solutions to a design project. Holding your own critique before you present your work to a class, an instructor, or a client allows you to check your thinking and gain insight into your particular style of problem solving. How do you hold a critique? Here's a guide:

Part I: The Project

1. Restate the goal or aim of the project in your own words. Make sure you understand the project or problem.

2. Did you fulfill the goal or did you miss the point of the original problem? At times, you may come up with an approach to a problem that does not directly answer the problem, but you like it and pursue it regardless. Be aware that sometimes it pays to let go of a gimmick or approach that is not on target, even if you love it.

3. Is your solution appropriate for the purpose of the project? Often, it can be difficult for beginners to determine when a design or a design element is inappropriate. For example, if you design a business card for a banker, you certainly would not want to create a design that conveyed a playful or unstable spirit.

4. Is your solution appropriately executed? Is your choice of color, media, size, and style right for the purpose or goal of the problem?

5. Did you create a hierarchy of information? Have you designed your solution so that your audience knows what to read or look at first, second, and third?

6. Does your solution communicate the intended message to your audience? Ask people to tell you what message they are receiving from your design.

Part II: The Process

1. Did you do any research? And if so, did you use it? If you did not do any research, how did you gather information about the subject matter? Do you need to do more? (Whether you go to the library, or access photo archives, or use an encyclopedia on CD-ROM, make sure you do research.)

2. How many thumbnail sketches and roughs did you do before creating the comp? How much time did you spend thinking about the problem? Did you go to the finish before working out any bugs in the solution?

3. Did you lock yourself into your own area of strength rather than experimenting with less familiar tools, techniques, or methods? For example, if you always use the computer to create your design, were you willing to try cut paper or another technique?

4. Did you make any false assumptions about what you could or could not do, or did you take a positive approach and assume you could do anything if you really tried? Did you experiment? Experimentation is very important; it can lead to exciting discoveries. Even mistakes can yield interesting results. For example, if you accidentally move an image while it is being photocopied, the copy will be distorted. The distortion may be interesting and appropriate for your needs. You can also use flip, stretch, skew, or speckle commands on the computer to experiment.

5. Did you really become involved with the problem? Did you use your intuition and feelings? Was your solution person-

Figure 1-11
Logo, "Day Without Art," 1990
Design firm: M Plus M Incorporated,
New York, NY
Art directors: Takaaki Matsumoto,
Michael McGinn
Designer/illustrator:
Takaaki Matsumoto
Client: Visual AIDS

This logo was for the first, annual demonstration day titled "Day Without Art", sponsored by Visual AIDS, a non-profit AIDS awareness organization.

al or removed? Not everyone finds the same subject matter or project exciting. Remember, it is not the subject or the project that is exciting, it is what you do with it.

6. Were you too judgmental? Did you give yourself a chance to be creative? Were you patient with the project and with yourself? Try to be as supportive of your own work as you would be of a friend's work.

7. Did you take chances? Were your solutions innovative? Did you dare to be different, or did you do what most people would do? When the critique is held in class, one way to test whether your solution is original is to notice how many others came up with similar solutions.

This critique guide is in the first chapter so you can use it for all the projects in this text. It will make a great deal more sense once you actually apply it to your projects. Make a photocopy so it is always handy. The process of assessing your own and others' work will become more natural with practice and you will see that critiques are essential to learning.

You can learn an enormous amount about graphic design by studying your work and the work of others. In addition to assessing what you have learned from your own solution to a project, it is helpful to notice how others have successfully solved the same problem. Did they approach the problem the same way as you did? What did they do differently?

Another way to improve your analytical skills is to assess the advertisements you see, the design of logos and magazines that you come across, or any graphic design (See Figure 1-11 and Colorplate 2). One of the advantages of studying graphic design is that you are surrounded by examples, both good and bad. Turn on the television and you see commercials (See Figure 1-12). Take a drive and you see billboards (See Figure 1-13). Go to the market and you see package design (See Figure 1-14). Become a critical observer—you can always learn something through observation.

You may begin to notice you enjoy some styles or some areas of design more than others. Are you more attracted to classical or unconventional design? (See Figures 1-15 and 1-16). Noticing what you like may help you decide on the direction of your graphic design career.

Figure 1-12
Television commercial,
"Faster, Faster"
Agency: DDB Needhan,
New York, NY
Art director: David Angelo
Writer: Paul Spencer
Agency producer: Eric Herrmann
Production Company:
Coppos Films
Director: Brent Thomas
Client: New York Lottery

Figure 1-13
Outdoor Board, 1992
Agency: Phillips-Ramsey,
San Diego, CA
Art director: Robert Kwait
Writer: Art Bradshaw
Illustrator: Darrell Milsap
Client: San Diego Wild
Animal Park
©1992 Zoological Society
of San Diego

*This board was utilized to
promote a robotic dinosaur
exhibit at the San Diego Wild
Animal Park.*
*The board was placed in
different locations, adjusting the
mileage line to promote the
proximity of the Park.*

Elizabeth Bell, Vice President,
Account Supervisor

Only 22 miles as the Pteranodon flies.
Wild Animal Park

Figure 1-14
Cocolat Retail Packaging, 1988
Design firm: Morla Design, San Francisco, CA
Art director/designer: Jennifer Morla
Client: Cocolat, Berkeley, CA

Morla Design created an elegant, cost-effective product packaging system for gourmet chocolates. Due to budget constraints, each individual package was specified as black plus one PMS color, and a color palette was designed to unify all the two-color packages in a multi-colored product line. The elegant labeling and reusable containers make these packages attractive gifts.

Morla Design

Figure 1-15
Logo
Designer: Paul Rand
Client: IBM Corporation

Figure 1-16
57th Annual Awards
Banquet Poster, Invitation and Admission
Agency: Weiden & Kennedy, Philadelphia, PA
Creative director: Vince Engel
Art director/writer: Paul Renner
Client: Art Director's Club of Philadelphia

Looking At The Illustrations

As stated earlier, an enormous amount can be learned by studying the work of others. Whether you study the work of your peers in class, examine the examples of work in this text, closely observe your instructor's demonstrations, or analyze masterworks, you will enhance your learning by asking *how* and *why* others did what they did. The examples provided in this text are just that—examples. There are innumerable solutions to any exercise or project. The examples are here to give you an idea of what is possible and what is in the ball park; they are not meant to be imitated, nor are they by any means the only "correct" solutions.

Creativity in graphic design, or any visual communications discipline, is not measured in terms of right and wrong, but rather by the degree of success demonstrated in problem solving, applying visual skills, and expressing personal interpretations.

When you look at the examples of the greats—the highly respected professionals in the various art fields—do not look at them and think, "Oh, I could never do that." Instead, think, "This is great stimulation. I could learn a lot from these people." We can and should learn from the creativity of others. Creativity can be enhanced by study. It is simply a matter of deciding you can be creative and having someone guide the way.

Approaching the Advertising Problem

Understand the Facts
- The market — industry - sales competition
- The consumer — who, where, why
- The competition — who, where, how
- The presentation — packaging
- The position

Develop A MARKETING PLAN - based on Facts.

Develop A Position

Promote a STRONG point — what sets the product apart from the competition in the eyes of the consumer.

Consumer Benefit
Unique Selling Proposition (USP)
Primary Selling Proposition (PSP)

Where do you want to "go" with the adverting — a creative idea which is presented to the client for the "go-ahead" to develop the idea.

- Strong Reconigtion of Brand
- Get to the Point
- Make sure you address the T.A.
- A strong USP
- A strong PSP
- A strong Consumer benefit

- Encourage action (call, write)
- Expansion capabilities (a campaign)

Chapter 2
Fundamentals of Graphic Design

Objectives

■ to understand and be able to design with the formal elements—line, shape, color, value, texture, and format

■ to understand and be able to employ principles of design—balance, emphasis, rhythm, and unity

■ to be able to manipulate graphic space

PART I: FORMAL ELEMENTS

Draw a line on a page (paper or electronic). Now add another line. This seems like a simple exercise, but here are a few questions. Where did you draw the first line on the page—at the top or at the bottom? Where did you draw the second line? Were they on angles? How long were the lines? How thick were the lines? Did the lines touch? Did the lines bend or curve, or were they straight? If you used a computer, which tool did you use, the straight line or the curve tool?

How can drawing two lines on a page become so complicated? If you think of the two lines as the first two moves in a chess game, you can begin to see how important each is to the outcome. As soon as you draw one line on a page, you begin to build a design.

Lines are one of the basic building blocks of design. These building blocks of two-dimensional design are called the formal elements. They are:

• line
• shape
• color
• value
• texture
• format

These elements are at the foundation of all graphic design.

Line

You probably have been drawing with lines for years, and never stopped to define or analyze them—probably because a line seems like a simple element.

Let's start with a definition. A **line** is a mark made by a tool as it is drawn across a surface. The tool can be almost anything—a pencil, a pointed brush, a computer and mouse, even a cotton swab. A line can also be cut into a hard surface—this practice is called engraving. Sometimes a line is defined as a moving dot or point. In this sense, moving the point of a pencil across a page creates a line. A line can also be called an open path.

Considering a line as a moving point may prompt you to ask some questions. In what direction is the line moving? What happens if you move your mouse up and down or your hand up and down while moving the point of your pencil? If you use a rosebud dipped in ink to make a fat, short mark—is it a line? Are all lines the same? What you discover as you ask these questions and explore this element is that there are different types of lines and all lines have direction and quality. Establishing a vocabulary allows us to discuss the aspects of lines intelligently.

The first and most obvious category is line type. A line's **type** or **attributes** refers to the way it moves from its beginning to its end. Lines may be straight, curving, or angular. This is a simple difference that can be used to distinguish different types of lines.

The second category is line direction. The **direction** of a line describes a line's relationship to the page. Horizontal lines move across the page, east to west or west to east. Vertical lines move up and down on the page, north to south and south to north. Diagonal lines look slanted in comparison to the edges of a page.

Figure 2-1
Diagram: Representational shape
Illustration: Rose Gonnella

Figure 2-2
Diagram: Non-representational shapes
Illustration: William Stanke

The final category that we will discuss is line quality. **Line quality** refers to how a line is drawn. The adjectives we use to describe the qualities of lines are the same we might use to describe music or a voice. A line may be delicate or bold, smooth or broken, thick or thin, regular or changing. All these adjectives, as well as many others, describe a line's visual quality.

It is important to remember that all three of these categories applied when you were asked to draw two lines on the page. For example, you may have drawn a thin, angular line that moved in a diagonal direction, or you may have drawn a smooth, curving line that moved in a horizontal direction. As you can see, these three categories—type, direction and quality—give us a vocabulary to completely describe the lines we draw.

Shape

You already know what a shape is. Looking at a jacket in the store, you may think, "Well I like the color, but I don't like the shape." Or you might like the shape of one car and not another. The general outline of something is a **shape**; it can also be defined as a closed form or closed path. There are many ways to depict shapes on a two-dimensional surface. One common way is with lines. Lines can be used to describe a flat shape, like a triangle or square, or a volumetric shape, like a pyramid or a cube. A shape can be open or filled with color, tone, or texture. How a shape is drawn gives it a quality; a shape may be curving or angular, regular or changing, flat or volumetric, and so on.

We can translate the three-dimensional forms of the real world into representational two-dimensional shapes on a page by describing their particular edges using lines (See Figure 2-1). We can also create non-representational shapes with lines (See Figure 2-2). In this way, lines are used as outlines or edges, clearly defining the limits of forms. This method of describing shapes is termed linear. We apply this term to art when there is a predominant use of lines to describe shapes or when lines are used as a way to unify a design. The illustration for the Moving Announcement for Authors & Artists Group is linear; lines are used to describe the objects and map and to unify the illustrations (See Figure 2-3).

There are ways other than using lines to create shapes on the two-dimensional surface. Color and collage are two examples. An area of color (or an area of gray created by black and white) that is *not* surrounded by a line, yet is

Figure 2-3
Moving Announcement
Design firm: Robert Valentine Incorporated,
New York, NY
Designer: Robert Valentine
Client: Authors & Artists Group

clear and distinct, is considered to have a hard edge and can define a shape, as in this graphic identity by Harp & Company (See Colorplate 3). The same is true for collage. **Collage** is the act of cutting and pasting different bits of materials, like lace, paper, sandpaper, or photographs, onto a two-dimensional surface.

Color

Do you always know which color shirt to wear with a suit, or do you have problems selecting colors for your wardrobe? Do you notice when people are wearing colors that do not suit their complexions? Do you have definite color preferences?

The whys and hows that relate to color come more easily to some than to others, but one thing is certain—the study of color deserves your attention. It is a powerful and highly provocative design element. If you have ever studied painting, then you know how difficult it is to learn to select and mix colors and create interesting and successful visual effects with color. Color is difficult to control when creating an original work, and even more so when a work is reproduced in print or on film.

We can discuss color more specifically if we divide the element of color into three categories: hue, value, and saturation. **Hue** is the name of a color, that is, red or green, blue or orange. **Value** is the range of lightness or darkness, that is, a light red or a dark red, a light yellow or dark yellow. Shade, tone, and tint are different aspects of value. **Saturation** is the brightness or dullness of a color, that is, bright red or dull red, bright blue or dull blue. Chroma and intensity are synonyms for saturation.

In paint or pigment such as watercolors, oils, or colored pencils, the primary colors are red, yellow, and blue. They are called primary because they cannot be mixed, yet other colors can be mixed from them. Mix red and yellow and you get orange. Mix yellow and blue and you get green. Mix red and blue and you get violet. Orange, green, and violet are the secondary colors. You can mix these colors and get numerous variations.

Suggestions

- Choose colors appropriate for your design concept.

- Choose colors that will communicate your client's spirit or personality.

- Make sure the colors will enhance the readability of the type.

- Examine the amount of color contrast in your design. Is there enough contrast to create visual impact?

- Create many color sketches (at least twenty). This is very easy to do on a computer. If you do not have a computer, make a line drawing, make several copies on a copier, and then color them with markers.

- Try to design the same piece with one color, two colors (a limited palette and budget), and then with full color.

- Analyze the use of color in successful contemporary and master design solutions.

- When designing with color on a computer, remember you are looking at an electronic page and the color will look different when printed on a reflective surface.

- Study the use of color in the history of graphic design.

- Study color symbolism in different cultures. Color symbolism is not universal—red may mean one thing in one culture and something else to another.

- Stay abreast of the trends in color. Look at recent CD covers, book jackets, magazines, and packaging.

- Visit a printer. Go to paper shows. Visit a design studio. Talk to printers, paper sales representatives, and professional designers about color and paper stock, special effects, special colors, and varnishes.

Color on a computer is made by mixing light, which acts differently than pigment. When working with light, the three primaries are green, red, and blue. Mix red and green and you get yellow. Mix red and blue and you get magenta. Mix green and blue and you get cyan. White light is produced by mixing the three primary colors; these primaries are also called the additive primaries because when added together they create white light. When working on the computer's color palette you can mix more than 16 million colors. On many computers, you can display at least 256 colors on the screen simultaneously.

In printing, yellow, magenta, and cyan are the colors of the process inks used for process color reproduction. A fourth color, black, is added to increase contrast. Using all four is called four-color process. Four-color process is used to reproduce color photographs, art, and illustrations. Printing inks can be matte, high gloss, metallic, fluorescent, transparent, opaque, or coated with varnish; printing inks also can be non-toxic, non-flammable, and non-polluting. There are books available that illustrate the various mixtures resulting from mixing two, three, or four colors. The Pantone Matching System, (PMS), offers many custom mixed colors with PMS books to illustrate the available colors, for example.

There have been many scientific studies of color as well as many unscientific theories. (You may want to read the color theories of Josef Albers, Johannes Itten, and Faber Birren.) Most of what you need to know about color and its use in graphic design will come from experimentation, experience with print production, and observation. In graphic design, color depends on the use of printing inks, so color choices can be dictated by budget constraints, as well as a client's needs and a designer's or client's taste.

Allow your design solution to guide your color choices; some colors are more appropriate than others for certain problems or clients. For example, if you were to design a one-color logo for an insurance company you probably would not choose pink. In popular culture, pink may be thought of as a frivolous color and therefore would not be appropriate. Notice the color choices that award-winning designers make and ask yourself why they made those choices.

If you make keen observation a habit when looking at existing package, poster, film, or any other design, it will become an integral part of your design education. You may have noticed

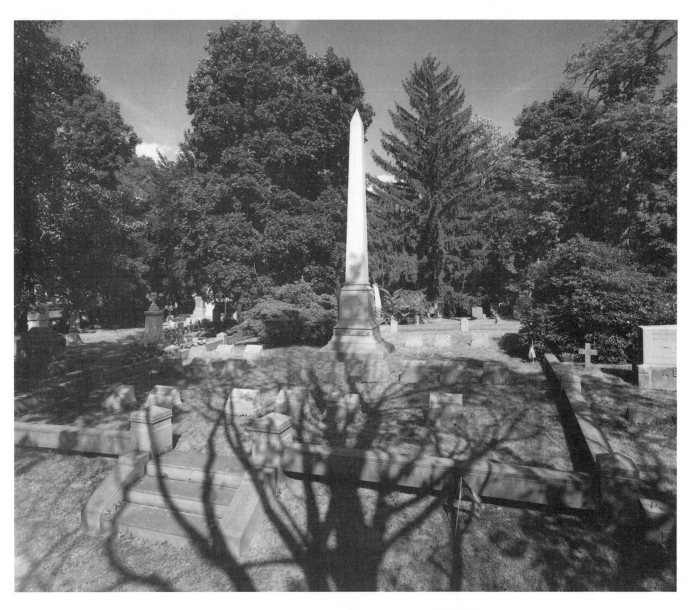

that gold, for example, is often used in the package design of cosmetics; it is associated with luxury and quality. Try not to lock yourself into using your favorite colors in all your design solutions. Experimentation, experience, and keen observation will help develop your ability to use and control color.

Value

Look at this black and white photograph, entitled the "Richards Family Plot" (See Figure 2-4). This photograph is from a commissioned project by the New Jersey Historical Society, Newark, New Jersey; the project is called "Urban Oasis: Newark's Mt. Pleasant Cemetery," and Tony Velez was the project photographer. Notice all the shapes, details, and textures and ask yourself which formal element gives them depth or dimension. It is value. Value is the term we

use to describe the range of lightness or darkness of a visual element.

The relationship of one element (part or detail) to another in respect to lightness and darkness is called value contrast. This allows us to discern an image and perceive detail. We need value contrast in order to read words on a page. If the words on a page were almost the same value as the page, then it would be difficult, if not impossible, to read them. Most text type is black and the page white—it gives the most contrast.

Different value relationships produce different effects, both visual and emotional. When a narrow range of values, which is called low contrast, is used in a design, it evokes a different emotional response from the viewer than a design with a wide range of values, or **high contrast**. The **low contrast** of this booklet cover for Barney's is achieved with a vellum

Figure 2-4
Photograph, "Richards Family Plot," Mt. Pleasant Cemetery Project, Newark, NJ
Photographer: Tony Velez, Brooklyn, NY
Client: New Jersey Historical Society, Newark, NJ

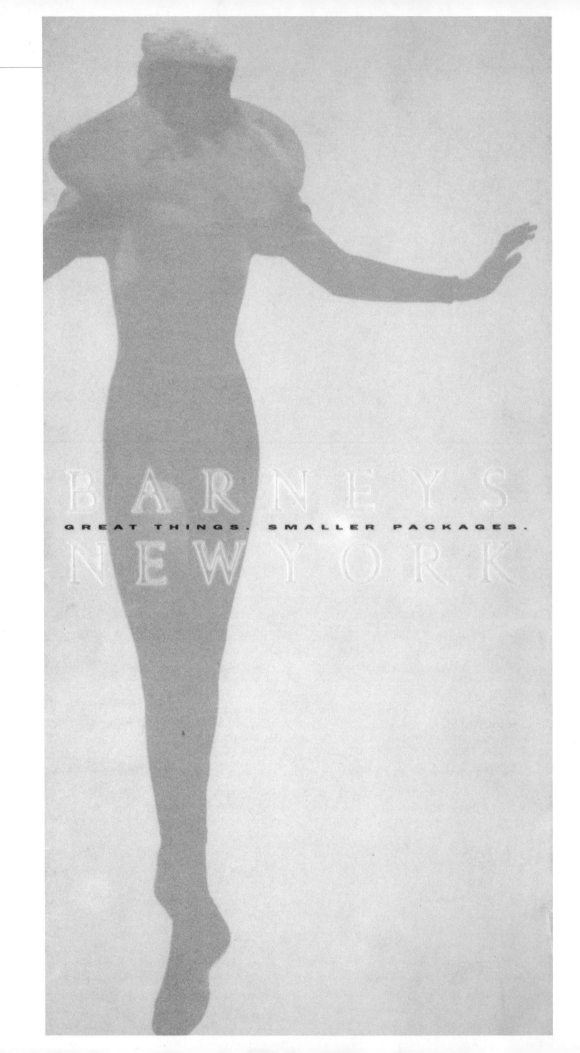

BARNEYS NEW YORK

GREAT THINGS. SMALLER PACKAGES.

Figure 2-6
Poster for Greenleaf Medical,
1990
Design firm: Earl Gee Design,
San Francisco, CA
Art director/designer: Earl Gee
Photographer: Geoffrey Nelson
Client: Greenleaf Medical

This is a poster for Greenleaf
Medical, a developer of a
computerized hand evaluation
system for hand surgeons and
therapists. It is designed as art
for the offices and clinics of
hand surgeons and therapists.
The poster combines a diverse
array of hand-related quotes and
hand visuals to portray the hand
as a universal symbol of time
and utility.

Earl Gee, Principal,
Earl Gee Design

overlay, a somewhat transparent covering over the photograph (See Figure 2-5). The high contrast in this poster for Greenleaf Medical, a developer of a computerized hand evaluation system for surgeons and therapists, creates dramatic light and dark effects (See Figure 2-6).

Texture

Sometimes you decide just by looking at a texture whether or not you want to touch it. Some textures are appealing, like velvet, while others, like rust, are not. Velvet, rust, linen, and hair all have texture. The tactile quality of a surface or the representation of such a surface quality is a texture. In art, there are two categories of texture—tactile and visual. Tactile textures are real; we can actually feel their surfaces with our fingers. Visual textures are illusionary; they simply give the impression of real textures.

Tactile textures can be created in many ways. You can cut and paste textures, like lace or sandpaper, to a surface; you can create an embossing (a raised surface) by impressing a texture in relief; or you can build up the surface of a board or canvas with paint, which is called **impasto**. Creating the illusion of a texture or the impression of a texture with line, value, and/or color is called **visual texture**. One way to create visual textures is by grouping various lines together. Varying line qualities, types or attributes, directions, and lengths will yield a wide range of textures. Different drawing instruments will yield different line qualities, and the way you use the instruments will increase the variety. Visual textures can be created with direct marks made with pens, markers, pencils, computer software, and paint or with indirect marks made by rubbing or blotting tactile textures. On the computer, you can digitize textures like lace or crumpled paper, or you can buy a CD of

Figure 2-7
Poster for Rosarito to Ensenada 50 Mile Fun Bicycle Ride, Fall 1990
Design firm: Studio Bustamante, San Diego, CA
Designer/illustrator: Gerald Bustamante
Client: Bicycling West, Inc.

*The client wanted to add another date to an already established ride, but did not wish to produce a separate poster. In order to convey all that information as simply as possible, I took the graffiti wall approach, painted a tandem bicycle, and surrounded the image with all the pertinent information, as condensed as possible. It is not unlike a wall one might find in Ensenada, Baja California, Mexico.
Materials: acrylic/spray paint on cardboard*

Gerald Bustamente,
Studio Bustamante

textures. Compare the rough visual textures of the type and visual in this poster to the many intricate visual textures in this package design (See Figures 2-7 and Colorplate 4).

The method for creating visual textures is closely linked to that for creating patterns. Pattern can be defined as a repetitive arrangement of elements, like a wrapping paper design or a plaid shirt. These patterns were created by the designer Martin Holloway in preparation for a cover design (See Figure 2-8). Most textures create some sort of pattern, but patterns do not always have texture.

Format

Brochures, posters, business cards, book covers, shopping bags, envelopes, newsletters, magazines, and newspapers are just some of the many formats designers use. Whether it is a page or a business card, whatever you start out with is the **format**. The format is a vital element in two-dimensional design. Most beginning students take the format for granted, not realizing that it is an active element in design. If you think of an average page as two vertical lines and two horizontal lines joined at right angles, then the first line you draw on a page is actually the fifth

line. Like that fifth line, all of the other formal elements are contained by, and interact with, the original shape of the format.

If you draw lines on a given format, like on a page or business card, the lines can be either parallel to the format or move in an opposing direction. For example, if you draw a horizontal line on a rectangular electronic screen, it will be parallel to the horizontal edges of the screen. However, if you draw a diagonal line on the same screen, the line moves in an opposing direction at the edges.

There are many categories of formats and each one—like shopping bags or magazines—has a different function, with advantages and limitations that must be considered in the design solution. Some formats, like posters, are meant to be seen from a distance. Others, like print advertisements or business cards, are meant to be seen up close. You need to consider how a format will be seen or used. Within each category of format there are differences as well. For example, both *TV Guide* and *Rolling Stone* are magazines, but they are different sizes.

There are as many different formats as there are ways to shape and fold paper. Take a regular 8 1/2" x 11" sheet of paper. If you use the

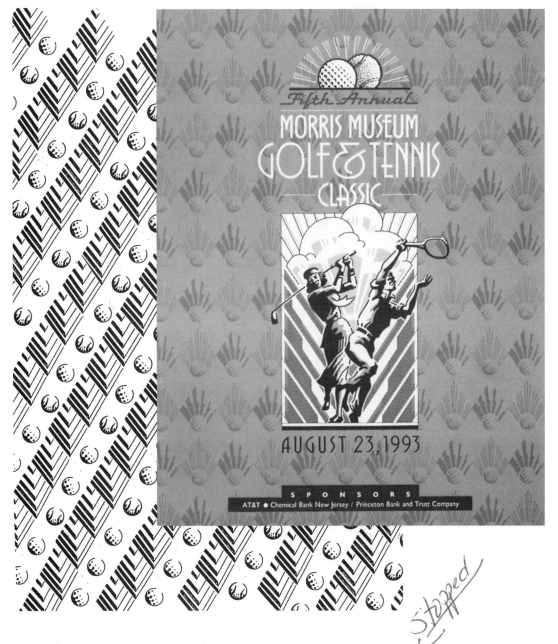

Figure 2-8
The Morris Museum Golf &
Tennis Classic Booster Book,
1993
Design firm: Martin Holloway
Design, Warren, NJ
Designer: Martin Holloway
Client: The Morris Museum,
Morristown, NJ

entire single sheet, you are working with a standard rectangle. If you fold it to create a folder, then you have a different format, with different requirements. Fold it a different way and you have yet another folder with new challenges. When working on the computer, select different sizes. For each format, you must consider its size, shape, and where and how it will be seen and how it will be used.

Knowing how to use these formal elements is essential to building a design. Every choice you make about color or shape is important. All the formal elements comprise your team of players on the page; they are interdependent and interact with one another. Whether you want to design a newsletter or a logo, the formal elements are always the same.

PART II:
THE PRINCIPLES OF DESIGN

Balance

You strive for balance in many aspects of your life: in your meals, in your budget, and between your work and play. When you arrange furniture and art objects in a room, you make decisions about balance. At times, you can be so sensitive to the position of things that you might move a couch or a vase for hours until it looks "right." This sense of balance functions similarly in graphic design.

Very simply, **balance** is an equal distribution of weight. When a design is balanced we

Figure 2-9
Poster, "Between the Wars," 1977
Design firm: Chermayeff & Geismar,
New York, NY
Client: Mobil Corporation

This poster was designed to promote a television series on events during the period 1918-1940, with emphasis on the successes and failures of diplomacy. The hats symbolize the two wars, and the diplomacy between them.

Thomas H. Geismar, President,
Chermayeff & Geismar, Inc.

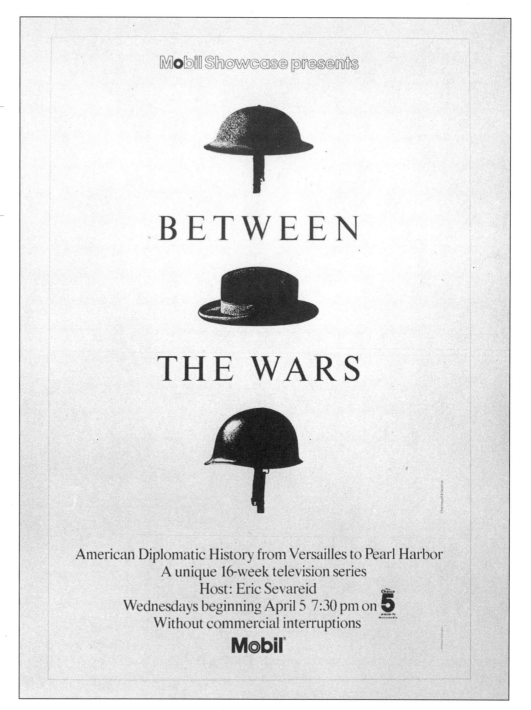

tend to feel that it holds together, looks unified, and feels harmonious. When a design is imbalanced it can make us feel uncomfortable. Understanding balance involves the study of several interrelated visual factors: weight, position, and arrangement.

When you make a mark on a page, that mark has a visual weight—it can appear to be light or heavy. **Visual weight** can be defined as creating the illusion of physical weight on a two-dimensional surface. To better understand this idea, imagine a mark on a page can be held in your hand and you can feel its weight.

The size, value, color, shape, and texture of a mark all contribute to its visual weight.

Where you position the mark on the page also affects its visual weight. The same mark positioned at different points on a page—bottom right, bottom left, center, top right, or top left—will appear to change in visual weight because of its position. In visual perception, different areas of the page seem to carry more or less visual weight. For example, the center of the page is very powerful and can carry a good deal of weight. Several studies of this phenomena have been conducted,

clichés, and are almost authorless. By repeatedly appropriating things that are out in the environment, without any identifiable source, they become part of a universal popular culture. They speak very clearly to the audience. Everybody knows what they mean, and the context that the designer puts them in will give them a certain slant. The "Loaf" poster is a good example. It says: "He is an idle man." and you have to decide whether you agree with that or not. When is he idle? Sitting in his lounger? Or is he an idle man who is working very hard physically, but not mentally? What does that mean? What do you think? What's your bias? ...**Edward Fella:** Or is he out of work? That was part of the discussion. The word "Loaf" has a double meaning. It is also a verb as in "Gee, all these people are loafing," when the truth might be that they're unemployed because there is no work, that masses of people are idle for other reasons than the fact that they themselves are somehow responsible. There might be no demand for their physical labor. Those were the questions that Scott Zukowski was raising with that particular poster. Also, it is important to know that that poster was a critical exercise. It was not meant to convey a particular message, the way Paul Montgomery's lunchbox was meant as a product. So the two, even though they use the same imagery, were done in a totally different context. However, in Montgomery's case too, it was hardly condescending. It was the idea of celebrating the working man or the work, that this was not something that should be ignored or marginalized or somehow made invisible. **Kathy:** Hugh also touched on a related discussion about the use of French Post-Structuralism and literary theory. He assumes that because there is a Marxist element in the literary theory, it is strange for largely upper middle-class graduate students in the Midwest to be applying these ideas. He was questioning the appropriateness. I think probably a lot of those ideas are fairly workable without that particular brand of late 20th century European intellectuals' Marxism. I think these ideas bend fairly well to an American social democratic populace. It can be anti-authoritarian, but in an American popular ethic, or better yet, a frontier individualist ethic, as opposed to the European late Marxist ethic. Hugh might contend that you can't separate it from the Marxism, but we feel you can.

! Loud dog bark !
! Loud dog bark !
! Loud dog bark !

Emigre: When I was in Switzerland, I met with many young Swiss designers who, each in their own way, were revolting against the legacy of designers such as Emil Ruder and Armin Hoffmann. They kept mentioning that Swiss Design "oversimplified" things, they mentioned that it "reduced the truth." My comments on some of the Cranbrook work would be that it often overstates the contents. Sometimes you can't see the trees for the forest. Is it possible to overstate the designs by using too much personal or cryptic or ambiguous meaning? **Scott:** Of course you can overstate messages. You try to draw a line, but there is a lot of work produced at Cranbrook that goes way over that line. But those are the things that shape you, and you can always pull back. If you don't go out far enough, you will never know what's possible. **Ed:** You know that adage about science taking very complex ideas and trying to simplify them, whereas philosophy takes fairly simple ideas and complicates them? Those are attitudes that exist within design, too. Sometimes, when there are

fairly simple messages to convey, the philosophical approach, complicating them, makes them more interesting. Another approach to design when you have very complex messages to convey is to synthesize and simplify them. **Kathy:** Every project is different and requires a different kind of treatment. Once you leave Cranbrook, you have to be capable of doing the range of design approaches ...**Ed:** Right! And nobody is advocating this "overstating" approach for a manual for, let's say, brain surgery. This "overstated" approach frequently is done for things that are cultural messages that would include a time, place, date and name, and where there isn't really anything in the information that's very complicated. But the culture that surrounds it; the context, is very complex, and that is what's put into these pieces.

! Baby cries !

Emigre: Part of the work produced at Cranbrook is explained as a reaction against Modernist ideas. In the book *Cranbrook Design: The New Discourse*, it is stated that there are "serious doubts about the function of the International Style as a means of visual communication," and that students have "challenged the sterility of this 'universal design'." But most of the work that you do here, in a reaction to Modernist ideas, is work that is played out in very ideological projects. It is not played out, for instance, in corporate identities, which is really where, in your eyes, Modernism has failed. The Cranbrook book shows posters for the most part; there is not one corporate identity shown. **Kathy:** In the alumni part of the book there are several logotypes. But yes, we really chose to publish the more polemical work. People come to Cranbrook after doing very systematic, program-driven work as professional designers. The idea is that during the two years at Cranbrook, you can involve yourself in more personal, more culturally oriented work. One thing that might not show up, but is certainly embedded in my own personal process, and I think it probably comes out in a lot of the critiques I give of work, was in an ongoing project called the "Vernacular Message Sequence." This project was more or less the foundation of our approach to graphic design, although we didn't show too many examples of this in the book. This project's sequence goes from the extremely analytical, reductivist approach, where you are working on a message analysis and coming up with hierarchies and structure as the entry point, before proceeding to the more creative expressive personal phases of the project. The project covers the full range, from the highly objective to the highly subjective. I believe that today, everybody learns this in undergraduate school, or has learned it on the job, before they come to Cranbrook, so we don't spend too much time doing that anymore. It's embedded in their thinking. It might not be visible in the final manifestation, but hopefully, as you approach the content, as you are reading it, you will get an intuitive sense of that structure. Nobody is following grids much, currently, but that thinking is embedded in our students' methodologies.

! Baby cries !

Scott: Are you saying that it might be interesting to see some work produced here that would challenge a more systematic approach? **Emigre:** Yes, I would find it interesting to see the experimental work that is done here be applied to, let's say, a huge corporate identity, instead of posters only. **Scott:** I think it is possible. It's one of many things possible, but it doesn't necessarily have to be studied here. Many of us have come to Cranbrook to more or less de-professionalize, and that means also ceasing to work on systematic projects for a while, to give our brain cells a little bit of a break and to look into other directions. **Kathy:** Scott Santoro has taken the experiments of his student work and is beginning to apply them to his professional work. Of course it is not quite as radical, but that is because he is working with different parameters, with strict program criteria. **Emigre:** But most of the work done by Cranbrook graduates is still for art institutions or culturally oriented projects. **Kathy:** Not all of it is, but yes, you will see that an awful lot of the work in the book is for somewhat culturally connected clients. One thing we talk about a lot here is the message, and how it is the designer's duty to take somebody else's message and give form to it, and how your design is only as interesting as the message. So one thing that people do when they leave here is look for the interesting clients who have something worth saying, as opposed to, for instance, discount shoe stores. If it's banal going in, it's going to be banal coming out, no matter how fine a designer you are. So on the one hand it's a process of natural selection. The work of the people that leave here is more appropriate for culturally connected things, but they're also very consciously seeking out interesting, worthy clients.

Katherine McCoy, P. Scott Makela and Mary Lou Kroh
Page from the book *Cranbrook Design: The New Discourse* '90

Book Format Design Concept.

The intention of this book format is to raise some questions about normal syntactic expectations in our readers. These ideas began in the essay "The New Discourse," published in ID (March/April 1988). The basic page proportion is based on a classical or traditional text block centered horizontally with generous margins on all sides. The Bodoni Book (by Bitstream) body copy face is generously leaded and justified, both also traditional book approaches. A centered axis runs through the copy block like a "Fault line" that offsets the right half of the text from the left a fraction of a horizontal line space. In the essay, word pairs are interwoven through the copy block organized on the centered axis. (This idea comes from the 1989 Design Department Poster.) The word pairs are dualities that describe to the range of possibilities in design: material/immaterial, geometric/poetic, critical/lyrical, etc. The tension point created by this central fault line refers to the creative tension found in design in the resolution of seemingly oppositional values, philosophies and forces such as art and science or the visual and verbal. This visual theme suggests the multivalent, ambiguous and continuously changing nature of design. This centered axis is referenced in the other essays as a thin vertical space (like a "lazy line" on a Navaho blanket) that runs vertically through each centered copy block. The line should be almost subliminal, almost not noticed. On the other hand, it almost seems to indicate that the page's text is divided into two columns, so the reader must see if reading sense comes from reading the full line across the lazy line. The page numbers are reversed out of a small block that has also been fractured on the fault line of each page. Since the essays are all together at the beginning of the book, the centered text block of Bodoni is a constant in all the essays to unify the section.
The book's title logotype continues the idea of the Fault line. Although each word itself remains in horizontal alignment, the frames that carry the words are fractured slightly as they cross the central axis of the type unit. The head and subhead are deliberately intermixed to encourage alternate readings, including "The New Cranbrook Design" and "The Cranbrook Design Discourse." A Victorian-era face called Egyptian (by Bitstream) is used in some of the heads, subheads and as part of the caption text. It has a 19th century book text look to it. It is frequently mixed with an early Modern face called Geometric (by Bitstream), a close relative of Futura.
The text, quotes, captions and photos are positioned to just meet at their left or right edges, suggesting patches of type or photos "pasted" onto the page. This sort of magnetic attraction between elements is also a departure from layout "norms." The images are generally centered in white space with generous margins, a traditional convention. The caption text faces are Geometric Bold, Bodoni Book and Egyptian; the various faces differentiate the various elements of the captions.
The intention is a conservative format rooted in classical book design, but with subtle interventions to break the rules of normalcy. Hopefully, on a quick scan, the pages appear traditional, but when read will reveal subtle aberrations that make the reader conscious of the syntax or grammar of book text.

Katherine McCoy

Figure 2-10
Spread from *Emigre* 19, 1991
Designer/publisher: Rudy Vanderlans
Typeface designer: Barry Deck

Ever since I started conducting my own interviews, I have been intrigued with the idea of how to recreate the actual atmosphere or mood of a conversation. Usually, as a graphic designer, you receive a generic-looking, typewritten transcript, written by someone else, that you lay out and give shape to. Before I start the layout of an interview, I have spent hours transcribing the tape, listening to the nuances of the conversation, the excitement in someone's voice, etc. Much of the expressive/illustrative type solutions that I use in Emigre are a direct result of trying to somehow visualize the experience of having a conversation with someone. Although this approach is not always successful (some readers are put off by the often "complex-looking" texts), when it does work, and the reader gets engaged in deciphering and decoding the typographic nuances, the interview inevitably becomes more memorable.

Rudy Vanderlans, *Emigre*

the most famous by Rudolf Arnheim.

There are basically two approaches to the arrangement of elements in a design. You can arrange all identical or similar visual elements so that they are evenly distributed on either side of an imaginary vertical axis, like a mirror image. This is called **symmetry**; it is always balanced.

The design of this poster, "Between The Wars," is symmetrical (See Figure 2-9). All the elements are centered. Imagine a vertical axis dividing the poster in half. You can see an equal distribution of weight on either side of it. When you arrange dissimilar or unequal elements of equal weight on the page, it is called **asymmetry**. This spread from *Emigre* is asymmetrical but balanced (See Figure 2-10). The

Figure 2-11
HMV "Oscar Pettiford" Poster, 1990
Design firm: Frankfurt Balkind Partners, New York, NY
Creative directors: Danny Abelson, Kent Hunter
Designer: Johan Vipper
Photographer: Herman Leonard
Writer: Danny Abelson
Client: HMV Music Stores

Black and white photographs depicting various genres of music were combined with a tag line expressing the emotion of music. The HMV "dots" were carried over into video and newspaper advertising.

Kent Hunter, Executive Design Director and Principal, Frankfurt Balkind Partners

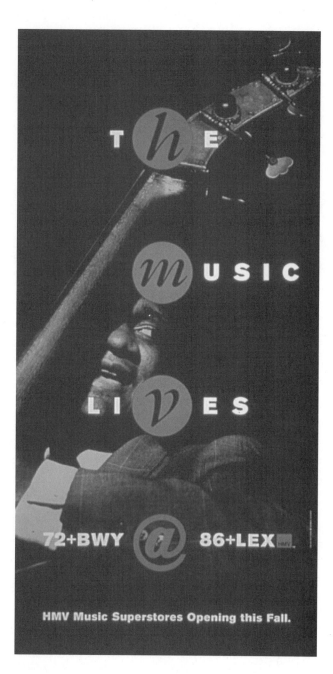

arrangement of elements, their visual weight, and position contribute to the balance.

To achieve asymmetrical balance, the position, visual weight, size, value, color, shape, and texture of a mark on the page must be considered and weighed against every other mark. The arrangement of all the elements—the **design** or **composition** of everything in relation to one another—is crucial to achieving asymmetrical balance. It is almost impossible to list ways to achieve asymmetrical balance because every element and its position contribute to the overall balancing effect in a design solution. If you move one element you may affect the delicate balance of the design. The

decision of whether to use symmetry or asymmetry in your design solution should be dictated by the subject matter, the message, and the feelings you wish to convey.

Emphasis:
Focal Point and Hierarchy

We constantly are bombarded by visual information; every poster, magazine, and brochure has lots of it. How does the reader or viewer absorb this information? How does the audience know what is most important? Most people are passive recipients and depend upon the designer to direct their attention. It is this

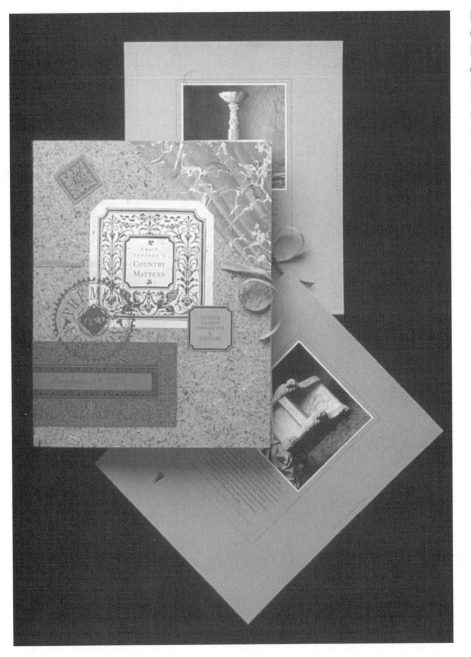

Figure 2-12
Catalog, 1990
Design firm: Pentagram Design Inc., San Francisco, CA
Art director: Kit Hinrichs
Designer: Susan Tsuchiya
Photographer: Barry Robinson
Client: Country Matters

Country Matters is a business that sources unique garden ornaments from around the world for sale to U.S. clients. They approached Pentagram for a catalog. The market is so exclusive, however, that an ordinary catalog would hardly have been appropriate. Instead, a "gift portfolio" was devised.

Each object was photographed and tipped into leaves of recycled paper with descriptions written in the manner of an art catalog and printed letterpress. The portfolios were individually numbered and addressed to clients.

Alison Merkley, Project Manager, Pentagram Design Inc.

need for direction that brings us to the importance of **emphasis** in design. Emphasis is the idea that some things are more important than others and important things should be noticed.

When you look at a well-designed poster, what do you look at first? You probably look at what the designer (and possibly the client) thought was most important. We call this point of emphasis the **focal point**—the part of a design that is most emphasized. The focal point of this poster (See Figure 2-11) is "hmv," the name of the HMV Music Stores. We are then led to all the other elements in the design because they have been arranged according to emphasis. How does the designer choose a focal point? A focal point (or point of focus) is usually deter-

mined by the relative importance of the chosen element to the message and by what the designer believes will attract the viewer.

The designer usually has a main message to communicate and other peripheral information or messages. For example, on a poster promoting responsible drinking, the message "drive sober" is much more important than who is sponsoring the poster. A primary focal point can be established along with supporting focal points, which we call **accents**. Accents are not as strongly emphasized as the main focal point. You first notice the title of this gift portfolio for Country Matters because it is centered, framed, and lighter in value than the rest of the cover (See Figure 2-12). The other typographic and

Figure 2-13
Book Cover, *The Cone With The Curl On Top, The Dairy Queen Story,* 1990
Agency: Little & Co., Minneapolis, MN.
Designers: Karen Geiger, Beth Madson
Illustrator: John Kleber
Client: International Dairy Queen
Courtesy of Little & Co.

The cover needed to say "history" and "Dairy Queen" so it was logical to use DQ's icon, the cone with the curl on top, and have it illustrated in a historical style.

Mary Moos,
VP-Marketing, Little & Co.

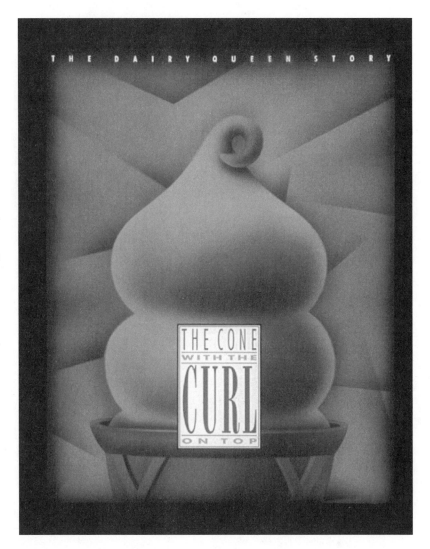

decorative graphic elements—the subtitle, date, decorative square in the upper left—are all accents.

It is important to remember that if you give emphasis to all elements in a design, you have given it to none of them. You will just end up with visual confusion. How can you establish a focal point? What type of elements dominate a page and in what way? The position, size, shape, direction, hue, value, saturation, or texture of a component can make it a focal point. Here is a list of possible ways to make something a focal point:

- make it brightest
- make it a different color
- make it in color if everything else is in black and white or vice versa
- make it go in a different direction
- make it a different value,
- position it differently
- give it a texture or a different texture than the other elements
- arrange all the elements to lead to it

- make it a different shape than the other elements
- isolate it
- make it clear and the other elements hazy
- reverse it
- make it an opaque color and the other colors transparent
- make it glossy and the other elements dull

Establishing a **visual hierarchy**, which means arranging elements according to emphasis, is directly related to establishing a point of focus. It goes beyond a focal point to establish a priority order of all the information in a work.

A) Where do you look first?
B) Where do you look second?
C) Where do you look third?

John Rea, vice president/creative director at McCann Erikson, New York, calls these questions the "ABC's" of visual hierarchy, where a few elements take emphasis or priority over other elements. To establish a hierarchy, decide

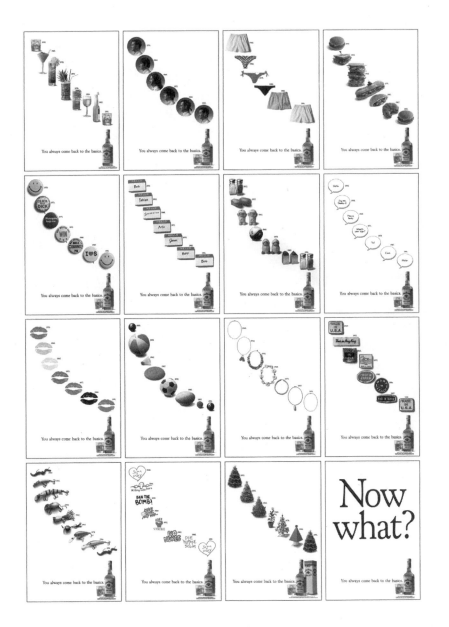

Figure 2-14
Direct Mail and Collateral Brochures
Agency: Fallon McElligott, Minneapolis, MN.
Art director: Bob Barrie
Writer: Jarl Olson
Photographer: Rick Dublin
Client: Jim Beam Brands

on the importance of the elements that are part of your design. Use factors like position, size, value, color, and visual weight to make sure your audience sees these elements in the order of importance. Create a flow of information from the most important element to the least. On this book cover, we first notice the title, *The Cone with The Curl On Top*, then the visual, the ice cream cone, and finally the subtitle, "The Dairy Queen Story," (See Figure 2-13).

Rhythm

In music, most people think of rhythm as the "beat"—a sense of movement from one chord to another, a flow, accent patterns, or stresses. In design, you can also think of rhythm as the beat, but a beat established by visual ele-

ments rather than by sound. **Rhythm** is a pattern that is created by repeating or varying elements, with consideration given to the space between them, and by establishing a sense of movement from one element to another.

When you draw evenly spaced vertical lines on a page, you establish a steady repetitious rhythm because the lines have the same amount of space between them and our eyes move from one element to another consistently. If you vary the distance between the lines, you establish a different type of rhythm, one with variation or dynamics.

The key to establishing rhythm in design is to understand the difference between repetition and variation. Repetition occurs when you repeat visual elements consistently, as on these direct mail and collateral brochures for Jim

Beam Brands (See Figure 2-14). Variation can be established by changing the color, size, shape, spacing, position, and visual weight of the elements in a design, as in this brochure (See Figure 2-15).

Unity

When you flip through a magazine, do you ever wonder how the graphic designer was able to get all the type, photographs, illustrations, and graphic elements to work together as a unit? How does a designer successfully organize all the elements in an advertisement? There are many ways to achieve what we call **unity**, where the elements in a design look as though they belong together. Achieving unity relies on a basic knowledge of the formal elements and an understanding of other basic design principles, such as balance, emphasis, and rhythm. In other words, the designer must know how to organize elements and establish a common bond among them.

Unity is one of the goals of composition. Unity allows the viewer to see an integrated whole, rather than unrelated parts. We know from studies in visual psychology that the viewer wants to see unity; if a viewer cannot find unity in a design, he or she will lose interest. We borrow the term *gestalt* from Gestalt psychology to describe this concept of visual unity and wholeness. Unity contributes to memorability, total effect, and clear communication; it is about how well a design holds together.

One or more principles (or devices) may be employed to get the desired results for unity. Here are some of them.

Correspondence: When you repeat an element like color, direction, value, shape, or texture, or establish a style, like a linear style, you establish a visual connection or correspondence among the elements. The designers of this folder and poster use several elements, type, lines, and a grid, to establish correspondence (See Figure 2-16).

Continuity is related to correspondence. It is the handling of design elements, like line, shape, texture, and color to create similarities of form. In other words, continuity is used to create

Figure 2-16
Area Secession Poster, 1989
Design firm: Concrete
Design Communications,
Toronto, Ontario
Designers: John Pylypczak, Diti Katona
Client: Area, Toronto,
Ontario, Canada

Manufactured by Wiesner Hager in Austria, this line of furniture was inspired by the Viennese Secession. The Canadian distributor, Area, needed a vehicle to promote the line.

We responded with a two-sided poster that folded down into a 10" by 10" folder. Printed economically in one color, the poster uses quotes by artists and architects of the secession.

Diti Katona, Concrete
Design Communications

family resemblance. For example, if you were designing stationery, you would want to handle the type, shapes, colors, or any graphic elements on the letterhead, envelope, and business card in a similar way to establish a family resemblance among the three pieces. A certain level of **variety** can exist and still allow for continuity. Let's say, for example, you used the same design on the letterhead, business card, and envelope, except the letterhead is printed in red, the envelope in green, and the business card in blue. Your design would have variety within continuity.

Grid: Subdividing the format into fixed horizontal and vertical divisions, columns, margins, and spaces establishes a framework for organizing space, type, and pictures in a design. This is called a grid. It may be used for single page formats or multipage formats. The grid gives a design a unified look. (The grid is examined in depth in Chapter 5.)

Alignment: Visual connections can be made between and among elements, shapes, and objects when their edges or axes line up with

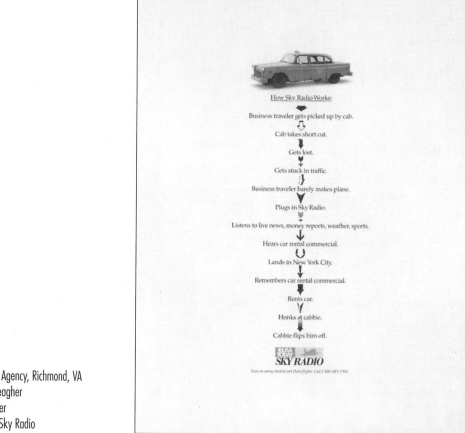

Figure 2-17
Ads, 1993
Agency: The Martin Agency, Richmond, VA
Art director: Bob Meagher
Writer: Joe Alexander
Client: USA Today/Sky Radio

Figure 2-18
Levi's Jean Screen Header Card
Design firm: Zimmerman Crowe Design, San Franscisco, CA
Art director: Neal Zimmerman
Designer: John Pappas
Client: Levi Strauss & Co.

The purpose of this placard is to attract consumers to "stop and touch the screen." This interactive product information "jean screen" is located in the Levi Strauss section of retail stores. The imagery is simply a replication of the act that is desired, presented in a way that is (hopefully) arresting or intriguing enough to prompt a consumer to respond accordingly.

Three overall elements unify the basic design:
* *The white directional arrows help to describe the desired "act" and visually connect the illustration as one composition.*
* *The type not only instructs the consumer, it also acts as a visual element that verifies and connects the elements of the illustration.*
* *The vertical stripes in the background, through repetition, also help to connect the separate elements into a unified message.*

All line art was generated from various sources. Type was typeset "outlined" on a typositor. It was hand-spaced and curved. Vertical striped halftone gradations were produced on a Macintosh. The art was silkscreened with four Pantone colors.

Neal Zimmermann, Zimmermann Crowe Design

one another. The eye easily picks up these relationships and makes connections among the forms. All the elements in these advertisements are arranged on a central vertical axis and the type is centered (See Figure 2-17).

Flow: Elements should be arranged so that the audience is led from one element to an-other through the design. Flow is also called **movement** and is connected to the principle of rhythm. Rhythm, in part, is about a sense of movement from one element to another. The designer of this poster (See Figure 2-18) manages to arrange the type and visuals so you move from one element to another across the elongated horizontal format and back again.

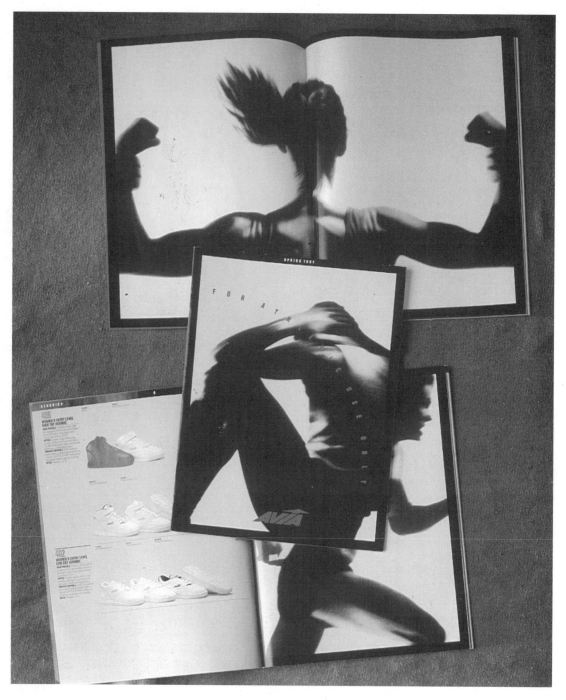

Figure 2-19
Catalog, "For Athletic Use Only," 1990
Agency: Sandstrom Design, Portland, OR
Designer: Steven Sandstrom
Photographer: C.B. Harding
Client: Avia Group International, Portland, OR

Avia's advertising campaign used the slogan "For Athletic Use Only." The photographic style used in this catalog attempted to reflect the emotions and passion of that positioning line. We specifically avoided "fashion" shots of attractive models using or wearing Avia Athletic shoes and apparel. Through the use of hand-tinted black-and-white Polaroids we attempted to capture the intensity of sports participation—giving viewers a chance to project themselves into the photos.

Rick Braithwaite, President, Sandstrom Design

Figure 2-20
Logo
Design firm: Chermayeff &
Geismar Inc., New York, NY
Designer: Tom Geismar
Client: The National Aquarium,
Baltimore, MD

*The National Aquarium in
Baltimore is about fish and
aquatic animals, but also about
the waters they inhabit. The
symbol combines images of fish
and water in a figure/ground
relationship.*

Thomas H. Geismar, President,
Chermayeff & Geismar Inc.

PART III:
THE MANIPULATION OF
GRAPHIC SPACE

Positive and Negative Space

Let's say you are going to take a snapshot of a friend and you want to get some of the background into the shot. You frame your friend in the camera's viewfinder, which is a rectangular space. That rectangle is your format, your friend is the figure, and the space surrounding your friend is the background. Since you want the snapshot to look good, you'll probably try to create as interesting a relationship between the figure and background as possible. The same factors come into play when you have to solve problems of graphic space.

Try this. Draw a shape on a page. By doing so, you instantly create a positive/negative spatial relationship. The shape is the positive space, or figure, and the rest of the space on the page is the negative space, or ground. This sounds simple enough, but there is a lot more to it. In a successful positive/negative relationship, the positive and negative space is interdependent and interactive. In other words, no space is dead or leftover. Dead space refers to blank areas that are not working in the overall design. Leftover space does not mean that all blank space must be filled with clutter or meaningless

forms. It means the designer must be constantly aware of the blank spaces and make them work in the design. All space, both positive and negative, should be considered active. Considering all space active forces you to consider the *whole* space. Again, the term gestalt, the concept of visual unity and wholeness, applies to positive and negative space. The viewer wants to see unity, not unrelated elements or spaces.

The arrangement of the figures of Godzilla and King Kong in this "Peace" poster (See Colorplate 5), creates interesting and powerful negative shapes. The negative shapes are so powerful they become positive—like the positive message of hope and survival communicated by the design concept. The cover of this catalog published by the Avia Group presenting its footwear collection for athletes makes dynamic use of positive and negative space. Notice the loose triangular shapes created within the figure and the shapes made by cropping the figure in relation to the format (See Figure 2-19). Both figure and ground, fish and water, are given great consideration in this logo design for the Baltimore Aquarium (See Figure 2-20). All models are silhouetted on monochrome pages, where both shape and color work to create exciting relationships. In these spreads from *Elle* magazine, tension exists between the negative and positive space because the art director thought of the figures, objects, type, and background as active shapes (See Figure 2-21).

Figure 2-21
Magazine Spreads for Elle,
"Bag It" and "Be A Sport"
Publisher: Hachette Filipacchi
Magazines, New York, NY

Every format has a limited amount of space and a shape of its own. A thoughtful designer will always see the format as an active force in the creation of positive or negative space. Each shape or object should be considered in relation to the format and to one another. The space around and between each shape or object must be carefully considered. Some designers call this "charging the negative space." Becoming conscious of the negative space forces you to consider your whole design—to organize the space as a total unit.

Illusion

Let's say you are asked to design a cover for a book about the history of flight. You would probably want to create a design that is appropriate for the subject and that would capture the attention of someone browsing in a book shop. How do you do that? Do you use photographs or illustrations? Do you create a flat, geometric cover design or a design where airplanes look like they are flying off the page? In order to make an intelligent decision, you would have to

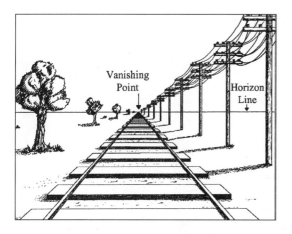

Figure 2-22
Diagram
Illustration: William Stanke

know what your options are and what is possible on a two-dimensional surface, and also how to manipulate graphic space—the space on any given surface.

In general, there are two possibilities when designing a two dimensional surface: you can keep it flat or you can create the illusion of three-dimensional space or spatial depth. The illusion of spatial depth can be shallow or deep, recessive or projected. In order to learn about these possibilities, let's try some experiments.

Draw evenly spaced vertical lines of the same line quality from top to bottom on a page. The result is that the page looks flat. Why? You kept the surface of the page flat because all you did was repeat the page's edges. The identical vertical lines that you drew do not suggest or give the illusion of depth.

Now try another experiment. Draw five vertical lines on one page and vary the length of the lines. The lines do not have to touch the page's edges. Unlike the first experiment, this page should not look flat. The shortest line should appear to be further away from you and the longest line should appear to be closer to you.

Now try this. Draw five squares on one page; vary the size of the squares. Does your design appear to have spatial depth? Why? In visual perception, the smaller things are, the further away they appear to be. The larger things are, the closer they appear to be. Therefore, the size and scale of shapes or objects play an important role in creating the illusion of spatial depth. Used effectively, the size of one shape or object in relation to another, what we call **scale**, can make elements appear to project forward or recede on the page. Overlapping shapes or objects can also increase the illusion of spatial depth. When you overlap shapes, one shape appears to be in front of the other.

Here is the last experiment. Draw a cube at the bottom corner of the page. Then draw vertical lines behind it. The cube will appear to project forward off the surface defined by the vertical lines. A cube is a volumetric shape. **Volume**, on a two-dimensional surface, can be defined as the illusion of a form with mass or weight (a shape with a back as well as a front).

In all of these experiments, you have been playing with what we call the **picture plane**. When you set out to do a design on a two-dimensional surface, like a board or a piece of paper, you begin with a blank flat surface. That surface is called the picture plane. It is your point of departure; it is where you begin to create your design.

As soon as you make one mark on the surface of the page, you begin to play with the picture plane and possibly create the **illusion of spatial depth**. The illusion of spatial depth means the appearance of three-dimensional space, where some things appear closer to the viewer and some things appear further away—just as in actual space.

You can suggest the illusion of depth very easily. Draw a diagonal line on a piece of notebook paper. By doing so, you are suggesting that the page is not flat. Why do diagonals create the illusion of depth? Their direction imitates the appearance of three-dimensional forms in space, like the side of a table or a box. If you draw diagonal lines and connect them with horizontal and vertical lines, you create a tilted plane on the surface—and you begin to enhance the illusion of spatial depth. This is a traditional Western convention for creating depth. It is a very simple version of what is called perspective.

Think of the common image of train tracks. If you are standing on train tracks, the tracks appear to converge in the distance. You know the tracks do not converge but actually remain parallel. Perspective is a way of mimicking this effect. **Perspective** is based on the idea that diagonals moving toward a point on the horizon, called the vanishing point, will imitate the recession of space into the distance and create the illusion of spatial depth. Perspective is a schematic way of translating three-dimensional space onto a two-dimensional surface (See Figure 2-22).

Perspective is just one way to create the

Figure 2-23
Wexner Center Calendar of Events, December 1990
Designers: Gary Sankey, Wexner Center Design Department
Wexner Center for the Arts, The Ohio State University

The newsletter was designed in October of 1990.
The Wexner Center for the Arts at The Ohio State University is a multidisciplinary contemporary arts center dedicated to presenting the work of emerging and established artists who challenge the norms. Through the use of color, typography, photography and contrast, the design of this newsletter series seeks to convey the qualities of vitality, diversity and risk-taking that distinguish the institution. The newsletter is printed in two colors and employs a square module grid that permits variety throughout the series while making a strong reference to the center's distinctive architecture.

Gary Sankey, acting design director, Wexner Center Design Department

illusion of depth and to manipulate the visual position of the picture plane. You can use another convention, **atmospheric perspective**, where the illusion of depth or distance is created by reducing value contrasts, color intensity, and detail in order to imply the hazy effect of atmosphere on forms as they recede. On this cover of a newsletter for the Wexner Center for the Arts, atmospheric perspective is used to give the visual a great sense of spatial depth; the background transforms into a deep and foggy

illusion (See Figure 2-23). Volumetric shapes, such as cubes, cones, and cylinders, can also create the illusion of spatial depth.

You can create such impressive illusions that the viewer, at first sight, is in doubt as to whether the thing depicted is real or a representation. This effect is called **trompe-l'oeil**. The use of shadows and overlapping shapes can create wonderful trompe-l'oeil effects, as on this book jacket design, *Graphic Design USA:12*, and this cover for *Design Quarterly 110* (See

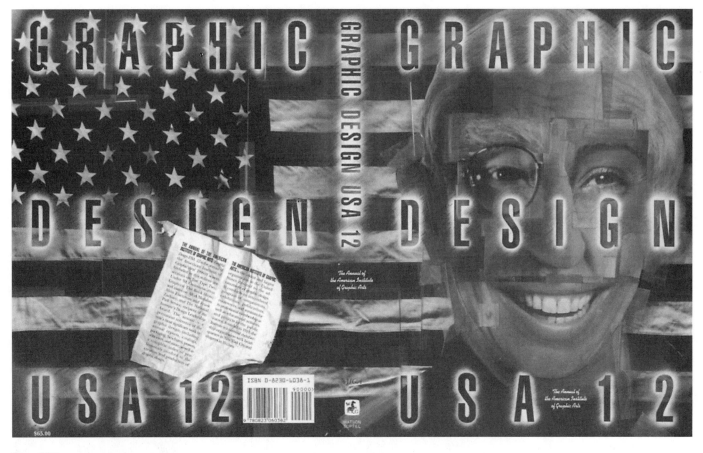

Figure 2-24
Book Jacket, *Graphic Design USA: 12,* 1990
Design firm: Muller + Company, Kansas City, MO
Art director/designer: John Muller
Collage photographer: Michael Regnier
Client: A.I.G.A.

When asked by A.I.G.A. to design the cover for their design annual, the goal was to create an interesting, powerful image. The collage image is actually a compilation of some famous A.I.G.A. medalists: Alvin Eisenman, Frank Zachary, Paul Davis, and Bea Feitler.

The photos supplied by A.I.G.A. were reprinted in toned colors, cut and torn apart, and reassembled (with Scotch tape, etc.). For example, Paul Davis' mole is right next to Bea Feitler's mouth, below Frank Zachary's nose, flanked by Paul Davis' right eye, Bea's left eye, and Alvin Eisenman's hair; the neck and torso belong to John Muller, the designer.

John Muller, president, Muller + Company

Figures 2-24 and 2-25). In both examples, you feel as though you might be able to pick elements off the surface because of the illusion.

Creating the illusion of depth on a two-dimensional surface is something that fascinates many designers and their audiences. Look at this cover design by Paul Rand for *Direction* Magazine (See Figure 2-26). Rand uses the horizontal stripes as a back wall or backdrop behind the dancer. The stripes seem to hold the surface in a fixed position—they define the picture plane. Rand has created the illusion that the picture plane is no longer on the surface of the page, but has moved back behind the dancer. However, the picture plane does not seem to be too far away from us; the illusion of spatial depth seems shallow. Shallow space can have great impact. Why? Because it immediately engages

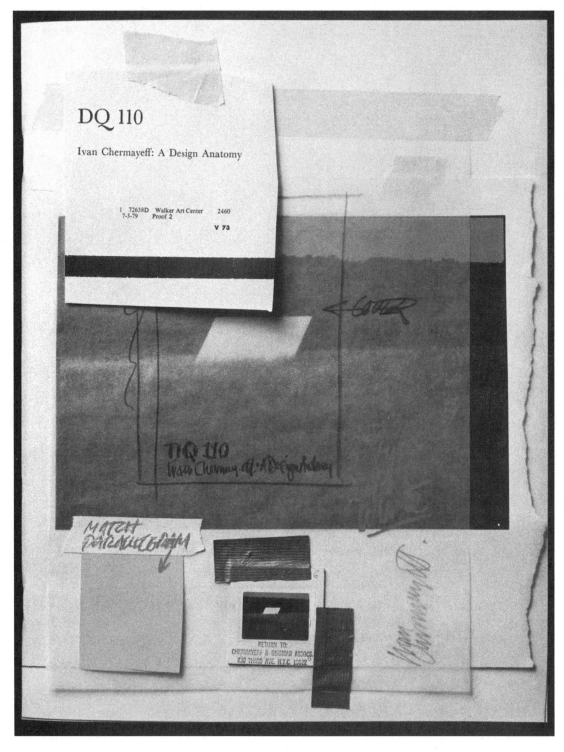

Figure 2-25
Cover, *Design Quarterly 110*, "Ivan Chermayeff: A Design Anatomy," 1979
Designer: Ivan Chermayeff

A collage of personal images, notes, type proofs, etc., used for the cover of a magazine special issue devoted to the work of Ivan Chermayeff.

Thomas H. Geismar, President, Chermayeff & Geismar Inc.

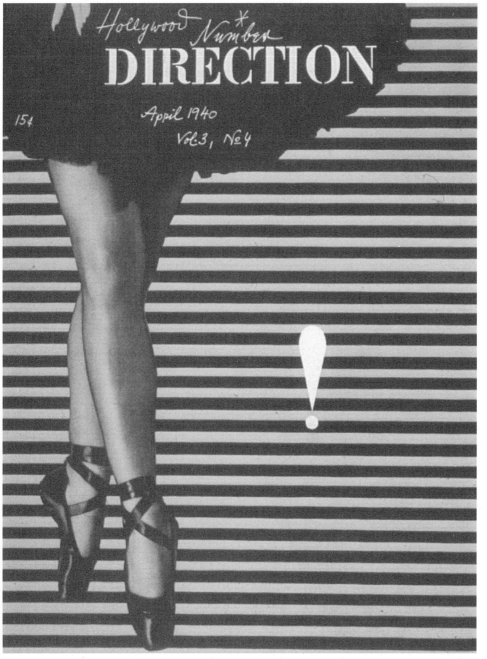

Figure 2-26
Magazine Cover, *Direction,* **1940**
Designer: Paul Rand

our attention; our eyes cannot wander off into deep space.

Remember, as a designer manipulating space you have many choices. You can maintain the flatness of the picture plane or create the illusion of spatial depth. You can create a shallow or deep space, or create the illusion that forms are projecting forward. Understanding the illusion of spatial depth will enlarge your design vocabulary and enhance your ability to affect an audience. A good way to begin to learn about this is to analyze advertisements and designs to see how other artists manipulate graphic space.

The foundation of a solid graphic design education begins with a study of two-dimensional design—the formal elements, principles of design, and the manipulation of graphic space. This study provides the necessary basic perceptual and conceptual skills to go on to study typography, layout, and graphic design applications.

Comments

Varying the distances between the lines and the thickness of the lines creates the illusion of swelling or warping on the surface of the page. The areas where the lines are light and close together may seem to recede and the areas where lines are heavier and further apart may seem to advance. Using line, you created an optical illusion.

Exercise 2-1
Exploring Lines

1. Divide a page into four units.
2. Draw a curving line from corner to corner in each square.
3. Draw different types or attributes of lines of varying direction and qualities in the divided areas.

Project 2-1
Creating Illusion with Lines—A Warp

1. Using a black marker or the line tool on your computer's software, draw horizontal lines of varying thickness completely across the page.
2. Vary the distance between the lines.
3. Do several versions or thumbnails before going to the comp.

Note: This project is well-suited for the computer.

Presentation
Create a comp on an 11" x 14" smooth board using black marker, or mount a computer-generated comp on an 11" x 14" board.

Comments

It is important to be able to recognize and create shapes that have similar qualities so that your ability to discern shapes becomes more acute. Composing the shapes introduces you to the process of designing elements on a page.

Exercise 2-2
Designing Shapes

1. Design ten shapes that have similar qualities, for example, curving shapes or angular shapes. Design your own or choose from a software palette.

Project 2-2
Shape

1. Draw four 5" x 7" rectangles, two in a horizontal format and two in a vertical format (or flip to a vertical format or direction).
2. Within each rectangle, design four shapes that have similar qualities, for example four geometric shapes or four free-form shapes.
3. Arrange the shapes so that the viewer's eyes will move from one shape to the other with ease.
4. Produce several thumbnail sketches (or versions) and roughs before creating the comps.

Presentation
Present each of the four comps on an 8 1/2" x 11" board.

Comments

If someone asked a group of people to think of the color blue, each person would probably think of a different blue. Some would think of a blue with green in it, and some would think of a blue with red in it. Being able to make subtle distinctions among hues will enhance your ability to create successful color solutions.

Exercise 2-3
Use of Color in Graphic Design

1. Find ten examples of color in graphic design, such as logos, labels, and packages.

2. Analyze the use of color in these examples in terms of appropriateness for the subject matter, the audience, and the feelings and ideas expressed or communicated.

Project 2-3
Hue Analysis

1. Divide a 9" square into nine equal sections.

2. Look through magazines and pull out every red you can find. Or create a color palette on the computer.

3. Select one hue that you believe to be a pure red, with no blue or yellow in it, and place it in the center section.

4. Find eight different reds and arrange one in each of the remaining sections.

5. Repeat the process with blue, green, and violet.

Presentation
Present the finished project on an 11" x 14" board.

Comments

It is essential for any designer to be able to see differences among values. You can use your gray scale as a ruler—try to guess values and test them against your gray scale.

Exercise 2-4
Low Contrast and High Contrast

1. Find two examples of graphic design solutions that use low contrast and two examples that use high contrast.

Project 2-4
Value Scale

1. Look through magazines (or use your CD-ROM library) for photographs and tear out all the different grays you can find, as well as a black and a white value. Print out what you find on the CD-ROM.

2. Create a 10-step scale of grays ranging from white to black.

3. Cut the grays into shapes.

4. Arrange the gray shapes on a page to create the effect of moving back into space.

5. Create another scale using grays created by typography.

6. Compare the gray scale of photographic fragments to the one of typographic grays.

Note: This project also can be executed on the computer, in paint, or with colored paper.

Presentation
Present the comp on an 11" x 14" board.

Comments

Graphic designers need to be aware of all the textures available to them. Paper has tactile texture. Inks and varnishes can create tactile textures. Visual textures, including indirect marks like rubbings and blottings and direct marks like the ones in this project, should become part of any designer's vocabulary.

Exercise 2-5
Rubbings and Blottings

1. Use tracing paper and pencils or crayons to make rubbings (also called frottages) of textured surfaces. For example, place tracing paper on the bark of a tree and pick up the texture by rubbing it with the side of a crayon.

2. Create blottings by dipping several objects with interesting textures into black paint or ink and blot them on paper.

Note: These textures can be simulated with computer software.

Project 2-5
Creating Visual Textures

1. Draw an object, face, or landscape. Using a drawing instrument and technique, for example stippling or cross-hatching, create shading. The shaded part of the drawing should have a texture.

2. To create a stippled effect, draw with dots.

3. To cross-hatch, draw a series of lines that move in the same direction and then another series of lines in an opposing direction that cross over the others.

4. Produce at least ten visual textures before creating the finished comp.

Presentation
Present your comp on an 11" x 14" board.

Comments

It is crucial to remember the format is a full participant in any design. Other components, like shapes, type, or photographs are not the only ones to be considered. The format is more than a frame—it is an important formal element.

Exercise 2-6
Rectangular Formats

1. Draw rectangles of different sizes and shapes.

2. Draw a horizontal line, a vertical line, a diagonal line, and a curve in each rectangular format.

3. Analyze the relationship of each line to the different formats.

Project 2-6
Designing in Different Shape Formats

1. You will need four different shape formats: a large circle, two extended rectangles (much longer in one dimension than the other)—one vertical and one horizontal, and a standard page.

2. In each one, arrange three shapes.

3. Consider how each shape looks and is arranged in relation to the others and to the format.

4. Produce at least five sketches for each of the four formats.

Note: This project may be executed on the computer, with cut paper, or with markers.

Presentation
Present each format on a separate 11" x 14" board.

Comments

Arranging a symmetrical design is not difficult. You divide the page in half with a vertical axis and evenly place similar or identical shapes on either side of the axis. Each side mirrors the other. Arranging a balanced asymmetrical design is a challenge because it is not a mirror image and each element's position and visual weight must be decided and becomes crucial to the overall effect.

Exercise 2-7

Creating a Balanced Design

1. Find a headline, a visual (photograph or illustration), text type, and a photograph of a product from different advertisements.
2. Arrange them into a balanced design on an 8 1/2" x 11" page.

Project 2-7

Destroying Symmetry and Retaining Balance

1. Create a symmetrical design on a 10" square format using solid black shapes.
2. Make a copy of it.
3. Cut the copy into 1" horizontal strips.
4. Cut the strips in half vertically.
5. Rearrange the strips to create a balanced asymmetrical design.

Presentation
Present the finished comp on an 11" x 14" board.

Comments

Learning to arrange elements in order of their importance is critical to good graphic design. Visual hierarchy helps the audience glean information. You must direct your audience's attention in order to communicate a message efficiently.

Exercise 2-8

Creating a Focal Point

1. On a 10" square format, draw ten arrows that all lead to one point or area on the page.
2. The arrows should be visually interesting; they may vary in quality and texture, and they may bend, curve, or intersect.
3. On an 8 1/2" x 11" page, draw seven arrows that lead to a main focal point and three arrows that lead to a secondary focal point. Make sure the arrows are visually interesting; give them texture, tone, various line qualities, and vary the directions and lengths.

Project 2-8

Creating a Visual Hierarchy

1. Draw seven shapes of varying sizes.
2. Use color or texture on some of them; leave some in outline.
3. Cut them out.
4. Decide which shapes should be seen first, second, third and so on.
5. On an 8 1/2" x 11" page, arrange them in hierarchical order.
6. Produce ten sketches and one rough before creating a comp.

Presentation
Present the comp on an 11" x 14" board.

Comments

Varying the type, direction, quality, and position of the lines, as well as the size, position, and visual weight of the dots, squares, and type will give your design rhythm.

Exercise 2-9
Creating Rhythm

1. Using vertical lines and dots on a page, establish a steady rhythm.
2. Using vertical lines and dots on a page, establish a rhythm with variation.

Project 2-9
Rhythm

1. On an 8 1/2" x 11" page, create a rhythm with great variation.
2. Use vertical, horizontal, and diagonal lines, dots, squares, and type.
3. Create ten sketches and one rough before going to the comp stage.

Note: This project can be executed on the computer, with marker, or with cut paper.

Presentation
Present the comp on an 11" x 14" board.

Comments

Unity is all-encompassing. If the design is not unified—if it does not hold together—then not much else is going to work. You need to be aware of the total effect of your design. Sometimes it helps to take a break from your work and look at it a day or two later. When you come back to it, ask yourself if it looks as if all the elements belong together.

Exercise 2-10
Using Alignment to Achieve Unity

1. Look through a magazine and find headline type, text type, and a visual (photograph or illustration).
2. Using the principle of alignment, align all the elements on a page.

Note: Photographs can be scanned into a computer and size and shape can be altered.

Project 2-10
Achieving Unity

1. Choose a group of objects, like tools or chess pieces, and photocopy or draw them.
2. Cut them out.
3. Arrange them on a page with type (found type or hand-lettered).
4. To achieve unity, use the principles of flow and correspondence. For example, repeat colors in the design to create visual relationships among the elements.
5. Create at least ten sketches and two roughs before going to the comp.

Note: This project may be executed on the computer using a scanner.

Presentation
Present the comp on an 11" x 14" board.

Comments

Letters are forms; they are composed of positive and negative spaces. The negative spaces they create when positioned next to one another are crucial to designing with type. The spaces between letters are important; they affect readability, legibility, and the memorability of the design.

Exercise 2-11

Positive and Negative Space

1. Paint a black shape on a board. Use water based paint, like poster paint or acrylics.

2. The shape should be big enough to touch the edges of the board in places. (The black shape is the positive space and left-over white area is the negative space.)

3. Paint a bold white X entirely across the black shape.

4. With white paint, paint the remaining white areas of the board so that they are connected to the X.

5. This should result in four pielike shapes.

6. Now, it should be difficult to tell what is positive and what is negative. Do you see black shapes on a white board or white shapes on a black board?

Note: This project may also be executed with cut black and white paper or on the computer.

Project 2-11

Letterforms as Positive and Negative Spaces

1. Using your initials, design the letters on an 8 1/2" x 11" page so that both the positive and negative space is carefully considered.

2. The letters should touch all the edges of the page.

3. The letters may be cropped or reversed.

4. Create at least ten thumbnail sketches and two roughs before going to the comp.

Note: This project can be executed on the computer, with marker, or with cut paper.

Presentation

Present the comp on an 11" x 14" board.

(Exercises and Projects continued on next page)

Comments

Project 2-12 is designed to develop an understanding of how to create the illusion of spatial depth on a two-dimensional surface. As soon as you draw one volumetric shape on a flat surface, you begin to create the illusion of spatial depth. If the shapes you create overlap or vary in size, the effect will be greater.

Exercise 2-12

The Picture Plane

1. Draw vertical and horizontal lines that oppose one another on an 8 1/2" x 11" page.

2. Every line you draw must touch another line. Imagine your lines are like string and that you are tying a package.

3. Touch all edges of the page.

Note: This exercise can be done with pencil, marker, black tape, or drawing software.

Project 2-12

The Illusion of Spatial Depth

1. With a light pencil, draw a one-inch grid on a 10" square.

2. Using either a black marker or black 1/4" tape, draw volumetric shapes like cones, cubes, and pyramids.

3. Use the grid as a guide for the vertical, horizontal, and diagonal lines.

4. Fill the entire board.

5. Avoid creating flat shapes like squares and triangles.

6. Produce at least two roughs before creating the comp.

Presentation

Present your comp on an 11" x 14" illustration board.

Chapter 3
Overview of Graphic Design

Objectives

- to become familiar with the four components of a graphic design solution: strategy, concept, design, and craft.

- to be able to write an objectives statement

- to become familiar with the graphic elements of a design: format, type, and visuals

- to understand the importance of craft

- to gain a basic understanding of the design profession

Four Components of Graphic Design Solutions

A successful graphic design solution is, as the old saying goes, the result of perspiration and inspiration. As much as people would like to believe it, designers are not born designers. People are born with intelligence, visual acumen, and inclinations (or what most people call talent), which is probably why they are initially attracted to the visual arts. They must spend years learning and practicing a specific visual discipline, like graphic design, in order to become successful at it. Even after years of study and practice, each graphic design solution requires research, work, and focused creative energy.

Sometimes a graphic design solution comes very quickly; at other times, solving a design problem can be very frustrating. Most often, finding a solution is a matter of following a few tried and true steps and understanding the vital components of a graphic design solution. Strategy, concept, design and craft are the four main components in the creation of a graphic design solution.

Strategy

Design solutions must be relevant to stated objectives and clear in the communication of messages. The visual message must fit into a larger marketing, promotion, or communication plan to achieve the goal.

The graphic designer works in collaboration with a client. Whether the client is a local business owner or a large corporation, the graphic designer's role is to provide solutions to visual communication problems. The problem may be to create an identifying mark (logo) or an extensive visual identity system involving the design of a logo, packaging, stationery, posters, labels, and reports. Sometimes the client is not sure of his or her own needs, so the designer must help the client clarify the design problem. In addition to collaborating with a client, the graphic designer works with a printer and may work with other visual communications professionals, such as commercial photographers, illustrators, copywriters, and art directors. Sometimes the graphic designer also works with editors, marketing experts, industrial designers, interior designers, film directors, or architects.

During the first step of the process, the client and designer work together to establish objectives. Then the graphic designer interprets the objectives into a visual communication. In a classroom situation, you will work with your instructor to establish these objectives—a verbal account of what needs to be accomplished and what problems need solving. It helps to write an objectives statement for each graphic design problem. Write a clear, succinct description of your objectives. This statement should summarize the key messages that will be expressed in the design, for example, facts or information, desired personality or image, and position in the market. This statement is the narrative or verbal version of the visual you need to create. Once the design is roughed out, you can evaluate your design on how well it expresses this objectives statement. The following set of questions will help you clarify your design objectives for each project.

Figure 3-1
Travel Guides, 1988
Design firm: Vignelli Associates,
New York, NY
Graphic Design:
Vignelli Associates
Client: Fodor's Travel Guides

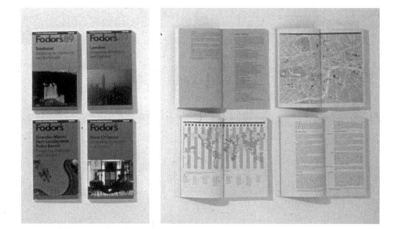

What is the purpose or function of the design? All graphic design serves a purpose. The three basic types of graphic design are information design, editorial design, and promotional design. **Information design** informs and identifies; it includes logos, identity systems, symbols, pictograms, charts, diagrams, maps, and signage. **Editorial design** is the design of publications such as magazines, newspapers, books, and newsletters. **Promotional design** essentially is meant to promote sales, or to persuade. It includes advertisements, packaging, point of purchase display, brochures, sales promotions, posters, book jackets, and covers. These applications often overlap. A package design, for example, identifies a product, its ingredients, and its manufacturer, however it is also intended to promote the sale of the product. The purpose of these design applications is to provide accessible information about ideas, products, and services; to create or reinforce a product/service/client image; to create a bond between the consumer and the client; to promote sales; or to enhance communication. Promotional design has the highest degree of persuasive intent and information design the lowest degree. Always remember that graphic design is functional and it must meet the client's and audience's needs.

Who is the audience? Graphic design is aimed at a mass audience that may vary in size and demographics. A design may be intended for a local, national, or international audience. It may be intended to communicate with a specific professional or trade group. Defining your audience will help you to understand who you are designing for, while keeping their collective preferences, culture, taste, and income in mind. Every audience presents different considerations.

What is the competition and marketplace? A client's product or service may be unique, but most often it will be competing with similar products or services in the marketplace. You need to know a product or service's position in the marketplace; know the competition and how they have solved similar problems. You want your design solution to stand out and you do not want it to look like or to be confused with the competition. Find out how the client's product or service compares in price, quality, uniqueness, special offers, and consumer ratings with the competition. Find out where (environment, context, type of store) and when it will be seen. For example, there are many travel guides on a bookstore shelf. Fodor's Travel Guides (See Figure 3-1), by the design firm of Vignelli Associates, stand out because of successful design.

What message needs to be communicated? Remember, designs have at least two levels of meaning. The first is the primary meaning, which is the direct message of a word, sign, or image. The secondary meaning is what is conveyed or suggested by the overall design. Keep both of these in mind while you work. (Philip B. Meggs, a noted design historian and critic, calls these two levels of meaning denotation and connotation.) Because of the clear presentation of information in the design of the identity program for Aetna Life and Casualty (See Figure 3-2), soundness and intelligence are suggested, which is the secondary meaning.

What kind of personality should be conveyed? The purpose and appearance of a product or service begins to establish its personality. The graphic design created for that product or service further establishes its personality. Make a list of descriptive words that you would use to describe a client's product or service. These words will help you establish a personality or image for the product and give you a direction in which to move.

All the formal elements of color, line, shape, texture, value, and the way they are put together

Figure 3-2
Logo, Corporate Identity, 1988
Design firm: Vignelli Associates, New York, NY
Graphic Design: Vignelli Associates
Client: Aetna Life and Casualty, Hartford, CT

using the principles of graphic space, balance, rhythm, and unity, contribute to a design solution's personality. What kind of response is desired from your audience? If you can get the audience to react, to feel, to think, then you have made a connection with them—you have communicated.

Concept

The design concept is the creative solution to the design problem. The concept is expressed through the combination and arrangement of visual and verbal (typographic) materials. Successful concepts are innovative and creative, not stereotypical or commonplace.

Graphic design begins with a visual concept. You formulate a creative idea—a design concept—and put it into visual form. How do you come up with a concept? It can happen in a variety of ways. Sometimes you immediately visualize a solution in your mind. At other times, you may struggle until the last minute trying to find an appropriate and original design concept.

There is no one way to find or formulate a design concept; it is a very individual process. There are, however, tried and true steps that designers take to work it out. It all begins with knowing what needs to be accomplished— defining your design objectives (strategy). The next step is research. Finding material, information, and visuals about your subject can open up possibilities. Then you start sketching, draw-

ing, doodling—thinking with a marker in your hand. If you are having trouble, try any or all of the following methods.

Brainstorm. Make a list of anything and everything related to your subject. If you do not want to do it alone, get someone to talk it out with you. The brainstorming list or session may conjure up some ideas or visuals.

Fool around. Find some visuals related to your subject. Try cropping them or cutting them and putting them back together in a different way. Photocopy them in strange or unusual ways. Change colors. Add textures. Combine images. Use paper or find paper that you would not ordinarily employ. Use the process of trial and error.

Let it be. Go do something else. Get away from it, but do not forget about it. Take your mind off the work itself. Just think about it for a few days before returning to sketching. Sometimes concepts come to people when they are relaxed or doing something unrelated to their assignment.

Get some visual stimulation. Look at award-winning designs in professional magazines or annuals. Research how other designers have solved similar problems. Go to the movies. Go to a store and look at package design. Look at old or antique labels, woodcuts, etchings, typefaces, and drawings. Go to a museum or gallery.

Suggestions

- Know your objectives. You need to know the purpose and function of the design. Design solutions must be relevant to the strategy.

- Do a lot of research. The more research you do, the greater your flexibility. Note: CD-ROM technology brings great quantities of information to you. Tap all resources.

- Develop an understanding of your subject. You need to understand a subject in order to develop a design concept for it and to choose appropriate graphic elements.

- Graphic design communicates messages on several levels. Have a social conscience. Do not use racist, sexist or biased ideas.

- Work your concept out in thumbnail sketches and roughs. If a concept does not work as a sketch, it certainly will not work as a comp. Try to work out the bugs in the early stages of the design process.

- Be willing to modify your original concept. In the process of working on a design problem, you may need to make changes. This may mean extra work, but if it yields an original or appropriate solution, then it is worth it.

- Be willing to give up your concept if it is not working. Inevitably, you will develop a better one.

- Save your thumbnail sketches. You may need to go back to them if your concept does not work out or if the client or your instructor is not satisfied. Also, you may be able to use them for another project. If you are working with computer software, do not keep all your thumbnails or ideas on disk. Print them out and look at them on paper. Add color with markers. It is a good idea to include your working sketches in a separate binder in your portfolio to demonstrate your ability to think visually and conceptually.

Think of the wrong answer. You are probably so worried about the right answer that you cannot find it—so try to find the wrong one. At least you willl know what *not* to do.

Change directions. If you have been exploring one type of solution and nothing is happening, drop that direction and explore a new one. Try not to get stuck in a line of reasoning or in anything if it is not working for you. Go in a totally different direction to find a solution.

Formulating a design concept—whether easy or difficult—is simply part of the designer's task. It is something you are trained for in school or get used to through practice. You will learn to rely on your intuition, intellect, training, and experience. (Also see the "Suggestions" at left).

Design

The way you put everything together—how you arrange the elements—is the design. Design solutions should be consistent with principles of visual organization and graphic space. Your solutions should express a personal aesthetic and a point of view (a style, perhaps), although this point of view should not interfere with the client's message; it should enhance it.

You have already developed your strategy and design concept; your next task is to translate them into visual communication. Writing the objectives statement may stimulate a visual response in your mind.

Research may also help you develop visual ideas. Now it is time to design, to visualize, to develop design concepts and small quick sketches. Explore concepts and design options, as many as time permits. Remember, this is the step where concepts are explored; this is not the time to refine your design. Develop the design only to the extent that the ideas can be clearly visualized. If you can visualize in small sizes, it is a great plus at this point. Sketching and drawing skills are critical. All of your concepts should be evaluated on how accurately they communicate the objectives established.

To create roughs, choose your best thumbnail sketches and refine them on a larger scale. These should be made as tight as possible (without spending too many hours on them) so you can make a judgement about which one will be the finished piece.

Finally, you create comprehensives (comps) or mock-ups. This is the finished piece in as near finished form as possible, the tighter the

better. Most designers employ a variety of methods, materials, and techniques to produce tight comps. Any of the following may be used: computer-generated images, photocopies, color copies, photostats, dry transfer type, colored and textured papers, Image and Transfers (INTs)®, Color Keys®, magic markers, and colored pencils.

The Graphic Elements

Every graphic design problem involves decisions about graphic elements. These elements are format, type, and visuals.

The format is the support for the graphic design, for example, a brochure, a poster, a business card, or a shopping bag. There are many types of formats and, of course, there are variations within each format. For example, there are a variety of brochures in different sizes and shapes and each may open up differently. Each format presents its own problems and restrictions.

You must consider the shape and proportions of the format. Both the shape and its proportions can affect the impact of your design. Sometimes the design objectives will determine the shape, size, and proportions of a format. There also may be constraints concerned with where and how the design will be seen, for example magazine or billboard advertising, as well as monetary limits.

There are standard sizes for some formats. Compact disc covers, for example, are all the same size. Posters have a standard size, however, you can get a poster in almost any size, too. Any size format is available to the designer at varying costs. When working with three-dimensional formats, like packaging, the shape and size can greatly affect the cost and method of production. The size of a graphic design solution should be determined by the needs of the client, the design concept, function and purpose, appropriateness for the solution, and cost.

A designer works with **typography** or **type**. Type communicates a literal message by carrying information directly to the audience. However, type also conveys a connotative message—it suggests something more than its explicit or literal meaning. Most typefaces have distinct styles and personalities. The type you select should be appropriate for your design concept.

Graphic design is an expression of an idea. In combination, visuals and type work together to communicate messages and meaning to an audience. There are basically three types of visuals available to designers—photographs, graphics, and illustrations. Most graphic designers create their own graphics, and hire illustrators and photographers or use stock photography. Sometimes photography or illustration is supplied by the client.

Students do not have the resources to buy visuals or hire professionals. Many students, take their own photographs and create their own graphics or illustrations. It is perfectly acceptable to use found visuals; professionals looking at your portfolio understand the constraints of a student's budget and resources. Visuals can be combined or modified with the proper technology—cameras, computers, photocopiers, video, or film—to create unusual or hybrid imagery. Deciding what type and style of visuals to use and whether to create or find them is usually determined by the design objectives, your skills as a photographer or illustrator, the design concept, technological resources, and appropriateness to the design concept.

Your job is to send a message to an audience, but how that message is communicated is a matter of creative expression. Graphic design is understood on at least two levels. The first is the direct message of a word or visual, which is the primary meaning. But what is conveyed or suggested by the design—through the type, visuals, arrangement, color, format, and materials—is the secondary meaning. For example, you see the word "house," or a photograph of a house, and you understand the direct message of the word or visual. You know what it means. However, the style of the typeface or the lighting in the photograph communicates to you on another level, often telling you how to feel.

All of these components—the format, shape, size, and proportions, the arrangement and style of type, the visuals and materials and the way they are all put together—visually express the design concept. The designer's job is to find the best *way* to do this. There are two main factors involved with this kind of creative expression: style and the creative leap.

The way elements are used together suggests style, the quality that makes something distinctive. Creating a style depends on the particular use of many elements: type, illustration, color, materials, format, shape, and proportions. For example, Warren Lehrer's innovative typographic style is a result of his intense interest in visualizing sound and speech and the distinctive way he layers type, mixes typefaces, combines

Figure 3-3
Spread, "Political Argument,"
French Fries, 1985
Designer/co-author:
Warren Lehrer
Co-author: Dennis Bernstein
Client: Visual Studies Workshop

The book called French Fries *takes place inside the third largest burger chain in the Western Hemisphere.* French Fries, *is a visual translation of a play written by Dennis Bernstein and me. It is a quick service circus of culinary discourse, dream, memory and twisted aspiration. In this double page spread from* French Fries, *a political argument breaks out between patrons and staff at Dream Queen. Overlay of words and images reveal the sonic and psychological cacophony of argument in the context of a fast-food joint.*

Warren Lehrer,
Designer/co-author

Figure 3-4
Spread, French Fries, 1985
Designer/co-author:
Warren Lehrer
Co-author: Dennis Bernstein
Client: Visual Studies Workshop

This double page spread from French Fries *shows how each character is typecast into a distinct color and typeface.*

Warren Lehrer,
Designer/co-author

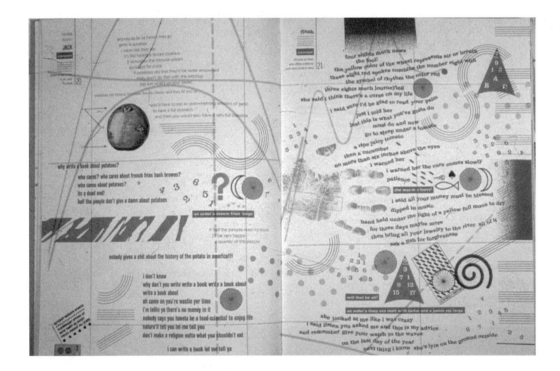

and layers type and visuals, and uses the page (See Figures 3-3 and 3-4). The best way to learn about style is to study the history of graphic design and fine art. There are excellent texts available on the history and development of style in graphic design. Refer to the bibliography on p. 291.

When you solve a graphic design problem in a routine way, you are merely getting the job done. When you go beyond a perfunctory solu-tion you make a creative leap—you make art. You can take a mundane problem and turn it into art when you synthesize the formal, tech-nical, practical, and conceptual components of that design problem into a personal vision. Then the solution address both the functional requirements of the design (the right design for the market and audience) and your personal aesthetic. You will have presented a personal

Suggestions

There are many schools of thought in graphic design. Many styles last for years and at the same time, trends come and go. Trends in music, politics, popular culture, literature, and fine art, influences from different cultures, countries, and technology all affect graphic design. Some famous designers have rules about design; some say there are no rules and if there are any, they should be broken. Students, however, need a point of departure. Here are some useful suggestions:

On Graphic Principles

- Maintain balance. It makes a design feel harmonious.

- Establish emphasis. The viewer should see the most important message first.

- Establish rhythm. Understand the difference between repetition and variation.

- Establish correspondence. Using the same or similar elements creates a sense of continuity.

- Establish alignment. Elements in a work should make visual connections. Edges or axes should line up.

- Establish a visual path. Allow the viewer's eyes to move from one element to the other with ease.

- Establish unity. Do whatever it takes to make your work hold together visually.

On Style

- Stay in touch with contemporary culture. It is important to be aware of what is going on in the world in terms of style and content.

- Be eclectic. Look to many time periods and to world culture for inspiration.

- Learn the history of art and graphic design to understand style and movements. Know what is possible, what has happened, and why it happened that way.

- Stay current with trends in typography.

- Stay current with technology and tools. It is wise to have every possible technological advantage.

In General

- Only use one visual trick per piece. It is best to have one creative focal point and not overwhelm or distract the viewer.

- Break lines of type in logical places. Type should follow natural speech patterns.

- Create a meaningful or cooperative relationship between type and image.

- Take great care in the selection of typefaces. They have distinct personalities and styles and not every face is appropriate to every design concept.

point of view while meeting your design objectives. Your design can reflect your individuality while still solving your design problem. There are no uninteresting assignments, only uninterested designers. Also, no tool, not even the computer, can make a creative leap. The computer makes it easier for you to work and produce; only you can make the creative leap.

Craft

Craft refers to the physical handling of materials. It includes the use of papers, inks, varnishes, cutting and pasting, even computers. Well-crafted work is always a plus. You might put your whole portfolio on disk, but most potential employers still prefer to see hard copies; clients like to see comprehensives or mock-ups. People respond to the visceral impact of your work. Therefore, design solutions should be neat, clean, accurate, functional (from a production viewpoint), and ecologically safe (recyclable if possible and not wasteful).

You should familiarize yourself with as many materials, tools, and processes as possible. Papers, boards, inks, adhesives, cutting tools, and drawing tools (markers, pens, pencils, chalks, brushes, crayons) and graphic aids (ruling guides, rulers, triangles, T-squares) are readily available. Research materials by going to art supply stores and looking at paper stock and getting paper samples from printers and paper suppliers. Learn about the different types of inks, finishes, and printing techniques. Visit a printer and see how things are done. In addition to the basic materials listed, there is a wealth of transfer type (rub-down type), tapes, and matting (presentation) materials. Access to a computer for type, type manipulation, graphics, and illustration is essential. Almost anything that can be done by hand can be created on the computer. You must learn to use a computer—especially since technology is moving ahead at great speed. Computing will be ubiquitous.

Learning technical processes is critical to the creation of finished-looking comprehensives. These include Color Keys® (transparent colored acetate overlays), Image and Transfers® (custom made colored transfer type), Color Tag® (transferable heat sensitive color), photostats (direct photographic prints—color or black and white), photocopies (duplicates made photographically—color or black and white), and posterizations (a photomechanical technique used to make high-contrast prints). Other traditional fine art processes such as printmaking, papermaking, drawing, and painting can enhance or extend the range of your vocabulary.

The materials you use, whether for a comp or a printed graphic design solution, are critical parts of the design and contribute to effective communication, expression, and aesthetics. Craft and presentation are directly related to materials. The skill with which you craft your solution and present it can enhance or detract from it. Learning to cut, glue, mount, and mat is essential for a design student.

Presentation, the manner in which comps are presented to a client or in your portfolio, is important. The method of presentation should be determined by the type of work being presented and by who will see it. Do not underestimate the importance of presentation; it is as important as the work being presented. A good presentation can make ordinary work look great and a poor presentation can make great work look ordinary. Until you get to your portfolio, the rule is: simple and inexpensive but professional. You usually have to spend more money and time presenting the work that goes into your portfolio.

Of course, if you were working on a paid job for a client, the next step would be obtaining printing estimates and preparing the camera-ready mechanical art for printing. This is called **production**. The production usually involves layout, typography, producing all art and illustrative elements, proofreading galleys (with the client), cropping and scaling photographs, making stats and/or position prints for assembly on the mechanical, preparing the mechanical art for the printer with explicit printing instructions, delivering the art to the printer and meeting with the printer, checking blueprints and other

Suggestions

- Make it neat. You want people to notice your design, not how poorly something is cut or pasted.

- Present it professionally. A good and thoughtful presentation can enhance your design solution and a poor presentation can only detract from it.

pre-press proofs, and delivering the job to the client. Today, most production work is being done on the computer using digital prepress.

Critique Guide Revisited

Once you finish your graphic design solution, or even while you are creating roughs, you can use this expanded critique guide to help you make sure you are on the right path.

Strategy and Concept Development

- What is the purpose of the design?
- What information must be communicated?
- Does the design meet the objectives?
- What is the design concept?
- Does the design concept fit the strategy?

Design

- Did you use principles of graphic space such as balance, emphasis, rhythm, and unity?
- Did you experiment? Is your design solution merely competent or were you willing to take a creative leap?
- What kind of visuals did you use and why?
- Did you express a point of view?
- Did you employ any creative approaches?
- Is the design solution (design, color, type, style, personality) appropriate for the client's product or service?

Craft

- Is the execution appropriate? Did you use the materials that would best represent your design concept?
- Is it well-crafted?
- Is it presented professionally and appropriately?

The Design Profession

Imagine if all the products in a supermarket looked pretty much the same. That would be visually dull, and it would make differentiation very difficult. One of the main things that designers do is visually enhance information, products, and services. They make things look attractive so that potential consumers will want to read them or buy them. Graphic design is part of the free market system; it promotes and aids competition. It also enhances our visual environment.

Although all graphic designers are concerned with aesthetics or graphic impact, not all graphic designers do the same type of work. There are designers who solve all types of design problems, however, many graphic designers and studios specialize in information, editorial or promotional design. Some design studios specialize in even more specific areas, such as packaging or visual identity. Not all designers find the same areas of specialization in graphic design equally rewarding. How will you know which career path to choose? It is best to try all types of design problems in school and see which area(s) you prefer. It also helps to look through design annuals and magazines and try to notice what attracts you most.

Graphic design is part of a larger visual communications field that also includes illustration (the creation of imagery) and commercial photography (photography that serves commerce). When a design concept is decided on, graphic designers and advertising art directors hire illustrators and photographers or buy stock illustration and photography. When working on television commercials, advertising art directors and creative directors hire directors, location scouts, and post-production experts and may also be involved in the selection of actors, costumes and sets. It is important for graphic designers and art directors to recognize successful illustration and photography and be aware of styles and trends.

Most often, graphic designers work closely with their clients. From developing a strategy to negotiating a fee, the client and graphic designer collaborate. Together they may study the market and competition, develop strategies for meeting objectives, budget, format, check stages of production, and choose and hire other professionals, such as photographers, illustrators, and printers.

Graphic designers can work in design studios, corporate art departments, publishing houses, or advertising agencies. Many designers are self-employed. It is advisable to work for someone else to gain design experience and to learn all the aspects of running a small business before going out on your own. It is also beneficial to try to get part-time work, such as an internship or a cooperative educational experience in the design field while still in school. Attend the meetings of local art directors' clubs, the AIGA (The American Institute of Graphic Arts), and as many professional conferences or lectures as possible.

Chapter 4
Designing With Type

Objectives

- to consider the message, audience, format, and formal qualities of all visual elements when designing with letterforms
- to be able to differentiate among calligraphy, lettering, and typography
- to become familiar with type terminology
- to be able to identify parts of letters
- to understand how the principles of design apply to designing with type
- to be able to use type creatively and expressively

You are designing a poster. A title, text, date, time, address, and sponsor's name have to be included. How will you arrange these typographic elements in order to inform and interest the reader? When designing with type, there are several general factors you must consider: the message, the audience, the format, the letterforms, and the other visual elements.

Message, Audience, and Format

The **message** is what needs to be communicated. In any design using type, there is almost always a specific message to communicate, for example, the title of a book, the selling point of a service, or the ingredients of a product. In most cases, there is more than one piece of information to communicate. You must establish a hierarchy of information, ranging from the most important to the least. Each piece of information should be weighed in importance in relation to every other and to the overall message.

The **audience** is the readers or viewers to whom your message is directed. Defining your

Figure 4-1
Calligraphy
Design firm: Martin Holloway
Design, Warren, NJ
Calligrapher: Martin Holloway

audience will help you to understand who you are designing for, while keeping their collective preferences, culture, taste, and income in mind. Every audience presents different considerations.

The **format** is the surface on which the type will be designed, the vehicle or medium of your message. There are many different formats that a graphic designer uses—posters, brochures, newsletters, charts, covers, packages, advertisements, and stationery. Remember to consider the function, size, and shape of the format as well as where it will be seen (in a display, on a wall, on a shelf, outdoors) when selecting or designing with type.

Letterforms

The letterform is the particular style and form of each individual letter of our alphabet. Each letter of the alphabet has unique characteristics that

Figure 4-2
Custom Lettering
Design firm: Martin Holloway
Design, Warren, NJ
Lettering/designer:
Martin Holloway

must be preserved to retain the legibility of the symbols as representing sounds of speech. Letterforms are used by designers in three primary forms:

- Calligraphy: drawn by hand, it is a stroke or strokes of a drawing instrument, literally "beautiful writing" (See Figure 4-1).
- Lettering: letters that are custom designed and executed by conventional drawing or by digital means (See Figure 4-2).
- Typography: letterforms produced mechanically, usually with a computer. This is by far the most common means of using letterforms for visual communication.

Type is available in an infinite number of styles for the designer's use simply by selecting a font size and style. Nearly every graphic design solution illustrated in this book is an example of typography.

Nomenclature

Today almost all type is produced electronically or photographically, but many of the terms we use in reference to type originated in the days when type was made of metal. A letterform was cast in relief on a three-dimensional piece of metal, which was then inked and printed.

When working with type or typography, there are basic terms you must be familiar with:
Typeface: the design of a single set of letterforms, numerals, and signs unified by consistent visual properties. These properties create the essential character, which remains recognizable even if the face is modified by design.
Type style: modifications in a typeface that create design variety while retaining the essential visual character of the face. These include variations in weight (light, medium, bold), width (condensed, regular, extended), and angle

Figure 4-3
The Type Family
Chart by Martin Holloway

(Roman or upright, and Italic), as well as elaborations on the basic form (outline, shaded, decorated) (See Figure 4-3).

Type font: a complete set of letterforms, numerals, and signs, in a particular face, size, and style, that are required for written communication (See Figure 4-4).

Type family: several font designs contributing a range of style variations based upon a single typeface design. Most type families include at least a light, medium, and bold weight, each with its italic. (See Figure 4-3).

Guidelines are imaginary lines used to define the horizontal alignment of letters (See Figure 4-5).

Ascender line: defines the height of lowercase ascenders (often, but not always, the same as the capline).

Figure 4-4
The Typographic Font
Chart by Martin Holloway

THE TYPOGRAPHIC FONT

Capitals

ABCDEFGHIJKLMNOPQRSTUVWXYZ&

Lower Case

abcdefghijklmnopqrstuvwxyz

Old Style Figures

1234567890

Modern Figures (Lining, Ranging)

1234567890

Small Caps

ABCDEFGHIJKLMNOPQRSTUVWXYZ&

Ligatures

ffl ffi ff fl fi

Dipthongs

ÆŒæœ

Swash Characters

A MR ry

Accented and International Characters

ÅÁÀÂÄÑÇ åáàâäñçøß«» ¡¿

Punctuation

.:,;!?- - — ""''()[]/

Monetary Symbols

$¢£

Math Signs

+ − ÷ × = % °

Fractions

⅓ ¼ ½ ⅔ ¾

Reference Marks

→ SM TM Ⓟ ® Ⓒ □ ■ • * † ‡ §

Superior (Superscript) and Inferior (Subscript) Figures

1234567890
1234567890

Baseline: defines the bottom of capital letters and of lowercase letters (excluding descenders).
Capline: defines the height of capital letters
Descender line: defines the depth of lowercase descenders.
x-height: the height of a lowercase letter excluding ascenders and descenders.

A nomenclature exists that defines the individual parts of letterforms and how they are con-structed (See Figure 4-5). Here are some basic terms:
Apex: the head of a pointed letter.
Arm: a horizontal or diagonal stroke extending from a stem.
Ascender: the part of lowercase letters, b, d, f, h, k, l, and t, that rises above the x-height.
Bowl: a curved stroke that encloses a counter.
Character: a letterform, number, punctuation,

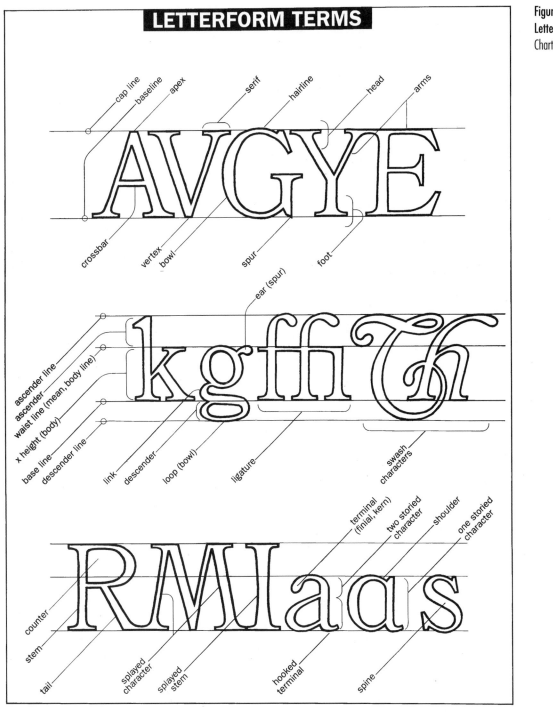

Figure 4-5
Letterform Terms
Chart by Martin Holloway

mark, or any single unit in a font.

Counter: fully or partially enclosed negative spaces created by the strokes of a letter.

Crossbar: the horizontal stroke connecting two sides of a letterform, as in an "A".

Descender: the part of lowercase letters, g, j, p, q, and y that falls below the baseline.

Foot: the bottom portion of a letter.

Hairline: the thin stroke of a Roman letter.

Head: the top portion of a letter.

Ligature: two or more letters linked together.

Lowercase: the smaller set of letters, a name derived from the days of metal typesetting when these letters were stored in the lower case.

Serifs: ending strokes of characters.

Stem: the main upright stroke of a letter.

Stroke: a straight or curved line forming a letter.

Terminal: the end of a stroke not terminated with a serif.

Uppercase: the larger set of letters or capitals. These letters were stored in the upper case.

Vertex: the foot of a pointed letter.

Typographic Measurement

The traditional system of typographic measurement utilizes two basic units: the point and the pica. The height of type is measured in points and the width of a line of type is measured in picas. Most type is available in sizes ranging

point size ——— *9/12 Times Roman Bold* *U/lc* *FL, RR* *MAX 15pi*

| point size plus leading | typeface | weight | upper and lower case | flush left, ragged right | line length. *If justified indicated as x15 pi rather than* max *15pi* |

elements of style

arrangement *also: justified, centered, flush right, ragged left (FR,RL)*

Figure 4-7
Type Specification

from 5 points to 72 points. Type that is 14 points and under is used for setting text or body copy, and is called **text type**. Sizes above 14 points are used for **display type**, such as titles, subtitles, headlines, and subheadlines (See Figure 4-6). A third typographic measurement, a unit, is used to measure the width of type. Note: points and picas are specific units of measure (pica = 1/6 inch, point = 1/72 inch), whereas units are proportional to type size and will vary depending upon the typesetting system.

Here are some terms you should learn:

Leading: in metal type, strips of lead of varying thickness (measured in points) used to increase space between lines of type; line spacing; interline spacing.

Line length: horizontal length of a line of type (measured in picas).

Line spacing: distance between two lines of type measured vertically from baseline to baseline, interline spacing, leading.

Point size (body size): in metal type, the height of the body (or slug) of lead the typeface is set upon (See Figure 4-6).

Quads: in metal type, pieces (or slugs) of metal in varying widths inserted between pieces of type to add horizontal spaces to a line of type. The basic unit is called the **em quad,** and is a square of the point size, for example the em of 11 point type is 11 points. An em quad is the approximate width of a capital letter M. The **en quad** is one-half an em quad. Fractions of the em quad also are used. For example, an em quad (or space) in QuarkXPress, an electronic page design software, is achieved by entering two en quads.

Set width: in metal type, the width of the body (or slug) of lead that a particular character is set upon, in other words, the width of type. This is measured in units. The size of a unit—thin, equal, vertical measurements—is governed by the em.

approximately 6 picas = one inch
12 points = 1 pica
approximately 72 points = one inch

Basic Type Specifications

When a designer wants to indicate the type size and the leading (or line spacing) to the printer, the following form is used: 10/11 indicates a type size of 10 with one point leading; 8/11 indicates a type size of 8 with 3 points leading. The amount of leading you choose depends on several factors, such as the type size, the x-height, the line length, and the length of the ascenders and descenders. When a designer does not want additional space between lines, type is set solid, that is with no additional points between lines, for example, 8/8. The horizontal length of the line of type may be added to the form in the following manner: 10/11 x 24, which means 10-point type with one point leading and a line length of 24 picas. The name of the typeface must be indicated as well (See Figure 4-7).

Classifications of Type

Although there are numerous typefaces available today, there are some major categories (See Figure 4-8) into which most fall:

Roman: 1) letterform designs having thick and

Figure 4-8
Classifications of Type
Chart by Martin Holloway

thin strokes and serifs. Originated with the ancient Romans. 2) Letterforms that have vertical upright strokes, used to distinguish from oblique or italic designs, which slant to the right.

Old Style: a style of Roman letter, most directly descended in form from chisel-edge drawn models, retaining many of these design characteristics. Characterized by angled and bracketed serifs, biased stress, less thick and thin con-

trast. For example, Caslon, Garamond, Palatino, and Times Roman.

Transitional: a style of Roman letter that exhibits design characteristics of both Modern and Old Style faces. For example, Baskerville, Century Schoolbook, and Cheltenham.

Modern: a style of Roman letter whose form is determined by mechanical drawing tools rather than the chisel-edge pen. Characterized by extreme thick and thin contrast, vertical-hori-

BAMO hamburgers BAMO hamburgers

Garamond, Palatino: Old Style

BAMO hamburgers

New Baskerville: Transitional

BAMO hamburgers

Bodoni: Modern

BAMO hamburgers **BAMO** hamburgers

Clarendon, Egyptian: Egyptian

BAMO hamburgers BAMO hamburgers

Futura, Helvetica: Sans Serif

BAMO hamburgers *BAMO hamburgers*

Bodoni, Futura: Italic

BAMO hamburgers

Palace Script: Script

Figure 4-9
Examples of Typefaces

zontal stress, and straight, unbracketed serifs. For example, Bodoni, Caledonia, and Tiffany.

Egyptian: a style of Roman letter characterized by heavy, slablike serifs. Thin strokes are usually fairly heavy. It may have Modern or Old Style design qualities; also called **square serif** or **slab serif**. For example, Clarendon, Egyptian, and ITC Lubalin Graph.

Sans Serif: letterform design without serifs and usually having monoline stroke weights (no clearly discernable thick and thin variations). For example, Futura, Helvetica, and Univers. Some letterforms without serifs have thick and thin strokes. For example, Optima, Souvenir Gothic, and Baker Signet.

Italic: letterform design resembling handwriting.

She's an ex-publicist. He's an ex-carpenter. Together, they make one hell of a bouillabaisse.

THE BELLPORT RESTAURANT. 159 SOUTH COUNTRY ROAD. BELLPORT VILLAGE. 516.286.7550

While you may espy the occasional celebrity in our restaurant, there's a place across the street where they all hang out.

THE BELLPORT RESTAURANT. 159 SOUTH COUNTRY ROAD. BELLPORT VILLAGE. 516.286.7550

Always drink in moderation. However, if you insist on getting hammered, may we suggest a cozy little place around the corner.

THE BELLPORT RESTAURANT. 159 SOUTH COUNTRY ROAD. BELLPORT VILLAGE. 516.286.7550

On the evenings we serve Cajun, you'll appreciate the service provided by our neighbor next door.

THE BELLPORT RESTAURANT. 159 SOUTH COUNTRY ROAD. BELLPORT VILLAGE. 516.286.7550

Figure 4-10
Ads, 1992
Art director: Kevin Weidenbacher
Writer: John Young, Bellport, NY
Client: The Bellport Restaurant

Letters slant to the right and are unjoined. Originally used as an independent design alternative to Roman. Now used as a style variant of a typeface within a type family.

Script: letterform design most resembling handwriting. Letters usually slant to the right and are joined. Script types can emulate forms written with chisel-edge pen, flexible pen, pencil, or brush. For example, Brush Script, Shelley Allegro Script, and Snell Roundhand Script.

Many typefaces may not fit precisely into one of these historical classifications of type. In order to help you discern various features and make informed and appropriate choices, here are some common traits or characteristics to look for.

Serifs: There are many different types of serifs, for example, bracketed, hairline, oblique, pointed, round, square, straight, and unbracketed. It is a good idea to become familiar with their historical origins.

Stress: the stress of letterforms is the axis created by the thick/thin contrast; stress can be left-slanted, right-slanted, or vertical.

Thick/thin contrast or strokes: the thickness of the strokes varies in typefaces, that is, the amount of weight differs between thick and thin strokes.

Weight: the thickness of the strokes of a letterform, determined by comparing the thickness of the strokes in relation to the height, for example, light, medium, and bold.

Type and Visuals

Type is usually designed with other visual elements, such as photographs, illustrations, graphs, and graphics (elemental visuals—both pictorial and abstract, rules, patterns, textures, etc.). The relationship between type and visuals is crucial—it should be synergistic. When a cooperative action between type and visuals is created, a design becomes a cohesive unit. In these advertisements for The Bellport Restaurant and for Giro, type and visuals cooperate to communicate the ad messages (See Figures 4-10 and 4-11).

The message, what needs to be communicated, will help you determine which visuals and

Suggestions

- Carefully consider the format; if type is designed for a poster it should be readable from a distance.

- Design type in a visual hierarchy. People tend to read the biggest elements first; they tend to read headlines or titles first, subtitles or pull quotes second, then captions, and finally text type.

- Type arrangement or alignment should enhance readability.

- Letterspacing, word spacing, and line spacing all factor into readability, communication and expression. Never depend on automatic spacing—adjustments are almost always necessary to enhance typography.

- Consider letterforms as pure forms; think about them as positive/negative space relationships.

- Color should enhance the message and expression and not hinder readability.

- Word spacing and line spacing establish a rhythm, a pace at which the viewer reads the message.

- The typography should be appropriate for the message and audience.

- Typography should enhance a message, not detract from it.

- When mixing typefaces, think about appropriateness to the message, contrast, weights, visual hierarchy, and scale.

- Become very familiar with, and learn to use, at least five classic faces, for example, Bodoni, Caslon, Futura, Univers, and Times Roman.

- Avoid novelty or decorative typefaces.

typefaces are appropriate. Some things to think about when designing with type and visuals:

- Consider the format in the design.
- Establish a visual hierarchy.
- Maintain balance.
- Carefully consider the size relationship (scale) of the type to the visuals.
- Determine the amount of type (both text and display) and the number of visuals.
- Consider the spirit, tone, and meaning of the visuals in relation to the spirit, style, and historical meaning of the typeface(s)

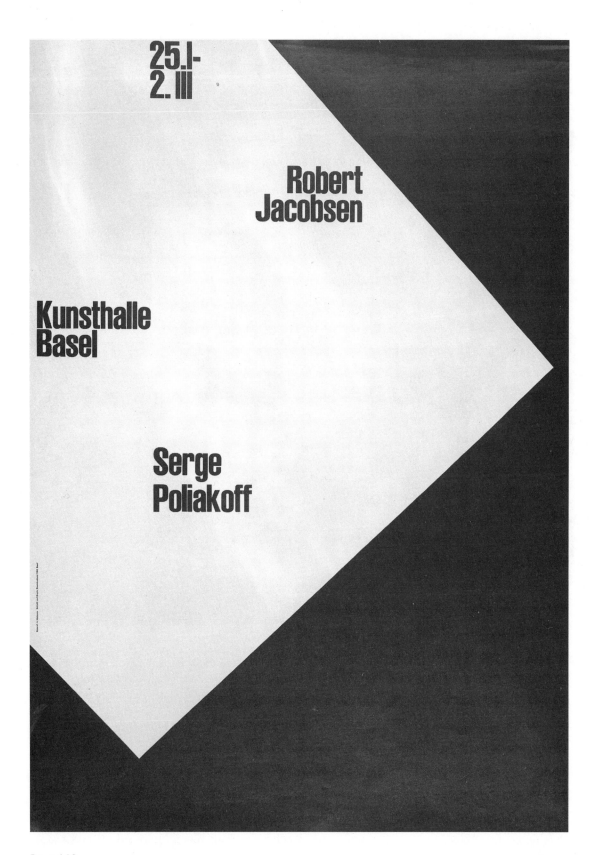

Figure 4-12
Exhibition Poster, Armin Hofmann, "Robert Jacobsen & Serge Poliakoff," 1958
Collection: Museum of Modern Art, New York, NY
Gift of the designer

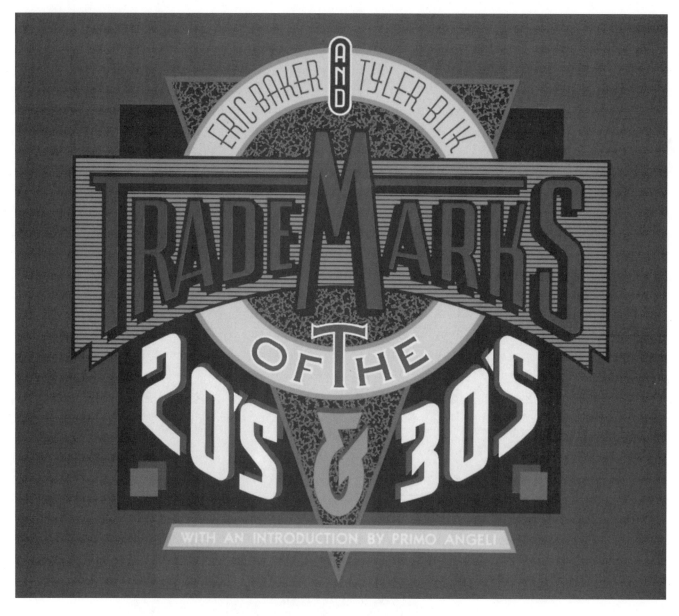

Figure 4-13
Book Cover for *Trademarks*
of the 20's & 30's/Eric Baker,
Tyler Blik, ©1985
Cover design: Michael Doret
Publisher: Chronicle Books,
San Francisco, CA

• Consider how the type and visuals look together, whether they are complementary in form and style.

The Principles of Design and Type

The fundamental organizational principles that apply to all of the visual arts also apply to typographic design. When arranging typographic elements, you should consider balance, emphasis, rhythm, unity, positive and negative space, and the manipulation of graphic space to create illusion. Equally, you should consider the interrelated visual factors of visual weight, position, and arrangement. On this exhibition poster,

notice where the type is positioned and its relationship to the format and to the inner shape containing the type. This positioning is crucial to the creation of balance (See Figure 4-12). If the inner shape were not there, the design would not be balanced. In contrast to Armin Hofmann's asymmetrical poster design, symmetry is used to achieve balance in this typographic design for a book cover by Michael Doret (See Figure 4-13). On either side of an imaginary vertical axis, type and shapes almost mirror each other in visual weight, position, color, and arrangement.

When typographic elements are arranged according to emphasis, most often there is a focal point. This is the element that is most

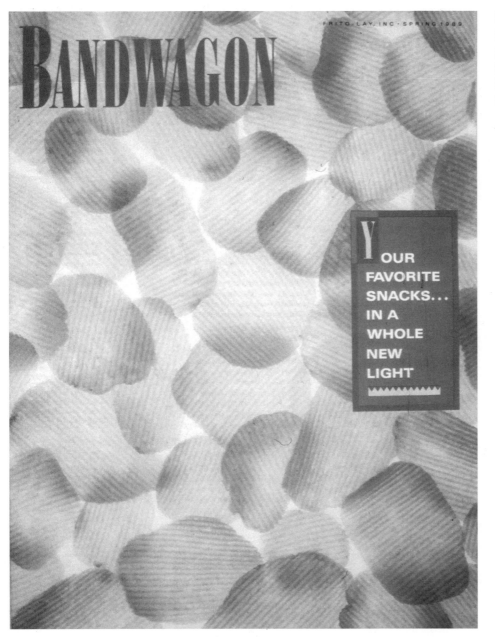

BANDWAGON

YOUR FAVORITE SNACKS... IN A WHOLE NEW LIGHT

Figure 4-14
Magazine Design, *Bandwagon*
Design firm: Peterson & Company, Dallas, TX
Designers: Scott Ray, Jan Wilson
Photographer: Peter Lacker
Client: Frito Lay, Inc., Plano, TX

prominent and most important to the communication of the message. Once you have decided which typographic element is most important, you must make decisions about all the others—what should be read first, second, third, and so on. You must direct the reader's attention, as Scott Ray and Jan Wilson do on this magazine design (See Figure 4-14). First, you read the title, *Bandwagon,* which is the focal point because it is larger and bolder. Then you read the type in the rectangle, which is the next largest element. Lastly, you read the remaining type. Of course, the arrangement, visuals, and color all are contributing factors to the visu-

al hierarchy. Even though this photograph (of the Metropole Hotel building in New York, 1909) is a very active visual, Chwast was able to make you notice the title first (See Figure 4-15). Then, you look at the photograph, subtitle, and remaining text.

When creating emphasis with typography, consider:

- position,
- rhythm,
- color contrast,
- size contrast,
- weights of the type: the lightness or boldness of a typeface; weights usually are light, medium and bold,

Figure 4-15
Exhibition Poster for Graphic Design In America, 1990
Design firm: The Pushpin Group, New York, NY
Art director/designer: Seymour Chwast
Photography: The Bettman Archive
Client: IBM Gallery, New York, NY

This poster, for an exhibit of all aspects of American graphic design, had to be developed without my expressing any specific design idiom. The image also had to be neutral. My design has a little bit of everything and no style in particular.

Seymour Chwast, The Pushpin Group

- initial caps: a large letter usually used at the beginning of a column or paragraph, and
- Roman vs. italic: Roman type is upright as opposed to italic which is slanted to the right.

You direct the reader from one typographic element to another by using visual hierarchy and rhythm (a pattern that is created by repeating or varying elements), by considering the space between elements, and by establishing a sense of movement from one element to another. The open spacing of the letters and the position of "Rock and Roll" in this spread, designed by Bradbury Thompson, moves our eyes across the page in syncopation with the circular visuals (See Colorplate 6). The remaining type acts like accents, enhancing the rhythm. The rhythm is further enhanced by the illusion of motion.

Some designers call it flow, some call it the beat. Whatever it is called, it is all about

Figure 4-16
Spread from Westvaco "Inspirations 192," 1949
Designer: Bradbury Thompson
Copyright by Westvaco Corporation

Seldom is there logic in using two different styles of typesetting in a design. But here, to provide a symmetrical relationship to symmetrical graphics, the type is set in centered style on the left page, while on the right page the text type is set flush right and ragged left to accompany asymmetrical graphics.

Karen Bloom, Manager, Public Relations Programs, Westvaco Corp.

moving the reader's eyes from element to element so that they get all the necessary information and messages. This spread from Westvaco "Inspirations," Vol. 192, entitled "M is for Men" utilizes two different styles of typesetting or alignment (See Figure 4-16).

The style or arrangement of setting text type is called **type alignment**. (The term alignment here is used more specifically than its broader definition in Chapter 2.) The primary options are as follows:

- **Flush left/ragged right:** text that aligns on the left side and is uneven on the right side
- **Justified:** text that aligns on the left and right sides
- **Flush right/ragged left:** text that aligns on the right side and is uneven on the left side
- **Centered:** lines of type are centered on an imaginary central vertical axis
- **Asymmetrical:** lines composed for

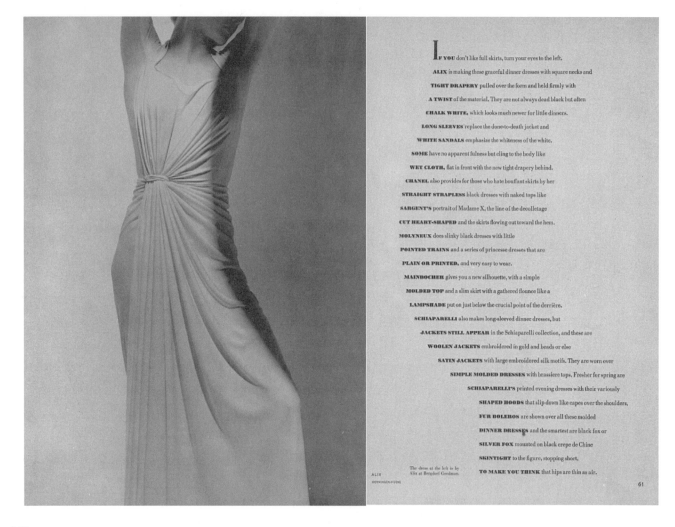

IF YOU don't like full skirts, turn your eyes to the left.
ALIX is making these graceful dinner dresses with square necks and
TIGHT DRAPERY pulled over the form and held firmly with
A TWIST of the material. They are not always dead black but often
CHALK WHITE, which looks much newer for little dinners.
LONG SLEEVES replace the done-to-death jacket and
WHITE SANDALS emphasize the whiteness of the white,
SOME have no apparent fulness but cling to the body like
WET CLOTH, flat in front with the new tight drapery behind.
CHANEL also provides for those who hate bouffant skirts by her
STRAIGHT STRAPLESS black dresses with naked tops like
SARGENT'S portrait of Madame X, the line of the decolletage
CUT HEART-SHAPED and the skirts flowing out toward the hem.
MOLYNEUX does slinky black dresses with little
POINTED TRAINS and a series of princesse dresses that are
PLAIN OR PRINTED, and very easy to wear.
MAINBOCHER gives you a new silhouette, with a simple
MOLDED TOP and a slim skirt with a gathered flounce like a
LAMPSHADE put on just below the crucial point of the derrière.
SCHIAPARELLI also makes long-sleeved dinner dresses, but
JACKETS STILL APPEAR in the Schiaparelli collection, and these are
WOOLEN JACKETS embroidered in gold and beads or else
SATIN JACKETS with large embroidered silk motifs. They are worn over
SIMPLE MOLDED DRESSES with brassiere tops, Fresher for spring are
SCHIAPARELLI'S printed evening dresses with their variously
SHAPED HOODS that slip down like capes over the shoulders,
FUR BOLEROS are shown over all these molded
DINNER DRESSES and the smartest are black fox or
SILVER FOX mounted on black crepe de Chine
SKINTIGHT to the figure, stopping short,
TO MAKE YOU THINK that hips are thin as air.

The dress at the left is by Alix at Bergdorf Goodman.

ALIX
HOYNINGEN-HUENE

61

Figure 4-17
Magazine Spread from *Harper's Bazaar*, **15 March 1938**
Art director: Alexey Brodovitch
Photographer: Hoyingen-Huene
Courtesy of Harper's Bazaar,
New York, NY
Photograph courtesy of the
Walker Art Center,
Minneapolis, MN

asymmetrical balance—not conforming to a set, repetitive arrangement

There are many ways to ensure that all the type is interrelated, integrated into a whole design, and not seen as unrelated elements. To establish unity in a typographic design, consider:

- choosing typefaces that complement each other visually. Use contrasting styles, faces, and weights rather than using faces that are similar; typefaces with pronounced or exaggerated design characteristics seldom mix well; avoid mixing two or more sans serif typefaces in a design,
- establishing harmonious size relationships,
- determining how the size and choice of typefaces will work with the visuals,
- creating a cooperative action between type and visuals,
- creating tension between type and visuals,
- establishing color connections, harmonies, complementary relationships,
- establishing correspondence,
- using a grid (the term "grid" here is used in the traditional sense. Note the "grid" in electronic page design has a different meaning than the traditional graphic design term; in electronic page design software, different nomenclature may be used. For example, in QuarkXPress the grid is called the Master Page.),
- establishing alignment,
- establishing rhythm or a flow,
- positive and negative shape relationships, and
- type as an integral player in the communication of meaning.

Unity is established in different ways in both of these designs by Alexy Brodovitch. In this famous magazine spread, the text is masterfully designed to echo or correspond to the

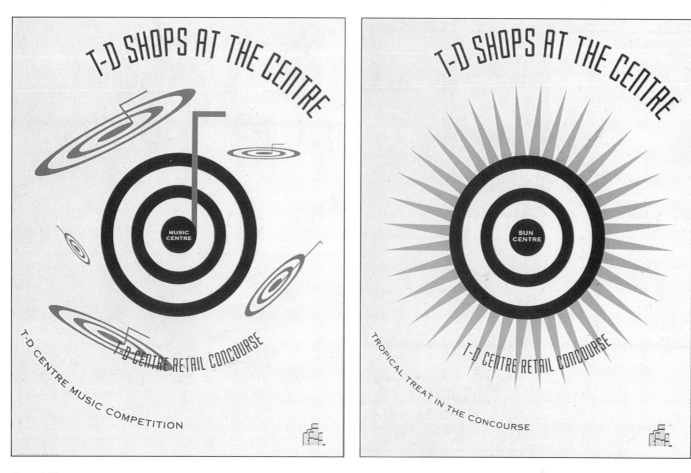

Figure 4-18
Poster, 1992
Design firm: Tudhope Associates Inc., Toronto, Ontario
Designer: Peggy Rhodes
Writer: Kelvin Browne
Client: T-D Centre, Cadillac Fairview, Toronto, Canada

The objective was to create interest and add energy to the underground concourse. The design approach was "less is more" to complement the simplicity of the Mies Van Der Rohe architecture.

Ian C. Tudhope, Principal, Tudhope Associates Inc.

shape of the photographic image (See Figure 4-17). This correspondence, repeating a visual element, establishes a visual connection. The heavier weight of all the type along the left-hand edge also echoes the values of the photograph. In these poster designs by Tudhope Associates, the type echoes the centered targetlike visual; correspondence is established (See Figure 4-18). Similarly, correspondence is established in the way the type follows the form of the globe

on these packages for CE Software (See Figure 4-19).

Understanding positive and negative space is crucial to designing with type. The spaces between letters, between words, and between lines of type must be carefully considered if you want your design to be legible and memorable. Once you lose legibility, you lose meaning. Factors that enhance legibility are:

- positive and negative shape relationships
- distinctiveness of individual letters
- thoughtful letter, word, and line spacing
- strong value contrast between letters and background
- word placement to encourage eye movement in the correct reading sequence.

There are three types of spacing you have to worry about when designing with type: letterspacing, word spacing, and line spacing or leading. **Letterspacing** is the space between letters. **Word spacing** is the space between words. **Line spacing, interline spacing,** or **leading** is the distance between lines of type. (In electronic page design, the terms auto leading, absolute

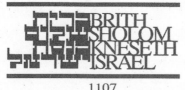

leading and incremental leading also are used. Spacing should enhance legibility and reader comprehension. If people have difficulty reading something, they probably will lose interest.

When a character is produced, digital typesetting machines or computer software automatically advance in units before generating the next character. It is not a good idea to rely on automatic spacing when designing with type. The designer can control the word spacing or letterspacing by tracking or kerning, which is the process of subtracting space between letters to improve the letterspacing. *You should always judge the letterspacing optically.* In setting display type, it is feasible to adjust letterspacing of individual characters since the number of words in headlines is limited. This fine tuning of negative space is a hallmark of typographic excellence. In text settings, since individual letterspace adjustment is impractical, the designer selects the letterspacing mode that the computer follows automatically. In electronic page design, what you see on the monitor's screen is what you get when it is printed. This is referred to as WYSIWYG (what you see is what you get).

Word spacing and line spacing also can be done automatically when typesetting. Once again, it is important to make any necessary adjustments by eye, not by measurement. There are some general considerations to keep in mind:

- spacing between words and lines of types should enhance legibility, readability, and overall comprehension of the message. Legibility refers to how easily the shapes of letters can be distinguished (usually refers to larger sizes) and readability refers to how easily type is read (usually refers to text type),
- the size of the type in relation to the amount of spacing,
- The length of the lines in relation to the amount of spacing, and
- spacing in relation to the characteristics of the typeface.

Figure 4-21
Poster Title, "The Art Faculty Annual 1991"
Design firm: Martin Holloway Design, Warren, NJ
Lettering/designer:
Martin Holloway
Client: James Howe Gallery, Kean College of NJ

The letterspacing and the shapes throughout this logo design for the Brith Sholom Kneseth Israel Congregation are close and powerful (See Figure 4-20). All the negative shapes are active because they are carefully designed. The Hebrew and English words balance one another. Tight letterspacing, used in this title for an art exhibition announcement, brings all the letterforms and numbers together as one unit (See Figure 4-21).

You might think it would be difficult to create interesting positive and negative shapes when there are only two numbers involved. It can be done effectively, as in this logo (See Figure 4-22). It was designed for KXTX Channel 39, a Christian format television station in Dallas, Texas. Similarly, dynamic positive and negative space is created in this logo for CE Software; the "E" is formed by the negative space (See Figure 4-23).

Using type, you can maintain the flat surface

of a page or you can create the illusion of spatial depth. The weights, color, size, position, and arrangement of type all are factors in the creation of illusion. In all of the following five designs (See Figures 4-24 through 4-27) there are varying degrees of the illusion of spatial depth. The type contained in the rectangle is closest to the viewer and defines the picture plane in this brochure entitled "A Season of Classics" (Figure 4-24). The next level of space is defined by the letters "NMSO," which are in front of the remaining type and visuals.

An illusion of spatial levels is created in this design. Printed in red, "Annual Report" pops forward off the blue-green background,

Figure 4-22
Logo, Channel 39, 1984
Design firm: Sibley Peteet, Dallas, TX
Designer: Walter Horton
Client: KXTX Channel 39

*This mark was selected from a group of
about thirty alternatives presented. The
mark's interest lies in the juxtaposition of a
positive three with the negative shape of the
nine, bleeding the common shapes of the
two number forms.*

Don Sibley, Principal, Sibley Peteet Design

Figure 4-23
Logo
Design firm: Muller + Company, Kansas City, MO
Client: CE Software

CE SOFTWARE

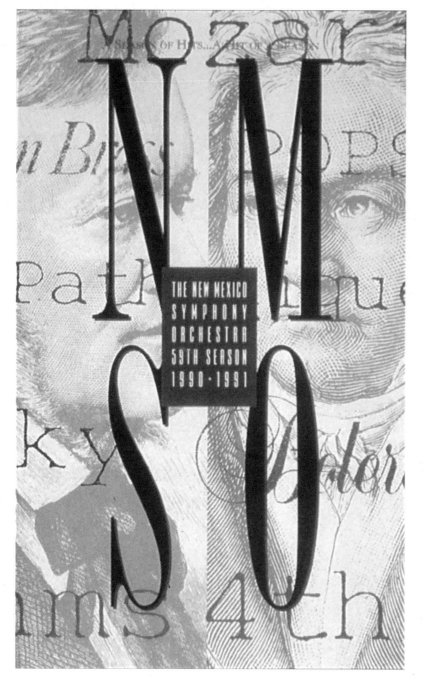

Figure 4-24
Brochure, "A Season of Classics," 1990-91
Design firm:
Vaughn Wedeen Creative, Inc., Albuquerque, NM
Designers:
 Steven Wedeen, Dan Flynn
Client: New Mexico Symphony Orchestra, Albuquerque, NM

There were three main challenges associated with this project. First, we had to use our resources wisely because of a limited budget. This was achieved by designing a TV Guide-size piece and using only two colors. Second and third, we needed to pack a lot of information into each page while keeping what is stereotypically a dull subject, classical music, exciting and energetic. This was achieved both typographically and by layering. Each layer represented a different aspect of the season: the composer, history of the music and the music itself. The overall impression on the subscriber was one of anticipated energy and excitement.

Holly Doggett,
Vaughn Weeden Creative Inc.

despite the white text running over it, on this Marcam Annual Report cover by David Warren (See Figure 4-25).

The overlapping of type on this spread from a promotional brochure for Mohawk Paper Mills gives the effect of several layers of space (See Figure 4-26). The variation in the range of values enhances the illusion and adds atmosphere. Size and value contrast are used to create the illusion of spatial depth in the pages of this sales portfolio by Petrula Vrontikis (See Figure 4-27).

Type and Expression

In addition to understanding the fundamentals of design and how they relate specifically to designing with type, it is essential to understand how type can be used creatively and expressively. The following design concepts

Figure 4-25
Annual Report Cover, Marcam, 1990
Design firm: Fitch Inc, Boston, MA
Designer: David Warren
Client: Marcam

Marcam wanted to express the global reach of the company and the depth of understanding within each market. The cover design used a corporate positioning statement repeated in various languages that interwove the message.

Robert Wood, Associate Vice President, Fitch Inc.

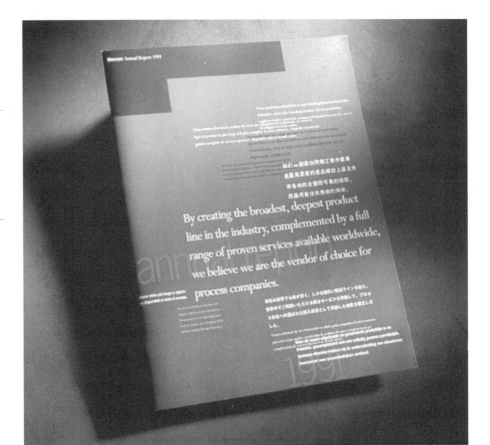

Figure 4-26
Promotional Brochure for Mohawk Paper Mills
Design firm: Liska and
Associates, Chicago, IL
Art director: Steve Liska
Designer: Brock Halderman
Client: Mohawk Paper Mills

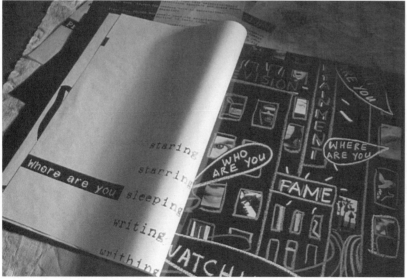

Figure 4-27
Sales Portfolio for E!, 1990
Design firm: Vrontikis Design
Office, Los Angeles, CA
Designer: Petrula Vrontikis
Illustrator: Huntley & Muir
Client: E! Entertainment
Television

*The purpose of this sales kit
was to present the concept of
E! Entertainment Television to
local cable operations around
the country. The design reflect-
ed a layering of words and
images being shown 24 hours
a day. The channel was to be
exciting and progressive. The
typography was created by
using plain "word processor"
type run through a fax
machine, then enlarged to
show its roughness. Basic
design principles such as
contrast in color and contrast
in size were key to the suc-
cess of the layouts.*

Petrula Vrontikis, Owner,
Vrontikis Design Office

Figure 4-28
Logo, "Mother & Child"
Designer: Herb Lubalin
The Design Collection at The Herb Lubalin Study Center,
The Cooper Union, New York, NY
Courtesy of the Lubalin Family

Figure 4-29
Mesa Grill Logo, 1991
Design firm: Alexander Isley Design, New York, NY
Client: Mesa Grill

What ever happened to Mary Jo Kopechne's five girlfriends who had the good fortune *not* to drive off with Ted Kennedy? See page 37. Why has there never been a best-seller or a movie or even a television docudrama about Chappaquiddick? See page 40. In the age of Everythingscam and Whatevergate, how, after 18 years, can the Chappaquiddick cover-up remain so airtight? Good question. And why won't anybody publish an impressive new investigative book that for once gets a Kennedy cousin and Chappaquiddick witness *on the record* about the incident? Read this article.

CHAPPAQUIDDICK

The Unsold Story

BY TAD FRIEND

EARLY IN THE MORNING of July 19, 1969, after attending an intimate party of male political cronies and female political aides, Senator Edward Kennedy drove his Oldsmobile off Chappaquiddick Island's Dyke Bridge and into Poucha Pond. His passenger, Mary Jo Kopechne, drowned.

This is not exactly news. Most of us recall that after a considerable public rumpus, Senator Kennedy took the extraordinary step of going on television to explain—altogether unconvincingly—this latest Kennedy tragedy.

Kennedy pleaded guilty to leaving the scene of an accident after causing personal injury and later promised to consider resigning his Senate seat (*Nahhhh*, he evidently decided, instead going on to win reelection three times).

After receiving a two-month suspended sentence, he clammed up. And so did everyone else in a position to fill in some of the blanks—the five women at the party who did not drown in Ted Kennedy's car, the five men at the party who did not swim away from a submerged Oldsmobile and then lie about it. So the inquiries have blundered along without Kennedy's help, or the help of his loyal friends at the party. And so, naturally, strange Chappaquiddick theories abound: Kennedy was driving; Kennedy wasn't driving; Kennedy murdered Kopechne because she was pregnant with his child, and jumped out of the moving car in the nick of time; and so on.

What is news—or should be—is that Joe Gargan, a cousin of Kennedy's who spent much of that fatal evening with the senator, finally did unburden himself of his Chappaquid-

Figure 4-30
"Chappaquiddick" Spread, *Spy* **Magazine, 1987**
Design firm: Alexander Isley Design, New York, NY
Client: *Spy* Magazine

use type in a structural way in order to express meaning. The ampersand (symbol for the word "and") inside the letter "o" and the word "child" inside the ampersand symbolize a fetus in the womb. This seems like a natural solution once we see how Herb Lubalin did it (See Figure 4-28). The design concept, the spacing, the positive and negative space, and the typeface all lend to the success of this design. Here are two creative typographic design solutions by Alexander Isley (See Figure 4-29). The Mesa Grill logo is a play on the word "mesa" which means "flat-topped mountain." In the *Spy* Chappaquiddick spread (See Figure 4-30), to represent Senator Ted Kennedy's famous misfortune, the words are shown sinking into water.

Used in conjunction with a visual, type is often the verbal part of the design message. However, type can also be the visual itself and can express the entire message. By designing the type to look cramped, Bonnie Caldwell express-es meaning through this typographic design (See Figure 4-31). Designed to demonstrate the effect of a crash, the right-hand side of the text type corresponds to the impact of the automobile in this advertisement for Geico Auto Insurance (See Figure 4-32). The design of the headline type on these trade advertisements for *Self* magazine expresses the meaning of the words (See Figure 4-33). Letters represent spoken sounds, and in this poster for "Project Read", type is used to evoke the sound of someone learning to read (See Figure 4-34).

Martin Holloway uses custom lettering and low contrast (created with a technical pen on graph paper) to express the rustic meaning of the words "Country Things" (See Figure 4-35). In Jennifer Morla's "AIGA: Environmental Awareness" Poster (See Figure 4-36), Morla uses type as a vehicle to express subtle shades of meaning that go beyond the written expression of the message.

IS THIS WHAT YOUR CURRENT OFFICE SPACE FEELS LIKE? ◆

Everyone knows a downtown office is good for business. Too bad it's also good for wall-to-wall buildings, crowded parking, and plant life of the plastic and silk varieties.

At Triad Center, things are different. No other downtown location provides you with so much fresh air, green grass, earth, sky and water. It's like a mini-oasis in the concrete jungle.

Best of all, the price at Triad Center gives you room to breathe as well. Inspite of the beautifully-manicured grounds, $11 a square foot buys a level of prestige worth $18-$20 a few blocks east.

To see how Triad Center can improve your working environment, call 575-5050.

Chris
Matthews
& ASSOCIATES

Figure 4-31
Ad, 1992
Agency: Williams & Rockwood, Salt Lake City, UT
Creative director: Scott Rockwood
Art director: Bonnie Caldwell
Writer: Chris Drysdale
Client: The Triad Center

We wrote this ad in an office the size of a shoe box on 2nd south in Salt Lake City. It went on to win many awards. But what pleased us most was that the ad was so effective. The Triad Center reached 95% occupancy in about a year. Just working on the ad had us convinced. We moved to the Triad Center six months later.

Williams & Rockwood

Figure 4-32
Ad, "Seatbelt," 1990
Agency: Earle Palmer Brown, Bethesda, MD
Art director: Barbara Scardino
Writer: Daniel Russ
Client: GEICO Auto Insurance

The GEICO campaign was conceived in late 1990 and produced (and run) in early 1991.

This ad is part of a TV and print campaign for GEICO, an insurance company specializing in safe drivers. While the ad obviously promotes the client's image, we also wanted it to have an informative, public service message. To that end, it was designed to have a clean, open, and sophisticated look that would also make the long copy approachable. The headline obviously called for a crashing car visual payoff. By having the car crash into the type, the whole idea is reinforced. It also makes the ad more visually dynamic to see what the car is crashing into. Your eye goes from the headline to the car, which brings you right into the copy. Incidentally, the type was set the old-fashioned way, in galley form, hand-ticked out for line breaks, and then hand-cut to create the smashed look. The fairly quick turnaround time we had and the state of computer capabilities available to us made this a more viable option.

Barbara Scardino, Senior Art Director, Earle Palmer Brown/Bethesda

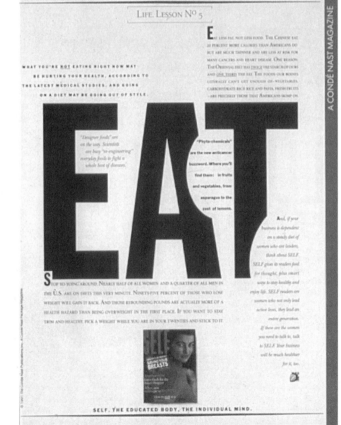

Figure 4-33
Series of Trade Ads for *Self* Magazine
Design firm: Robert Valentine Incorporated, New York, NY
Art director/designer: Robert Valentine
Designers: Robert Valentine, Tracy Brennan
Writers: Shari Sims, Dean Weller
Courtesy of Condé Nast Publications

Figure 4-34
Poster for "Project Read," 1990
Design firm: The Ralphus Group, Atlanta, GA
Art director: Joe Paprocki
Writer: Rich Paschall
Client: Project Read

There's...nuh...thing quite...as...re...ward ing...as...hear....ing an...ad...dult...read for.....the.........vair ree......first....time.

Teach an adult illiterate how to read. You don't need any special skills or experience. All you need is the desire to make a difference in someone's life.

Call us at 491-8160 to find out how you can become a volunteer teacher. Only then will you discover the true joys of reading.

Figure 4-35
"Country Things," 1983
Design firm:
Martin Holloway, Warren, NJ
Lettering/designer:
Martin Holloway

Designing with Type

Perhaps the most difficult part of any graphic design education is learning to design with type. Maybe it is because we tend to be literal. We concentrate on the literal meaning of words, and give their form short shrift. In order to design with type, you must consider four main points:

1. type as form,

2. type as a direct message-its primary meaning,

3. the secondary meaning (or connotation) of type, and

4. graphic impact.

Form

Let's say you are visiting a foreign country and the national language uses a different alphabet than yours. You might be more inclined to view the characters of that alphabet as forms since you cannot read them (See Figure 4-20). Pretend you cannot read English, and look at our letterforms as pure form. When we consider letterforms as positive and negative forms, we will be more aware of the visual interest they create. The stronger the positive and negative space relationships, the more dynamic and aesthetically pleasing the design.

Each letterform has distinguishing charac-

teristics. Some letters are closed forms, like the "O" and "B," and some letters are open forms, like the "E" and "M." The same letterform can vary in form depending on the typeface, like this lowercase "g" in "Times" and this lowercase "g" in "Helvetica." Have you ever the noticed the variations of the form of the letter "O" from typeface to typeface? For example, the "O" in some typefaces is circular and in others it is oval (See Figure 4-37). You may want to compare letterforms in a few classic typefaces, like Bodoni, Garamond, Century Old Style, Futura, Times Roman, and Univers. (In this case, classic means a typeface that has become a standard because of its beauty, grace, and effectiveness.) It is a great idea to be so familiar with at least two classic typefaces that you know every curve and angle by heart.

Each letterform is made up of positive and negative forms. The strokes of the letterform are the positive forms (sometimes just called forms), and the spatial areas created and shaped by the letterform are the negative forms (or counterforms). When two letterforms are next to one another, negative forms are created in between them, which are also called counterforms. Try to be as sensitive as possible to the forms of each letter and the counterforms between them. Remember that the negative forms are as important as the positive forms. In other words, interletter spacing is a crucial aesthetic consideration. Leading must also be considered. You must have enough space for ascenders and descenders and consider the negative space between lines of type.

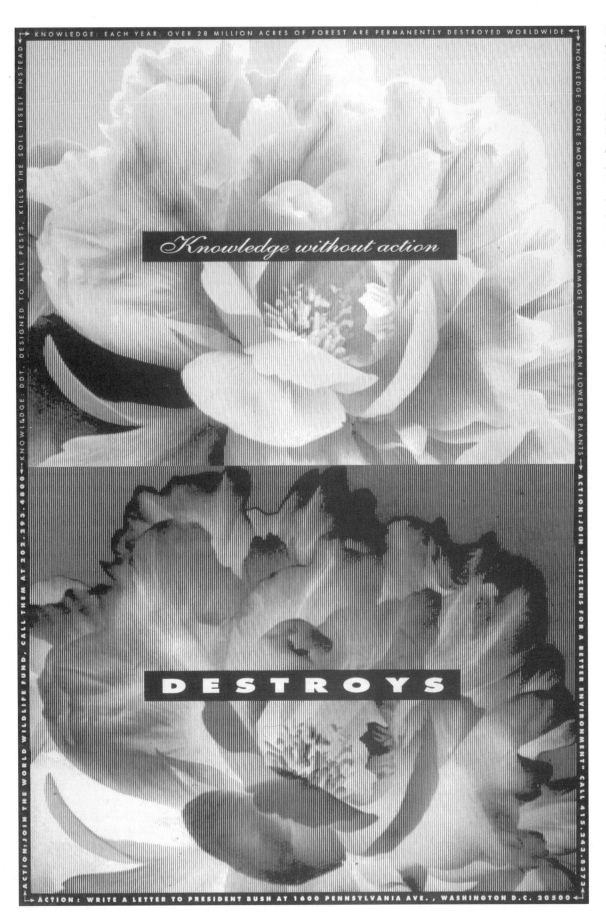

KNOWLEDGE: EACH YEAR, OVER 28 MILLION ACRES OF FOREST ARE PERMANENTLY DESTROYED WORLDWIDE

Knowledge without action

DESTROYS

ACTION: WRITE A LETTER TO PRESIDENT BUSH AT 1600 PENNSYLVANIA AVE., WASHINGTON D.C. 20500

Figure 4-36
San Francisco AIGA:
Environmental Poster,
1991
Design firm:
Morla Design,
San Francisco, CA
Art director:
Jennifer Morla
Designers:
Jennifer Morla,
Jeanette Arambu
Client:
San Francisco AIGA

Figure 4-37
Comparison of Letterforms in
Various Typefaces

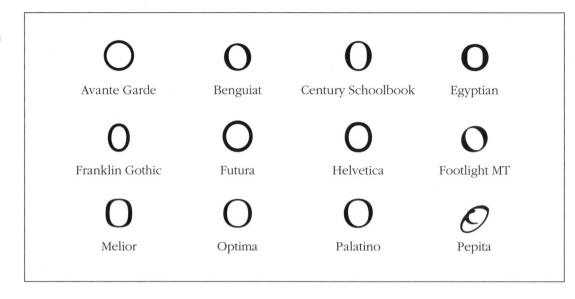

Direct Message

Both today and in the past, designers utilize and have utilized letterforms as purely decorative forms, ignoring their symbolic content. Most often, however, type is meant to be read. For the viewer to read display or text type and get the direct message, you must consider legibility and emphasis. Legibility contributes to readability and is the quality that makes type easily comprehensible. Many things contribute to readability: letterspacing, word spacing, line spacing, line breaks, line length, typeface, type size, width, weight, capitals and lowercase letters, type alignment, italics, and color. Let's examine some of these.

Just as letterspacing, word spacing, and line spacing (or leading) are crucial to the creation of interesting and harmonious positive and negative form relationships, they also are vital to readability. Too much interletter, interword, and interline spacing may detract from readability; conversely, too little space may make words difficult to read. As stated earlier, you must not trust automatic spacing—always make adjustments. Also, uneven letter spacing and word spacing may cause unwanted pauses or interruptions that make something more difficult to read. Here is a test: read the words aloud and see if there are any unwanted pauses or spaces. Similarly, if the line length is too long or too short, it will detract from readability. When designing display or text type, always ask yourself, "Can I read it with ease?"

There are many theories and rules of thumb about spacing, aesthetics, and readability. For example, some designers say that if you have open letterspacing, the word and line spacing

should be open. Conversely, if you have tight letterspacing, the word and line spacing should be tight as well. Consistency is important. Of course, others factors come into play, such as the typeface, type size, and weight. Try to read several books about designing with type in order to learn as many points of view as possible. Refer to the bibliography for books about type.

Obviously, when considering spacing, much depends upon the typeface(s) you are using and the type sizes, weights, and widths. Some typefaces seem to lend themselves to more open spacing because of their form. Some lend themselves to tight spacing. Study type specimens of display and text type to get a "feel" or "eye" for typefaces, weights, and widths. Some things to consider:

- Faces that are too light or too heavy may be difficult to read, especially in smaller sizes.
- Typefaces with too much thick/thin contrast may be difficult to read if they are set too small—the thin strokes may seem to disappear.
- Condensed or expanded letters are more difficult to read because the forms of the letters change. You may, however, choose to use a condensed width, if, for example, you are designing a narrow column of type.
- Larger sizes require tighter spacing than smaller sizes. If the type is a display size, you will have to space it differently than a text size.
- In both display and text sizes, type set in all capitals is generally more difficult to read. A combination of capitals and lowercase letters provides maximum readability.

- In general, type that is flush left, ragged right is easiest to read. That does not mean you should not use any other type alignment. Base your decision on several factors: the type size, the leading, the meaning, the audience, and the amount of type. Reading a short message in flush right, ragged left is not too difficult.
- Where you break the lines of type depends on two basic factors: aesthetics (appearance) and editorial meaning. Line breaks should be aesthetically pleasing. Break lines in natural places to enhance meaning. Indentations and leading between paragraphs also enhance legibility. Paragraphs that are too long are difficult to read. The use of initial capitals also can enhance readability.
- Remember: Italics are best used for emphasis, rather than for large blocks of text, which may be difficult to read.
- When the lines in a paragraph are too long or too short, they are hard to read. Around forty-five characters to a line is usually comfortable to read.

Color also is an important consideration. When a lot of text is involved, most designers choose black type on white or light backgrounds. The more value contrast between type and background, the greater the legibility. If the type and backround colors are similar in value, the type will be difficult to read. Highly saturated colors may interfere with legibility as well.

We use **emphasis** to determine the importance of information in a design. Viewers tend to read headings first, like titles or headlines, then subheadings, and finally other typographic elements such as paragraph headings, pull quotes (quotes pulled from the text and enlarged in size), type in panels or feature boxes, captions, and text or body copy. The designer must design the typography into a visual hierarchy.

Let's take an example. If you are designing a book cover, you will have to decide whether you want the viewer to read the book title first or the author's name first. If the author is well known, someone like John Grisham, you may want the viewer to see the author's name first. Of course, you would want to emphasize Grisham because John is a common name or give the first and last name equal emphasis, but you certainly would not emphasize John. In a more difficult layout, like a newsletter, you must use type size, weight, and width to control the order in which the viewer reads the information. Elements like initial caps, paragraph indents, rules, and icons will aid in establishing emphasis. Contrasts in size and weight will lead the eye from one element to the next. We tend to read larger, darker elements first.

Here is a tip: When designing something with a lot of information, sort out the information on index cards or individual sheets of paper. Type or print out the heading on one card, the subheading on another card, the date of the event on another card, and so on. Stack the cards in order of importance. This will help you to establish tiers of information.

Secondary Meaning

Let's say you have to design the following sentence: "It looks like a storm is brewing." Which typeface would you choose to enhance the direct message? What size, weight, and width? Would color enhance the meaning and if so, which colors? The direct message of the sentence is the primary meaning, the denotation. The way the type is designed suggests a secondary meaning, a connotation.

Each classification of typefaces has a different spirit or "personality," and the differences among the typefaces within each category give each typeface an individual spirit as well. Typefaces that defy categorization, and there are many, have individual spirits. Sometimes it is easier to determine the spirit of a novelty typeface, like Shatter, because it is more illustrative.

In addition to having personality, type has a voice. Type can scream or whisper. As you will see later in this chapter, type can communicate the same way as the spoken word. Consider the typeface, size, scale, and position in the layout when determining the typography's "voice."

Here is a standard example of secondary meaning. Most designers consider Old Style and Transitional typefaces more "conservative" or "serious" than Sans Serif faces. Perhaps it is because Old Style is based on Roman and 15th century humanistic writing. Perhaps it is because Sans Serif typefaces are from the modern era and considered newer. The first Sans Serif typestyle appeared in the early 19th century, which is a few centuries after the initial Old Style typestyle appeared in the late 15th century. It is important to study the history and origins of typefaces so you can make informed decisions.

Every typographic element (weight, width, stress, thick/thin contrast, size) and design element (color, texture, value) contributes to the secondary meaning. Whether the type is heavy

or light, Roman or Italic, black or red, carries meaning beyond the direct message. For example, picture the words "heavily armored combat vehicle" in your mind's eye. Most people would probably think of sans serif heavy capitals. Using a light script would suggest a meaning contrary to the direct message. If the designer did use a light script, he or she would be suggesting an ironic meaning.

In order to become sensitive to the secondary meaning of typography, study the work of successful designers like the ones in this text. Ask yourself why they choose the typefaces, weights, and widths they did to solve their design problems. Try to figure out the relationship between the primary and secondary meanings in their works.

Graphic Impact

You are designing with type and you have considered form, the direct message, and the secondary meaning. Now, how does it look? Yes, after all that, you have to consider aesthetics—the underlying beauty of the typography. Today, we use the term "beauty" loosely. In reference to contemporary graphic design, and especially to typography, the terms "aesthetically pleasing" and "beauty" seem archaic. What is beautiful to one designer is ugly to another. Some contemporary designers believe typography must be legible, balanced, and harmonious, while randomness, obscured type, and disjointed forms appeal to other contemporary designers. Graphic impact is probably a better term.

One way to determine the graphic impact of a typographic solution is to measure the "texture" or "color" of the solution. The terms texture and color have different meanings here. Some designers use these terms to refer to the tonal quality of type. The texture or color of typography is established by the spacing of letters, words, and lines, by the characteristics of the typeface, the pattern created by the letterforms, the contrast of Roman to italic, bold to light, and the variations in typefaces, column widths, and alignment. Here is a tip: Stand back and squint at typography to get a sense of its "lightness or darkness," its tonal quality.

Another way to measure graphic impact is to determine the appropriateness of the style for the client, the message, and the audience. Which style is appropriate for a serious message? Are certain styles appropriate for certain types of clients? Would you design in the same style for a young audience and for a mature audience? The style you choose should be appropriate for the client, message and audience. You would not design an ad for MTV the same way you would design an ad for a commercial bank; they are different clients with different needs and probably different audiences. For example, *Ray Gun* magazine appeals to the under-30 market. People raised on the look of music videos are more receptive to experimental typography.

Some designers are very aware of trends in music, fashion, art, and of course, in graphic design. Typefaces can be trendy as well. Trendy typefaces are difficult to use because their design can overpower the message. There are times when certain typefaces are more popular; everyone seems to be using one or two faces. Then a typeface can get played out. Articles in visual communications magazines are devoted to the loss of efficacy of a typeface because of overuse. There are many novelty or decorative typefaces that students seem to be attracted to but should avoid because they are difficult to design with; it is difficult to mix them with other typefaces, and they usually do not lend themselves to legibility. They tend to take over a design.

Years ago, most designers would have thought twice about using more than two typefaces in the same design solution. Although many good designers still would not use more than two, others believe using more can have great graphic impact. Try this experiment to become sensitve to mixing typefaces and using more than one typeface: Find an advertisement or any other design with a lot of type, both display and text. First, redesign the ad using only one typeface, one size, and one weight. Print out a copy and keep it as a control. Then change the heading to another typeface. Next, change the size of the heading and subheadings. Try various combinations. Experimenting with type is one of the best ways to learn about it.

On the college level, graphic design students usually take at least two courses in typography and then spend an entire career trying to master designing with type. Entire books are devoted to type and to designing with type. Consider this chapter a point of departure for further study.

Tips from Designers

**Alexander Isley, president,
Alexander Isley Design,
New York, New York:**

"Read the manuscript. It is surprising how easy it becomes to design when you understand what the writer's message is."

**Thomas Courtenay Ema,
Ema Design, Denver, Colorado:**
Designing with Type in General

"For me, designing with type is one of the most important and pleasurable aspects of graphic design. If design were visual music and layout, composition and grids are the structural elements of the music, then typographic elements are the notes. With these notes an accomplished musician can write beautiful music. It is possible to create visual music that can express any emotion or communicate any ideas."

Designing with Type and Visuals

"To fully express a communication message with type and image the designer must pay particular attention to the relationship between those two elements. The most effective design solutions exhibit a unique connection between the type and the visual that communicates something more than either one alone. This connection can sometimes be made by letting the type reflect or contrast the form, composition, pattern or color of the visual image. Remember that the type and image are all individual pieces of an overall design that should not be thought of alone, but in terms of how they work together to create the overall design and communication message."

Designing with Display Type

"One of the biggest traps for a student of typography to fall into in selecting and designing with type is giving in to the use of special display faces to communicate different ideas. If one truly understands the method of creating good typography, wonderful design solutions can be created with a limited group of proper type families such as Garamond No. 3, Helvetica, Univers, Times Roman, and Bodoni. If we use a musical analogy it is like playing different instruments. Do not try to play a hundred different instruments; learn to play a few instruments well!"

**Tom Geismar,
Chermayeff & Geismar Inc.,
New York, New York:**

"Typography forms the basis of almost all our design work. It is the way we express ourselves. It is the cornerstone of our practice."

**Martin Holloway,
Professor of Fine Arts,
Kean College, New Jersey:**

"There are at least two qualities that are always present in successful typographic design.

First is form: type should work in a purely formal manner. All visual elements, including letterforms, possess design properties such as line, texture, shape, and mass. These elements are configured into compositions—the arrangement of elements to achieve visual equilibrium.

Second is function: type should work as the visual counterpart of language. In spoken communications, factors such as syntax, inflection, and the emotional quality of the voice are inseparable from message content in terms of the impact the spoken word has upon the listener. Similarly, the selection of typeface, style, and size—and their placement relative to other visual elements—is equally inseparable from message content."

**Mike Quon,
Mike Quon Design Office,
New York, New York:**

- *"So often, people get so involved in the non-readability of things, ways to cover up words. Type is meant to be read. If we are not encouraging reading we are missing one of the better ways to communicate."*

- *"Do it the way you want to—trust your first instinct, then do it several more ways. Then put them all in front of you and compare them. The more successful solution will stand out. Develop a rationale; be able to explain why one is better than another."*

- *"The rules about designing with type are being broken. You have to find your own style and vision—what feels right for you."*

- *"I like headlines—because people look something over in seconds."*

- *"There is a lot of entertainment value in what we do."*

- *"There is a blur between the lines of good typography and bad typography. It is hard to say what is good or bad because it is a value judgement. Design and beauty are in the eye of the beholder, but there are different styles that people like. There is no one way, however—make it tasteful, simple, and not too hard to read."*

Comments

One of the greatest challenges facing a designer is to organize typographic elements into a visual hierarchy. Establishing a visual hierarchy is central to clear communication. The designer must order elements so the reader can comprehend the message.

Design Your Name

1. Get a book of typefaces.
2. Write down two or three adjectives that describe your personality or spirit.
3. Find typefaces that express your personality or spirit.
4. Design your first and last name. Middle name is optional.
5. Give careful consideration to the positive and negative forms in between the letters and the spacing between the letters.

Project 4-1
Design a Poster Entitled "Taking a Stand"

Step I

1. Research the civil rights movement in the United States.
2. Write an objectives statement. Define the purpose and function of the poster, the audience, and the information to be communicated. On an index card, in one sentence, write the objective of this poster.
3. Find typefaces that express the spirit of the subject.

Step II

1. Design a poster for a public television program entitled "Taking a Stand." The program is a documentary on the Civil Rights movement in the United States.
2. The poster should include the title and television station or channel. Optional: date and time of broadcast.
3. Your solution should be typographic, with no visuals.
4. Produce at least twenty sketches.

Step III

1. Produce at least two roughs.
2. Use a vertical format.
3. Be sure to establish emphasis.
4. Carefully examine your spacing between letters, among words, and between lines of type.

Step IV

1. Create a comp.
2. The poster should be no larger than 18" x 24".

Presentation
Present the comp either matted or mounted with a 2" border all around.

Comments

It is important to remember that type can be the visual! You do not have to rely on photographs or illustrations to grab the audience's attention.

Exercise 4-2
Expressive Typography

1. Look through a few magazines.

2. Find typefaces used in articles or advertisements that express the following: light-heartedness, seriousness, humor.

3. Find typefaces that you think are classics, retro (reminiscent of an era gone by), and trendy.

4. Defend your choices.

Project 4-2
All Type

Step I

1. Design a poster or invitation for an exhibition or film festival.

2. The design solution should be solely typographic with no visuals or visual accents.

3. Produce at least twenty sketches.

Step II

1. Produce at least two roughs.

2. Use a vertical format.

3. Carefully examine letterspacing, word spacing, and line spacing.

Step III

1. Create a comp.

2. The invitation should be 4" x 6"; the poster should be no larger than 18" x 24".

Presentation
Present the comp either matted or mounted with a 2" border all around.

Chapter 5
Layout

Objectives

▪ to understand the fundamental principles governing the layout of a page

▪ to become familiar with the grid as a layout device

▪ to be able to construct and design simple grids

Layout

If you have ever arranged furniture in a room, then you know how complicated a process layout can be. There are several goals—to fit the elements into a limited space, to arrange them so that they are functional and accessible, and to place them attractively. Designing a page is very similar. It is about arrangement. Layout is about arranging type and visuals on two-dimensional surfaces so all information is legible, clear and attractive. A **layout**, therefore, is the arrangement of type and visuals on a page.

How do you design a successful layout? As always, you begin by asking yourself a few questions: Who will be looking at or reading this? What style is appropriate for this audience? What will attract the audience's attention? What is the purpose of the design? What information or message has to be communicated? Where will it be seen? Once you have answered these questions, you can begin to produce thumbnail sketches in order to consider various layouts.

There are innumerable ways to arrange elements on a page. Once you have considered the previous questions and begin sketching, there are some basic factors to keep in mind. The most important design principles governing layout are emphasis (focal point and visual hierarchy), unity, and balance. Although they all have to be considered as you work, let's go through them one by one.

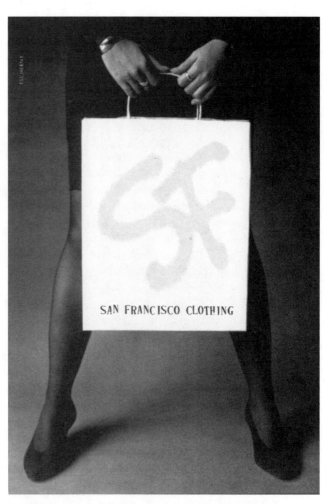

Figure 5-1
Postcard, San Francisco Clothing, 1990
Design firm: George Tscherny, Inc., New York, NY
Designer/photographer: George Tscherny
Client: San Francisco Clothing

The postcard was issued as a reduction of a poster. The company ID (here applied to a shopping bag) was produced with a can of spray paint and rubber stamp type to reflect the "punk" and youthful character of the customers.

George Tscherny, George Tscherny, Inc.

Figure 5-2
Ad Campaign
Agency: Goldberg Moser O'Neil,
San Francisco, CA
Client: The Red and White
Fleet, San Francisco, CA

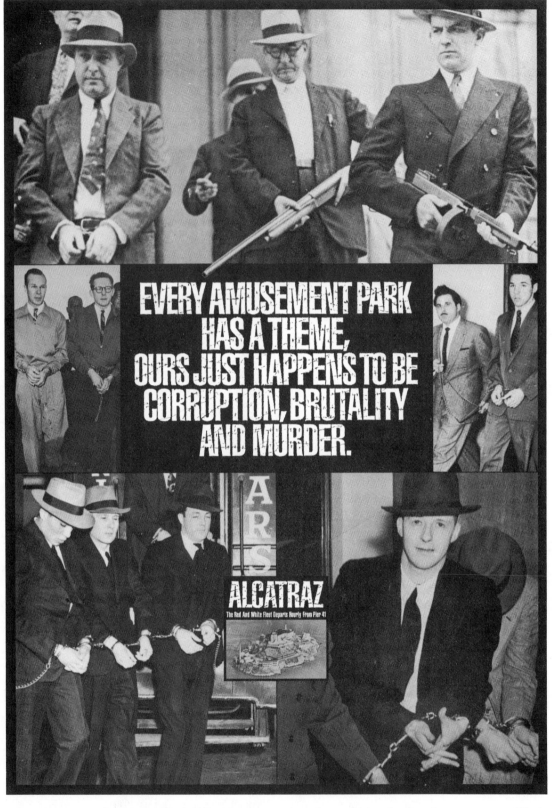

Emphasis. When you establish a focal point, you create a main area of interest on the page. Choosing which element should be the focal point, whether it is type or a visual, should be based on several factors:

- what primary message or information needs to be communicated
- which element is the most interesting
- which element is most important

For example, it is most likely that either the main visual component or the main verbal message (type) would be the focal point. It is unlikely that a secondary or tertiary point of information, such as the time of an event or a zip code, would be the focal point. In a layout the focal point can be established in the following ways:

- make it the brightest
- make it a different color, create a contrast in colors
- move it in a different direction, contrast of position/direction
- make it the biggest

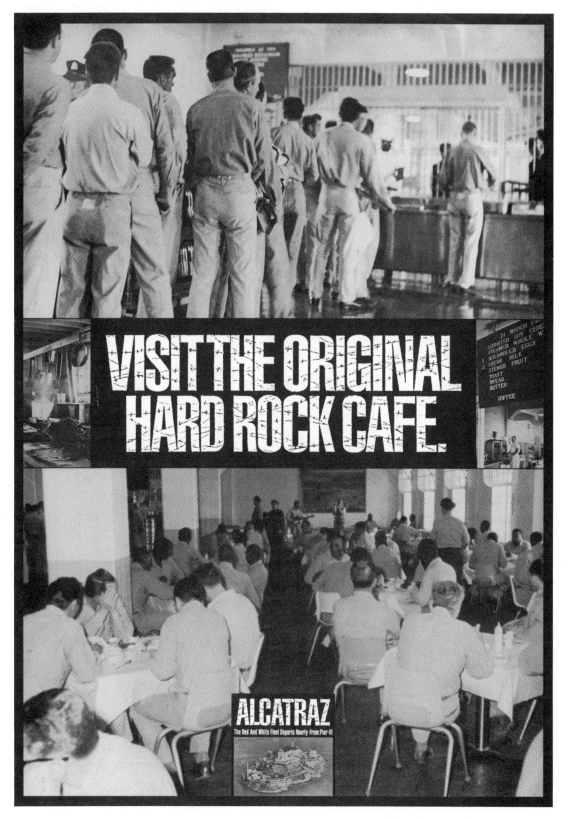

- make it a different value, create value contrast
- make it a different texture, create a contrast of textures
- have all other elements lead to it
- make it a different shape
- isolate it
- make it dull if everything else is bright
- make it sharp if everything else is hazy
- position it carefully

Using a strong, high-contrast, central focal point in this postcard design, George Tscherny attracts the audience's attention (See Figure 5-1). The centered figure and the angle of her legs and hands behind the shopping bag draw the audience's attention to the bag. Even though the high-contrast visuals in this witty advertising campaign (See Figure 5-2 pp. 98 and 99) for the Red and White Fleet are extremely interesting, the headlines are the focal points because of their central position on the page.

Without a doubt, the most important design

Figure 5-3
Advertisement, "Great Ideas of Western Man: Ralph Waldo Emerson," 1952
Designer: Herbert Bayer
Client: Container Corporation of America
Collection: Denver Art Museum, Herbert Bayer Collection and Archive, Denver, CO

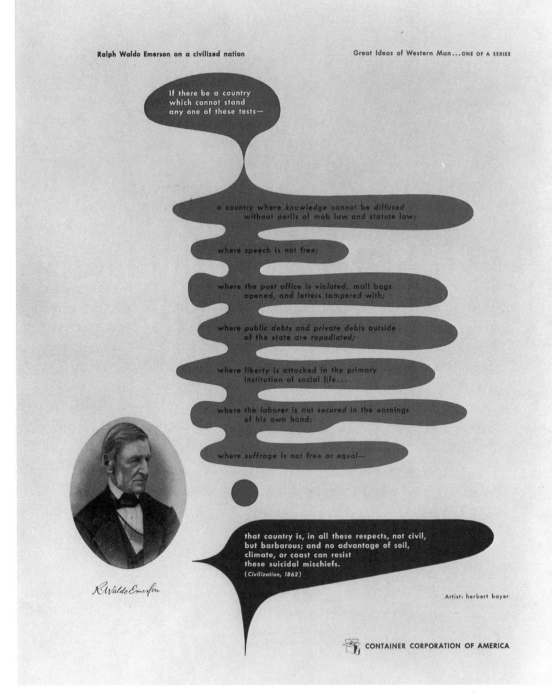

principle for a student to keep in mind is visual hierarchy, which means arranging elements according to emphasis. Establishing a visual hierarchy sets a priority order for all the information in a design. Usually, any graphic design piece has several elements, like a title, subtitle, text, and visuals. You must decide which elements take priority over other elements. This is crucial. You must ask yourself: What should the viewer see first? What should the viewer see second? What should the viewer see third? And so on.

The position of elements on the page, the relationship of one element to another, and factors including size, value, color, and visual weight all must be considered. Here are some general points to keep in mind when establishing visual hierarchy:

- position: because we read English from left to right and we begin to read at the top of a page, we naturally tend to move our eyes the same way when looking at a design
- size: we tend to look at bigger things first

and smaller things last

- color: we tend to be attracted to brighter colors but also to look at the color that stands out or is different from the surrounding colors
- value: a gradation of values, moving from high contrast to low contrast, can establish a flow from one element to the next
- visual weight: we tend to look at "heavier" elements first

Sometimes designers have to arrange a great number of elements on a page. Often, a client insists that a good deal of text and visuals be included, or a designer may choose to include multiple elements. In either case, the designer must be up to the challenge. In this advertisement for the Container Corporation of America, Herbert Bayer organizes a lot of text by encapsulating it in shapes that flow from one to the other (See Figure 5-3). The shapes create a visual vertical axis; visuals and text are balanced on either side. The designer of this poster (See Colorplate 7) was able to establish a visual hierarchy using both interesting typography and compelling visuals. The ordering of the elements is logical, moving our attention, in order, from the most important information to the least. In other words, the designer established tiers of information.

Figure 5-4
"In the Pocket" Promotional, 1993
Design firm: David Morris Design Associates, Jersey City, NJ
Creative director: David M. Annunziato
Art director/designer: Denise M. Anderson
Photographer: Elizabeth Watt

THE RIGHT SPIN ON YOUR DESIGN AND MARKETING

THE PROFESSIONALS AT DAVID MORRIS

DESIGN KNOW ALL THE ANGLES.

HOW BEST TO REACH YOUR CUSTOMERS

WITH THE LOOK AND MESSAGE

THAT WILL WIN YOU POINTS.

YOU'RE NEVER LEFT BEHIND THE 8-BALL

WE ALWAYS GIVE YOU OUR BEST SHOT.

WE DELIVER ON CUE—AND WITHIN BUDGET.

WITH DAVID MORRIS DESIGN, YOU'RE

ALWAYS ON A ROLL. BANK ON IT.

201-434-7797

PHOTOGRAPHY: ELIZABETH WATT
212-929-8504
PRE-PRESS/PRINTING: WASHBURN GRAPHICS
1-800-438-0378

The Four Oxen and the Lion

A LION used to prowl about a field in which four Oxen used to dwell. Many a time he tried to attack them; but whenever he came near, they turned their tails to one another, so that whichever way he approached, he was met by the horns of one of them.

At last, however, the Oxen fell a-quarreling among themselves, and each went off to pasture alone in a separate corner of the field. Then the Lion attacked them one by one and soon made an end of all four.

United we stand, divided we fall.

Figure 5-5
Spread from a New Edition of *Aesop's Fables*, **Designed in 1991, Artwork created in 1947**
Design firm: Milton Glaser, Inc., New York, NY
Artwork: John Hedjuk, architect
Publisher: Rizzoli International Publications, Inc.

Unity. In order for a layout to be successful, it must hold together. It must be unified. There are many ways to achieve unity. Four of the most important devices are correspondence, alignment, flow, and the grid.

When you repeat an element such as color, a visual, shape, texture, or establish a style, you establish a visual connection or correspondence among the elements.

Denise M. Anderson uses alignment to establish unity in this promotional piece for David Morris Design Associates (See Figure 5-4); the billiard balls, headline, and text are aligned on a vertical axis. Visual connections can be made between and among elements, shapes, and objects when their edges or axes line up with one another. The eye easily picks up these relationships and makes connections among the

Figure 5-6
Ad, 1989
Agency: The Martin Agency, Richmond, VA
Client:
Ethyl Chemical Corporation

We were trying to think of a visual that would represent something that does not age. Both the writer and I grew up watching American Bandstand, so the solution was easy.

Dick Clark provided the photo, for which he was paid handsomely.

The Martin Agency

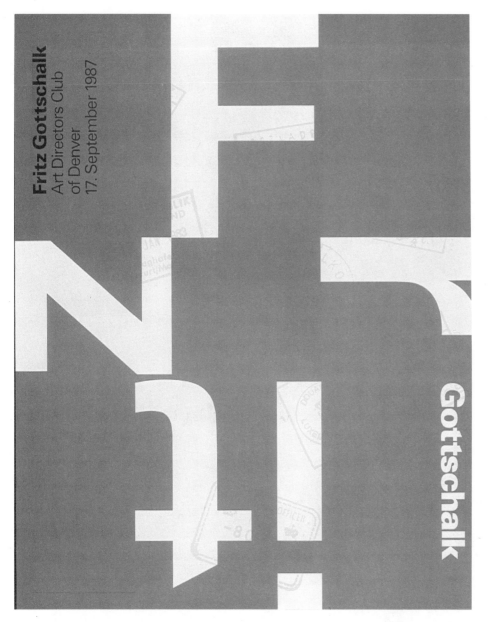

Figure 5-7
Fritz Gottschalk Poster, 1987
Design firm: Ema Design,
Denver, CO
Art director/designer: Thomas Ema
Client: Art Directors' Club of
Denver, CO

Having studied with Gottschalk in 1984, Ema arranged for his mentor to speak to the Art Directors' Club of Denver. Ema used international passport stamps as the announcement's random design elements—and later later learned that Gottschalk's topic was his design of the new Swiss passport!

Thomas Ema, Owner, Ema Design

forms. Similarly, the arrangement of elements in the photograph leads our eyes to the alignment of elements on the calendar pages (See Colorplate 8).

Balance. We take comfort in balanced design. When a design is imbalanced it will look uneven, as though something about it is not right. Balance is an equal distribution of weight in a layout. Like visual hierarchy, it is crucial to a successful layout. To balance a design, you must consider visual weight, position, and arrangement. A spread for the Time Warner 1990 annual report successfully balances four strong and colorful visuals (See Colorplate 9).

Try a little experiment using this spread, designed by Milton Glaser, from an edition of *Aesop's Fables* (See Figure 5-5). Cover the graph-

ic element (artwork) in the lower right-hand corner. You'll notice that the layout is no longer balanced. The same is true for this clever ad by the Martin Agency; cover the Ethyl logo in the bottom right-hand corner (See Figure 5-6). This demonstrates just how important the arrangement of every element is to a successful layout.

The term "format" has two related meanings: the actual thing or substrate you start out with—like a poster or brochure—and the limits of that substrate, such as the edges and overall shape of a poster. Never forget a primary player in any layout is format. All elements respond to the shape of the page. Each letter of the name "Fritz" touches the edges of the format in this poster design announcing Fritz Gottschalk's lecture at the Art Directors' Club of Denver (See Figure 5-7). The designer, Thomas Ema,

Figure 5-8
Exhibition Catalog Cover,
"Ohio Perspectives," 1991
Design firm: Nesnadny +
Schwartz, Inc., Cleveland, OH
Designers: Joyce Nesnadny,
Ruth D'Emilia
Client: Akron Art Museum,
Akron, OH

Fig. 5-8 & 5-9
This catalog, for a show of 15
architectural, graphic, and industri-
al designers, was produced on a
very limited budget. Photographs
were provided by the individuals
in the show, so the quality and
attitude of imagery was quite var-
ied. We responded to this dispari-
ty by devoting one spread to each
exhibitor and designing each
spread to reflect the personality of
the contributors' work.

Mark Schwartz, President,
Nesnadny + Schwartz

Figure 5-9
Exhibition Catalog Spreads,
"Ohio Perspectives," 1991
Design firm: Nesnadny and
Schwartz, Inc., Cleveland, OH
Designer: Joyce Nesnadny
Writer: Akron Art Museum
Client: Akron Art Museum

creates dynamic positive and negative shape relationships between the typographic elements and the format. We start with the letter "F" and move clockwise, reading the name and the other information.

On the cover of this exhibition catalogue by the design firm of Nesnadny & Schwartz, "Ohio Perspectives," elements touch and are thoughtfully arranged in relation to the edges of the format (See Figure 5-8). Like the cover, the layouts of the catalogue pages are also thoughtfully arranged (See Figure 5-9).

In Mike Quon's advertisement for *Business Week*, the background is active space as a result of the thoughtful arrangement of the visuals (the ties) and the type in relation to the spread (See Figure 5-10). This ad is part of an advertising campaign, consisting of four ads that ran in business publications such as *Advertising Age*.

BusinessWeek reader

Non-BusinessWeek reader

BusinessWeek =Information=Understanding=Insight =Knowledge=Power=Success=Profit. **PROFIT BY IT**

All of the principles of graphic design apply to layouts. Once you feel comfortable with the fundamentals of graphic design, you can begin to lay out a single page. Many graphic designers work on multi-page designs, such as books, magazines, newspapers, brochures, newsletters, and reports. This is called editorial or publication design. When a designer has to maintain balance, emphasis, rhythm and unity throughout a series of consecutive pages, the task becomes very difficult. For this reason, most designers use a grid.

The Grid

Open up a magazine. How many columns do you see? Are there photographs on the page? Is there a title and subtitle? If so, how are they organized? All the elements, display and text type, and visuals (illustrations, graphics and photographs), on the pages of a magazine, book or newspaper are almost always organized on a grid. A **grid** is a guide—a modular compositional structure made up of verticals and horizontals that divide a format into columns and margins. Note: "grid" is a traditional layout term. When working on some electronic page design software programs the term used is "master page." Margins are the spaces around the type and other design elements. A grid's proportions and spaces provide a consistent visual appearance for a design; a grid underlies all the design elements. It is a way for a designer to establish unity for either a single page or multi-page format.

Your assignment, strategy, concept, and budget will help you determine whether you will be designing a single or multi-page piece, what kind of image should be established, what needs to be communicated and how it should be communicated, and what size and shape it should be. The size and shape of the paper is an important consideration in establishing a grid. There are many standard size papers and traditional ways of dividing them into workable spaces.

When you have many elements to organize—display type, text type, and visuals—you usually need to establish an underlying structure that can provide help in maintaining clarity, legibility, balance, and unity. This is especially true when you are working with a multi-page format where you need to establish a flow or sense of visual consistency from one page to

Figure 5-10
Ad, 1992
Design firm: Mike Quon Design Office, New York, NY
Designer: Mike Quon
Client: *Business Week*

I used my simple, freehand style—brush pen on rice paper—to add a very personal quality and a human touch.

Mike Quon,
Mike Quon Design Office

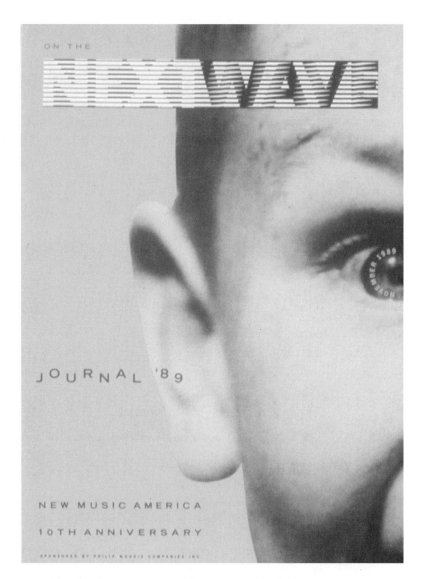

Figure 5-11
**Catalog, "New Music America
Festival," 1989**
Design firm: Alexander Isley
Design, New York, NY
Art director: Alexander Isley
Designer: Alexander Knowlton
Client: Brooklyn Academy of
Music "New Wave Music
America" Festival
(See also p. 107)

another. There are many systems for dividing up space, but here is one way to begin experimenting with grids.

Take an 8 1/2" x 11" page (paper or electronic) and place a margin around the entire format (think of it as a border). Decide on the number of inches for the margin. The margins can be adjusted to any size you find aesthetically pleasing and functional. Now you are left with a central space or "live area" within which to place and arrange design elements. That central space may be thought of as a single-column grid.

Now try another experiment. Take two pieces of an 8 1/2" x 11" paper and place them next to each other to form a two page spread (17" x 11"). Create a single column on each page (using the method described above). Are the columns the same? Do they repeat one another? Or are they mirror images? Now divide the columns with horizontals.

Now try this. On an 8 1/2" x 11" page, create a margin and divide the remaining area into two columns. Now divide the two columns into four. Divide them again into eight. Divide the columns with horizontals. Analyze the differences in appearance and function.

You have just created a few very simple grids. There are many grid options. There are even and odd number grids, usually two and four column grids or three and six column grids. A grid need not be iron clad. You can break with the grid occasionally for the sake of drama or dynamics. If you break it too often, however, the visually consistent structure it provides will be lost. How do you know which grid to use or design? The best way to begin is to consider your design concept, format, and the amount of information that needs to be designed. Each format has a different structure and presents different considerations.

Looking at these designs—a catalog cover and spreads for the Brooklyn Academy of Music "New Music America" festival (See Figure 5-11)

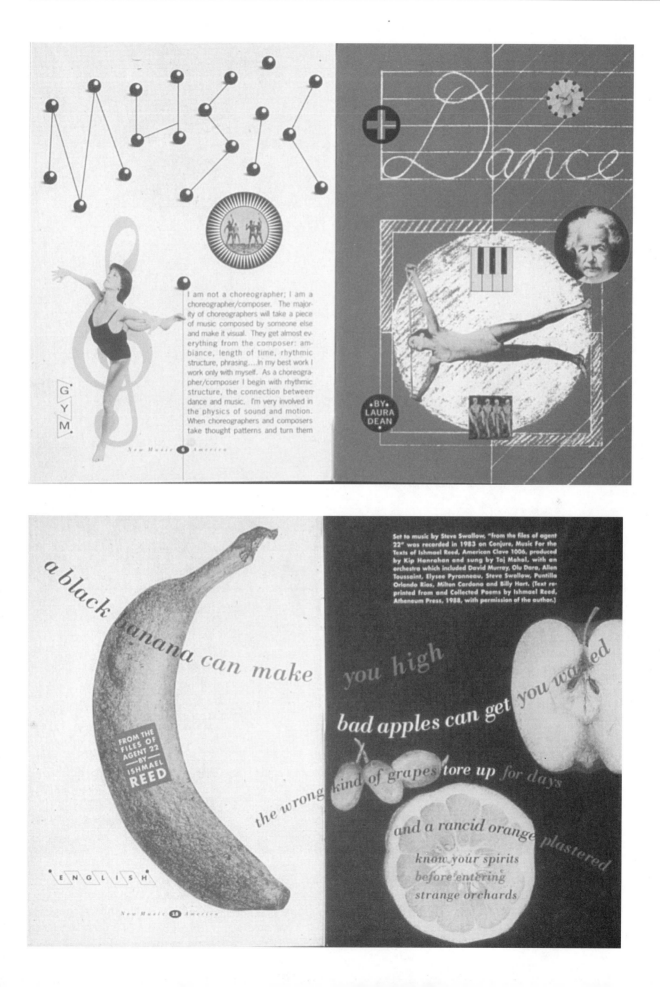

I am not a choreographer; I am a choreographer/composer. The majority of choreographers will take a piece of music composed by someone else and make it visual. They get almost everything from the composer: ambiance, length of time, rhythmic structure, phrasing....In my best work I work only with myself. As a choreographer/composer I begin with rhythmic structure, the connection between dance and music. I'm very involved in the physics of sound and motion. When choreographers and composers take thought patterns and turn them

BY LAURA DEAN

Set to music by Steve Swallow, "from the files of agent 22" was recorded in 1983 on Conjure, Music For the Texts of Ishmael Reed, American Clave 1006, produced by Kip Hanrahan and sung by Taj Mahal, with an orchestra which included David Murray, Olu Dara, Allen Toussaint, Elysee Pyronneau, Steve Swallow, Puntilla Orlando Rios, Milton Cardona and Billy Hart. (Text reprinted from and Collected Poems by Ishmael Reed, Atheneum Press, 1988, with permission of the author.)

a black banana can make you high

bad apples can get you waxed

the wrong kind of grapes tore up for days

and a rancid orange plastered

know your spirits before entering strange orchards

FROM THE FILES OF AGENT 22 BY ISHMAEL REED

Figure 5-12
Annual Report, 1990
Design firm: Stoltze Design,
Boston, MA
Designers: Clifford Stoltze,
Kyong Choe
Illustrator: Tim Carroll
Client:
Massachusetts Higher Education
Assistance Corporation

*This is the fourth report we
have done for this client, and it
was our first opportunity to do
something really different. They
had come up with the theme
for the copy—a report that
would describe the process of
getting a student loan. The pri-
mary audiences are lenders,
schools, and students. We
wanted them to understand
what is involved, and we want-
ed to make the lending process
seem as user friendly as possi-
ble. It was a theme that would
have been difficult to do photo-
graphically, so we suggested
Tim Carroll's line-art style,
which also worked well with
the budget. The client liked the
cartoon aspect of the illustra-
tion, while we responded to the
layered shapes Tim incorporates
in his drawings.*

Clifford Stoltze, Principal,
Stoltze Design

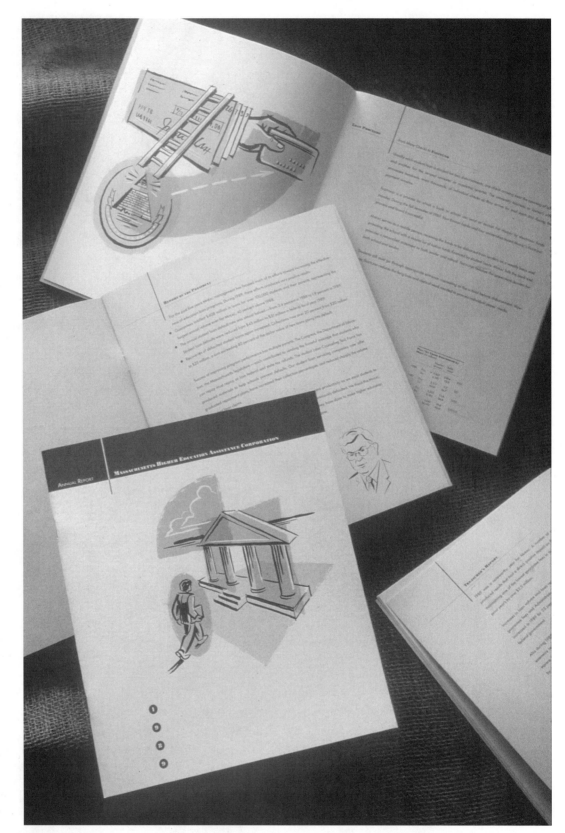

and an MHEAC annual report—you can clearly see the column structures (See Figure 5-12). Although the design concepts are very different, both designs are balanced and consistent. Consistency is a very important element in multi-page design; it provides flow from one page to the other. The respective design concepts and styles in these works are reflective of considerations such as the audience and the purpose of the design.

Figure 5-13
Manual for American Express Travel Related Services,
"Establishment Services Communications Guidelines, " 1990
Design firm: Shapiro Design Associates, Inc., New York, NY
Art director/designer/writer: Ellen Shapiro
Agency responsible for American Express Card design elements: Ogilvy & Mather, New York, NY
Client: American Express Travel Related Services, Co., Inc., New York, NY

Figure 5-14
New Section Design for *The Wall Street Journal,* Second Front Page, 1980
Design firm: Shapiro Design Associates, Inc., New York, NY
Art director: Ellen Shapiro
Publisher: Dow Jones & Co. Inc., New York, NY

A four-column grid is used in this manual
for American Express Travel Related Services
(See Figure 5-13). Although designer Ellen
Shapiro uses four, somewhat narrow columns,
she establishes a strong horizontal emphasis
that echoes the extended horizontal format of
the manual. Newspaper grids are particularly
crucial since there is so much text, especially in
a paper like *The Wall Street Journal*, where
photographs are usually at a minimum. Ellen
Shapiro's design was used for more than five
years by the *WSJ* (See Figure 5-14).

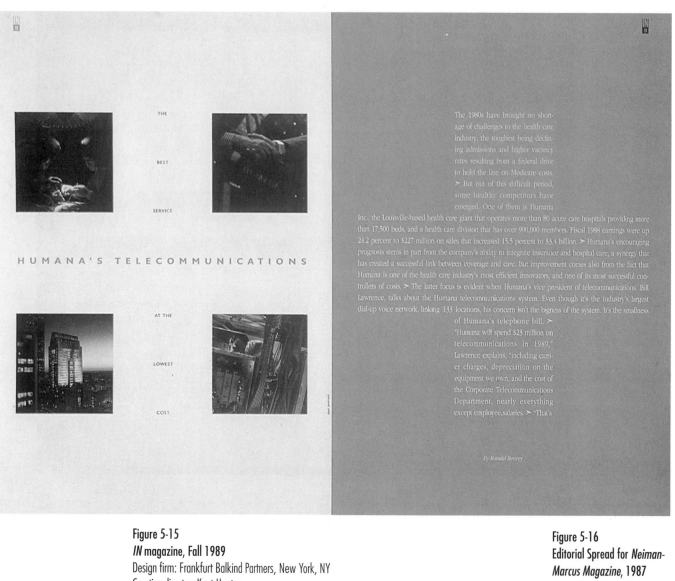

The 1980s have brought no shortage of challenges to the health care industry, the toughest being declining admissions and higher vacancy rates resulting from a federal drive to hold the line on Medicare costs. ➤ But out of this difficult period, some healthy competitors have emerged. One of them is Humana Inc., the Louisville-based health care giant that operates more than 80 acute care hospitals providing more than 17,500 beds, and a health care division that has over 900,000 members. Fiscal 1988 earnings were up 24.2 percent to $227 million on sales that increased 15.5 percent to $3.4 billion. ➤ Humana's encouraging prognosis stems in part from the company's ability to integrate insurance and hospital care, a synergy that has created a successful link between coverage and care. But improvement comes also from the fact that Humana is one of the health care industry's most efficient innovators, and one of its most successful controllers of costs. ➤ The latter focus is evident when Humana's vice president of telecommunications, Bill Lawrence, talks about the Humana telecommunications system. Even though it's the industry's largest dial-up voice network, linking 133 locations, his concern isn't the bigness of the system. It's the smallness of Humana's telephone bill. ➤ "Humana will spend $23 million on telecommunications in 1989," Lawrence explains, "including carrier charges, depreciation on the equipment we own, and the cost of the Corporate Telecommunications Department, nearly everything except employee salaries. ➤ "That's

By Ronald Bentrey

Figure 5-15
IN magazine, Fall 1989
Design firm: Frankfurt Balkind Partners, New York, NY
Creative director: Kent Hunter
Designer: Riki Sethiadi
Photography: Mark Jenkinson
Client: MCI Communications

In this spread from a story about telecommunications at Humana, Inc., the health care corporation, the designers at Frankfurt Balkind used the icon of a cross in a classic positive/negative layout where type became an integral design element.

Kent Hunter, Executive Design Director and Principal, Frankfurt Balkind Partners

Figure 5-16
Editorial Spread for *Neiman-Marcus Magazine*, 1987
Design firm: Susan Slover Design, New York, NY
Client: Neiman-Marcus, Dallas, TX

Figure 5-17
Contents Spread for
Emigre #5
Designer/publisher:
Rudy Vanderlans

Designer Riki Sethiadi had fun with the text on this spread from *IN*, a quarterly published by MCI Communications (See Figure 5-15). The text in the three-column grid echoes the white space on the opposite page.

This editorial spread for *Neiman-Marcus Magazine* by Susan Slover is a wonderful example of how cohesive the layout for a spread can be (See Figure 5-16). The *trompe-l'oeil* effect of the torn page uncovering the photograph of Milan Kundera spills over onto the opposite page.

Some designers have such a strong sense of layout they can abandon a grid, as in this contents spread for *Emigre* magazine (See Figure 5-17). The designer's only grid was the cropmarks. A grid is not readily apparent in Anne Schedler's and Steven Liska's cover for this

MAGNIFICENT OBSESSIONS

MILAN KUNDERA

"It was a wonderful time, a great time. You would never believe the joy and sweetness of the people, their hope to at last put a 'human face' on their society," recalls today's quintessential European novelist.

Milan Kundera settles uncomfortably into his chair. He stares at the microphone and tape recorder but a moment and wonders if he has made the right decision. Detesting interviews, tape recorded or not, he has written that any words printed without his byline or copyright should not be considered his own. Yet here he is again, his tall, thin frame in a muscular stoop, his hands clasped beneath his chin, answering questions with a thoughtful, ambivalent look as he must have once before in front of civil authorities and party officials.

"Czechoslovakia and Central Europe are in my mind," Kundera says. "They no longer exist for me, except up here." Exiled since 1975 and famous throughout the literary world since the publication of The Book of Laughter and Forgetting in 1979, he still must deal with the twin themes of his life and work: the loss of privacy and the loss of the past, the first leading to the second as party officials clamped down on the Prague spring, causing Kundera and his wife, Vera, to leave their country for France, and then the second leading to the first again because Laise and the importance of Kundera's writing have made the avid and curious knock at his door.

His insistent rejection of political interpretations of his work is well-known, and yet Kundera himself admits the importance of political events in his life. "The decisive event that transformed the world into a trap was, without doubt, the war of 1914, called (for the first time in history) the World War. It is not by chance that the vision of the world transformed into a trap has found its most powerful vision in Central Europe: it is there, in effect, that the war found its origins, that the collapse of the Austro-Hungarian Empire was perceived as a prefiguration of the end of all of Europe and from which was traced the path that led to the biggest European defeats, Munich and Yalta."

History has made his life political. As a result he is, without wanting to be, the spokesman for Central Europeans, especially those giving up his love of privacy to fulfil a role that fate seems to have thrust upon him. Even in these rows of relative freedom in Russia, there are thousands of writers struggling with suppression in the countries of Central Europe, thousands more in exile struggling with the absence of a language, culture or past, and he is one of the few who has survived, succeeding like no writer since Nabokov in creating and molding an audience on a worldwide scale. Like Nabokov, he has stubbornly disdained political questions in favor of esthetic ones, and like Nabokov as well, he has been plagued with questions about the sexual propriety of his narratives.

Although some accuse him of sexism in his treatment of female characters, Kundera sees those accusations as specious. The politics of lost and power are burdened with similar philosophic weight, and the serious novelist must not avoid important questions: What does it mean to be human (male or female)? What can a writer, a fiction writer, say concretely, sensually, about the human situation? What is the sensation of jealousy, fear or powerlessness? With such questions in mind, the machinations of love, sex and government make absolute narrative sense because, since 1914, nothing that happens can be local or individual, and, as he has written in The Art of the Novel, "no one can escape," especially those under the sway of the Soviet Union.

In one of his essays, Kundera quotes a Soviet officer in 1968: "You should know that we love the Czechs. We love you!" He goes on to report, "They all spoke as he did: their attitude was founded not on the sadistic pleasure of the rapist, but on another archetype: the wounded lover. 'Why don't the Czechs (whom we love so much) want to live with us and in the same way as us? What a shame that we had to use tanks to teach them about love!'"

Kundera's dislike of Russia is legendary among his fellow exiles. The history of Central European countries like *(Continued on page XX)*

His characters struggle for hope and definition in a gray world shadowed by the hand of the totalitarian state. In exile in Paris, novelist Milan Kundera confronts the betrayals of Central European history. By Fred Misurella

Figure 5-18
Paper Promotion, "Noir et Blanc on Quintessence,"
1990
Design firm:
Liska & Associates, Inc.,
Chicago, IL
Client:
Potlach Paper Corporation

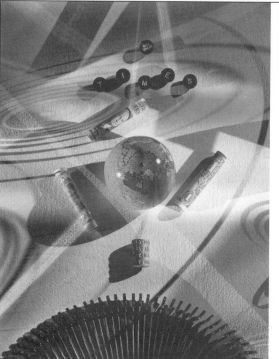

Figure 5-19
Editorial Spread for
Reserve/7, 1992
Design firm:
Concrete, Chicago, IL
Designer: Jilly Simons
Writer: Reserve/7 Staff
Client: Federal Reserve
Bank of Chicago

paper promotion (See Figure 5-18). It is obvious, however, that the layout has been carefully planned; correspondence and unity have been established. These spreads for Reserve/7, a quarterly publication for employees and retirees of the Federal Reserve Bank of Chicago, show how creative one can be with a grid and columns (See Figure 5-19).

There are many ways to approach layout and many schools of thought. Consider this chapter a point of departure. Read texts devoted to the grid system. Studying the history of graphic design and analyzing layouts will increase your knowledge in this area.

Comments

If someone put an open magazine in front of you, would you be able to identify the magazine by its design? There are some magazines so distinctive in design that one can identify them by format, layout, and typography. A spread is an extended rectangular format. Remember, you must establish unity across the entire format. A successful layout is legible, aesthetically pleasing, and offers information in a hierarchical order.

Exercise 5-1
Designing with a Simple Grid

1. Using the single-column and two-column grids you created earlier, design a layout.
2. Cut display text, subheadline, text type, and some visuals out of a magazine.
3. Make a few photocopies of each element, reducing and enlarging a few. Also, make several photocopies of your grids. Use a scanner and computer if they are available.
4. Try different arrangements of the elements on the grids.
5. Remember the principles of balance, emphasis, rhythm, and unity.

Project 5-1
Design a Magazine Spread

Step I
1. Buy a music or entertainment magazine.
2. Analyze the grid system used in the magazine.
3. Choose an appropriate subject for your spread, for example, an article on a musician or celebrity.
4. Write an objectives statement. Define the purpose or function of the spread, the magazine's audience, and the information that needs to be communicated. On an index card, write a one sentence statement about the article.

Step II
1. Design an opening spread (two pages) for an article in a music or entertainment magazine.
2. Use the magazine's grid system for the spread.
3. Include the following elements: display text, visual(s), and text type.
4. Produce ten sketches.

Step III
1. Produce two roughs.
2. Establish emphasis, balance, and rhythm.

Step IV
1. Refine the roughs. Create a comp.
2. The dimensions of the spread should be the same as those of the magazine you chose.
3. You may use black and white or full color.

Presentation
Mat the spread on a board with a 2" border all around.

Chapter 6
Logos, Symbols, Pictograms and Stationery

Objectives

- to understand and be able to design logos, symbols, pictograms and stationery
- to address the needs of the client and audience when designing logos, symbols, pictograms, and stationery
- to be able to successfully combine type and visuals
- to be able to design an elemental visual
- to be able to express meaning and convey information
- to be able to develop a design concept and follow it through

Logos

If you go shopping for athletic footwear, you need only glance at the logo to know a lot about the shoe—who manufactures it, the quality, the price range, and perhaps even which athletes wear it. Brand name logos such as Nike and Reebok are designed consistently so the consumer will recognize them instantly. Not only does the logo serve as a label, but it conveys a message about the spirit and quality of the product, one that is reinforced through marketing, advertising, and product performance.

An identifying mark, such as a logo or a trademark, communicates a great deal about a product, service, or organization. When you create a logo, you are faced with the task of creating a design that will identify your client's product or business and distinguish it from the competition. Therefore, a logo should be unique, memorable, and recognizable at a glance; it should become synonymous with the

Suggestions

The following list of criteria, a test by which you can judge your work, may help you to establish some basic objectives when designing a logo. Your objectives are:

- to design clear and legible type
- to create a distinctive look for your client
- to differentiate the product, service, or organization from the competition
- to create a logo that is appropriate for your client's business
- to express the product's, service's, or organization's spirit or personality
- to create an aesthetically pleasing design, or one with graphic impact
- to create a design that is consistent with the principles of balance and unity
- to create good positive/negative shape relationships
- to design a memorable logo
- to design a logo that works well in both black-and-white reproduction and color
- to design a logo that reproduces well when reduced and enlarged

Figure 6-1
Graphic Identity, 1992
Design firm: Harp and
Company, Big Flats, NY
Designers: Douglas G. Harp,
Linda E. Wagner
Client: Children's Hospital at
Dartmouth, Dartmouth-
Hitchcock Medical Center,
Lebanon, NH

Children's Hospital at Dartmouth

*For the Children's Hospital at
Dartmouth's identity, it was
necessary to strike the proper
balance between playfulness
and dignity. It had to be
appropriate for audiences
ranging from young children to
teenagers, and also their
parents. It is an identity that
has to survive in the context of
the parent medical center's
existing identity, as well.*

*The "C" is meant to
capture the spirit of a child, but
does not pretend to be drawn
by one. Selecting the
Dartmouth-Hitchcock Medical
Center "H" and the Dartmouth
varsity letter sweater "D"
seemed to be the obvious
choice for this playful solution.
The lowercase Century
Expanded "a" plays no less
vital a role, and helps to hold
the other three forms together.*

Douglas G. Harp, President,
Harp and Company

product or service it represents. It also is important for a logo to be used in a consistent manner. For this reason, some designers develop extensive guidelines for logo use and reproduction.

A logo must be designed appropriately in terms of style (characteristic manner or appearance), type, shapes, and symbols. For example, what might be appropriate for an insurance company might not be appropriate for an amusement park. A logo should express the spirit or personality of the product, service, or organization.

Since most logos are used for long periods, you need to create a logo that will stand up to the test of time in terms of style and trends. Of course, a logo should be aesthetically pleasing, have graphic impact, and be designed according to sound principles. There are innumerable applications for a logo: packaging, stationery (letterhead, business card, envelope), signage, advertisements, clothing, posters, shopping bags, menus, forms, covers, and more. A logo should work for all applications that would suit the client's needs.

Figure 6-2
Logotype for Restaurante Brasil, 1992
Design firm: Martin Holloway, Warren, NJ
Designer: Martin Holloway
Client: Restaurante Brasil, Martinsville, NJ

Figure 6-3
Logo, "Once In A Lifetime," 1990
Design firm:
Tobias Oleson Design Inc, New York, NY
Art director: William R. Tobias
Designer: Jeffrey Oleson
Client: Nablo/Troxel Building Contractors

Cheryl Troxel is both architect and designer. Jeff Nablo is a master craftsman/cabinetmaker. Their relationship is beyond equal—they function as one on projects. It was essential to convey this "lack of separateness." They are unified—in fact, they have subsequently married!

William R. Tobias, Partner, Tobias Oleson Design Inc.

A logo may be designed in any of the following configurations.
Logotype: the name spelled out in unique typography
Initials: the first letters of the name
Pictorial visual: representation of object or objects that symbolize the product, service or organization
Abstract visual: non-pictorial visual forms to symbolize the product, service or organization
Combination: any of the above used together

Four different typefaces were used to distinguish the initial letters, CHAD, of each word in Douglas G. Harp's design for the Children's Hospital at Dartmouth (Figure 6-1). One example of a logotype is Martin Holloway's design for Restaurante Brasil (Figure 6-2) Holloway's unique hand lettering and use of texture give the Restaurante Brasil logo its personality.

Art director William R. Tobias and designer Jeffrey Oleson created a logo for the construction firm of Nablo/Troxel using the firm owners' initials (See Figure 6-3). The bold, simple letters are appropriate for a construction company; the interesting positive and negative shapes created by layering the letters foster memorability.

Figure 6-4
Logo, "ReFlect," 1989
Design firm: M Plus M Incorporated, New York, NY
Art directors: Michael McGinn, Takaaki Matsumoto
Designer: Michael McGinn
Illustrator: Jack Tom
Client: Rebo Research, New York, NY

Figure 6-5
Logo Design and
Graphic Identity, 1988
Design firm:
Liska & Associates, Inc., Chicago, IL
Client: American Society of Aesthetic Plastic Surgeons, Arlington Heights, IL

THE AMERICAN SOCIETY FOR
AESTHETIC PLASTIC SURGERY, INC.

Figure 6-7
Logo
Designers: Daniel Schroll, Alison Wenz
Client: Meadowlands Foot & Ankle Center

Figure 6-6
Logo, 1990
Agency: The Slesinger Company
Art director/designer: Ted Nuttall
Client: R.A. Meyers Enterprises

This logo was designed for a small, individually owned electrical contracting firm. The budget was small, which did not allow for a lot of time spent on the project, but the client, in turn, was open to whatever approach I wanted to take. The final logo was the first idea out of the chute and my client was very pleased. It was also a fun project for me.

Ted Nuttall. Art Director/Designer

Figure 6-8
Logo/Masthead, 1975
Design firm: Bernhardt Fudyma Design Group, New York, NY
Designer: Craig Bernhardt
Client: Electrical Digest, New York, NY

When I put the uppercase "E" and "D" next to one another and saw the negative spaces in the "E" as the prongs on an electrical plug, which the shape of the "D" resembled, the solution was obvious.

Craig Bernhardt, Bernhardt Fudyma Design Group

The logo for Rebo Research, "ReFlect," whose business is research and development for film and video technology, is a bi-directional, fiber optic transmission (See Figure 6-4). White lines are used to delineate this graphic drawing.

This logo design and graphic identity for the American Society of Aesthetic Plastic Surgeons is balanced and abstract (See Figure 6-5). Its format and line direction conjure up the illusion of a three-dimensional body contour.

Combining type with visuals is a popular way of designing logos. The graphic drawing of a cable is used as the negative space in this initial cap (capital letter) designed for a small, individually owned electrical contracting firm (See Figure 6-6). Similary, the initial "M" is combined with a foot and ankle to represent the Meadowlands Foot & Ankle Center (See Figure 6-7). The horizontal rule under the initial emphasizes the negative space of the letter "M," making it more memorable.

Another successful example of combining type with an image in a meaningful way is this logo and masthead for *Electrical Digest* (See Figure 6-8).

This humorous looking design, by Ann Houston for LouLou's cookies, uses hand lettering and a simple illustration to convey a "homemade" feel (See Figure 6-9). Woody Pirtle's famous design, combining type and visual in a cooperative way, is a personal logo for Mr. and Mrs. Aubrey Hair (See Figure 6-10). The Quaker Oats Company logo is one that many of us see every morning at breakfast. The pictorial part of this logo is an excellent example of high contrast shapes used to create light and shadow yielding a memorable image (See Figure 6-11).

Figure 6-10
Logo, 1976
Design firm: Pentagram Design Inc., New York, NY
Designer: Woody Pirtle
Client: Mr. and Mrs. Aubrey Hair

Figure 6-11
The Quaker Oats
Company Logo
Logo used permission of
The Quaker Oats Company

Figure 6-9
Logo for LouLou's Cookies, 1992
Design firm: A. Houston Advertising, Atlanta, GA
Creative director: Ann Houston
Calligrapher: Joey Hannaford
Client: Lulabelle's Gourmet

Figure 6-12
AMMI Logo, 1991
Design firm: Alexander Isley Design, New York, NY
Client: American Museum of the Moving Image

The client is the American Museum of the Moving Image, which is a very long name, so we came up with a shorter symbol for the museum. We did not want to use a cliché film symbol. We looked at more than one hundred eyes before we settled on the one we liked best.

Alexander Isley, President, Alexander Isley Design

Figure 6-13
Logo
Designer: Daniel Schroll
Client: Professional Golf
Course Management

Figure 6-14
Peace Symbol
Illustration: David C. DeSantis

Creating a unique identifying mark is very important. A logo should become synonymous with the client, as the AMMI logo has (See Figure 6-12). Here is a successful example of type arranged below a visual, by designer Daniel Schroll. In the logo, the visual is conceived as a unit with the type. The elements are balanced and the weight and style of the typeface works with the particular visual (See Figure 6-13).

Symbols

It is hard to think of anti-war protest posters without thinking of the nuclear disarmament symbol designed by Gerald Holton in 1956. This graphic, a circle with a few lines in it, stands for something as profound as the abstract idea of peace (See Figure 6-14). Similarly, it would be hard to think of Christianity without thinking of the cross. These graphics are symbols. A **symbol** is a sign, a simple (elemental) visual, that stands for or represents another thing. For example, an object such as a dove can be used to represent an abstract concept: peace. A symbol can be a printed letter meant to represent a speech sound, or a symbol may be a non-pictorial visual such as the question mark. There is an enormous range of visual symbols,

from arrows and exclamation marks to software icons and scientific symbols. Symbols may be simple visuals, but they are a powerful graphic ally when used to convey information and express meaning.

A symbol may be designed in any of the following configurations.
Pictorial visual: representation of an object or objects
Abstract visual: a non-pictorial visual
Typographic: letter(s) or word(s)

Designer David Meyer multiplied and stacked the Star of David, the traditional symbol for Judaism (See Figure 6-15). Starting from the lower left, each star gets progressively more defined and more three-dimensional.

Arrows, which are traditional symbols for direction, are used in different configurations by designers Earl Gee and Fani Chung as symbols for Sun Microsystems Worldwide Operations program, a program of standards and guidelines providing a unified direction for Sun Microsystems' global operations (See Figure 6-16). Each symbol, in combination with words, evokes imagery—the globe, a torch, a target, and a building. A metamorphosis, a change of form, is used to symbolize rehabilitation for teenage

Memphis Jewish Community Center

Figure 6-15
Logo, "Preserving our past...Building our tomorrow," 1993
Art director/designer: David Meyer, Memphis, TN
Client: Memphis Jewish Community Center

This logo for the Memphis Jewish Community Center Capital Funds Campaign needed to work on two levels. On the surface, it needed to symbolize the actual building renovations and additions that were taking place. On another level, it needed to communicate that the Center was achieving this growth by building on the traditions of its past. The only way to assure that these traditions continued to be passed down was to create an environment that would permit the Center to grow and thrive in the future. By "preserving our past" we were "building our tomorrow."

David Meyer, Art Director/Designer

[WORLDWIDE OPERATIONS] [MISSION STATEMENT] [STRATEGIC INITIATIVES]

[VALUES] [ARCHITECTURAL DIRECTION] [COMPONENTS]

Figure 6-16
Symbols for Sun Microsystems, 1991
Design firm: Earl Gee Design, San Francisco, CA
Art director: Earl Gee
Designers: Earl Gee, Fani Chung
Illustrator: Earl Gee
Client: Sun Microsystems

The symbols convey the chairman's belief in "putting all the weight behind one arrow."

Earl Gee, Principal, Earl Gee Design

Suggestions

Here is a checklist of things to think about when designing a symbol. Your objectives are:

- to create a simple visual

- to convey information or express meaning

- to create a distinctive sign

- to create a design that can be recognized quickly

- to design an appropriate symbol for the idea or thing it represents

- to design a symbol that will work well in black-and-white reproduction

- to design a symbol that will work in various sizes

Figure 6-17
Symbol, 1990
Design firm: The Knape Group, Dallas, TX
Designer: Michael Connors
Client: Girl's Adventure Trails

Figure 6-18
Symbol, "Human Relations on New Jersey Campuses"
Design firm: Martin Holloway Design, Warren, NJ
Designer: Martin Holloway
Client: New Jersey Department of Higher Education in cooperation with The National Conference of Christians and Jews
(New Jersey Region)

food bank of alaska

Figure 6-19
Symbol, 1992
Design firm: Northwest Strategies, Anchorage, AK
Designer: Diana Ford
Client: Food Bank of Alaska

My first step in designing a logo is to make a list of words that correspond to the title. Then I break down the title and make a separate list for each word. Then I bring words from different lists together and see what kind of image they create. Usually its very obvious when the right combination of words create the perfect image. The Food Bank of Alaska logo came together in about ten minutes using this method.

I chose a very simple technique to illustrate the logo because I did not want to overpower the concept, and I chose a common lowercase typeface in keeping with the humility of the organization.

Diana Ford, Northwest Strategies

Figure 6-20
Disability Access Symbols Project, 1993
Produced by the Graphic Artists Guild Foundation with the support and technical assistance of the National Endowment for the Arts, Office for Special Constituencies
Graphic design: X2 Design, New York, NY

The project was extremely challenging in terms of design because the client insisted on having organizations representing people with various disabilities review and comment on the proposed symbols. With the help of a disability consultant, we were able to reach consensus among all these groups and still achieve the primary objective—for organizations to use these symbols to better serve their audiences with disabilities.

Several existing symbols did not meet the standards we established and needed redesign. For example, the old symbol for Assistive Listening Systems focused on the disability (an ear with a diagonal bar through it). The new symbol focuses on the accommodation to the disability, i.e., a device that amplifies sound for people who have difficulty hearing. Other upgraded symbols include Sign Language Interpreted, Access (Other than Print or Braille) for Individuals Who Are Blind or Have Low Vision, and the International Symbol of Accessibility. A new symbol for Audio Description for TV, Video and Film was developed which, through design, proved less likely to degenerate when subjected to frequent photocopying.

GAG Foundation

girls in the Girl's Adventure Trails symbol (See Figure 6-17). Designer Michael Connors used a circle changing into the sun to symbolize rehabilitation.

Transforming messy strokes into a clean, straight arrow, designer Martin Holloway created a symbol of conflict resolution for a human relations conference. This symbol was used for several applications including signage (See Figure 6-18). Diana Ford designed this symbol for the Food Bank of Alaska (See Figure 6-19). Many people think of bread as a food staple that is needed to sustain life; in combination with a heart, a symbol most understand to represent love, we get a new symbol about giving food to the needy.

Pictograms

We are so used to the simple graphic visuals on restroom doors denoting the sexes that we may forget that these visuals are symbolic—they stand for men and women. These signs communicate quickly, and because they are purely visual (non-verbal), they cross language barriers. This type of sign is called a **pictogram**, which is a simple picture representing an object or person. Although most pictograms are simple, like the ones on restrooms, some have more detail or are more illustrative. Whether the pictogram is elemental or illustrative, essential information should be communicated in a glance. There is much crossover among logos, symbols, and pictograms; sometimes the nomenclature is not as important as the function of the design.

The primary objective of the Disability Access Symbols Project is for organizations to use these symbols to better serve their audiences with disabilities (See Figure 6-20).

On this holiday greeting for Spalding Rehabilitation Hospital, you see graphic pictograms representing two people changing into one pictogram of a reindeer (See Figure 6-21).These pictograms, for Port Blakely planned community,

Figure 6-21
Christmas Card
Design firm: 601 Design, Inc.,
Denver, CO
Art director: Bruce Holdeman
Designers: Bruce Holdeman,
Ann Birkey
Client: Spalding Rehabilitation
Hospital, Boston, MA

Figure 6-22
Pictograms for a Planned Community, 1992
Design firm: The Rockey Company, Seattle, WA
Client: Port Blakely Mill Company

Figure 6-23
Symbols, 1992
Design firm: The Baker Group,
Salt Lake City, UT
Art director: Dave Baker
Designer: Dave Malone
Client:
Oquirrh Park Fitness Center

THE *SAFETY* ZONE

SPY TECH

HOME SAFETY

PERSONAL SECURITY

OFFICE SECURITY

CHILD SAFETY

LOCKS AND SAFES

SPORTS AND PROTECTIVE CLOTHING

CAR SAFETY AND SECURITY

HOME SECURITY

PERSONAL SAFETY

PET SAFETY

Figure 6-24
Store Signage
Design firm: Doublespace,
New York, NY
Client: Safety Zone,
White Plains, NY

are illustrative and detailed; however, they communicate quickly, and share a common style and format (See Figure 6-22). For Oquirrh Park Fitness, Dave Baker and Dave Malone used a linear style to create a series of activity symbols (See Figure 6-23). Dots and triangular strokes used to connote movement make these symbols unique. Diamond shapes are used as an element of continuity in the store signage (pictograms) for the Safety Zone (See Figure 6-24).

Many pictograms are designed as part of a larger system, such as the ones used in the Olympics or these designed by Cook & Shanosky Associates for the U.S. Department of

Suggestions

Here are some design considerations for the creation of a pictogram. Your objectives are:

- to create a simple or elemental visual

- to clearly and quickly communicate a message or information

- to design a pictogram that is aesthetically pleasing

- to create a design that is consistent with the principles of balance and unity

- to create a pictogram that works in black-and-white reproduction

- to create a pictogram that works when enlarged or reduced

- to create a pictogram that could be expanded into a system of pictograms

Figure 6-25
Symbol Signs, 1974–1976 original thirty-four symbol signs;
Design firm: Cook and Shanosky Associates, Inc., Princeton, N.J.
Designed and produced by Roger Cook and Don Shanosky
Client: United States Department of Transportation

After reviewing and evaluating twenty-four existing symbol systems in use around the world, the AIGA committee, consisting of Thomas Geismar, Seymour Chwast, Rudolph de Harak, John Lees, and Massimo Vignelli, recommended the adoption and public use of a basic group of thirty-four transportation-related, passenger and pedestrian-related symbol signs.

In 1974, as preparation for this project, the committee approached Roger Cook and Don Shanosky of Cook and Shanosky Associates, Inc., and requested that they present their work. After reviewing the work of various design firms, the committee awarded Cook and Shanosky the contract to design the symbol signs. While the AIGA committee was itself made up of designers, it was established at the onset that Cook and Shanosky would be the project designers, and the committee was to be the client. Cook and Shanosky eventually became part of the committee, yet remained the only designers.

Guided by the AIGA committee, Roger Cook and Don Shanosky developed each symbol for this system, from preliminary sketches to the finished artwork. The project to develop the initial thirty-four symbols lasted approximately two years and required dozens of meetings to present and review design solutions. Subsequent studies were completed in 1979, which resulted in Cook and Shanosky's designing symbols for sixteen additional messages areas.

Lauren C. DeAngelis, marketing manager, Cook and Shanosky Associates, Inc.

Transportation (See Figure 6-25). Designing a system requires a clear design concept and a consistent use of shapes, scale, and all the formal elements. The pictograms in a system look as if they belong to the same family. At times, more than one designer in a design firm or studio will work to produce a system. It is imperative to establish a firm design concept, style, and vocabulary of shapes in order for the system to look like it was created by one hand and mind.

Stationery

Look through your wallet. You probably have a business card in it. Look through your mail. You probably received correspondence on letterhead that was enclosed in a design-coordinated envelope. Of course, a business card or letterhead is meant to provide you with pertinent information like a person's phone or fax number. Stationery, however, also is meant to project an image for a company—one that will attract potential customers and make them remember the employee or the company *because of the design.*

Stationery usually consists of letterhead, envelopes, and business cards. The company's logo, name, address, telephone and fax numbers, and the owner or employee's name are included on the letterhead and business card. (The telephone and fax numbers are excluded from the envelope.) A rolodex card may also be included in stationery. Stationery is often part of a larger visual identity program (see Chapter 10).

Most designers position much of this information at the head, or top, of the page, which is why we call it letterhead. That kind of arrangement leaves ample room for correspondence. Some designers split the information and position some type at the foot, or bottom, of the page. Others break with tradition and position type, graphics or illustrations in any number of ways—in a vertical direction at the left or right side, all over the page in light or ghosted values or colors, or around the perimeter of the page.

Any arrangement is fine, as long as it works. You can design anything you want as long as it is a sound solution to a visual communication problem. The arrangement should leave a good amount of space for a message and it should be appropriate for the client. Information should be accessible. It should be in a visual hierarchy; for example, the zip code should not be the first thing the viewer notices. The logo is usually the most prominent element on the stationery; all

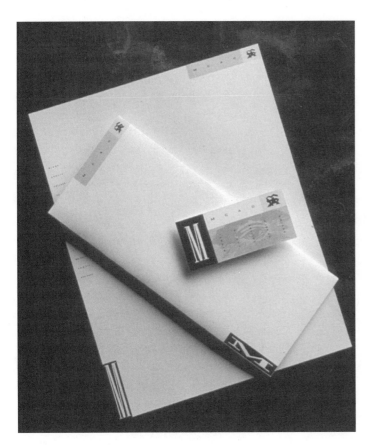

Figure 6-26
MCAD Stationery System, 1989
Design firm: Charles S. Anderson Design Company,
Minneapolis, MN
Art director: Charles S. Anderson
Designers: Charles S. Anderson, Daniel Olson
Photographer: Dave Bausman
Client: Minneapolis College of Art and Design

*This is the stationery system we designed for
MCAD after their split from The Minneapolis Insti-
tute of Arts. The elements, which include an eye
toward the future, a stylized figure raising a pen-
cil as a flag and a capital "M" in a classic type-
face, are symbolic of their new-found indepen-
dence and their renewed commitment to design
and the arts. This clean and simple design was
chosen to retain its vitality over time.*

Charles S. Anderson Design Company

other type and visuals should be arranged accordingly, from most to least important. An element other than the logo can be the most prominent element in your design, as long as your solution is logical and stems from your strategy and concept.

Choosing paper for your letterhead, envelope, and business card is part of a design solution. There are many paper companies and numerous qualities, styles and colors of paper. The weight of the paper is very important because the letterhead and envelope must stand up to typewriters, computer printers, pens, and markers. Letterhead must be sturdy enough to withstand being folded. A business card is usually inserted into one's wallet and therefore must be a heavier weight paper than the letterhead. When choosing paper, think also about texture, how the color of the paper will work with the ink's color, and whether the shape will fit into a standard envelope. Most paper companies provide paper samples and have shows to promote their products. They also advertise in leading graphic design periodicals.

Papers and envelopes come in standard sizes. Anything other than standard size is more expensive. A business card should be of a size and shape that fits into a wallet—usually the size

of a credit card. If someone has to fold a card to fit it into their wallet, the design is being compromised. (Folded cards are an exception.) A designer must also be aware of the printing processes available, including special technical processes such as die-cuts, varnishing, and embossing. Research the printing process by visiting a good print shop.

The design—the arrangement of the elements, the creation of a visual hierarchy, the use of the logo, the selection of colors and typefaces—usually is consistent on all three parts of the stationery. Any design system, whether it is stationery or an extensive visual identity program, should have continuity—that is similarities in form. Some designers feel it is perfectly acceptable to have slight variations in color, type, or arrangement among the letterhead, envelope, and business card. You can design a unified stationery system that incorporates variety.

Think of all the business cards or letterheads you have seen. Do any come to mind? Were any of them unique or particularly well-designed? A well-designed piece is usually memorable, such as this one designed for the Minneapolis College of Art and Design (See Figure 6-26); the type and visuals have been thoughtfully arranged in relation to the format.

Figure 6-27
Stationery system for a digital film/video post-production company, "FINIS," 1989
Design firm:
Siebert Design Associates, Inc., Cincinnati, OH
Designers/Illustrators: Lori Siebert, Lisa Ballard
Client: FINIS, Cincinnati, OH

We created an interchangeable logo system. Always a square with letterforms inside spelling "FINIS," always incorporating spirals somehow—no beginning, no end—relates to company name.

Lori Siebert, Siebert Design Associates, Inc.

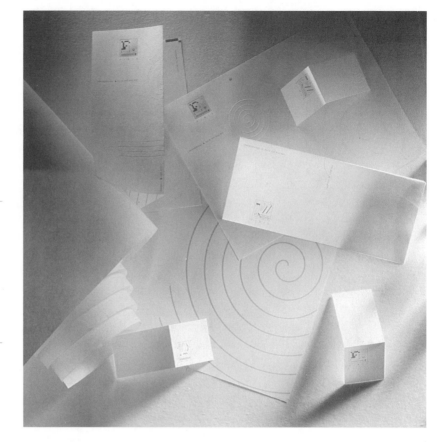

Figure 6-28
Stationery, 1990
Design firm:
Clement Mok Designs, Inc., San Francisco, CA
Art director: Clement Mok
Designer: Sandra Koenig
Client: Pillar

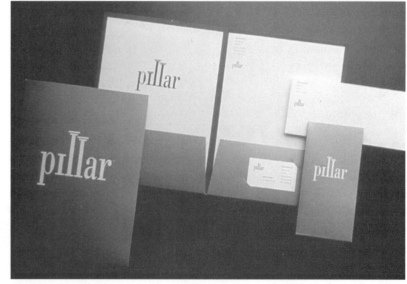

Designers and illustrators Lori Siebert and Lisa Ballard created this interchangeable logo system for FINIS, a digital film/video post-production company (See Figure 6-27). Its uniqueness is found in the several abstract symbols used in combination with a logo. The designer's objective for Pillar (See Figure 6-28) was to project a concept of financial modeling software in a graphical way. The logo, by Clement Mok Designs, was created to appeal to financial institutions.

The type on this stationery for the Vietnam Widows Research Foundation appears to be a rubbing taken from a memorial, such as the Vietnam Veterans' Memorial in Washington, D.C. (See Figure 6-29). By centering the title at the head of the page and aligning it with the type below, unity is established.

Figure 6-29
Stationery, 1991
Art director: Frank Perrone
Designer: Tommie Ratliff,
Crestwood, KY
Client:
Vietnam Veterans Widows
Research Foundation, KY

The project was one of the those rare instances where, from the moment the idea comes to you, you know it is perfect. From that point, it is a matter of getting the piece produced the way you see it in your mind's eye. In this case, that included making a metal plate and doing dozens of pencil rubbings to have as a starting point for the artwork. I was able to achieve the effect I wanted even though it was a one-color piece.

Tommie Ratliff, Crestwood, KY

Suggestions

Although every rule in graphic design can be broken with a successful creative solution, here are some that a novice should keep in mind. A letterhead design should provide ample room for correspondence, and should not interrupt the correspondence. The design on the envelope should meet with postal regulations for the positioning of information. The design should work equally well on all pieces of the stationery. Your objectives are:

- to develop a unique, appropriate, and interesting concept

- to create a design that is immediately identified with the sender

- to coordinate the letterhead, envelope, and business card; establish unity

- to design and use legible typography

- to clearly display the address, telephone, and fax numbers

- to express the spirit or personality of the company or client

Figure 6-30
Ema Design Logo and
Stationery Package, 1989
Design firm:
Ema Design, Denver, CO
Designer: Thomas Ema

With a three-letter name like
Ema, the prospect of creating
an original logotype is too
intriguing to resist. Using
primary colors and subtle
embossing, Ema's identity
expresses his passion for
simplicity.

Thomas Ema,
Owner, Ema Design

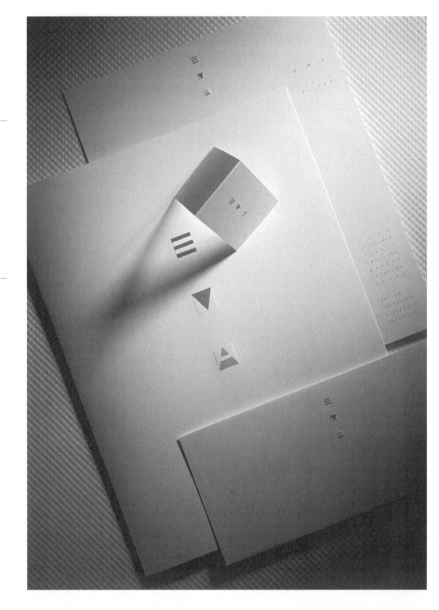

Figure 6-31
Laughing Dog Creative
Stationery, "Top Dog," 1992
Design firm: Laughing Dog
Creative, Inc., Chicago, IL
Creative director:
Frank E. E. Grubich
Designer: Joy Panos

The primary objective here was
to exploit the sounds in the
phrase "Bow Wow Tee Hee."

Frank E. E. Grubich,
Laughing Dog Creative, Inc.

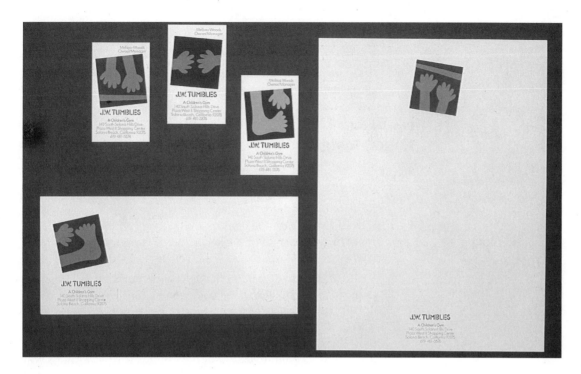

Figure 6-32
Stationery, 1987
Design firm: Richardson or Richardson, Phoenix, AZ
Designers: Forrest Richardson, Rosemary Connelly
Client: J.W. Tumbles, San Diego, CA

The client's trademark is a series of symbols, or glyphs, that may be tumbled to any position while still communicating the primary business—a children's gymnasium. The six different symbols combined with the various positions and six color options create an almost endless choice of looks for use on stationery and cards. Each symbol is an actual label that is self-adhesive and is applied by the client at the time of use to the single color, pre-printed stationery paper.

Richardson or Richardson

Designing stationery for yourself is particularly demanding. Even though you are the subject, you still have to follow the usual steps in formulating a strategy and concept. Since you are a designer or design student, people will look at your stationery as an example of your capabilities, as a piece in your portfolio. After all, if you design a great piece for yourself, you will probably come up with a great solution for someone else. Thomas Ema's self-promotional logo and stationery system reflects his personal design style; potential clients can get a sense of his work by looking at his stationery (See Figure 6-30).

The stationery for Laughing Dog Creative, designed by Joy Panos Stauber, uses overlapping type of varying weights to create the illusion of three-dimensional space and to conjure up sounds (See Figure 6-31). The design firm of Richardson or Richardson came up with a playful stationery solution for J.W. Tumbles, a chain of children's gymnasiums (See Figure 6-32).

Comments

The logo is the signature of a product, service, or organization; it is a visual image of the client's goals and spirit. It must be memorable, legible, appropriate, and visually and conceptually effective. The decision to use a logotype, initials, pictorial, or abstract visual should be dictated by the objectives statement and your analysis of the client's needs and image. Use the adjectives you choose as a test for your logo's success. Your solution should reflect the critical thinking and research that went into the design process.

Exercise 6-1
Examples of Logo

1. Find examples of logos that appear in the different configurations listed in this chapter. Maintain an ongoing collection. Keep a file or paste the logos into a book as source material.

Project 6-1
Logo Design

Step I

1. Choose a product, service, or organization.

2. Research your client. Gather information on your subject. Find related visuals that you could use as references. Find examples of logos with the style or look you think is appropriate for your client.

3. Write an objectives statement. Define the purpose and function of the logo, the audience, the competition, the message that needs to be communicated, and what kind of personality should be conveyed. It helps to write two or three adjectives on an index card that describe and summarize the spirit or personality that your logo should communicate. Keep the index card in front of you while sketching.

Step II

1. Design a logo in any of the following configurations—logotype, initials, pictorial visual, abstract visual or any combination of these. The logo should be self-contained. It should be able to "float" anywhere; for example, it should not be dependent upon being positioned in the corner of a page. There should be no bleeds—nothing running off the edge of a page. Note: If your final choice is an abstract or pictorial visual, you will have to choose type to work with it for the stationery.

2. Produce at least twenty different sketches before choosing a solution. At least four sketches should be devoted to each of the various configurations. In other words, you should make four sketches of initials, four sketches of an abstract visual, etc. You may want to work on tracing paper so you can trace parts of one sketch and incorporate them into another. (Hold onto the sketches for future reference and for your portfolio sketchbook.)

Step III

1. Refine the sketches into three roughs on 8 1/2" x 11" paper.

Step IV

1. Refine the roughs. Create a comp using computer-generated type or transfer type (as opposed to hand-lettered or comped type). The logo should be no bigger than 5" in any direction.

Presentation

The logo should be shown by itself in black and white, as a photostat, on an 11" x 14" board.

Optional: Design the logo on stationery : a letterhead, envelope and business card. Present the stationery on an 11" x 14" board, held vertically. Mount the letterhead first. Overlap the envelope and business card.

Exercise 6-2

Building an Image Making Vocabulary— Xerography

1. Go through a magazine or newspaper and find a few black-and-white photographs of people or objects.

2. Look at the Quaker Oats Company logo (Left and Figure 6-11). This logo uses high contrast shapes to depict shadows and forms.

3. Make copies of the photographs on a copier. If possible, adjust the lightness/darkness control on the copier to result in an image with extreme values or high contrast. Or use a scanner, a computer, and either page layout or drawing software. Scan in a photograph and apply the high-contrast setting to the image.

4. With a black marker, draw over the copies to increase the value contrast. Your objective is to convert light and shadow into black and white.

5. Trace the high contrast copies, picking up only the most essential black-and-white shapes to depict the image.

6. Choose your best drawing. Make a copy of it. Refine it. Present it as a comp on 8 1/2" x 11" paper.

Comments

In order to graphically symbolize an idea, person or thing, you must analyze it and reduce it to its most fundamental level. Though time and tradition play a great role in imbuing symbols with meaning, it is essential a newly designed symbol be the result of a valid design concept. This is a good lesson in developing a vocabulary of similar forms. Experimenting with various ways of developing shapes and images will greatly increase your ability to think visually and to design.

Exercise 6-3
Symbols

1. Write down three adjectives that describe your personality. Write down three adjectives that describe the personality of a celebrity.
2. Design an exclamation mark to express your personality
3. Design an ampersand or question mark to express the personality of a celebrity.
4. Create twenty thumbnail sketches for each design.
5. Refine the sketches into two roughs for each.
6. Refine the sketches into comps. Present one comp for each problem on 8 1/2" x 11" paper, held vertically. You may use color or black and white.

Project 6-3
Symbol Design

Step I
1. You are going to design four symbols to represent the four seasons (spring, summer, fall and winter), temperaments (choleric, sanguine, melancholic and phlegmatic) or elements (water, fire, earth and air). Research the meaning of the symbols.
2. On an index card, write down a simple, three- or four-word definition of each of the four you have chosen to represent.

Step II
1. All four symbols should be designed in either circular, square, or rectangular formats.
2. Create twenty thumbnail sketches. Try designing within the different formats.
3. Explore different ways of developing shapes and images. Try geometric shapes, shapes created with torn paper, linear shapes, photographically derived images, the style of woodcuts, or posterized images.
4. The four symbols should share a common vocabulary of shapes, lines, or textures.

Step III
1. Refine the sketches and create three roughs on 8 1/2" x 11" paper. Remember, all four symbols should share a common vocabulary.

Step IV
1. Refine the roughs and create a comp.
2. The circular or square formats should be 3" and the rectangular formats should be no larger than 3" in any direction.

Presentation
Present all four symbols on one 11" x 14" board, held vertically. The symbols all should be the same size and in black and white. When mounting, allow 1/2" of space between the symbols. **Alternate presentation:** one symbol per board, 3" symbols on 8 1/2" x 11" boards, held vertically.

Exercise 6-4

Building an Image Making Vocabulary—Printmaking

1. Go to the library and find books on printmaking: woodcuts, etching, drypoint, lithography, aquatint, and monotypes. If available, use a CD-ROM library.

2. Choose three types of printmaking. Try imitating the printmaking media style with black markers on white paper. In other words, try to imitate the look of a woodcut without actually doing a woodcut.

3. Choose an image, such as a tree or a shoe.

4. Depict the image in all three styles.

Exercise 6-5

Building an Image Making Vocabulary—Painting

1. Find photographs of fruit or buy some fruit for reference.

2. Go the library and find monographs on three modern painters, for example, Henri Matisse, Stuart Davis, and Georgia O'Keefe.

3. With any kind of water-based black paint that is available, imitate the style of one or two of the artists you choose, using the fruit as your subject matter.

4. When the paintings are dry, make copies of them on a copier.

5. You may have to "clean up" the copies or make adjustments.

6. Present two finished illustrations on separate sheets of 8 1/2" x11" paper, held vertically.

Comments

The pictograms should be in the same style, having similar distinctive characteristics. There should be a consistent use of the formal elements—line, shape, texture. They should be understood in an instant by the viewer. This project promotes two important objectives—the ability to maintain a vocabulary of shapes and style, and the ability to communicate through simple visuals.

Exercise 6-6
Pictogram Design

1. Find photographs of vegetables or buy some vegetables for reference.
2. Using geometric forms, design pictograms for two fruits.
3. Create twenty thumbnail sketches, ten for each.
4. Create two roughs for each pictogram.
5. Refine the roughs. Create one comp for each pictogram and present it in black and white on 8 1/2" x 11" paper, held vertically.

Project 6-3
Designing Pictograms for a Zoo

Step I
1. Choose a zoo, for example, the National Zoo in Washington, D.C., or your local zoo.
2. Research it. Find out what type of exhibits, format, services, and animals the zoo has.
3. Choose four subjects from among animals, a rest area, restaurants, first-aid station, information, gift shops, or anything you would find at a zoo.

Step II
1. Design four pictograms for a zoo.
2. Produce twenty different sketches, at least five for each subject.
3. Explore different ways of developing shapes and images. Try free-form linear shapes (such as the ones used in the 1994 Winter Olympics), geometric shapes, high-contrast images, or child-like images.
4. The pictograms should share a common vocabulary of shapes, lines, or textures; they all should be in the same style, that is, all geometric or all free-form. Note: Creating pictograms is made easier with a scanner and computer. Scan in a photograph and trace the essential elements of the form. Remove the scanned photograph from the image, and you are left with an accurate tracing. You can then manipulate the image in any number of ways to make it work; for example, fill it with black and then stretch or skew.

Step III
1. Refine the sketches and create two roughs on 8 1/2" x 11" paper, held vertically.

Step IV
1. Refine the roughs. Create a comp.
2. The pictograms should be no more than 3" in any direction.

Presentation
Present all four pictograms on one 11" x 14" board, held vertically. The pictograms all should be the same size and in black and white. When mounting, allow 1/4" of space between the pictograms. **Alternate presentation:** one pictogram per 8 1/2" x 11" board. **Option:** You may want to present a colored version as well.

Comments

In one way this is an easy project. You do not have to do any research because you are your own client. On the other hand, it may be difficult to define or develop an image for yourself. If your design is conservative, potential clients may think your work is conservative. If it is very trendy, they may think all your work is trendy. More importantly, if it is not well designed—and well thought out—it will say a lot about you. Make sure you apply everything you have learned about design fundamentals and the components of a design solution. Do not underestimate the importance of this piece. You may eventually want to coordinate your resume with your stationery.

Exercise 6-7
Stationery Design (for fun)

Design stationery for a fictional character or a famous individual, such as Sherlock Holmes or Mahatma Ghandi.

Project 6-4
Your Own Stationery Design

Design stationery for yourself including letterhead and envelopes. You may want to add a business card, rolodex card, or a label that can be attached to the back of your portfolio pieces or boards.

Presentation
Present the letterhead and envelope on one 15" x 20" board.

Chapter 7
Posters

Objectives

- to understand the purpose of a poster
- to understand the role of type and visuals in poster design
- to be able to apply graphic design principles to poster design
- to be able to design a poster

Posters

It is not unusual to walk through a public space, see a poster and think, "I would love to hang that in my home." And people do. Whether the poster is a promotion for an art exhibit or a musical group, it is common to see posters tacked on walls or framed and hanging in people's homes and offices alongside paintings, photographs, and prints.

Posters featuring attractive models and celebrities advertising The Gap clothing stores or Calvin Klein underwear adorn bus shelters. Posters promoting musical events and films hang in subway stations. Theatrical events, public service announcements, sporting events, rallies, museum exhibits—all are subjects for posters. Since the 19th century, the poster has been used to advertise events and inform the public.

No other graphic design format has been so successful in capturing the attention and hearts of museum curators, art critics, social historians, and the public. The American and European fine art worlds have embraced the poster; famous artists like Oskar Kokoschka and Ben Shahn have designed them (See Figures 7-1 and 7-2).

Figure 7-1
Poster, Oskar Kokoschka, *Drama-Komoedie*, 1907
Collection: Museum of Modern Art, New York, NY
Purchase fund

139

Figure 7-2
Poster, Ben Shahn,
*This Is Nazi
Brutality*, 1943
Collection:
Museum of Modern
Art, New York, NY
Gift of the Office
of War Information

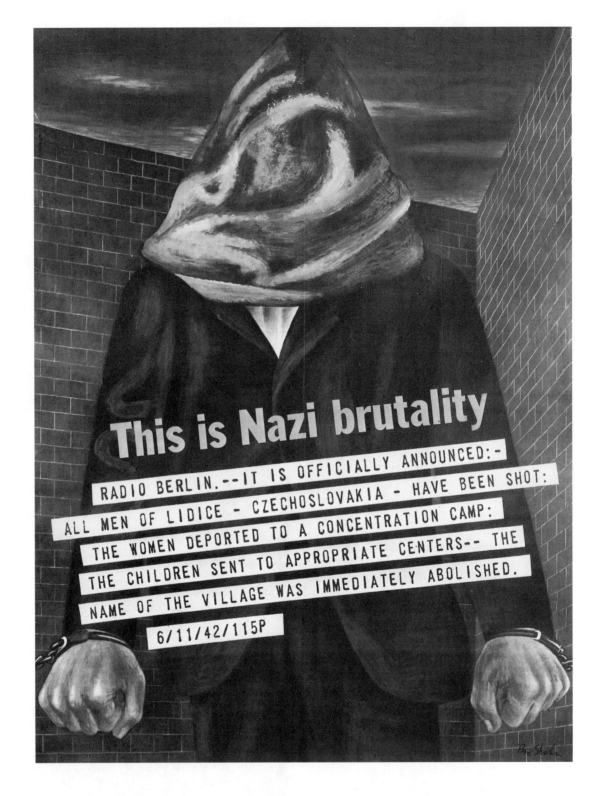

Perhaps it is because the poster was popularized by the French artist Henri de Toulouse-Lautrec that fine artists have accepted this art form that also serves industry and commerce (See Figure 7-3).

A **poster** is a two-dimensional, single-page format used to display information, data, schedules, or offerings, and to promote people, causes, places, products, companies, services or organizations. Most posters are meant to be hung in public places and to be seen from a distance. It is essential to remember a poster must catch the attention of passersby. Do not forget a poster also competes for attention with surrounding posters, billboards, and any other visual material.

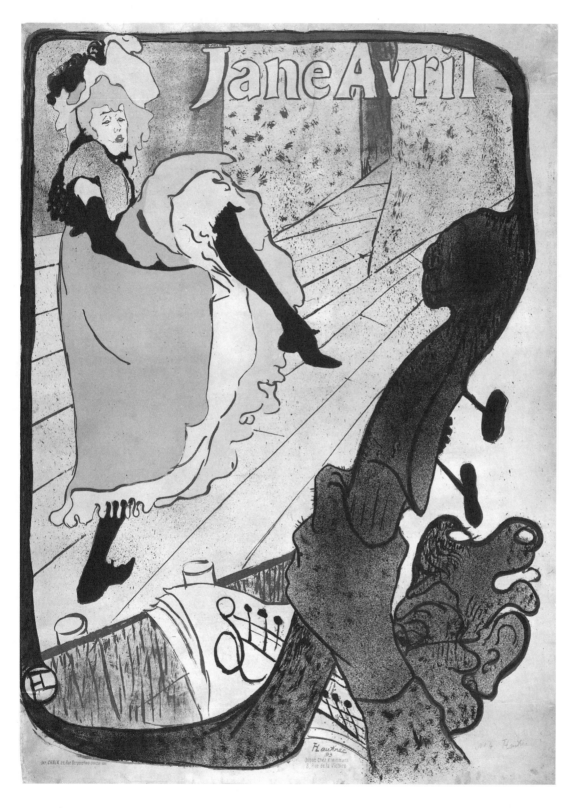

Figure 7-3
Poster, Henri de Toulouse-Lautrec, *Jane Avril,* **1893**
Collection:
Museum of Modern Art,
New York, NY
Gift of A. Conger Goodyear

Understanding the subject matter, ordering information so it can easily be gleaned, attracting the audience's attention and then keeping it long enough to communicate the information or message is essential to designing a successful poster. If you were designing a poster for a heavy metal band, you probably would want to reflect the musical style in the design. Alexander Isley's vanguard poster is designed to reflect, as the designer says, the "exciting, engaging, and fun" nature of the Brooklyn Academy of Music's festival, "New Music America" (See Figure 7-4).

Figure 7-4
New Music America Poster,
1989
Design firm:
Alexander Isley Design,
New York, NY
Art director: Alexander Isley
Designer: Alexander Knowlton
Client:
Brooklyn Academy of Music
"New Music America" Festival

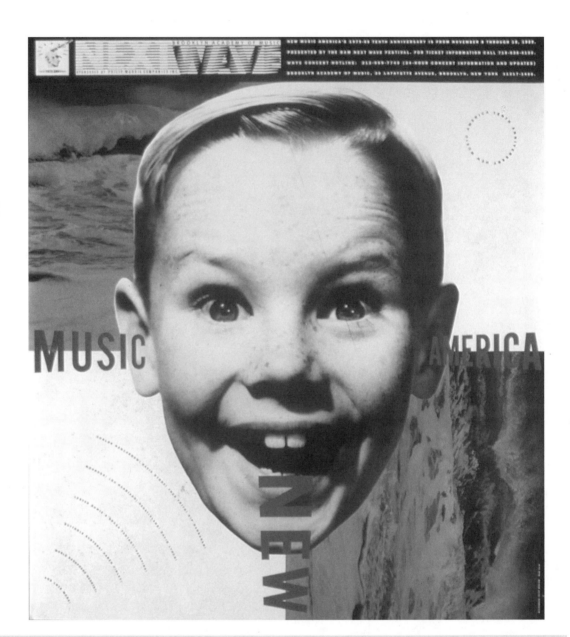

Suggestions

A poster may be designed with just typography or with a combination of type and visuals. The visuals may be abstract, pictographic, symbolic, illustrative, graphic, photographic, or a collage, or hybrid. Type may be designed within the visuals or there may be a fusion of type and visuals. Designing a poster is a challenge in terms of both design principles and message communication. This list of criteria will help you. Your objectives are:

- to communicate a clear and easily understood message

- to create a design that is immediately understandable and readable

- to create a design that is legible from a distance

- to include all pertinent information

- to establish a clear hierarchy of information

- to establish a visual hierarchy and unity

- to thoughtfully arrange elements according to the principles of graphic design

- to design appropriately for the subject, audience, and environment

- to express the spirit of the subject or message

Figure 7-5
Poster, Jan Tschichold,
Constructivists, **1937**
Collection:
Museum of Modern Art,
New York, NY.
Abby Aldrich Rockefeller Fund,
Jan Tschichold Collection

The funny, almost kitschy face, with words coming out of its mouth and words going into its ears to symbolize sound, is as hip as the concert series. Similarly, when Jan Tschichold designed a poster for an art exhibition of Constructivist work, he reflected the Constructivist style in his poster design (See Figure 7-5).

Like all other graphic design, the success of a poster depends upon the right combination of word and image. The word and image—also called the verbal and visual—must complement one another, as they do in this work by Josef Muller-Brockmann, *Less Noise* (See Figure 7-6). The visual dramatically shows someone suffering from noise pollution and the verbal message suggests a solution. Notice the visual hierarchy. You see the visual first, and then you read the words. The visual is thoughtfully designed in

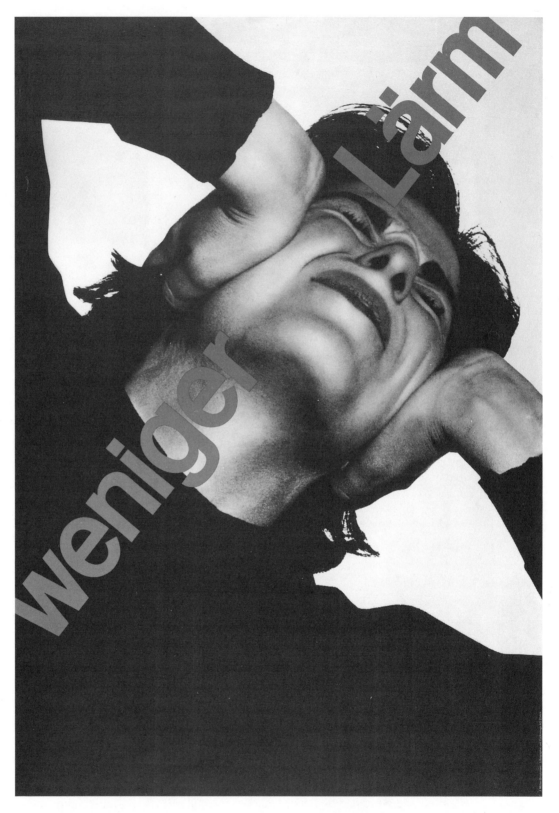

terms of positive and negative space and scale. The size of the image in relation to the format yields a powerful effect.

Understanding scale can give a designer an edge in creating the illusion of spatial depth, creating surprise, and creating visual dynamics or variations. This famous poster by Herbert Matter is a good example of a designer using extreme differences in size to create a strange mood and a somewhat disjunctive space (See Figure 7-7). In an homage to Matter, Paula Scher sets up a similar scale relationship (See Figure 7-8).

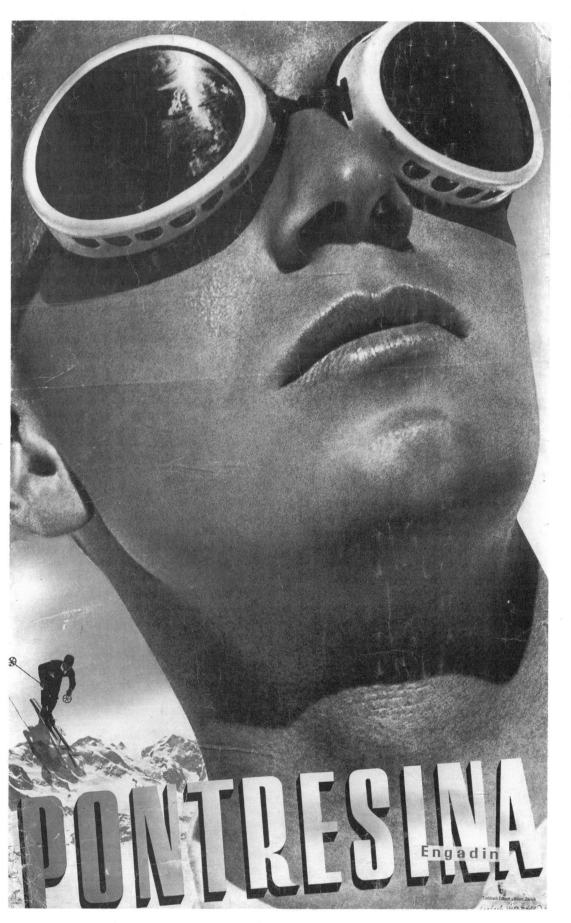

Figure 7-7
Poster, Herbert Matter,
Pontresina Engadin, 1935
Collection:
Museum of Modern Art,
New York, NY
Gift of the designer

Figure 7-8
Promotional Campaign,
Swatch Watch USA, 1984-85
Design firm:
Pentagram Design Inc.,
New York, NY
Designer: Paula Scher
Client: Swatch Watch USA

In keeping with Swatch's
irreverent, trendy marketing
identity, Paula Scher designed a
series of advertisements and
posters parodying graphics from
earlier design styles. Herbert
Matter's poster from the 1930s
was modified for one execu-
tion.

Sarah Haun,
Communications Manager,
Pentagram Design Inc.

Often a poster is part of a larger design project (See Figure 7-9). The design challenge for Richardson or Richardson was to create a trademark for the Phoenix Marathon that could be translated to signage, promotional materials, and event graphics.

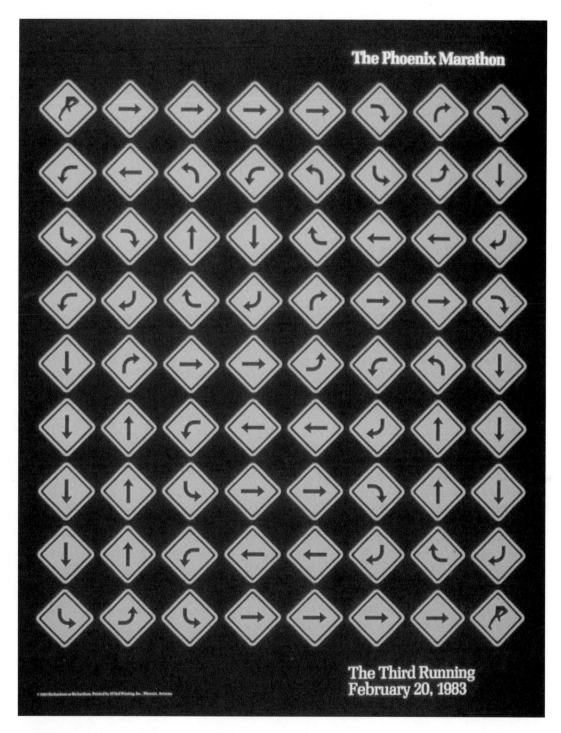

Figure 7-9
The Phoenix Marathon Poster, 1983
Design firm: Richardson or Richardson, Phoenix, AZ
Designer: Forrest Richardson
Client: The Phoenix Marathon

The design team developed the road sign symbol and methods for implementing it over existing signs, roadway light poles, and banners. The poster was a logical extension of the simple two-color system; a visual "maze" communicating the excitement of a road race winding through the streets of Phoenix.

Richardson or Richardson

Figure 7-10
Poster for an exhibition at a department store,
Seitaro Kuroda, *Seibu,* 1981
Collection:
Museum of Modern Art,
New York, NY
Gift of the designer

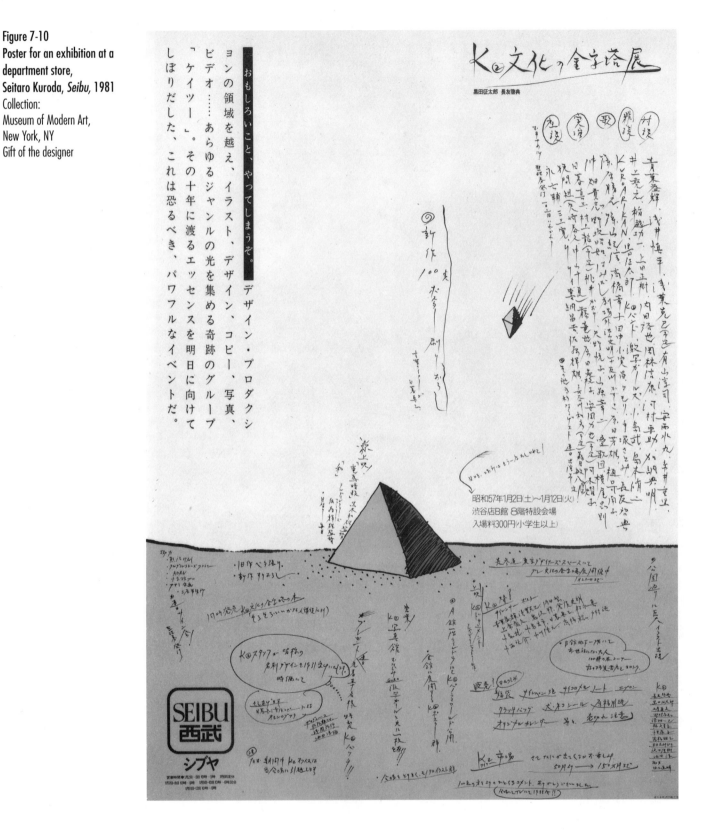

Compare the way these two designers use letterforms. Seitaro Kuroda uses lots of small characters, some handwritten and some typeset, to produce an energetic surface with a light-hearted effect (See Figure 7-10). Grapus combines set type and handwriting for a very different spirit (feeling) and message in his political poster (See Figure 7-11).

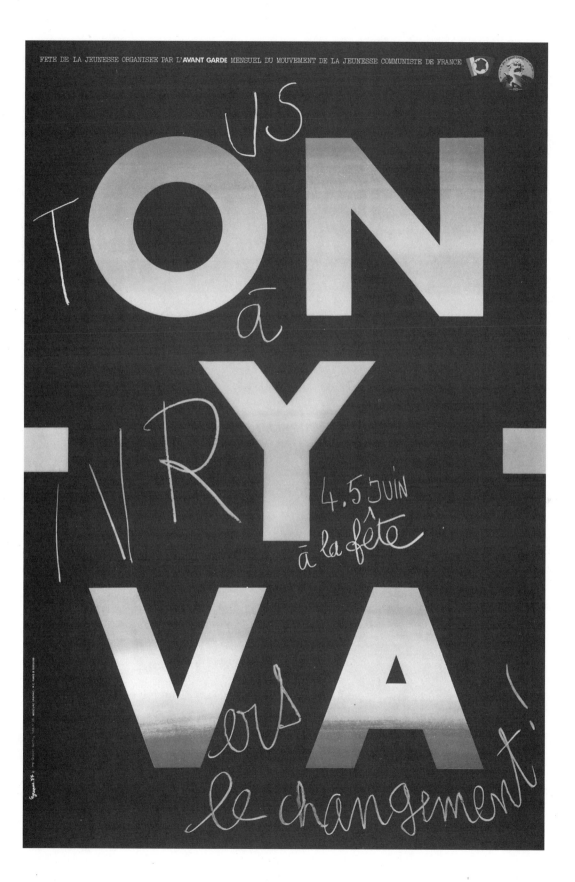

Figure 7-11
Poster, Grapus, *On Y Va*
(Let's Go), 1977
Collection:
Museum of Modern Art,
New York, NY
Gift of the designer

Figure 7-12
Exhibition Poster,
"The Modern Poster," 1988
Designer: April Greiman,
Los Angeles, CA
Client: The Museum of Modern
Art, New York, NY

*This was an invited competition
to design the poster for an exhi-
bition on "The Modern Poster."
We won!*

*The poster is a true "hybrid
image." It utilizes state-of-the-
art technology and is a compo-
sition of still video, live video,
Macintosh computer art, tradi-
tional hand skills, typography,
and airbrush.*

*The rectangular gradation
represents time and evolution
as graphic media have evolved
from photomechanical means
to the dynamic moving poster
of TV (the video rectangles that
are seen in perspective).*

April Greiman Associates

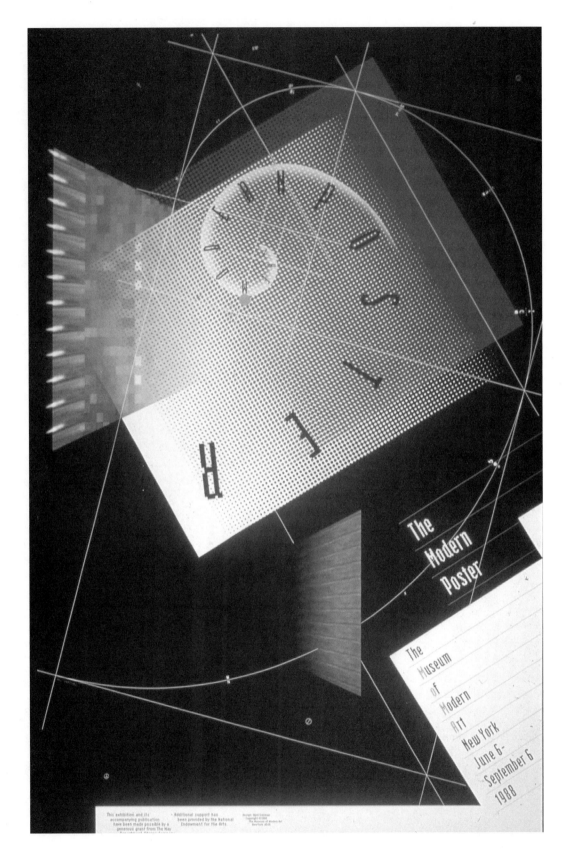

When a designer uses new technology to serve the design concept, innovative and imaginative things can happen. In these poster designs by April Greiman, hybrid imagery takes on symbolic meaning. For example, in her poster design for the Museum of Modern Art (See Figure 7-12), the rectangular gradation represents time and

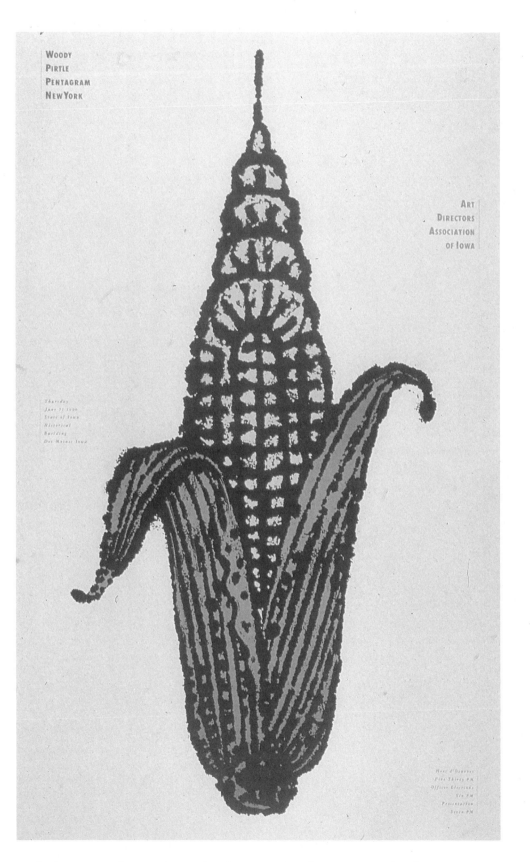

WOODY
PIRTLE
PENTAGRAM
NEW YORK

ART
DIRECTORS
ASSOCIATION
OF IOWA

Figure 7-13
Chrysler/Corn Poster, 1990
Design firm:
Pentagram Design Inc.,
New York, NY
Partner/designer/illustrator:
Woody Pirtle
Client: Art Directors
Association of Iowa

*This design was developed from
a sketch Woody Pirtle made
with a fountain pen on a
napkin during a lecture trip to
Iowa.*

Sarah Haun, Communications
Manager, Pentagram Design

evolution as graphic media evolved.

This poster by designer Woody Pirtle is a hybrid of agriculture and architecture. Woody Pirtle traveled from Pentagram's New York office to lecture on graphic design in Iowa in 1990. His announcement poster fuses an icon of the midwest, corn, with an icon of Manhattan, the Chrysler building (See Figure 7-13). Paul Rand

Figure 7-14
Poster, Paul Rand,
IBM, 1982
Collection:
Museum of Modern Art,
New York, NY
Gift of the designer

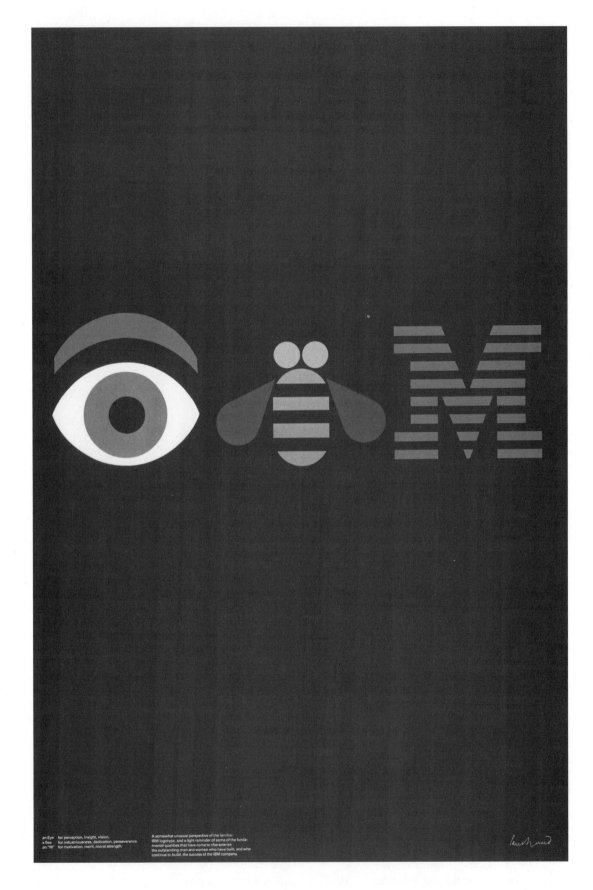

an Eye for perception, insight, vision.
a Bee for industriousness, dedication, perseverance.
an "M" for motivation, merit, moral strength.

A somewhat unusual perspective of the familiar
IBM logotype, and a light reminder of some of the funda-
mental qualities that have come to characterize
the outstanding men and women who have built, and who
continue to build, the success of the IBM company.

uses icons as a visual pun in this poster for IBM
(See Figure 7-14). As it states on the poster,
"An eye for perception, insight, vision; a bee for
industriousness, dedication, perseverance; and
an "M" for motivation, merit, moral strength,"
represent the spirit of the corporation.

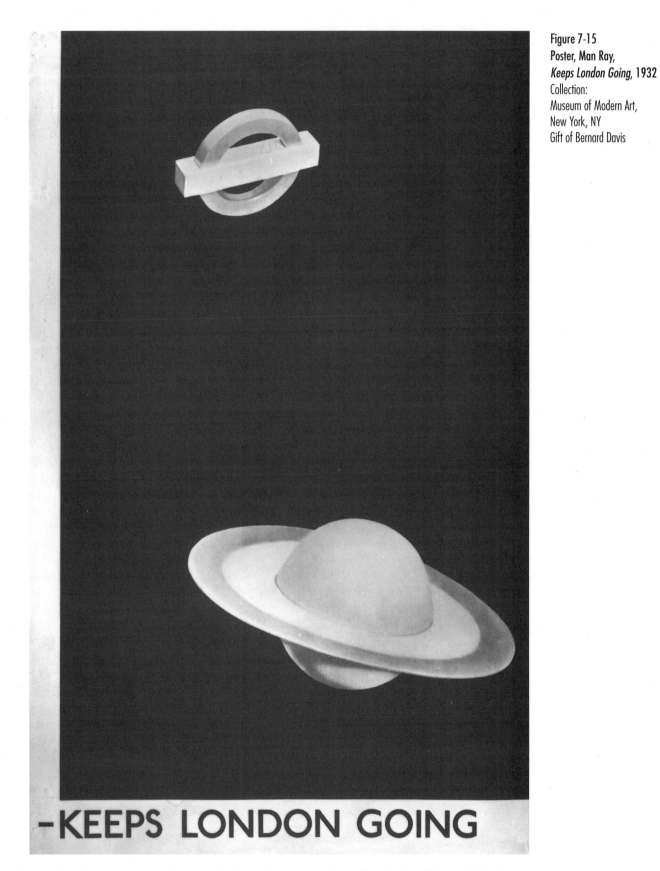

-KEEPS LONDON GOING

Figure 7-15
Poster, Man Ray,
Keeps London Going, 1932
Collection:
Museum of Modern Art,
New York, NY
Gift of Bernard Davis

Comparing these transportation posters by artists who were contemporaries demonstrates the stylistic range open to a graphic designer. Man Ray's poster for the London Underground has a surreal quality; its simplicity and the cooperative action between the visuals give it power (See Figure 7-15). A.M. Cassandre's poster for the Nord Express gets its power from the size of the

Figure 7-16
Poster, A.M. Cassandre,
Nord Express, 1927
Collection:
Museum Of Modern Art,
New York, NY
Gift of French National Railways

Figure 7-17
8 + 1 Poster, 1989
Design firm:
George Tscherny, Inc.,
New York, NY
Designer/Illustrator:
George Tscherny
Client: Sandy Alexander, Inc.,
Clifton, NJ

visual and title, the value contrast, and the complexity of the overall design (See Figure 7-16).

Sometimes we can almost see the designer thinking, and in these cases, the design concept is very clear. George Tscherny divides the poster into a grid and uses eight of the nine subdivisions to promote a new press capable of printing eight colors plus coating in one pass (See Figure 7-17). The poster, "Reflections from the Crystal City," was designed for the 1991 con- ference held by the Glass Art Society (See Colorplate 10); transparency and reflection are communicated through the design of the type and the layout.

"The Radical Response" poster is an appropriate solution for its subject—the lines of type break in atypical places, the type is difficult to read over a patterned ground, and the visual is exciting (See Colorplate 11).

Comments

Unlike an advertisement in a magazine which is seen up close, a poster has to grab attention from a distance. Since this poster is promoting a play, you have to carefully select visuals and words that will interest people; you have to motivate them to see the play. Try to create a meaningful relationship between what is being said (the verbal) and what is being shown (the visual). This is a good opportunity to use imagery or visuals that are essential or provocative without being a literal translation of the subject. Remember: Your goal is to communicate a message to an audience.

Exercise 7-1

Poster Design Variations

Step I

1. Find a poster; analyze its design concept and execution.

Step II

1. Redesign it three different ways: first, using only type.

2. Redesign it so the visual is the dominant element and the type is secondary.

3. Redesign it so the type is the dominant element and the visual is secondary.

4. Produce about twenty sketches before going to the rough stage.

5. Create one rough for each design problem.

Project 7-1

Poster Design for a Play

Step I

1. Choose a play. Read it. Research it.

2. Find related visuals you could use as references.

3. Write an objectives statement. Define the purpose and function of the poster, the audience, and the information to be communicated. On an index card, write down three adjectives that describe the spirit of the play, one sentence about the play's theme or plot, and images or visuals that relate to the play. Keep this card in front of you while sketching.

Step II

1. Design a poster to promote a play at your college or at a local theater. The poster should include the following copy: title, credits (author, producer, director, etc.), date, place, time, and admission prices.

2. Your solution should include type and visuals. The key to developing your design concept may be a visual that is symbolic of the play's spirit, message, or mood. Visuals do not have to be photographs of the cast or scenes from the play.

3. Produce at least twenty sketches.

Step III

1. Produce at least two roughs before going to the comp.

2. Be sure to establish visual hierarchy.

3. The poster should be in either a vertical or a horizontal format.

Step IV

1. Refine the roughs. Create one comp.

2. The size, shape, and proportion should be dictated by your strategy, design concept and where the poster will be seen (environment). The maximum size is 18" x 24"—no larger in any dimension.

3. You may use a maximum of two colors. **Optional:** design a playbill.

Presentation

Present the comp in one of two ways:

1. Matted on an illustration board with a 2" border

2. Mounted on an illustration board.

Comments

Designing a poster series demonstrates your ability to develop a design concept and follow it through in several ways or versions. It also provides you with an opportunity to develop a "look" or style for a series. Though each poster should stand on its own and send its own message, there should be a visual connection throughout the series; there should be continuity. You may want design companion pieces for this poster series, such as an invitation to events or a promotional button.

Project 7-2
Poster Series

Step I

1. Find out about a series of events on your campus or at a local museum.

2. Find visuals related to the events.

3. Write an objectives statement. Define the purpose and function of the poster series, the audience for the events, and the information to be communicated. On an index card, write one sentence explaining each event.

Step II

1. Design a series of posters for campus events or for a series of museum events.

2. The posters should have a similar style, looking as if they belong to a series.

3. Produce at least twenty sketches for the series.

Step III

1. Refine the sketches and produce one rough for each poster in the series.

2. Be sure to maintain visual hierarchy.

Step IV

1. Create a comp for each poster in the series.

2. There should be a minimum of three in the series.

3. Each poster should be no larger than 18" x 24". All the posters should be the same size.

4. You may use a maximum of two colors.

5. All the posters should be in a consistent format.

Presentation

The posters should be presented as tight comps in one of two ways:
1. Matted on a board with a 2" border
2. Mounted on a board.

Chapter 8
Book Jackets and CD Covers

Objectives

▮ to understand the purpose of book jackets and CD covers

▮ to be able to define objectives when designing book jackets and CD covers

▮ to be able to design book jackets and CD covers

Have you ever flipped through a bin of compact discs and stopped to look more closely at one because the cover was attractive? When browsing in a book store, have you ever picked up a book because the jacket looked interesting? Many people do. The design of a CD cover or book jacket may influence your decision to purchase the product. At the very least, it gives you a clue as to what is between the covers of the book or what type of music is on the disc.

Every book, magazine, or CD in a store is in competition. All are vying for the potential consumer's attention, though not every book or CD is aimed at the same audience. All the rules about developing a strategy apply here; you design with your audience and the marketplace in mind. A jacket or cover should give the consumer a sense of what the book or CD is about. You can think of it as a trailer or preview for a film. For example, if you are designing a book jacket for a murder mystery, you would want to convey a sense of the excitement, setting, time period, drama, and mystery in the book—but you would not want to give away too much information (especially not the ending). A book jacket or CD cover must communicate its message quickly and clearly, and arouse interest. The impact is similar to a poster's—it must attract attention, communicate a message, be aesthetically pleasing, and compete in the marketplace.

Like any other graphic design piece, a book jacket or CD cover most often combines type and image. In the case of the front cover of a book,

Figure 8-1
Album Cover, B.B. King, "There Is Always One More Time"
Design firm: Kosh/Brooks Design, Los Angeles, CA
Designer: Larry Brooks
MCA art director: Vartan
Photographer: Hiroyuki Arakawa
Client: © MCA Records

we usually see the title of the book and the author's name; sometimes, the price and series logo are included on the cover. Whether you design with type alone, type and photography, type and illustration, or type and graphics, depends on your strategy, concept and whether or not the book belongs to a series. If a book belongs to a series, the series should be visually coordinated.

Type and image should complement one another. Consideration must be given to the combination of these elements—how well they work together to convey a message and the spirit of the book or CD. When choosing type or visuals, it is crucial to make your selections based on your concept, the style or image you wish to convey, and the appropriateness to the

159

Figure 8-2
CD Cover, Danny Elfman, "Music for a Darkened Theatre"
Design firm: Kosh/Brooks Design, Los Angeles, CA
Designer: Larry Brooks
MCA art director: Vartan
Photographers: Dennis Keeley, David Norwood, Stuart Watson
Client: © MCA Records

Cover, Kim Carnes, "Voyeur"
Design firm: Kosh/Brooks Design, Los Angeles, CA
Designers: Kosh, Ron Larson
Photographer: Aaron Rappaport
Client: EMI America Records

Cover, Mary's Danish, "Circa"
Designer: Kosh/Brooks Design, Los Angles, CA
Designer: Kosh
Client: Morgan Creek Records

subject matter. There are many approaches to choosing imagery. The front of many CD covers show photographs or illustrations of the recording artist(s) or imagery related to the theme of the CD. We are less likely to see a photograph of the author on the front cover of a book, unless it is a biography, autobiography, or the complete works of the author. More often, the imagery relates to the subject matter or story. Your task as a designer is to translate the written words of a book or the music on a CD into visual communication. Whatever type and imagery is chosen should catch the potential audience's attention. Remember: Book jackets and CD covers are displayed—they promote the product.

CD Covers

A clear visual hierarchy is established on this record album cover designed by the firm of Kosh/Brooks for MCA Records (See Figure 8-1). First you see the photograph of B.B. King, then his name, and then the album title. Although the principals of many design firms tend to have a particular style or spirit, good designers understand it is important to adapt one's style to a particular design problem. These covers designed by Kosh/Brooks, including the B.B. King cover, demonstrate a range of design solutions. Notice how each solution is appropriate for the recording artist (See Figure 8-2).

Art Director/Designer Yolanda Cuomo worked directly with Paul Simon in the design of a CD/album cover (See Colorplate 12). "We

needed a photograph that captured the spirit of his music, and finally found the front cover

Figure 8-3
Special Edition CD Box, Paul Simon, "The Rhythm of the Saints," 1990
Designer: Jeri Heiden, Vice President, Creative Services, Chief Art Director, Warner Bros.
Client: Warner Bros. Records Inc., Burbank, CA

The package was done with a small budget, but we tried to maximize the impact on the viewer by using texture and handwork making it feel like something precious.

Jeri Heiden, Vice President, Creative Services, Chief Art Director, Warner Bros.

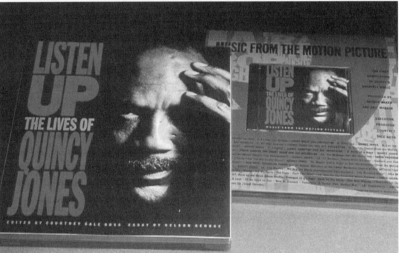

Figure 8-4
Listen Up: The Lives of Quincy Jones, 1991
Design firm: Frankfurt Balkind Partners, New York, NY
Creative directors: Kent Hunter, Danny Abelson
Designer: Johan Vipper
Cover portrait: Patrick Demarchelier
Conceived and edited by Courtney Sale Ross
Project director: Kent Alterman

The design was inspired by jazz album covers from the 1950s. Type and image are integrated throughout the book in a lively, syncopated design mix.

Kent Hunter, Executive Design Director and Principal, Frankfurt Balkind Partners

image, by Brazilian photographer Miguel Rio Branco. My inspiration for the special edition CD was religious mandalas." Visual texture and pattern is used to symbolize the music on Paul Simon's "The Rhythm of the Saints" Special Edition CD box used for promotional purposes only; it was sent to radio and publicity contacts (See Figure 8-3). The package is simple board outer wrap printed in three different African fabric styles, wrapped with raffia, and tied with an African bead and a feather.

The strong color combinations and imagery on the cover of David Byrne's "Rei Mono" CD instantly grab one's attention; the spirit of the design is carried through on the disc, inside booklet, and back cover (See Colorplate 13). The recurring circular motif, reds and greens, and visuals create unity throughout the CD package.

Book Jackets

Stacked uppercase type takes up about one third of the surface on the front of the book jacket for *Listen Up: The Lives of Quincy Jones* from the design firm of Frankfurt Balkind Part-

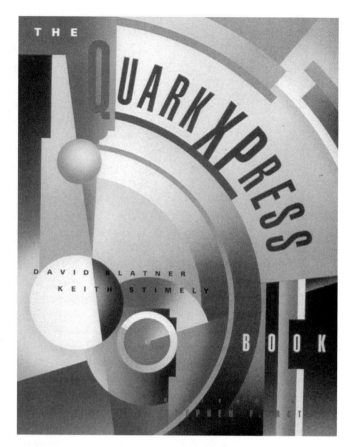

Figure 8-5
Book Jacket, *American Photography Five*, 1989
Design firm: Drenttel Doyle Partners, New York, NY
Designer: Stephen Doyle
Cover photographer: Herb Ritts

Figure 8-6
Book Cover, *The QuarkXPress*, 1990
Design firm: Ted Mader Associates, Seattle, WA
Art director: Ted Mader
Designer: Lynne Brofsky
Publisher: Peachpit Press

Suggestions

Book jackets or CD covers present similar design considerations. When designing a book jacket or CD cover, your objectives are:

- to attract potential consumers (readers or listeners)

- to express something about the contents of the book or CD

- to create a design that will stand up against the competition

- to communicate clearly and quickly

- to create something that is attractive and aesthetically pleasing

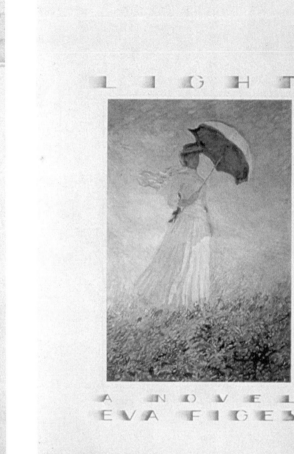

Figure 8-7
Book Jacket, *Chroma*, 1987
Design firm: Louise Fili Design, New York, NY
Art director/designer: Louise Fili
Publisher: Simon & Schuster, New York, NY

Figure 8-8
Book Jacket, *Light*, 1983
Design firm: Louise Fili Design, New York, NY
Art director/designer: Louise Fili
Cover painting: Claude Monet
Publisher: Pantheon Books, New York, NY

ners (See Figure 8-4). The implied vertical column created by the stacked type is echoed by the close-up, shadowed portrait of Jones, and a visual correspondence is established.

What else would a book about photography have on its cover other than a great photograph? This cover for *American Photography Five* has one by famed photographer Herb Ritts (See Figure 8-5). Art director Stephen Doyle and designer Rosemarie Turk made clever use of scale. The woman's head is large in relation to the size of the cover and the large scale proportions are maintained by using oversized type that does not quite fit on the cover. The design of this cover for *The QuarkXPress Book* makes

you feel that the book's contents would aid you in learning software—the circular forms and movements unify this book cover design, give the illusion of motion, and convey a feeling of speed and modernity (See Figure 8-6).

Louise Fili's style is apparent when you look at her body of work, and yet, like any good designer, she is able to adapt her personal vision to communicate the spirit of each project. Compare these two book jackets by Fili—*Chroma* and *Light* (See Figures 8-7 and 8-8). Both have Fili's distinctive typography and yet she is able to maintain the distinctiveness of each project's personality. Again, compare the book jacket designs for Pantheon Books' Kafka series

Figure 8-9
Book Jacket Designs,
Kafka Series, 1988
Design firm: Louise Fili Design,
New York, NY
Art director/designer: Louise Fili
Illustrator: Anthony Russo
Publisher: Pantheon Books,
New York, NY

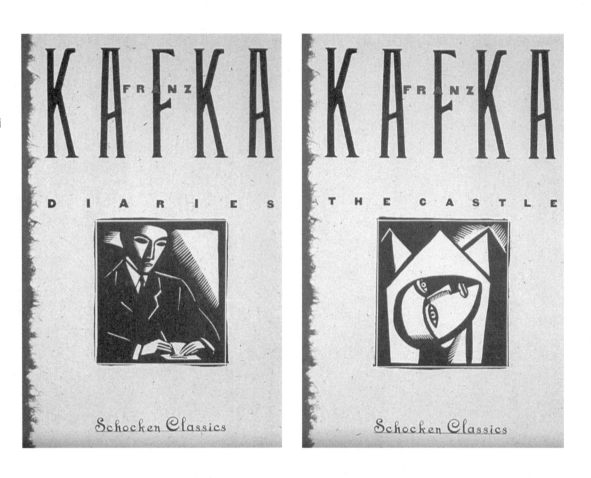

Figure 8-10
Book Jacket Designs,
Pantheon Modern Classics,
1983
Design firm: Louise Fili Design,
New York, NY
Art director/designer: Louise Fili
Illustrator: Dagmar Frinta
Publisher: Pantheon Books,
New York, NY

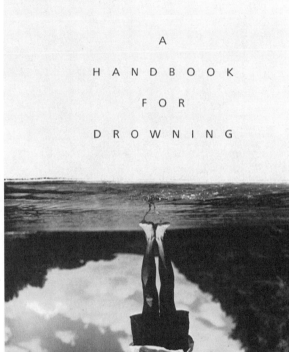

Figure 8-11
Book Jacket, *Watching the Body Burn*, 1989
Designer: Chip Kidd
Reprinted by permission of Alfred A. Knopf Inc.

Figure 8-12
Book Jacket, *A Handbook for Drowning*, 1992
Designers: Chip Kidd, Barbara de Wilde
Photographer: David Barry
Reprinted by permission of Alfred A. Knopf Inc.

to the Pantheon Modern Classics series (See Figures 8-9 and 8-10). Both used centered titles and images; both are balanced and carefully composed, yet each conveys different messages and feelings because of the choices of type and visuals. Notice how the titles and images are consistently arranged in each series to establish unity among the books.

When designing for a series, you must establish a "look" for the series, so people recognize the books as belonging together. A series should be identifiable as such. There should be visual similarities among the covers or jackets, for example, placement of the elements, type treatments, color, use of visuals. The author's name, book title, and visuals should be placed in the same position on each jacket or cover. If

one has photographs, they all should. If one is a purely typographic solution, they all should be, as in these designs by Jo Bonney for a Grove Press series of William Burroughs' books (See Colorplate 14).

Some designers find book jacket design particularly interesting because of the challenge of creating a successful marketing piece, an aesthetically pleasing design, and a design that expresses the meaning of a particular manuscript. Chip Kidd's design solution for *Watching the Body Burn* draws on popular culture for its imagery (See Figure 8-11). Although his design concept for this book jacket design, *A Handbook for Drowning*, is different, his witty use of visuals in combination with type is still apparent (See Figure 8-12). Kidd's distinctive bold and

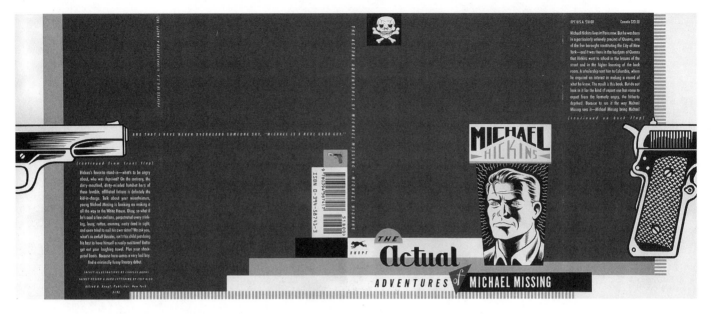

Figure 8-13
Book Jacket, *The Actual Adventures of Michael Missing,* 1991
Designer: Chip Kidd
Illustrator: Charles Burns
Reprinted by permission of Alfred A. Knopf Inc.

graphic style is further illustrated in his book jacket designs for *The Actual Adventures of Michael Missing* (See Figure 8-13) and *Brazzaville Beach* (See Figure 8-14). Both designs are balanced, however, one is symmetrical and the other is asymmetrical.

Rather than choose a firm with a history of designing textbooks, the Houghton Mifflin Co. selected Carbone Smolan Associates for their broad range of work and creative solutions.

The design program for The Literature Experience (See Colorplate 15), resulted in a series of highly acclaimed and unconventional children's textbooks for kindergarten through eighth grade. The books translate the excitement of a bookstore into each volume by capturing the diversity and spontaneity of individual books. An array of page-turning devices makes the books playful, funny, and interesting, quite beyond the textbook norm.

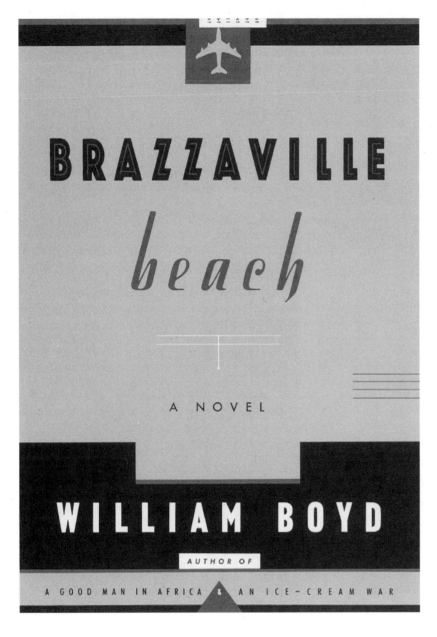

Figure 8-14
Book Jacket, *Brazzaville Beach,* 1991
Designer: Chip Kidd
Published in the United States by William Morrow & Co., Inc.
By permission of William Morrow & Company, Inc.

Comments

The covers should reflect the period and style of the music. It is important that the covers appeal to the appropriate listening audience. Remember: A wide variety of visuals may be used; you are by no means limited to using pictures of the recording artists. Go to music shops and analyze the different designs. You may want to design collateral material for this project, for example, a CD or cassette booklet, a CD longbox, the CD itself, a promotional T-shirt, or a poster.

Analyzing Book Jackets and CD Covers

1. Find five examples of book jackets or CD covers that express the spirit or personality of their contents. Justify your choices.

Project 8-1

CD and Cassette Cover Design

Step I

1. Choose a recording artist or group. Listen to the music.

2. Find visuals that relate to the music and recording artist or group.

3. Write an objectives statement. Define the purpose and function of this problem, the audience, and the information to be communicated. On an index card, write three adjectives that describe the music on this CD. Keep this card in front of you while sketching.

Step II

1. Choose or invent a recording label and design a logo for it. Have a clear idea of the type of music recorded on this label. The logo should reflect the type of music recorded on the label or in the series. (See Chapter 6 on designing logos.)

Step III

1. Design a compact disc cover (called a tray card) and a cassette cover (called a J card).

2. The cover's design should include the recording label or series logo, name of the CD, and name of the recording artist.

3. Your solution may be purely typographic or combine type and visuals. The visuals may be photographs of the recording artist or group or a visual related to the music's theme or spirit. The visuals should create or set a mood.

4. Produce at least twenty sketches. Reminder: Design with any or all tools that are appropriate—computer, pencils, markers—but do not lock yourself into using one tool for all projects.

Step IV

1. Create two roughs for each cover.

Step V

1. Refine the roughs. Create one comp for each cover.

2. It is advisable to buy a CD and cassette to see how your covers look in the plastic trays.

3. You may use black and white or full color. **Optional:** Design inside booklets for the CD and cassette.

Presentation

The covers should be matted or mounted on 11" x 14" boards or slip them into CD and cassette containers.

Comments

The best way to begin is to read the books in order to have a clear sense of your subject. Your designs must reflect the poet's works. It is crucial for a designer to learn to do research and to learn to translate editorial content and ideas into graphic design. Like the poster series, each book jacket should be able to stand on its own, but also belong to the series. Any book in the series should be identifiable as such. There should be visual similarities among the books, for example, placement of the elements, type treatments, color, and use of visuals.

Project 8-2
Book Jacket Design Series

Step I

1. Select three poets. Read their poetry. Research them. Ask a poetry expert or professor about them.

2. Write an objectives statement. Define the purpose and function of the problem, the audience for the books, and the information to be communicated. On an index card, write adjectives that describe the work of each poet.

Step II

1. Name the series. Design a logo for the poetry series. (See Chapter 6 on logo design.)

Step III

1. Design three book jackets—one for each poet in your series. Design front covers only.

2. The covers must be similar in style and yet express the individuality of each poet.

3. The logo must appear on each jacket in the same position.

4. Produce at least ten sketches for each jacket that could be expanded into a series format.

5. Your solution may be purely typographic or it may include visuals.

6. Think about the various ways the series could be tied together:

 • through the use of similar visuals: illustrations, graphics, photographs
 • through the use of a technique: woodcut, mezzotint, torn paper, xeroxography
 • through the use of typography

Step IV

1. Refine the sketches. Create two sets of roughs for the series.

2. Remember: Book jackets or covers are very much like posters—they must attract the potential consumer. They should have initial impact. Your book jacket design must compete against other books sitting next to it on a shelf.

Step V

1. Refine the roughs and create one comp per book.

2. The covers should be 6" x 9", held vertically.

3. You may use black and white or full color.

Presentation

Each book jacket should be matted or mounted on a separate 11" x 14" board.

Chapter 9
Packaging and Shopping Bags

Objectives
▪ to understand the purpose of package design
▪ to understand the requirements of package design
▪ to be able to design a package
▪ to understand the form and function of a shopping bag
▪ to see shopping bags as part of a larger identity design system
▪ to be able to design a shopping bag

Packaging

Packaging affects you more than you realize. If you walk into a store and see a package on display that is attractive, you pick it up. An attractive package can seduce you into purchasing a product at least once. A well designed package can make an inexpensive product look expensive, and conversely, a poorly designed package can make a superior product look inferior.

In addition to its decorative, promotional formal display aspect, packaging is functional. A **package** encloses a product and it must work; it must enable you to pour from it, open it easily, reclose it, and so on. Although packaging is essentially a three-dimensional design discipline, the two-dimensional design on the surfaces of a package is an integral part of the overall impact. A package has several surfaces and all must be considered in the design. Most packages are displayed on shelves where we see the cumulative effect of several packages lined up next to one another.

Packaging is a specialized area of the graphic design profession. Package designers must be knowledgeable about a range of construction and technical factors. They must be familiar with materials and their qualities, like glass, plastic, cardboard, paper, and metal, and with manufacturing, safety, display, recycling, and packaging regulations, as well as printing.

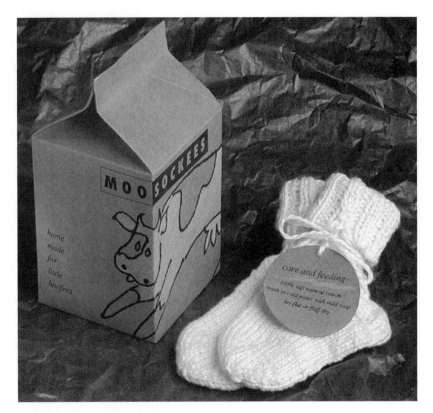

Figure 9-1
Package and Product Tag, Moo-Sockees
Designer/illustrator/writer: Patty O'Leary, Somerville, MA

This package was designed to hold a pair of 100% cotton (natural, unbleached) baby socks. They come with a tag that reads "Care and Feeding," which is actually the instructions for washing. Tagline reads "Home Made for Little Hoofers."

I also designed the actual socks, and produced the first ten or so prototype pairs.

This package snaps open and shut at the bottom so as not to destroy the top of the package. It is patterned after a regular half-pint milk container.

Patty O'Leary

The packaging design system for Barneys New York reflects the sophisticated image of the store (See Colorplate 16). Using simple, legible uppercase letters, subtle colors, and a classic simplicity of design, art director Nancye Green

171

Figure 9-2
Packaging Design, 1991
Design firm: Michel Design,
South Salem, NY
Designer: Deborah Michel
Illustrator: Charles Waller
Writer: Bruce Michel
Client: The Salem Food Co.

and designers Julie Riefler and Jenny Barry convey an image of quality merchandise.

Frequently, a designer must prepare companion pieces for a package, like a label or product tag. Patty O'Leary designed both the package and product tag for these baby socks,

Moo-Sockees (See Figure 9-1). Compare this design to the Barney's packaging to see how different packages are designed for different product categories. The Barney's packaging is for a very upscale clientele.

Both sets of packaging for the Salem Food

Figure 9-3
Private Label Packaging Program, Epicure Essentials
Design firm: Susan Slover Design, Inc., New York, NY
Designer: Tom Bricker
Client: Carter Hawley Hale Stores, CA

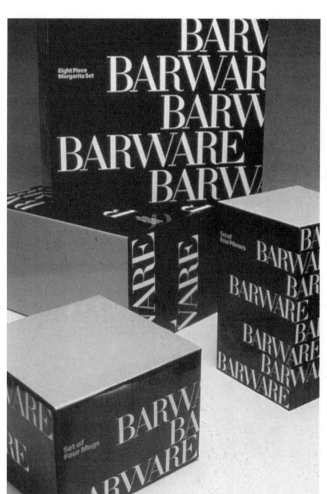

Figure 9-4
Private Label Packaging Program, Barware
Design firm: Susan Slover Design, New York, NY
Designer: Susan Huyser
Client: Carter Hawley Hale Stores, CA

Company have similar qualities and yet each set is distinctive (See Colorplate 17 and Figure 9-2). Art director Deborah Michel used type set against lush, detailed illustrations. The front of each package has a strong focal point. Notice how the selection of type works with the style of illustrations.

The type and illustrations work very well together in this label and package design for the client HAM I AM, which produces sauces for pork, beef, and fish dishes as well as other food products (See Colorplate 18). Color is an important design element. In the packaging of products like food, toiletries, and beverages, color often conjures up key associations.

An important part of packaging is providing the potential consumer with information. On this series of numerically coded packages for ProStainless cookware, photographs of the cookware dominate the package (See Figure 9-3). Designer Susan Slover makes excellent use of all sides of the package; we see the cookware with and without food as well as the clearly displayed number. Careful consideration is given to scale, the size of the photographs in relation to the size of the box, and to visual hierarchy (photos, number, text type), which makes for dramatic results. Slover uses typography and color as the primary design elements in these packages (See Figure 9-4).

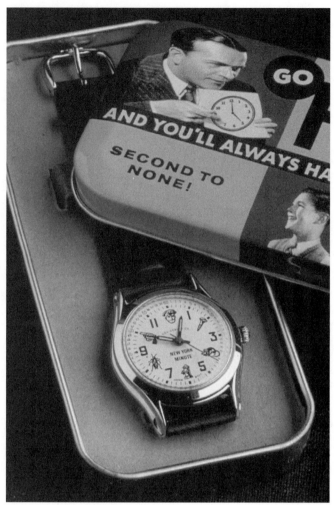

Figure 9-5
Package Design, Fossil Tins, 1991
Design firm: Charles S. Anderson Design Company, Minneapolis, MN
Art director: Charles S. Anderson
Designers: Charles S. Anderson, Daniel Olson, Haley Johnson
Writer: Lisa Pemrick
Photographer: Paul Irmiter
Client: Overseas Products International, Inc.

These are four out of a series of sixteen silkscreened tin boxes we designed for the Dallas, Texas-based Fossil Watch Company. Fossil's president and founder, Tom Kartsotis, is taking the fashion watch world by storm with some of the most interesting watch designs in the industry. Not to be outdone, we tried to make our designs for these tins as interesting and unique as the watches themselves.

Charles S. Anderson Design Company

Pulling imagery from American popular culture, the Charles S. Anderson Design Company clearly enjoyed this packaging design project (See Figure 9-5). "These are four out of a series of sixteen silkscreened tin boxes we designed for the Fossil Watch Company. In addition to the tin watch boxes we designed, we also developed a new mark for the Fossil Watch Company for use on their packaging, a new warranty card design, a new background card, along with a new paper shipping sleeve to prevent the tins from being scratched."

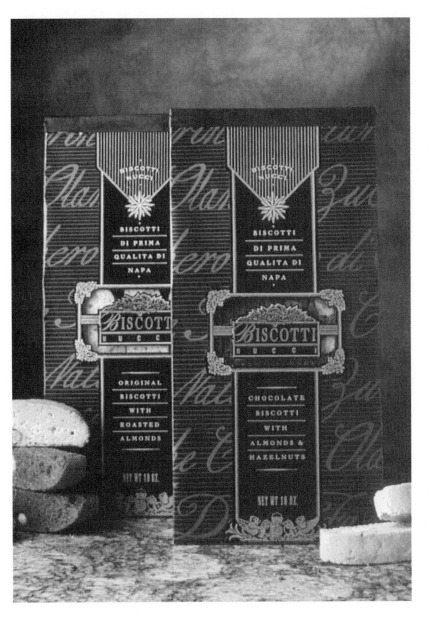

Figure 9-6
Biscotti Nucci Packaging Twelve-pack, 1991
Design firm: Morla Design, San Franscisco, CA
Art director: Jennifer Morla
Designers: Jennifer Morla, Jeanette Aramburu
Client: Prodotti Nucci, Napa, CA

Biscotti Nucci are original Venetian recipe Italian cookies that are sold at high-end specialty department stores and food emporiums. Our research found that competitive biscotti packaging all utilized brightly colored type against a vast white field. Wishing to make our client's product distinctive, attractive enough to give as a gift, and reflective of the recipe's heritage, we created a packaging system using rich metallic golds (for the more subtle background script and for the primary descriptive type). The descriptive gold type reverses out of a wide black band, accented by the engraved Venetian motifs of the lions and the sun.

Morla Design, Inc.

If you compare these package designs, one for candy bars and the other for biscotti, you can see they both have an upscale look. Both foods are rich and luxurious, and these qualities are communicated by the elegant type, patterns, and layout. Because the candy bars are all-natural, the designers at Charles S. Anderson Design Company decided to use soft pastels and fresh, loose charcoal illustrations. The foil innerwrap features the Cloud Nine logo in a repeated silver on silver pattern (See Colorplate 19). At Morla Design, research found that competitive biscotti packaging all utilized brightly colored type against a vast white field (See Figure 9-6). Wishing to make the client's product distinctive, attractive enough to give as a gift, and reflective

of the recipe's heritage, the designers created a packaging system using rich metallic golds (for the more subtle background script and for the primary descriptive type).

There are numerous software programs, each with a unique package design. The packaging for Smartware is intelligent and aesthetically pleasing; a colorful central square is the focal point of the design (See Figure 9-7). It is interesting to look at several software package designs by one design firm. Here are two package designs by Clement Mok designs, Inc. Clearly, each design is a result of different design objectives and each reflects the purpose and spirit of the product it contains (See Figures 9-8 and 9-9).

Figure 9-7
Package Design
Design firm:
Muller + Company,
Kansas City, MO
Client: Smartware

Suggestions

A package sitting on a shelf is in visual competition with the products sitting next to it. It must be attractive, legible, and appropriate for its audience and marketplace. Your objectives when designing a package are:

- to make it functional

- to be able to make a mock-up

- to research materials and construction

- to be aware of recycling and wastefulness

- to be aware of packaging as both a three-dimensional and a two-dimensional design problem

- to consider all sides of a package in the design

- to design an attractive, aesthetically pleasing piece that is appropriate for its intended audience

- to make it work with a larger visual identity system (if applicable)

- to ensure legibility and clarity

- to research the competition

- to make it stand out from the competition

- to consider it will be seen in multiples when on display

- to express the spirit or personality of the product and company or store

- to consider the appropriate color associations

- to coordinate it in color and design with other flavors or choices in a product line

- to identify its manufacturer, product name, contents, weight, and provide any other pertinent information

Guess which one will grow up
to be the engineer:

As things stand now, it doesn't take much of a guess.
Because by and large, *he* is encouraged to excel in math and science. *She* isn't.
Whatever the reason for this discrepancy, the cost to society is enormous because it affects women's career choices and limits the contributions they might make.
Only 4% of all engineers are women.
Only 13.6% of all math and science Ph.D.'s are women. And an encouraging, but still low, 26% of all computer professionals are women.

In the past ten years, IBM has supported more than 90 programs designed to strengthen women's skills in these and other areas. This support includes small grants for pre-college programs in engineering, major grants for science programs at leading women's colleges, and grants for doctoral fellowships in physics, computer science, mathematics, chemistry, engineering, and materials science.
We intend to continue supporting programs like these.
Because we all have a lot to gain with men and women on equal footing.

Colorplate 1

Ad, "Guess which one will grow up to be the engineer"
Creative director/writer: Bob Mitchell, Mitchell Advertising, Millwood, N.Y.
Art director: Seymon Ostilly, Associate creative director, Dentsu Advertising
Courtesy of IBM Corporation

Colorplate 2

Posters
Design firm: Muller & Company, Kansas City, Mo.
Creative director/designer: John Muller
Writer: David Marks
Production art: Kent Mulkey
Client: Mission Mall, Mission, Kans.

A regional shopping mall was going to open in two weeks. The developer of the mall called me and said, "We have 150,000 square feet of blank storefront barricades and it looks desolate in here!" So, in order to get something produced and installed in two weeks and respond to a limited budget situation, I designed a series of three-color silk-screen posters. We printed 75 each of the posters on cheap billboard paper 40" x 60" and simply wallpapered the entire mall. These posters quickly became collector's items.

John Muller

Graphic identity, 1991
Design firm: Harp & Company, Big Flats, N.Y.
Designer: Douglas G. Harp
Client: Coyote Loco Restaurant and Cantina

The coyote is a worn-out cliche, it seems, for all things—food, cloth-ing, etc.—to do with the Southwest. But its immediate association with this region is undeniable; our challenge, therefore, was to use this familiar icon, but to somehow give it a different spin. Here, the moon that the coyote is howling at is, in fact, a hot pepper, which is an unexpected visual twist. Instead of showing the entire coyote, more visual interest is created by unusual cropping and by presenting only the necessary details to indicate that it is a coyote's head. The shape is also reminiscent of a mesa, an interpretation that would also be appropriate for the Southwest.

Douglas G. Harp, president, Harp & Company

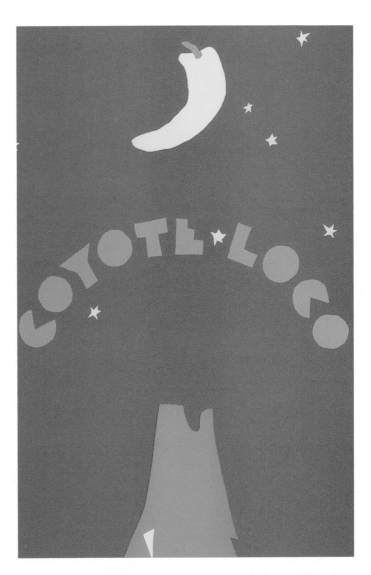

Colorplate 4
**Gift box packaging for
The Nature Company, 1990**
Design firm:
Gerald Reis & Company,
San Anselmo, Calif.
Art director: Gerald Reis
Designers: Gerald Reis,
David Asari
Client: The Nature Company

Colorplate 5
Poster, "Peace • Commemoration of the 40th Anniversary of Hiroshima," 1984
Design firm: Chermayeff & Geismar Inc., New York, N.Y.
Designer: Steff Geissbuhler
Poster: Peace—Godzilla and King Kong

Godzilla is a modern folk hero and a symbol of Japanese superpower called upon in times of crisis and invasion by other superpowers such as King Kong. Apparently, Godzilla emerged from the volcanic emptiness after a nuclear blast. Therefore, it is even more of a symbol relating to peace. King Kong was used as the American counterpart of Godzilla.

The centered red sun on a white background is another symbol of Japan (Japanese flag, etc.). The color palette of red, black, and white is classic, and typical in Japanese calligraphy, painting, and woodcuts. The red-to-white gradation in the background relates directly to contemporary airbrush techniques frequently used in Japanese design. Meaning of the poster:

The friendship of Godzilla and King Kong makes them mightier than any other single beast. Friendship does not mean that one has to eliminate the other. It means coexistence with mutual respect and understanding. Nobody has to be the winner—nobody has to lose.

Steff Geissbuhler, designer,
Chermayeff & Geismar Inc.

Colorplate 6
Interior spread from Westvaco "Inspirations 210," 1958
Designer: Bradbury Thompson
Copyright by Westvaco Corporation,
New York, N.Y.

This graphic design puts forth the illusion of color in motion as the saxophonist comes alive on the whirling record. Process printing plates were not employed, as just one halftone plate was printed in three process inks and on three different angles to avoid a moire pattern.

Karen Bloom, manager,
Public Relations Programs, Westvaco Corp.

Colorplate 7
Mardi Gras Galveston 1988/Carnevale de Venezia
Design firm: Sibley Peteet, Dallas, Tex.
Art director/designer: Don Sibley
Client: Galveston Park Board

Colorplate 8
David Morris Design Associates
Promotional Calendar, 1994
Design firm: David Morris Design
Associates, Jersey City, N.J.
Creative director:
David M. Annunziato
Art director: Denise M. Anderson
Photographer: Elizabeth Watt

Time Warner 1990 Annual Report, 1991
Design firm: Frankfurt Gips Balkind,
New York, N.Y
Creative directors: Aubrey Balkind, Kent Hunter
Designers: Kent Hunter, Ruth Diener
Photographers: Charles Purvis, Scott Morgan,
Lorraine Day, still from Time Warner Video
Client: Time Warner, Inc.

*Photographic icons represent the four pieces of
Time Warner, the world's largest entertainment
and information company. A color palette and lay-
out grid is established here for the rest of the
annual report. The spread is actually die cut hori-
zontally at the center grid, so readers can create
their own layout with the next two spreads.*

Kent Hunter,
Executive Design Director

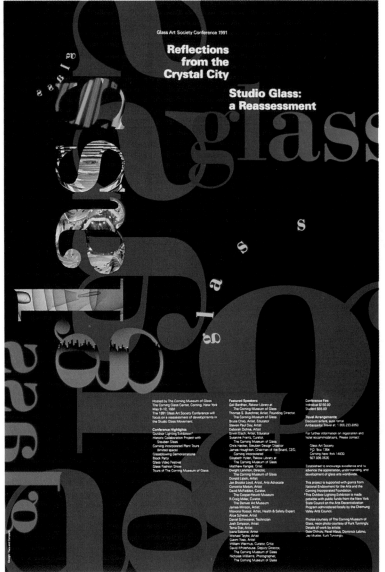

**Poster, "Reflections from the
Crystal City," 1991**
Design firm: Harp & Company, Big Flats, N.Y.
Art director: Douglas G. Harp
Designer: Linda E. Wagner
Client: Glass Art Society, Corning, N.Y.

*Our aim was to combine typography and imagery
in a way that communicates the vitality, color,
and reflectivity represented by this diverse group
of glass sculptors.*

Douglas G. Harp, president, Harp & Company

Colorplate 11
Poster, "The Radical Response," 1991
Design firm: Morla Design, San Francisco, Calif.
Art director: Jennifer Morla
Designers: Jennifer Morla, Sharrie Brooks
Client: The Museum of Modern Art, San Francisco, Calif.

*The Radical Response was the focus of the 1991 San
Francisco Museum of Modern Art Design Lecture Series.
The series investigated the qualities that make design
radical, featuring four individuals whose approach to
design have transformed the context of the ordinary into
the realm of the extraordinary. We created an image for
the Design Lecture Series that aggressively portrays the
title of the series.*

Morla Designs, Inc.

Colorplate 12
CD/Album Covers, Paul Simon,
"The Rhythm of the Saints," 1990
Art director/designer: Yolanda Cuomo
Photographer: Miguel Rio Branco
Client: Warner Bros. Records, Burbank, Calif.

*I worked directly with Paul Simon in the art direction and
design of the CD/album cover. We needed a photograph
that captured the spirit of his music.*

Yolanda Cuomo,
Art director/designer

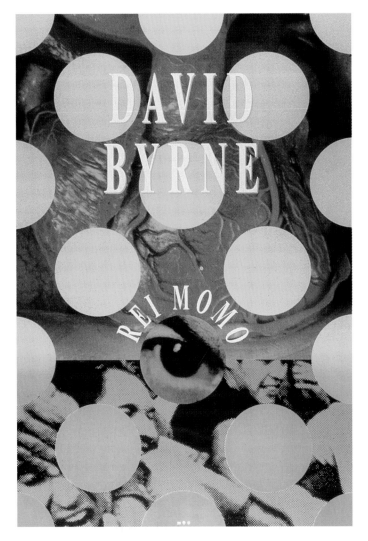

Colorplate 13

CD Package, David Byrne, "Rei Mono"
Design firm: Doublespace, New York, N.Y.
Client: Warner Brothers Records, Burbank, Calif.

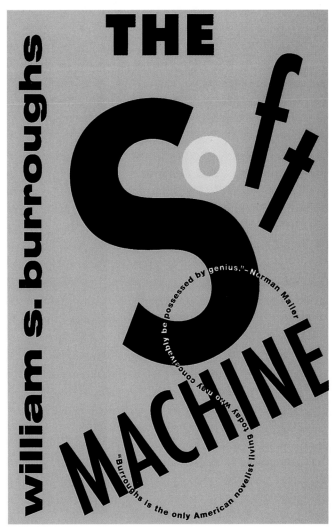

Colorplate 14

Book Jacket Designs, William Burroughs Series
Designer: Jo Bonney
Publisher: Grove Press, New York, N.Y.

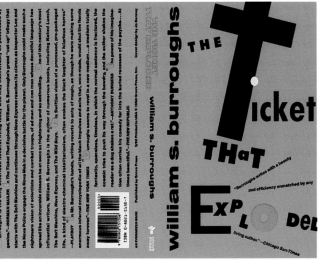

Colorplate 15
Book Jackets, "The Literature Experience,"
1989 & 1990
Design firm:
Carbone Smolan Associates, New York, N.Y.
Designer: Leslie Smolan
Client: The Houghton Mifflin Company

The Houghton Mifflin Company, long regarded as the industry leader in reading textbooks, had recently lost ground to one of its prime competitors. With 65 percent of its revenue dependent upon reading, a lot was at stake. The company had a bold idea: the key to success was to reevaluate the role of design in its books.

The books translate the excitement of a bookstore into each volume by capturing the diversity and spontaneity of individual books. An array of page-turning devices makes the books playful, funny, and interesting, quite beyond the textbook norm. After the books were in production, we were invited to design the marketing materials and kindergarten packaging. The gamble seems to be paying off— the program is in use in all fifty states and sales represent 25 percent of the industry-wide reading text market.

Leslie Smolan, principal, Carbone Smolan Associates

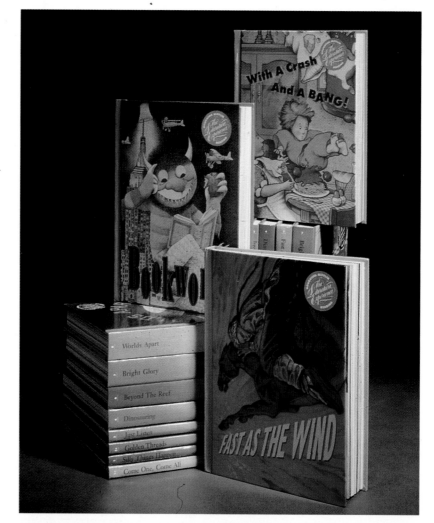

Colorplate 16
Packaging design,
Barneys, 1985
Design firm: Donovan and Green,
New York, N.Y.
Art director: Nancye Green
Designers:
Julie Riefler, Jenny Barry
Photographer: Amos Chan
Client: Barneys, New York, N.Y.

Colorplate 17
Packaging design, 1991
Design firm: Michel Design,
South Salem, N.Y.
Designer: Deborah Michel
Illustrator: Judith Sutton
Client: The Salem Co.

Colorpate 18
Hogwash Package design, 1990
Design firm: SullivanPerkins,
Dallas, Tex.
Art director: Ron Sullivan
Designers: Clark Richardson,
Art Garcia
Illustrators: Art Garcia,
Clark Richardson
Writer: Mark Perkins
Client: HAM I AM

Our client, HAM I AM, produces sauces for pork, beef, and fish dishes, as well as other food products. To keep with the up-scale feeling and humor the client wanted, SullivanPerkins printed a kraft paper label with an old engraving of a hog. The labels and seals were printed with PMS colors red, kraft brown, black, and gold on adhesive stock.

SullivanPerkins

Colorplate 19

Package design, Cloud Nine Candy Bars, 1991
Design firm: Charles S. Anderson Design Company,
Minneapolis, Minn.
Art director/designer/illustrator: Haley Johnson
Client: Cloud Nine Inc., Hoboken, N.J.

*This is an example of the labels we designed for this
100 percent natural line of environmentally-aware
gourmet chocolates. Because the bars are all-natural,
we decided to use soft pastels and fresh, loose char-
coal illustrations. The foil innerwrap features the
Cloud Nine logo in a repeated silver on silver pattern.*

Charles S. Anderson Design Company

Colorplate 20

Shopping Bag, NorthStar Mall, 1987
Design firm: SullivanPerkins, Dallas, Tex.
Art director: Ron Sullivan
Designer: Linda Helton
Client: The Rouse Company, San Antonio, Tex.

*We have done shopping bag designs and other design
and advertising for this San Antonio shopping center
for some years. The "N" and Star" motif was devel-
oped for a series of shopping bags so well liked, they
replaced the mall's logo and now appear on letter-
head and other identity items.*

SullivanPerkins

Colorplate 21

**Identity and Graphics Program for the IDCNY,
1983-1989**
Design firm: Vignelli Associates, New York, N.Y.
Designers: Massimo Vignelli, Michael Bierut
Client: International Design Center of New York,
Long Island City, N.Y.

*IDCNY, the International Design Center of New York,
is an international furniture merchandise mart in Long
Island City. The logo portrays elegance and strength
by the choice of two contrasting typefaces. The pro-
gram includes graphics, invitations, publications,
advertising, and signage. Based on three very basic
elements—Bodoni type with black and red colors—
the program is nevertheless extremely articulated and
vibrant, and has achieved a very strong identity often
imitated by similar organizations.*

Vignelli Associates

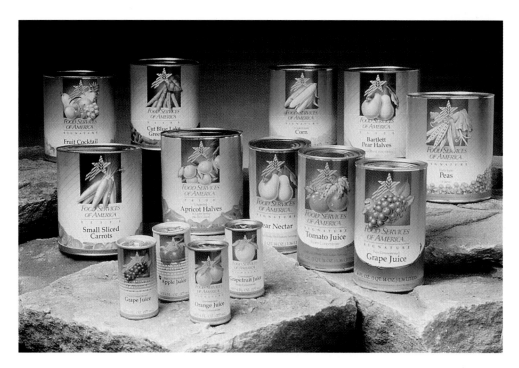

Corporate and brand identity and product packaging, 1987-88
Design firm: Hornall Anderson Design Works, Inc., Seattle, Wash.
Designers: John Hornall, Jack Anderson
Client: Food Services of America, Seattle, Wash.

Because of a name change, the client was faced with new packaging. The overlapping, rich images on the can are interchangeable, allowing for diversity and individualization of contents. The color system of teal, red, and gold clearly delineates product levels and is easy to identify in crowded low-lit warehouses.

Christina Arbini, marketing assistant, Hornall Anderson Design Works

LS Collection Identity System, 1989
Design firm: Designframe Inc,
New York, N.Y.
Client: The LS Collection, New York, N.Y.

The elements of the L S collection were created to reflect the design and personality of the store, incorporating the corporate mark and copper color.

James A. Sebastian, president,
Designframe Incorporated

Colorplate 24

Identity and packaging, 1990

Design firm: Pentagram Design Inc., New York, N.Y.
Partner: Colin Forbes
Associate/Designer/Typographer: Michael Gericke
Designer: Donna Ching
Illustrator: McRay Magleby
Interior Design: Intradesign, Los Angeles, Calif.
Client: Hotel Hankyu International
Produced with: OUN Design Corporation and Dentsu Inc.

In a reversal of the usual procedure, the client commissioned the identity program before any other design project, and the graphic elements were used to guide development of the hotel's interior design and architecture. Pentagram New York coordinated the project with the client, consultants, and promotional advisers in Osaka as well as the Los Angeles based interior designers.

Hankyu specified a distinctive emblem that would communicate quality, internationalism, and the "universal appeal of flowers." The visual concept is a modern interpretation drawing upon the glamour of steamer trunk labels from the art deco era. The program also expresses luxury by differentiating each item in the hotel with special detailing. Applications include signage, room folders, stationery, labels, menus, and amenity packages for male and female guests.

Sarah Haun, communications manager,
Pentagram Design

Colorplate 25

Z Contemporary Cuisine Menus, 1992

Design firm: Nesnadny & Schwartz Inc., Cleveland, Ohio
Creative directors/designers:
Joyce Nesnadny, Mark Schwartz
Writer: Zachary Bruell
Photographer: Tony Festa
Client: Z Contemporary Cuisine

The client required a system of lunch, dinner, dessert, and wine menus for a newly opened restaurant. The design system had to reflect the unique character of the physical space as well as the inventive nature of the menu offerings. At the same time, the entire system had to accommodate daily updates to the content of the menus. We proposed a system of menu covers that utilized a relatively minimal design/color approach. The interiors employed a more vibrant color palette as well as a pattern of photographic images of food. All of this was linked conceptually through the use of various graphic permutations of the letter Z.

Mark Schwartz, Nesnadny & Schwartz

Öola is a chain of Swedish candy stores in American shopping malls. The company intended to enter the U.S. market under the name "Sweetwave," but when Paula Scher was commissioned to design their retail identity in 1988, she expressed a concern that the name would not be interesting enough to American consumers. Scher recommended playing up the company's European origins with a new name and a bright clean graphic look.

The word "öola" was invented and became the basis for the stores' entire visual identity. Öola was chosen for its Scandinavian sound, geometric letterforms and the umlaut, which has become a central motif in graphic applications.

Sarah Haun, communications manager

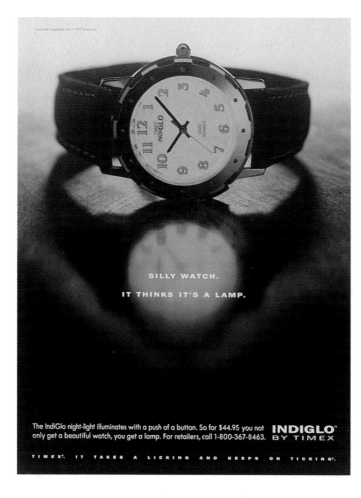

SILLY WATCH.

IT THINKS IT'S A LAMP.

The IndiGlo night-light illuminates with a push of a button. So for $44.95 you not only get a beautiful watch, you get a lamp. For retailers, call 1-800-367-8463. **INDIGLO** BY TIMEX

TIMEX. IT TAKES A LICKING AND KEEPS ON TICKING.

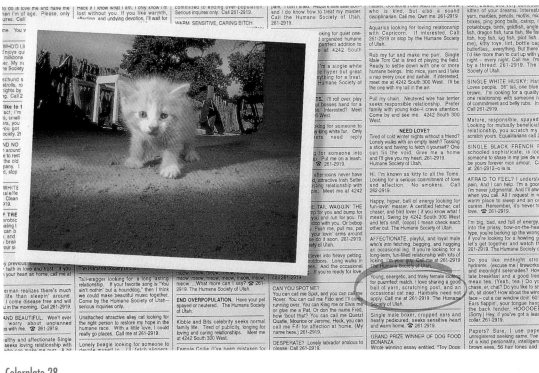

Colorplate 28

Ad, 1993

Agency: EvansGroup,
Salt Lake City, Utah
Art director: Steve Cardon
Writers: John Kinkead, Rebecca
Bentley-Mila, Bryan DeYoung
Photographer: Chip Simons
Client: Humane Society of Utah

Do we drive our mechanics too hard?

Colorplate 29

Ad, Volkswagen

Agency: BMP DDB Needham,
London, England
Art director: Mark Reddy
Writer: Tony Cox
Photographer: Andreas Heumann
Client: V.A.G.(United Kingdom)
Limited

SURPRISE YOUR WIFE.

BERNIE'S TATTOOING

Colorplate 30

Poster, Bernie's Tattooing, 1990, 1991, 1992
Agency: The Martin Agency, Richmond, Va.
Art director: Jelly Helm
Writer: Raymond McKinney
Client: Bernie's Tatooing

"Surprise your wife" was inspired by a picture in a tattoo magazine. The model was featured in the publication.

Raymond McKinney

Colorplate 31

Ad Campaign, "It Hits Home," 1992
Agency: DMB & B, St. Louis, Mo.
Creative director/writer: Steve Fechtor
Art director: Vince Cook
Photographer: Scott Ferguson
Client: The United Way

We tried to make the posters poignant. We felt the copy had to be read and dwelled on, so we dropped the visuals behind the words. The effect was dream-like, as if the images were reminiscences in the mind of the person who had suffered. It must have worked, because more than one person got choked up when they read it.

Vince Cook

Your father dies of a heart attack at the age of 54. You loved him. And you miss him. And you hate him for leaving you so suddenly.

But he's gone. So you grieve. And life goes on.

Then one day you're doing the dishes, and there's something about the way the soap suds look that makes you sob uncontrollably.

And even when the sobbing stops, it never stops in your head. So the dishes go undone. And the grass goes unmowed. And the kids go uncared-for. And the dog never gets let out.

Because you're spending all of your time in your room. In your bed. In the dark.

It happens. Just like that.

There are more than 200,000 cases of severe depression in St. Louis. You can help. Please give to your United Way. It hits home.

You're packing your bags, and you're loading the car, and you're moving out of your house. The kids try to help, but they're just in the way. And the baby is crying, and needs to be changed. And it looks like that last bag won't fit in the car. And all you can think of is, "What will we do with the goldfish?" Because you can't take it with you where you're going. Because you don't know where you're going. Because you once had a husband, who had a job, that paid the mortgage, and fed the kids. And now, you don't.

It happens. Just like that.

There are more than 8,000 homeless people in the St. Louis area. You can help. Please give to your United Way. It hits home.

Colorplate 32
Ad, Comfort "Cactus"
Agency: Ogilvy & Mather London Ltd.
Photographer: Peter Rauter
Client: Lever Bros. Ltd.

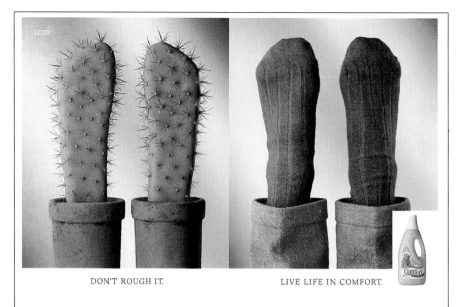

DON'T ROUGH IT. LIVE LIFE IN COMFORT.

Colorplate 33
Ad campaign, 1992
Agency: GGT Advertising, London, England
Creative team: Kate Stanners, Tim Hearn
Typography (Specially Cut Typeface):
Len Cheeseman
Photographer: John Parker
Retoucher: Lifeboat Matey
Client: Lurpak Butter

Colorplate 34
Rollerblade Ad, 1991
Agency: Carmichael Lynch, Minneapolis, Minn.
Creative directors: Kerry Casey, Jack Supple
Art director: Jeff Terwilliger
Writer: Kerry Casey
Photographer: Peter Stone
Photo courtesy of Rollerblade, Inc.

Figure 9-8
Software Packaging System
Design firm: Clement Mok designs, Inc., San Francisco, CA
Art director: Clement Mok
Designers: Clement Mok, Mark Crumpacker
Illustrator: Ron Chan
Client: Macromedia, San Francisco, CA

Figure 9-9
Packaging System for OmniPage OCR-Software, 1989
Design firm:
Clement Mok designs, Inc., San Francisco, CA
Art director: Clement Mok
Designer: Chuck Routhier

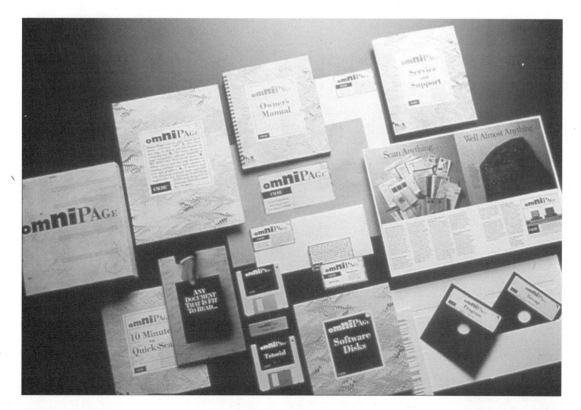

Shopping Bags

Most people will use a shopping bag more than once, especially people who are environmentally conscious. The more unique and attractive a bag, the more likely consumers will use it over again. Think of a shopping bag as a portable store display.

There are no standard sizes for shopping bags, and although paper and plastic is used most often, other materials are suitable, such as cotton or burlap. The main thing to remember is aside from being attractive, a **shopping bag** must be functional—it must hold things. Bags often are designed in several sizes; proportions should be considered in relation to function and aesthetics.

Your choice of materials, your design of the bag, and what is on the bag all should be dictated by the design concept. Often, a shop-ping bag is part of a larger marketing strategy and is linked to other graphic design materials, like boxes, packaging, signage, or displays. If this is the case, the designer must coordinate everything in terms of design concept, style, colors, visuals and type. In this design for Springer's, a complete visual identity was created (See Figure 9-10).

Art director Nancye Green and designer Eileen Boxer created shoeboxes and bags that are identical in surface design in this packaging system for Polly Bergen Shoes (See Figure 9-11). This bag, Body, Mind, Soul, for Natural Organics Inc., a holistic center, cafe, health food store, and New Age bookstore, is part of an identity system, a large graphic design plan (See Figure 9-12). Ellen Shapiro's hand-lettering is bold; the stacked words and the design of the letters create monumental, architectural shapes.

Figure 9-10
Corporate Identity, 1990
Design firm: Carbone Smolan Associates, New York
Designer: Ken Carbone
Client: Springer's

A retailer's identity has to capture the variety and strength of the company while conveying a distinct image to its target audience. When John and Judy Springer came to us for an identity for their three-year-old company, they needed a high profile image that would reflect their broad selection of classic, upscale fashions without signaling one designer or trend. This singular image had to be created within a modest budget.

Our solution was to create a comprehensive program of signature graphics for Springer's, including a logotype, advertising, signage, and packaging, which gives the business a distinctive place in the market. The Springers' investment in design has been a valuable investment for the future of their business.

Leslie Smolan, Carbone Smolan Associates

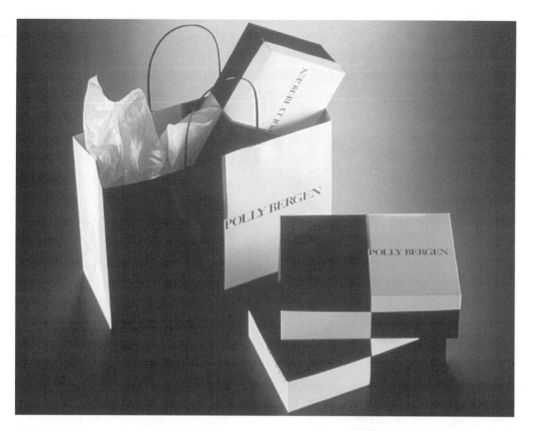

Figure 9-11
Packaging Design System, Polly Bergen Shoes
Design firm: Donovan and Green, New York, NY
Art director: Nancye Green
Designer: Eileen Boxer
Photographer: Amos Chan
Client: Polly Bergen Incorporated, New York, NY

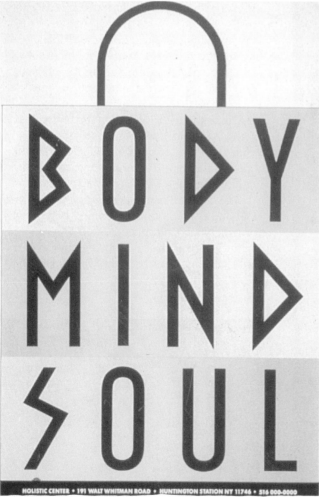

Figure 9-12
Identity Program/Shopping Bag,
Body, Mind, Soul, 1989
Design firm: Shapiro Design Associates Inc.,
New York, NY
Designer/lettering: Ellen Shapiro
Client: Natural Organics, Inc., Huntington, NY

Figure 9-13
"Dial Santa" Shopping Bags, 1980
Designer: Alan Robbins, New York, NY
Client: New York Telephone

Figure 9-14
Shopping Bag, F. Schumacher & Company, 1989
Design firm: Designframe Incorporated,
New York, NY
Designer: James Sebastian
Client: F. Schumacher & Company

Sometimes, companies issue shopping bags around holiday times or in honor of special events. "Dial Santa" is the subject of this shopping bag designed and illustrated by Alan Robbins (See Figure 9-13). Visual textures can be very appealing in packaging and display items like shopping bags. Designframe Incorporated created a special shopping bag to celebrate a centennial for F. Schumacher & Company (See Figure 9-14). The pattern and visual texture of the damask fabric is printed on the entire inside of the bag and overflows onto the top and front. Both the shape of the faux fabric at the top and the type running across the bottom act like a frame for the central rectangle.

The SullivanPerkins design firm created two bold and contemporary shopping bag designs for malls (See Colorplate 20 and Figure 9-15). Figure 9-15 was designed in celebration of the thirty-year anniversary of the Cherry Hill Mall.

Figure 9-15
Shopping Bag, Cherry Hill Mall, 1990
Design firm: SullivanPerkins, Dallas, TX
Art director: Ron Sullivan
Designer: Jon Flaming
Writer: Mark Perkins
Client: Cherry Hill Mall

For its 30th anniversary, Cherry Hill Mall asked us for slogans (More Together Than Ever) and an advertising campaign. These bags picked up the theme of the advertising campaign, which declared that the mall and its community were closer to each other more than ever after 30 years.

SullivanPerkins

Suggestions

The logo or company name need not be the main visual on a bag. Anything can work as long as it is a sound design concept. Here are objectives to keep in mind when designing a shopping bag:

- to design a bag that is easily folded

- to design a sturdy bag with handles

- to consider all sides of the bag in the design

- to create a pleasing, interesting, functional shape

- to coordinate it with any other graphic design material in the visual identity system

- to express the store or company's spirit or personality

- to think of it as a promotional display

Comments

When you create a package for a food or beverage, it must be visually appetizing. Your objective is to create an attractive, functional, and legible design. Since the products are of gourmet quality, the packaging should look upscale. Make sure the line of packages has a similar style, that they look like they belong to the same group, and that they have similar distinctive characteristics. Consider how they will look next to one another on the shelf and next to the competition.

Tips on how to invent a product name:

- The name should be appropriate for the client's product or service.
- The name should communicate the client's spirit or personality.
- The name should be memorable and creative; that is, different, cutting edge, fresh, funny, sweet, clever, colorful, or whatever makes sense for the client.
- The name should convey what is different or special about the product or service.
- Think about using metaphors or similes.
- Brainstorm all words and things related to the product or service. Categorize the brainstorming list. Choose one in each category. Write three or four variations on each.

Exercise 9-1
Redesign a Package

1. Choose a low-priced (not the top of the line brand) packaged product, like a box of pasta or a package of cookies.
2. Analyze the package design.
3. Redesign the package so it looks expensive or upscale.

Project 9-1
Create a Package Design for a Gourmet Beverage

Step I
1. Choose a line of gourmet coffees or teas, or invent one.
2. Research the product line and similar products.
3. Find examples of gourmet coffee or tea packaging.
4. Write an objectives statement. Define the purpose and function of the packaging, the audience, and the information to be communicated. On an index card, write two or three adjectives that describe the line. Keep this card in front of you while sketching.

Step II
1. Design a minimum of two packages for a line of gourmet ground coffees or teas.
2. The packages should include the following information: logo, brand name, and flavor.
3. You may use an existing company logo (for a company that makes this type of beverage) or design a logo. (See Chapter 6 on logo design.)
4. Your solutions may be type only or type and visuals.
5. Produce at least twenty sketches.

Step III
1. Produce at least two roughs for each package before creating a preliminary mock-up (a three-dimensional piece).
2. Create a preliminary mock-up of one package to see how it will look in three-dimensions. **Optional:** Design an individual packet for a tea bag or coffee bag.

Step IV
1. Create a finished mock-up for each package.
2. The size of the package should be similar to the sizes of other products in its category.
3. You may use two colors or full-color .

Presentation
Create actual size mock-ups of the packages.

Comments

You should carefully consider your subject and audience; a package designed for a game would be markedly different than one for spreadsheets. Similarly, different types of computer games might appeal to different audiences and therefore would be designed differently—for example, adventure games versus word games.

Project 9-2

Create a Package Design for Computer Software

Step I

1. Choose a software program or font package.

2. Research it. Use it if possible.

3. Write an objectives statement. Define the purpose and function of the software, the audience for it, and the information to be communicated. In one sentence, explain what the software does.

Step II

1. Design a package for the software.

2. The package should reflect the nature of the software.

3. Design a logo for the product or company. (See Chapter 6 on logo design.)

4. You may use type only or type and visuals.

5. Produce at least twenty sketches.

Step III

1. Create two roughs.

2. Create one preliminary mock-up to see how it looks.

Step IV

1. Create a finished mock-up.

2. The size should be standard for software packaging.

3. You may use as many colors as you like.

Presentation

Create an actual-size mock-up.

Comments

Whichever type of specialty company you choose, make sure the design concept is appropriate for the potential audience. You should try to avoid visual clichés, for example, type for a Chinese food store does not have to look like type from the Far East. Sometimes using unexpected type or visuals, or making a connection between unusual elements, makes something unique. Note: Although most design solutions can be executed on the computer and printed on a laser printer, some projects require hand skills, for example, cutting, gluing, and building. It is important not to loose touch with hand skills.

Exercise 9-2

Analyzing Shopping Bag Design

1. Find five examples of shopping bags for specialty stores.
2. Analyze their designs: figure out the designer's objectives and design concept.

Project 9-3

Design a Shopping Bag and Box for a Food Store or Company

Step I

1. Find or invent a specialty take-out food or catering company.
2. Research your client. Find out what makes them special or different.
3. Write an objectives statement. Define the purpose and function of the bag and box, the audience, and the information and image to be communicated. On an index card, describe the image of the company or store in two adjectives.

Step II

1. Design a shopping bag and box for a specialty take-out food or catering company.
2. Design a logo for the client. (See Chapter 6 on logo design.)
3. Your solution may be type only or type and visuals.
4. Produce at least twenty sketches.

Step III

1. Produce at least two roughs.
2. Create one preliminary mock-up to see how it will look.

Step IV

1. Create mock-ups of the bag and box.
2. Use as many colors as you like.
3. The maximum size for the bag is 16" x 18". The box should easily fit in the bag.

Presentation

Create actual size mock-ups of the shopping bag and box.

Chapter 10
Visual Identity

Objectives

▪ to comprehend the meaning of a plan that coordinates every aspect of graphic design material

▪ to understand the objectives of a visual identity system and its component parts

▪ to be able to design a visual identity system

Visual Identity

When your local department store mails announcements to you about sales and special offers, they also are sending messages to you about the type of store they are and the type of customer they aim to please. The design of their logo, stationery, brochures, mailers, and shopping bags, product identification, and their own brand labels are all part of a larger plan. That plan is a **visual** or **corporate identity** system or program—a master plan that coordinates every aspect of graphic design material.

A visual identity system integrates every aspect of a company's graphic design including typography, color, imagery, and its application to print and television. Continuity must be established among the various designs in a visual identity system. There must be a "family resemblance" among the designs. Of course, you can have a certain level of variety and still maintain visual unity. The identity and graphics system for the International Design Center of New York, 1983-1989, includes graphics, invitations, publications, advertising, and signage (See Colorplate 21). Vignelli Associates used Bodoni type and a limited color palette emphasizing black and red.

Most designers prepare a **graphics standard manual** that guides the client in the use of the identity system detailing the use of the logo, colors, and other graphics and imagery. This may seem stringent and restrictive, but it demonstrates just how crucial graphic design is to a client's image and success. Richard Danne was

Suggestions

Creating a visual identity system is an extensive design project and you will need a list of criteria to keep in mind. Your objectives are:

- to coordinate all of a company's graphic design material

- to establish an image for the company

- to express the personality or spirit of the company

- to create an appropriate design for the client

- to create a system that is flexible enough to work in a variety of applications

- to create a system with a long life span

- to create a system immediately identified with the company

- to create a system that will stand up against the competition

design director of the visual identity program for the National Aeronautics and Space Administration, Washington, D.C (See Figure 10-1). A

Figure 10-1
NASA Graphics Standards Manual
Design firm: Richard Danne & Associates Inc., New York, NY
Design director: Richard Danne
Client: National Aeronautics and Space Administration, Washington, D.C.
Material supplied by Richard Danne & Associates Inc.

A United States Government Agency dedicated to aeronautics research and space exploration, NASA is headquartered in Washington, D.C., with ten individual centers across the nation.

In 1974 the firm of Danne & Blackburn Inc. was selected to develop and design a unified visual communications program for the agency. The acronym NASA was more recognizable than either the full name or its previous symbol. Building on this, the NASA logotype was developed. A system was devised that incorporates the logotype and sets standard configurations for the full agency name and the various centers.

This program was honored in 1985 with one of the first Presidential Awards for Design Excellence from President Reagan.

Richard Danne, Richard Danne & Associates

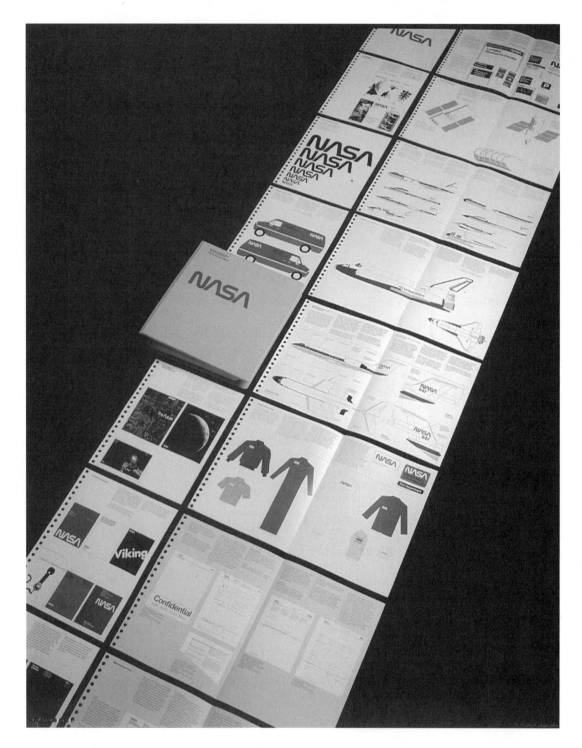

comprehensive 110-page graphic standards manual was developed, designed, and written that included paint schemes for aircraft, the Space Shuttle, and other space vehicles as well as graphic systems for all publications, signage, forms, and media.

When designing an identity system, you must know your audience. Clearly, this identity system developed for Levi's SilverTab Jeans is aimed at a young audience (Figure 10-2). The models' poses, the use of patterns, collage, photomontage, and the contemporary typography all work together, contributing to the hip spirit of the visual system.

This corporate and brand identity and product packaging for Food Services of America communicates a high level of quality and service (See Colorplate 22). The design is made up of a "kit of parts" that allows it to be reproduced in a variety of methods on a variety of surfaces.

The elegance of The L S Collection of fine

Figure 10-2
Levi's SilverTab Graphic Identity System
Design firm: Michael Mabry Design,
San Francisco, CA
Advertising Agency: Foote Cone & Belding
Client: Levi's

Indianapolis Museum of Art

Figure 10-3
Graphic Identity Program,
Indianapolis Museum of Art, 1991
Design firm: Richard Poulin Design Group Inc.,
New York, NY
Art director/designer: Richard Poulin
Designers: Kirsten Steinorth, Debra Drodvillo
Client: Indianapolis Museum of Art, Indianapolis, IN

Richard Poulin Design Group, Inc. developed and designed a comprehensive design program for the Indianapolis Museum of Art to coincide with the recent expansion of the museum's facilities. It was a rare opportunity for our firm to not only develop a new graphic identity but also to establish graphic and sign standards for the entire complex.

The project included the development and design of all architectural graphics and sign elements, exterior banners and site signs, stationery, brochures, a monthly magazine, promotional print materials (including formats for a calendar of events, membership, tourism and education brochures, etc.), shopping bags, and exhibition interpretive graphics for the museum's major collections.

The fine arts museum is located on a 152-acre parklike site in the city of Indianapolis. The facility itself is comprised of the Eli Lilly Botanical Garden, four art pavilions—including the newly constructed Mary Fendrich Hulman Pavilion, designed by Edward Larrabee Barnes/John M.Y. Lee & Associates of New York—a lecture hall, theater, concert terraces, restaurants, and shops.

Richard Poulin, President

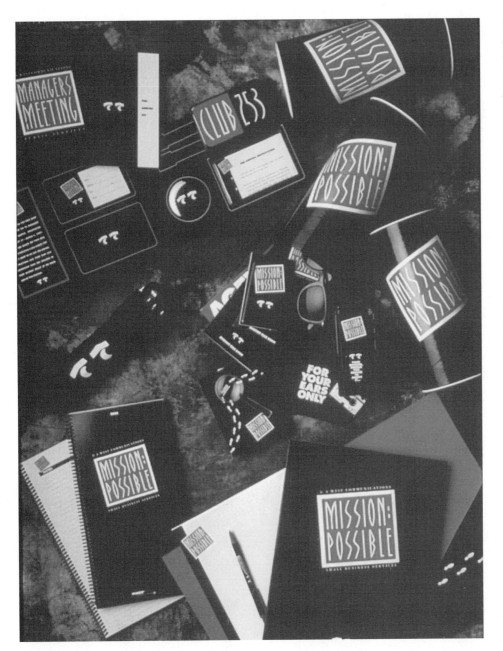

Figure 10-4
Graphic Identity System,
"Mission: Possible," 1991
Design firm: Vaughn Weeden Creative, Inc.,
Albuquerque, NM
Designers: Steven Weeden, Lisa Graff
Client: U.S. West Communications, Phoenix, AZ
Courtesy of Vaughn Weeden Creative, Inc.

The identity created for a four-day manager's meeting was extremely successful because of the "palette" of design elements used: typeface (hand-rendered), color scheme, "Spy eyes," and type treatment outside of the logo. This enabled us not only to create a theme but also helped us in that it was simple enough to produce quickly. Corporate events can be invigorating or stable; this meeting was very successful because of a mood that was created through our design. This proved how important graphics can be in setting a tone. What is seen here is only a sampling of materials used; other materials included audio-visual, signage, theatrical themes, and apparel.

Holly Dogget, Vaughn Weeden Creative, Inc.

objects for the home is expressed through James Sebastian's minimalist use of type, choice of textured paper, exquisitely lighted photography, and of course, layout (See Colorplate 23).

For the corporate identity created for the Hotel Hankyu (See Colorplate 24), Pentagram Design developed a system of six stylized flower symbols, a custom alphabet, a coordinating color scheme, and decorative motifs. The program expresses luxury by differentiating each item in the hotel with special detailing. Applications include signage, room folders, stationery, labels, menus, and amenity packages for male and female guests.

The identity system for the Indianapolis Museum of Art, by the Richard Poulin Design Group, Inc., is comprehensive (See Figure 10-3).

Designing an identity system for a museum poses a unique problem. Creating something aesthetically pleasing is crucial—you have to assume that museum-goers are more visually astute than the average audience.

Here are two very different examples of creative solutions. The "Mission: Possible" graphic identity system is bold with great value contrast (See Figure 10-4). The "Mission: Possible" logo is the focal point of the design—it is large and in red and white on a black ground. The "Z" in the menu design and graphic identity system for Z Contemporary Cuisine is the focal point (See Colorplate 25). Although there are several interesting variations of the "Z", its use as the focal point maintains an identifiable image.

Figure 10-5
Corporate Identification Program, W.R. Grace & Company
Design firm: George Tscherny, Inc., New York, NY
Designer: George Tscherny
Photography: John T. Hill
Client: W.R. Grace & Company, New York, NY

The Grace graphics program was started in 1973, and, unlike many corporate design programs that lose acceptance within a company or deteriorate for other reasons, this program has continued to expand.

During the early stages, the emphasis was on establishing and monitoring graphic standards in architectural graphics, stationery, vehicle identification, advertising, and so on, primarily for the parent company.

Now the focus is on bringing subsidiary companies, such as Herman's sporting goods stores or Cyovac, which had previously not been recognized as Grace owned companies, into the program.

George Tscherny

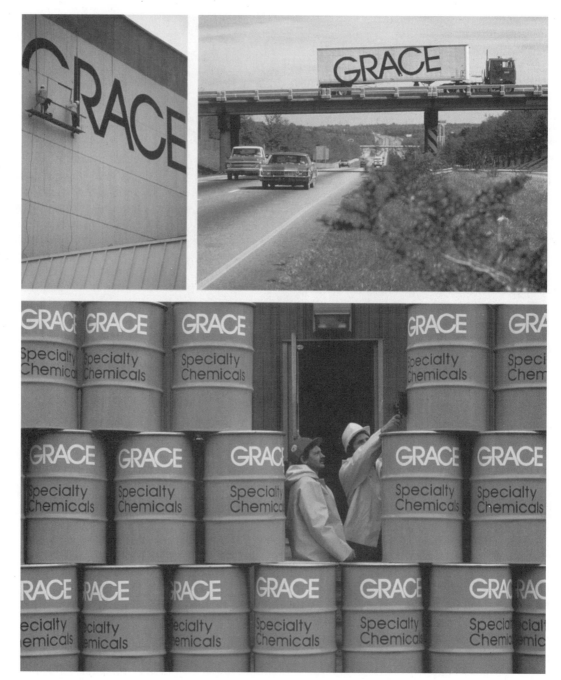

Compare these visual identity systems for W.R. Grace & Company, a specialty chemicals company, and Öola Corporation, a chain of Swedish candy stores located in American shopping malls, to understand the range of visual identity systems (See Figure 10-5 and Colorplate 26). The design for W.R. Grace, by George Tscherny, is dignified in its use of legible, well-proportioned type; it projects an image of reliability and seriousness. On the other hand, the shapes and colors in the design for Öola, by Paula Scher, project a fun-loving and playful image. Without being illustrative, its colorful positive and negative shapes almost look edible—like candy.

Some of the basic applications for a visual identity system are logos, stationery, packaging, covers, editorial materials (folders, brochures, newsletters, annual reports), advertising, posters, signage, promotionals, invitations, and shopping bags.

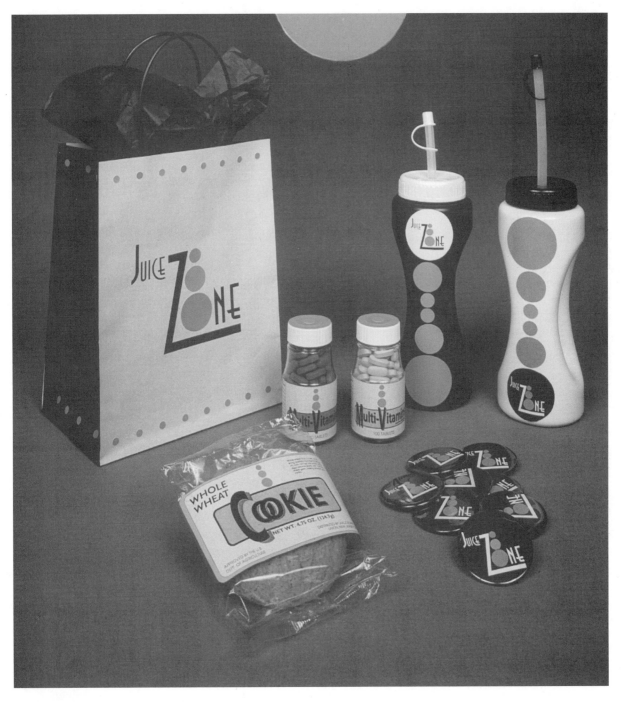

Figure 10-6
Visual Identity System, "Juice Zone," 1993
Designer: Mair Lewandowski
Photographed by Tony Velez

Comments

The foundation of the identity system is usually the logo. Your logo should establish the store's image and express its personality; it should also be flexible enough to be used in a wide variety of applications, such as packaging and store promotion. All the other pieces should continue in the same direction as the logo; they should enhance the store's image, making their products seem unique and superior to the competition. This project allows you to create a comprehensive identity for a store—from its marketing strategy to its packaged goods. It demonstrates your ability to be consistent yet creative.

This is a difficult and involved assignment. It demonstrates to potential employers your ability to formulate a strategy and design concept and follow it through with several design applications. The experience and knowledge gained here can be applied to any identity system. If your solution to this project is successful, it could be one of the most important pieces in your portfolio.

Designing a logo, or an entire visual identity system, is a creative activity, but do not forget the bottom line. To persuade, identify, and inform—these are the goals of the graphic designer. If you can create a design that communicates to a mass audience and is aesthetically pleasing and creative, you are designing.

This is a multi-faceted project. Once you have completed it, keep going. Do variations on it. Create another visual identity system for a different type of business. (See Figures 10-6 through 10-8)

Exercise 10-1
Identifying a system

1. Find an example of a visual identity system.

Project 10-1
Designing a Visual Identity System for a Health Food Store

Step I

1. Invent a name for a health food store, market, or cafe. Try to be creative with the name (it does not need to have the word "health" in it). For example, "Eat Your Veggies" or "The Green Zone." Decide on the type of health food store it will be (general, specialized, discount, exotic, high-tech, family-run, part of a chain, upscale). Figure out what makes your store special, what sets it apart from the others. Where would your store be located—in a mall, a strip mall, or on a neighborhood street?

2. Work on your strategy. Who is the audience? What is the competition and marketplace? What products are sold there? What is the interior design of the store like? What kind of atmosphere does it have? What is your store's image? Identify key descriptive words.

3. Write an objectives statement.

4. On an index card, write one sentence about the store using two adjectives to describe it.

Step II

1. Design a logo for the store. Be sure to use your objectives statement and your strategy. (See Chapter 6 on logo design.)

2. Design stationery consisting of a letterhead, envelope, and business card. Include store name, address, telephone and fax numbers, and manager's name. (See Chapter 6 on stationery design.)

3. Design a store brand for packaged goods. Your designs must be consistent—you are creating an identity for the store.

4. Design at least two packages, for example, a box for pasta and a bag for chips. The logo must appear on the packages. (See Chapter 9 on package design.)

5. Design a shopping bag. (See Chapter 9 on shopping bag design.) **Optional:** Design at least one other promotional or informational item, for example, a menu, a mailer, a poster, a T-shirt, a calendar, a mug, a calorie or food chart, or a water bottle.

6. Produce at least twenty sketches for each design problem.

7. You may use black and white or color.

Step III

1. Refine the sketches and create two roughs for each design problem, the logo, stationery, packages, and shopping bag.

Step IV

1. Refine the roughs and create one comp for each design problem.

Presentation

The stationery (letterhead, envelope, and business card) should be matted or mounted on one 11" x 14" board and the logo on a separate 11" x 14" board. Create mock-up packages and build the shopping bag with handles. (Make sure you can fold it.)

Figure 10-7
Visual Identity System,
"Eat Your Veggies," 1993
Designer: Melanie Decker
Photographed by Tony Velez

Figure 10-8
Visual Identity System, "The Fodder Hangar," 1993
Designer: Colin E. Fuchs
Photographed by Tony Velez

Chapter 11
Advertisements

Objectives

▌ to understand the purpose of advertising

▌ to learn how to create an advertising concept, and to design and write a print advertisement

▌ to learn how to create an advertising campaign

▌ to learn how to create a storyboard

▌ to understand the role of the creative team

▌ to be able to distinguish different types of advertisements

▌ to learn the elements and components of an advertisement

▌ to understand creative expression

▌ to explore creative approaches

Advertising is all around us. We are surrounded by outdoor boards, bus and train posters, bombarded with television commercials, inundated with direct mail and print advertisements. They tell us what to eat and drink, what to wear, who to vote for, and where to go on vacation. Advertising is part of daily life—it is everywhere. It also is an integral part of commerce and is inseparable from American popular culture. Advertising brings commerce, mass media, and design together to create a unique popular art form.

Figure 11-1
Ad, 1992
Agency: Folis DeVito Verdi, New York, NY
Creatives: Sal DeVito, Rob Carducci, Arri Aron
Client: Daffy's

Objective: To do something fun and different for an otherwise forgettable holiday.

Julie Rosenberg, Account Executive, Folis DeVito Verdi

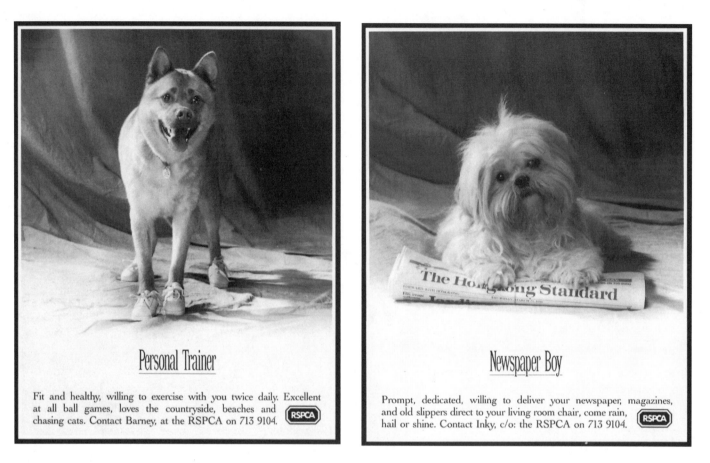

Personal Trainer

Fit and healthy, willing to exercise with you twice daily. Excellent at all ball games, loves the countryside, beaches and chasing cats. Contact Barney, at the RSPCA on 713 9104. **RSPCA**

Newspaper Boy

Prompt, dedicated, willing to deliver your newspaper, magazines, and old slippers direct to your living room chair, come rain, hail or shine. Contact Inky, c/o: the RSPCA on 713 9104. **RSPCA**

Figure 11-2
Print Campaign, RSPCA
Agency: Backer Spielvogel
Bates/ Hong Kong
Art director: Philip Marchington
Writers: Paul Regan, Rowan
Chanen
Photographer: Kevin Orpin
Client: RSPCA

We are so used to seeing television commercials and print advertisements in magazines and newspapers that we forget the powerful effect they have on us. Advertising is designed, and often intended, to inform, persuade, provoke, or motivate. Advertising pushes us to buy things, calls us to action, and informs us about products, services, people, events, and causes.

How do the advertising professionals create effective ads? How do they create fresh ads that will break through the clutter and entice the consumer, or as Creative Director Tom McElligott says "...get through to the consumer in ways they haven't been gotten to before"? Let's see.

What's in it for me? This is what a potential consumer wants to know. Will this product or service make me happier, healthier, richer, more attractive, get me where I want to go, or make my life easier? The potential consumer wants a benefit and an ad should clearly communicate one. Whether the ad lets the viewer know that he or she saves money (See Figure 11-1) or finds the perfect dog (See Figure 11-2)—there has to be a benefit or the consumer will not be drawn in.

The client also wants a benefit. Advertising is a vehicle the client uses to increase sales, influence voters, promote causes, obtain contributions, and so on. Advertising is used in a free market system to promote one brand over another. Advertising sells things. Therefore, an ad should make you believe the product or service being advertised is superior to its competitors. Most competing brands are parity products and services, meaning they are equivalent in value. For example, even though many people prefer one cola beverage to another, most colas are the same. Cola beverages are one example of parity products. On the other hand, some products have a unique selling point or unique selling advantage (USP or USA), something special about a brand that the competition does not have.

Timex watches have a unique selling point—INDIGLO© night-lights illuminate the dial with the touch of a button (See Colorplate 27). The Eveready Battery Company's USP for this product is a lifetime replacement warranty for its batteries. Using a familiar phrase about rock and roll, this ad points out this product's USP (See Figure 11-3).

If the client does not benefit from advertising, there is no reason to advertise. A leading health care products manufacturer discovered through market research that advertising did not affect sales of dental floss—so it stopped advertising that particular product. For thousands of other products and services, advertising does promote sales.

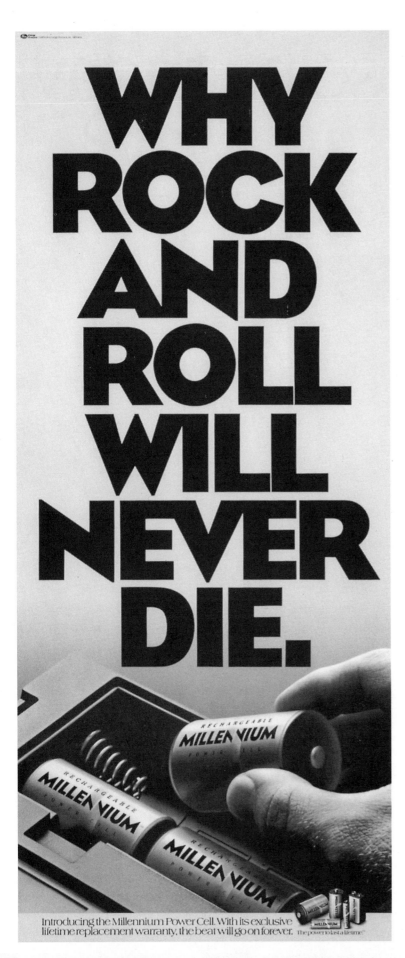

Figure 11-4
Ads
Agency: Fallon McElligott, Minneapolis, MN
Art director: Nancy Rice
Writer: Tom McElligott
Client: Church Ad Project
(See also p. 199)

Whose birthday is it, anyway?

The Episcopal Church believes the important news at Christmas is not who comes down the chimney, but who came down from heaven. We invite you to come and join us as we celebrate the birth of Jesus Christ.
The Episcopal Church

In advertising, **the creative team** is comprised of an art director and a copywriter. They are the people who create the ads. The **art director** is responsible for the art and design decisions, and the copywriter is responsible for the writing. Together they develop the idea behind the advertisement. The creative team usually is supervised by a **creative director** who makes the ultimate decisions about both the art direction and the copywriting. The creative team hopes

You shouldn't have to go through channels to talk to God.

If you believe there ought to be more to God
than a flickering image interrupted by commercials, join us as we worship
and discover the joy of God together in the Episcopal Church.
The Episcopal Church

their ads will benefit the client; if the client's profits do not increase, the client may switch to another ad agency or stop advertising. If the client does profit because of the ads, the agency may make more money and attract more or better accounts. The creative team also aims to create an ad that is aesthetically pleasing, interesting, provocative, or perhaps innovative—an ad that will squeeze through the competition and media glut and get to the potential audience. They want to create an ad that will be noticed—one that might even win awards from their peers. The creative team of Nancy Rice and Tom McElligott has won numerous awards for its creative ads. Their ads tend to take surprising approaches, as do these for the Church Ad Project (See Figure 11-4 pp. 198 and 199).

Sometimes an ad may win awards and gain

Figure 11-5
Ad, Albany Life
Agency: Lowe Howard-Spink,
London, England
Art director: Andy Lawson
Writer: Adrian Holmes
Photographer: Jimmy Wormser
Client: Albany Life Insurance

The one on the left has claimed more victims.

A nice, comfy floral-patterned armchair? What possible harm could that do to anybody?

According to the latest medical opinion, the answer is plenty.

The people at risk, we're told, are the retired (and nowadays that can mean mere youngsters of 55 or so).

They've worked hard all their lives. Now they feel they deserve to take things a bit easy.

Quite right, too.

The trouble begins when taking things easy turns into lazing in an armchair all day.

Too many naps, too many snoozes, and the body can suddenly decide it's simply not worth waking up again.

The message from the doctors is loud and clear. Don't just sit there. Do something.

Opt for an active retirement, in other words.

You're always daydreaming about the things you wish you'd done with your life.

This will be your chance to do them.

Go ahead, build your ocean-going catamaran. Start up your vegetarian restaurant on Skye. Open that donkey sanctuary in Wales.

There'll be nothing to stop you.

Except money, of course.

And that is why you should be talking to Albany Life.

Not later on in your career. But right now, in your thirties or forties.

Start putting a regular sum into one of our high-growth savings plans and you can build yourself a very nice wodge of capital indeed.

We'll collect every penny of tax relief due to you. We'll then lump the two sums together and invest them on your behalf.

And our investment advice is arguably the best there is.

We retain the services of none other than Warburg Investment Management, a subsidiary of the merchant bank S. G. Warburg & Co. Ltd.

If you'd like to hear more about our retirement savings plans, post off the coupon.

We'd hate to see you sitting in a chair just because you couldn't afford to do anything else.

To learn more about our plans, send this coupon to Peter Kelly, Albany Life Assurance, FREEPOST, Potters Bar EN6 1BR.

Name
Address
Tel:
Name of your Life Assurance Broker, if any.

Albany Life

recognition from the advertising community, and still not meet the client's needs. Great design does not necessarily translate into sales. There can be many reasons for this: the ad may have been too esoteric; the timing may not have been right; the product or service may have been positioned incorrectly; and countless other predictable and unpredictable reasons. For example, Reebok positioned its shoes as fashion footwear in the extremely creative "Reebok lets UBU" campaign. Unfortunately, sales dropped. It seemed that people who bought Reebok athletic shoes preferred not to think of them as fashion footwear.

Two painkillers nurses should have
on them at all times.

It's hard to be an angel of mercy when your feet hurt like the devil. So we've created an entire line of stylish and durable nurse's shoes, such as the Westbrooke pictured above. All with proven Hush Puppies comfort innovations like Bounce® technology and Body Shoes® featuring Comfort Curve® soles—designed to make walking easier. Two of these and you'll be back on your feet in no time.

Hush Puppies
PROFESSIONALS
For information call 1-800-433-HUSH.

Figure 11-6
Ad, Hush Puppies
Professionals
Agency: Fallon McElligott, Minneapolis, MN
Creative director: Pat Burnham
Art director: Bob Barrie
Writer: Mike Gibbs
Photographer: Joe Lampi, Dublin Productions
Client: Hush Puppies Shoes

Types of Ads

There are basically three major categories of ads: consumer, trade, and public service. Consumer ads are directed at the general public, for example, this ad for life insurance (See Figure 11-5). Trade ads are directed at specific professional or business groups. This ad for Hush Puppies pro-fessional shoes is aimed at nurses (See Figure 11-6). Public service ads are created for the public good, and include ads for charities, causes, and non-profit organizations. The Humane Society of Utah used a public service ad to encourage people to adopt pets (See Color-plate 28). Even profit-making companies will sponsor public service ads. This ad, sponsored

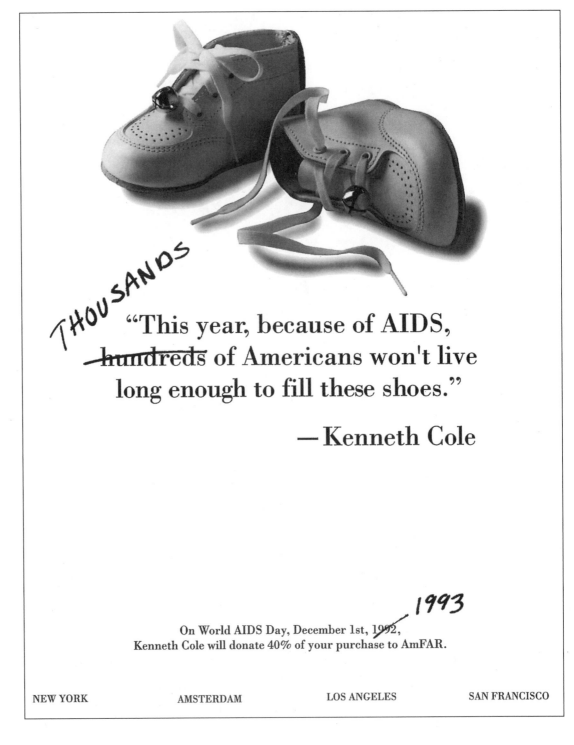

by Kenneth Cole shoes, is a fund raiser to benefit children with AIDS (See Figure 11-7), but its style corresponds to the company's retail ads (See Figure 11-8). Due to this similarity, the consumer is able to make a connection.

All of these types of ads may appear in **print**—newspapers, magazines, direct mail, posters, or outdoor board displays—or on television and radio. General interest or specialty newspapers and magazines, both local and national, usually carry consumer and public service ads. Trade or professional magazines, as well as other professional publications, tend to carry trade ads. Outdoor board (billboard) display is primarily used for consumer or public service advertising. Sometimes outdoor boards reinforce ads that we see in magazines and newspapers; other ads are created specifically for billboard displays. Hoping to attract outdoor advertisers, the Reagan Outdoor Agency

Figure 11-8
Ad, Kenneth Cole Shoes
Agency: Kenneth Cole In-House
Art director: Kerry Kinney
Writer: Leslie Herman
Client: Kenneth Cole Shoes

Figure 11-9
Billboard Sequence, 1992
Agency: EvansGroup, Salt Lake City, UT
Art director: Steve Cardon
Writer: Bryan DeYoung
Client: Reagan Outdoor Agency

This billboard message was produced by EvansGroup for Reagan Outdoor Advertising. The billboard was posted in June. Over the course of seven weeks, more and more mannequins were added each weekend until the board was full. The billboard was selected by the Outdoor Advertising Association of America as one of the three best billboards of 1992.

Steve Cardon, Art Director, EvansGroup

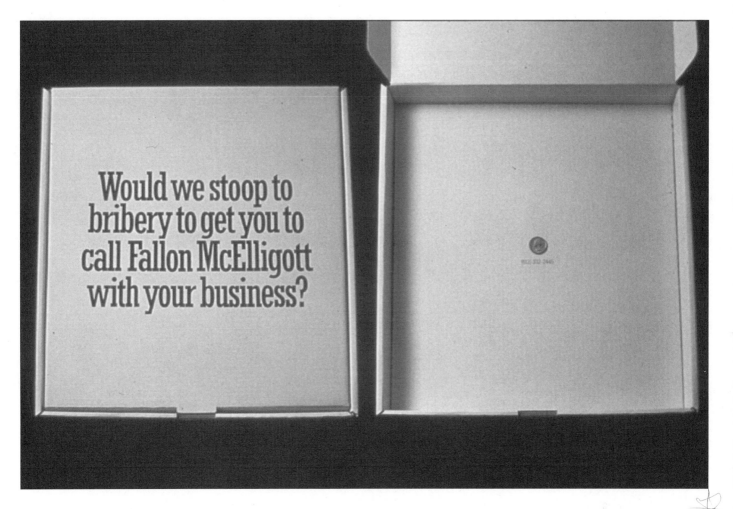

Would we stoop to bribery to get you to call Fallon McElligott with your business?

Figure 11-10
Collateral Direct Mail
Agency: Fallon McElligott,
Minneapolis, MN
Art director: Tom Lichtenheld
Writer: Luke Sullivan

used a clever and unusual outdoor board sequence (See Figure 11-9).

Rather than renting space in a magazine or newspaper or on a billboard, an advertiser may send an ad directly to you, which is called **direct mail.** The ad may be in the form of a brochure, a calendar, a package, or any other publication or piece that will catch your attention. This unusual piece is by the award-winning agency Fallon McElligott (See Figure 11-10).

Usually, television commercials are either consumer or public service ads. Both local and national commercials appear on television. Ads are carefully placed on television to aim at the different consumer groups who watch different types of television programs. For example, situation comedies during prime time viewing hours (7:00 PM to 11:00 PM) appeal to families, and cartoons during morning hours on weekends appeal to kids.

How does one know which forum will be most effective? Several factors should determine where an ad is placed: whether the client needs a regional or national audience; whether there is a very specific audience; and cost effectiveness.

Elements of an Ad

Most ads consist of the following elements: a visual, a line, body copy, a claim, and a sign-off. In this ad for Timberland (See Figure 11-11), the line is: "What To Have On Your Feet When The Only Thing Dry Is The Heaves." The photograph of the ocean is the primary visual; the body copy is the text type. The sign-off is the product shot of the shoes, and the claim is "Boots, Shoes, Clothing, Wind, Water, Earth And Sky." The **visual** is the image, which may be a photograph, an illustration, graphics, typography, or any combination. The **line**, which many people refer to as the headline, is the main verbal message. It may be positioned anywhere on the page, not just at the head. The **body copy** is the narrative that further explains the advertising concept and may provide more information. The **claim**—also called the end line, tagline, or slogan—is the verbal message associated with a product or service and is in a campaign of ads. The claim establishes a theme and captures the spirit, quality, and benefit of the product or service being advertised. The strategy

WHAT TO HAVE ON YOUR FEET WHEN THE ONLY THING DRY IS THE HEAVES.

If you know the sea, you know there are days when nothing will stay down.

Not breakfast. Not lunch. Not even a rum and tonic. And certainly not the boat, which the ocean seems to be trying to upchuck. On such days the waves look like bile. No wonder they call it "blowing like stink."

In turbulence so extreme, there may not be a boat shoe on the face of the earth that can give the experienced sailor all

the protection, agility and traction he deserves. We'd like to introduce the one possible exception. A new class of performance boat shoes from Timberland. Shoes that are proving so superior to anything else in competitive trials we urge you to check them out.

What drives these shoes is a proprietary technology called the Interactive Grip System. So named for its ability to maximize slip resistance through the interaction of a radically advanced sole design with

the hazardous surface of a storm-tossed deck.

Let us explain, starting with the sole. It has such a profusion of siping (razor cuts for traction) that the number of leading edges exceeds the traction capacity of traditional soles by a good 50 percent. What's more, the edges

are clustered in a special quadrant cut pattern, a Timberland exclusive. This new cut so amplifies grip that any comparison with the traditional wave cut (a design almost three decades old) becomes a lopsided contest. Wave cuts are obsolete, period.

Part Two of the Interactive Grip System makes sure that your foot stays in the right place so the quadrant cut sole can do its work. Your foot is secured by an Internal Fit System, a contoured sleeve that keeps your toes from jamming when the boat makes a violent lurch.

All of which may leave only one place for your old boat shoes.

Dry land.

INTERACTIVE GRIP SYSTEM

Quadrant cut sole has 50% more leading edges than standard wave cut soles.

Quadrant cut exceeds wave cut for traction, providing 360° of grip.

Internal Fit System keeps foot in correct position for comfort, balance and grip.

Timberland

BOOTS, SHOES, CLOTHING, WIND, WATER, EARTH AND SKY.

© 1991 The Timberland Company. Timberland and ⊕ are registered trademarks of The Timberland Company.

Figure 11-11
Ad, 1991
Agency: Mullen, Wenhan, MA
Main visual: Stock photography
Courtesy of The Timberland Company

behind the sales pitch is usually revealed in the claim, for example, "Hey, you never know" for New York Lotto. The **sign-off** is the product or service's logo, a photograph or illustration of the product, or both.

Sometimes the visual, by itself, conveys the advertising concept, so there is no need for a line. Sometimes the line says it all and there is no need for a visual. For example, the Anti-Defamation League campaign created by the Earle Palmer Brown Agency is all type (See Figure 11-12). Sometimes the product is the visual and there is no need for a sign-off.

Four Components of an Ad

Advertising is different than other graphic design; it has the highest degree of persuasive intent. An ad must stimulate sales or motivate behavior. Words are important carriers of this kind of message; for this reason the art director works with a partner, the copywriter. In other areas of graphic design, where there are more formats, the designer usually is given the copy, and the design solution is not necessarily created to

directly stimulate sales. The four main components involved with the creation of a print ad are slightly different than those mentioned earlier in this text, in relation to other graphic design application. They are strategy, concept, design, and copy.

A strategy usually is provided to the creative team by the client or by the agency account manager (the liaison between the creative team and the client). Sometimes the creative team or creative director determines it. The **strategy** is the starting point; it determines who the potential audience is and how to position the product or service in the market and against the competition. As creative director/copywriter John Lyons puts it, "A strategy is a carefully designed plot to murder the competition."

The foundation of any successful ad is a concept or idea. The **concept** is the creative solution to the advertising problem. The concept is the foundation of the advertising message; it answers the question, **"What's in it for me?"** and promotes the benefit. An ad concept should be creative enough (and flexible enough for a campaign) to allow you to communicate a mes-

"I'm Not Prejudiced. I Just Don't Like ~~Him~~ Jews."

THERE'S NO EXCUSE FOR PREJUDICE.

"I'm Sorry, You're Not ~~Qualified~~ White."

THERE'S NO EXCUSE FOR PREJUDICE.

"She's Not My ~~Kind Of Person~~ color."

THERE'S NO EXCUSE FOR PREJUDICE.

sage, establish a benefit, aim at your audience, and possibly establish a unique selling point. The concept has to be clear enough that the advertising goal—motivation, persuasion, or information—is achieved.

Together, the design and copy (the visual and words) express the concept in a visual/verbal relationship. Hopefully, this is a synergistic relationship where the image and type work cooperatively to produce a greater effect than that of either part alone. This is called a seamless ad. Visual/verbal synergy is established in a creative ad for Volkswagen (See Colorplate 29). The headline and visual depend upon one another for the total ad message. Here is a way to test for visual/verbal synergy. Cover the visu-

Figure 11-12
Poster Series,
"Jews/White/Color"
Agency: Earle Palmer Brown,
Bethesda, MD
By permission of the
Anti-Defamation League

Suggestions

There are no hard and fast rules in advertising because it is a business that often breaks rules to get through to people. Some great professionals, like David Ogilvy, do suggest rules in their books, and they are very helpful. So let's put it this way—the novice needs some guidelines in order to know how to begin. Here are some suggestions that many students will find useful.

Concept Development

- Establish a benefit
- Limit yourself to one message per ad
- Avoid clichés both in visuals and words
- Have a social conscience—do not use racist, sexist, or biased ideas, visuals or words
- Be original, fresh, and innovative (as long as it makes sense for the concept)
- Tell the consumer something they did not know
- The visual and line should not repeat one another
- The ad should make sense—it has to be understood
- The ad should be believable; it should not sound like an empty sales pitch

Copy

- Write in plain, everyday, conversational language, not hype
- Do not use a thesaurus—the language probably will sound contrived
- Break copy lines in logical places; line breaks should echo breaks in speech
- Do not use the product's or service's logo as the headline
- Avoid poems or rhymes
- Avoid philosophical statements; keep it simple and natural
- Avoid one word lines—it is difficult to get an idea across in one word
- Do not use lines, claims, or body copy from existing ads
- Do not insult or talk down to the consumer
- Avoid two-part headlines—they tend to break the flow of the idea
- Check spelling and grammar
- Keep it short—most people prefer to look at visuals

Design

- Establish a visual hierarchy
- The line and the visual should not be the same size; they will compete for attention
- Experiment with page design; all your ads should not have the same layout
- Render in markers or use colored copies/scanned images (not pencil or paint)
- Generate type on a computer and check the letter and word spacing
- Ads should be either a single page (8.5" x 11") or a double page spread (11" x 17"), or in proportion to either of these
- Remember: Type has a voice.

The best way to learn the rules, even if only to break them, is to immerse yourself in advertising. Watch television commercials and look through magazines and newspapers. You might also subscribe to professional journals such as *Archive, Art Direction, Print,* and *Communication Arts,* or look at award annuals like *The One Show* or the AIGA's *Graphic Design USA.* You can learn a lot by being a critic and analyzing the ads you see while also becoming aware of current trends in design, copywriting, attitude, approach, and style. Do not copy what you see—analyze it.

al and read the line. Do you get the meaning of the ad? Now reverse it, cover the line and look at the visual. Is the ad message communicated? Now look at the entire ad. The message should be clear because of the cooperative action of the visual and verbal components.

The design or art direction is the visual part of an ad. Everything you have learned about the fundamentals of design and the principles of graphic space should be used to create a visual that expresses the concept, complements the copy, attracts the viewer, is aesthetically pleasing, is current (captures the spirit of the time), establishes a visual hierarchy, and is appropriate for the client. The design includes the main visual, the layout, the typography, the sign-off, the style, and the presentation.

The copy is the verbal part of the advertising message. It should express the concept while working cooperatively with the visual. It should be clearly written, easy to understand, and written in everyday language. The line, body copy, and claim should be unifed and based on a common strategy and concept. The language should be appropriate for the client. It is important to understand that the copy in an ad assumes a voice. The voice may be that of an authority, a maternal voice, the voice of science, or it may be the voice of a professional or the client's own voice.

The Creation of a Print Ad

Here is a short summary of the steps many students take in the creation of an ad.

The first step is research. Find out everything you can about your client's product or service. Try the product or service (if possible). Call the company to get more information. Ask people what they think of it. This step is quite important, but unfortunately many students do not take it seriously, because of a lack of experience, the naive belief that they already know everything, or plain old laziness. At any rate, this is not a step to skip. The more you know about your client's product or service and about the potential audience—the more solid your strategy and concept will be. Use the following questions as a point of departure for your research: What are the advantages of the product or service? Who is the audience, that is, who will use this product or service? What is the competition?

The second step is to develop a strategy to determine the benefit of your product or service, target the audience, and position your product or service in the market and against the competition. For example, let's say your product is

yogurt. You may claim that the benefit of eating this brand of yogurt is getting calcium in your diet. You may want to target adult women who tend to need more calcium in their diets. Since most yogurts contain calcium, an ad based on this feature would not reflect a unique selling point. If your yogurt contains added live yogurt cultures and the competition does not, then you may want to emphasize this unique selling point as the benefit and aim at a different audience. Once you have decided on a strategy, you may want to write the claim or tag line. Writing the claim at this step of the process may help you clarify your strategy.

The third step is to develop a concept. Here is where the creative process gets tricky. As Anthony Angotti, art director at Angotti, Thomas, Nedge, said when judging the best ads of the '80s for The One Show, "My judging criteria consisted of three things: concept, concept, concept." The concept should communicate a benefit and persuade potential consumers to buy your product or use your service.

The fourth step is to think of a line and visual that will express your concept. Make sure there is a cooperative relationship between the verbal and visual and that there is *one* clear message—*one* clear benefit. Your visual and line have to grab potential consumers and get them to notice your ad. Once they have noticed it, the ad must convince them that your product is better than the competition.

In the process of working, sometimes a visual comes to mind and you have to work at writing the line, or the line may come to mind quickly and you have to struggle for the visual. (See the section in this chapter on Creative Approaches for some ways to think about copy and visuals.) Some people say if a concept is really good it will generate (almost automatically and simultaneously) a visual and line that work as a unit. Do not be discouraged; it takes a long time to get the hang of it.

The fifth step is writing the body copy. This copy should relate to and enhance the overall concept, giving more information or pushing the benefit. If you have not written a claim yet, now is the time to do so. (If you have trouble writing a line, try writing the body copy first. You might be able to pull a line out of the body copy.) Keep the body copy short and simple.

Finally, you have to design the page so it best serves your advertising concept. If you have a wonderful idea that is designed poorly, most likely it will not be noticed. Make sure your design works with your concept. The ad

Perception.

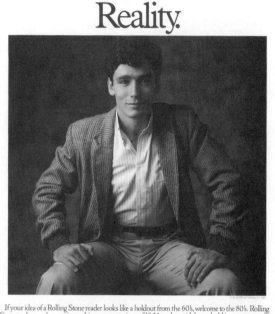

Reality.

If your idea of a Rolling Stone reader looks like a holdout from the 60's, welcome to the 80's. Rolling Stone ranks number one in reaching concentrations of 18-34 readers with household incomes exceeding $25,000. When you buy Rolling Stone, you buy an audience that sets the trends and shapes the buying patterns for the most affluent consumers in America. That's the kind of reality you can take to the bank.

Figure 11-13
Ad Campaign, *Rolling Stone,* **1985-1994**
Agency: Fallon McElligott, Minneapolis, MN
Art directors: Pat Burnham, Nancy Rice, Houman Pirdavari,
Mark Johnson, Ashby Parsons
Writer: Bill Miller
Photographer: Jim Marvy
Client: Rolling Stone Magazine

The campaign has changed the way I think about what I do. I do not think of myself as just a writer. The line between art director and copywriter, in this instance, is blurred. What is required here are concepts, not just a clever headline, not just a compelling visual. But concepts, pictures and words that work together. Coming up with ideas for the Perception/Reality campaign is a great creative exercise. It requires you to think in visual shorthand. The body copy writes itself. It is frosting. The best concepts are not those that finish 14 inches in front of your face on the magazine page; the best concepts finish inside your head. If your objective is to make a connection with a reader, you cannot get closer than that.

Bill Miller, Copywriter, Fallon McElligott

should be well executed and professional looking. Conversely, if you have a wonderfully executed ad that has no strong concept, it will not be remembered. Both the concept and the execution should be thoughtful.

These steps certainly vary from professional to professional, or from student to student. If you come up with great ideas, that is all that counts. If you are really having difficulty, try following the suggested steps.

The Ad Campaign

A **campaign** is a series of ads that share a common strategy, concept, design, spirit, style, and claim. The ads all may have the same line and different visuals, or all have different lines and the same visuals, or all have different lines and visuals, but usually share the same layout. You may have variety, but you must establish continuity in the campaign.

Notice the layout, line, style, and theme are consistent in this famous campaign for Rolling Stone Magazine (See Figure 11-13).

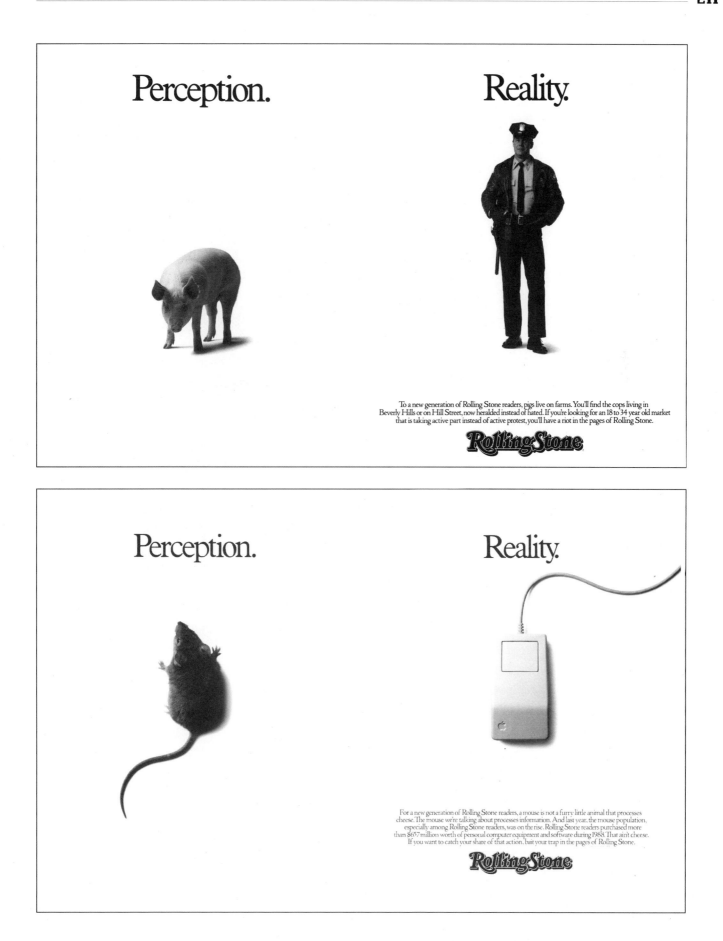

Figure 11-14
Billboards: "Got Milk?/
Gingerbread Man," 1993
"Got Milk?/Peanut Butter
& Jelly," 1993
Bus Shelter:"Got
Milk?/Chocolate Chip
Cookie," 1993
Agency: Goodby, Berlin & Sil-
verstein, San Francisco, CA
Creative directors: Jeffrey
Goodby, Rich Silverstein
Art directors: Rich Silverstein
and Peter diGrazia (all except
"Peanut Butter & Jelly,")
Mike Mazza ("Peanut Butter &
Jelly")
Writer: Chuck McBride
Photographer: Terry Heffernan
Client: California Fluid Milk
Processors Advisory Board

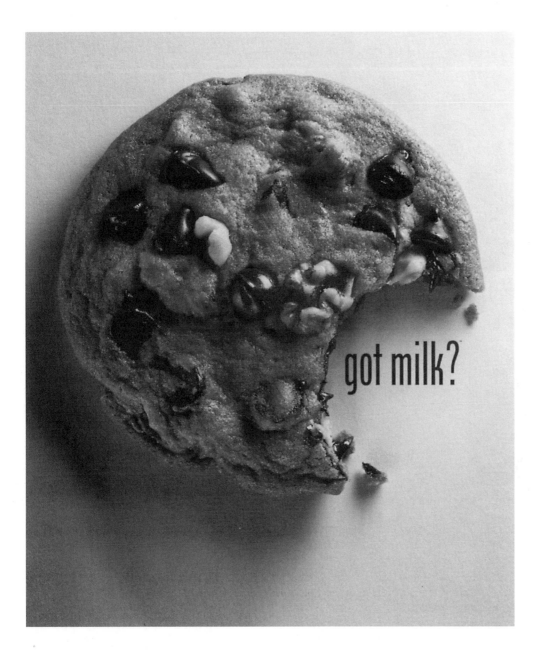

Changing the potential consumer's and advertiser's notions of who reads *Rolling Stone* is the concept behind this campaign. Two visuals are juxtaposed in each ad to explain the difference between people's perception and reality.

To promote milk, this campaign points out all the foods people enjoy with milk (See Figure 11-14). The line in all the ads is "Got Milk?" In this campaign, for ESPN (2), all the layouts are spreads (See Figure 11-15 pp. 214 and 215). Clearly, these hip trade ads are aimed at a specific audience—as their claim states: "They've Got Their Audience. We Have Ours." They are hoping to get advertisers to buy advertising time on ESPN (2).

Television Commercials

Television is another interesting medium for designers. Television has several advantages over print. Television allows you to use sound (including music, voice, and special effects), movement (action, dance, demonstration, visual effects), and it gives you time to explain your concept. Since TV has some advantages over print, it would seem in some ways that it is harder to attract consumers with print advertising. With print, you get one visual and approximately two seconds of the viewer's attention or time. Creating ads for TV is like making mini-

Figure 11-15
Ads
Agency: Weiden & Kennedy,
Philadelphia, PA
Creative directors: Larry Frey,
Stacy Wall
Art director: Paul Renner
Writer: Sally Hogshead
Client: ESPN

movies. Great TV ads are ones people notice, remember, and relate to, like the funny one for the New York State Lottery (See Figure 1-12).

Until recently, television advertising has been one-way, a communication from advertiser to consumer. Now advertisers are investigating and using interactive technology, a two-way convergence of television, telephone, and computer technology. For example, an interactive commercial may ask the viewer to answer questions using a video prompt and remote control; the information superhighway opens up a whole new realm of interactive advertising for businesses to explore. Due to the proliferation of cable channels, network advertising is suffering. Also, people "zap" through and around commercials with their remote controls. Using interactive technology for advertising is one way for advertisers to ensure their message is getting across to potential consumers.

Visualizing an ad for television begins with a storyboard. A **storyboard** illustrates and narrates key frames of the television ad concept. The visuals are drawn in frames, in proportion

to a television screen, and the action, sound, or special effects, and dialogue are written underneath each frame. Here is one example of a storyboard for Pizza Hut (See Figure 11-16).

Television advertising is very expensive and usually is saved for seasoned professionals. Due to the proliferation of cable television and multimedia, beginners in advertising agencies may have the early opportunity to work on television commercials. Interactive television will present new opportunities as well. Working on a TV ad would require knowledge of many things—like production, direction, casting, and post production—that are learned from years on the job and rarely are taught in college or university graphic design programs. It is a good idea to take video, film, and multimedia courses and to create a few storyboards while in school.

Critique Guide

Here is a guide you can use while creating ads. It will keep you on target. After you finish, use

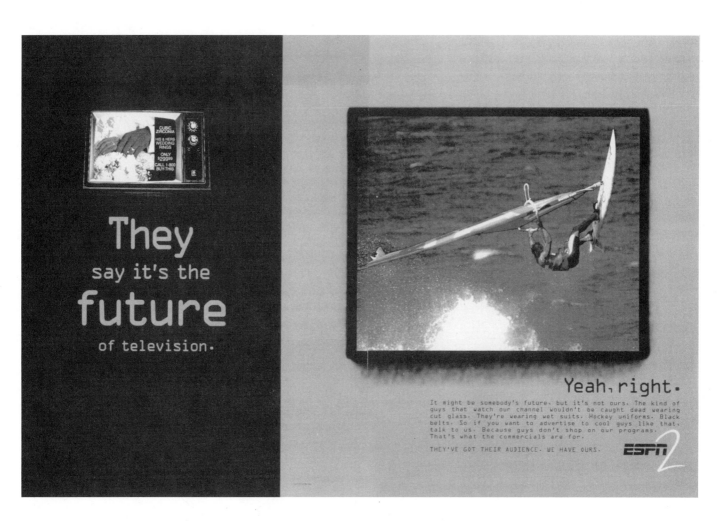

it as a critique before you show your work to others.

Concept Development

- Did you develop a concept?
- Did you establish a benefit? Did you take the viewer's position and ask, "What's in it for me?"
- Did you communicate a clear message?
- Do your visuals and copy express your concept?

Design

- Did you establish a visual hierarchy?
- Did you design the page using the principles of design, including balance, rhythm, and flow?
- Did you experiment with layout?
- Did you include a sign-off?
- Did you present your work professionally?
- Is your design fresh? Is it innovative? Is it cutting edge?

Copy

- Is your writing clear?
- Did you use everyday language?
- Is your copy, line, body copy, and claim unified by a common concept and writing style?

Design and Copy

- Did you establish a visual/verbal relationship?
- Does the ad have visual/verbal synergy?
- Is this a seamless ad?

Expression

Advertising is visual and verbal communication. The advertiser wants to communicate a message to the potential consumer; how well the message is communicated is a matter of creative expression. The creative team's job is to find the best way to express the ad message. To accomplish this, the team might use demonstrations, endorsements, declarations, narratives,

Figure 11-16
Storyboard, The Pizza Head Show, "Super Steve To The Rescue"
Agency: Goodby, Berlin & Silverstein, San Francisco, CA
Creative directors: Jeffrey Goodby, Rich Silverstein
Art director: Paul Renner
Writer: Erik Moe
Producer: Cindy Fluitt
Client: Pizza Hut

Figure 11-17
Ad, "Fold Here," June 1992
Agency: The Martin Agency, Richmond, VA
Art director: Cliff Sorah
Writer: Ken Hines
Client: Residence Inn

The designer believed the design of this ad is fairly straightforward. (The man and woman embrace when the full-page ad is folded in half.)

This ad always runs on the left-hand side of the paper, so the crease appropriately folds inward.

Dan Bartges, VP/Account Supervisor, The Martin Agency

recognition, association, or emotional appeals.

An ad may demonstrate how a product or service works. Here you see a demonstration of what will happen if you go on a Weekend Getaway (See Figure 11-17). What makes this ad so effective is it invites participation. An ad may fea-

One Friday morning, an 18-wheeler didn't see Darlene and Tom driving to work until it was too late. Their Saturn sedan was blindsided. It spun around and rolled, ending up in the highway median.

The hospital stay was short—under two hours. But still, being thrown against shoulder and lap belts at highway speed, no matter how safe your car is, hurts. For Tom, the old college lineman, the aches and pains felt kind of familiar. And he was back at work on Monday. For Darlene, who'd never played football, it took a little longer.

Everyone at work was glad to hear how the car held up in the crash. Many of them own Saturns, too. In fact, there's quite a high percentage of Saturn owners where the Robisons work.

The Saturn SL2

At Saturn, safety is one of our top priorities. So, among other things, we use a reinforced steel spaceframe, offer optional anti-lock brakes on all our models, and our 1993 cars all come with driver-side airbags as a standard feature.

They happen to work for us, in Spring Hill. And, after ordering another Saturn, Tom let everyone know, recent events notwithstanding, that he liked his present job just fine, and had no plans to become a test driver.

A DIFFERENT KIND *of* COMPANY. A DIFFERENT KIND *of* CAR.

DARLENE and TOM ROBISON were run off the highway, rolled their car, and took the rest of the day off.

Figure 11-18
Ad, "Darlene & Tom Robinson"
By permission of Saturn Corporation

ture a celebrity who uses or endorses the product or service, or it may feature an endorsement from an everyday person with whom the potential consumer can identify (See Figure 11-18).

An ad may declare its product or service is best, is scientifically proven to work, was chosen above all others in taste tests, and so on. These ads for Häagen Dazs declare that their ice cream is "blended from the purest ingredients..." and has "...only the world's best ingredients" (See Figure 11-19). An ad may tell us a story, a narrative, which may take many forms: it may look like an editorial; it may look like a cartoon; it may be a single story telling picture; it may look like photojournalism; or it may be a sequential illustration. These funny ads for the Everfresh Juice Company are narratives (See Figure 11-20). (Ads using cartoons tend to have high readership.) An ad may use a symbol, logo, or something we recognize and come to identify with the product or service, like the dog in this ad for Hush Puppies (See Figure 11-21).

An ad may create an association for us with a particular lifestyle or look. This also is called image advertising. Timberland is not just selling

you clothes in these ads; they are selling you a way of life, an attitude (See Figure 11-22). Ads that have emotional appeal tend to be very memorable, like the ones for Bernie's Tattooing, which make you chuckle (See Colorplate 30). The stories are so moving in a campaign for the United Way, they might move some people to tears (See Colorplate 31). Compassion for animals certainly is provoked in this campaign for Volunteer Services for Animals (See Figure 11-23). Of course, you have heard that sexy ads can sell anything, and unfortunately, sex is used inappropriately and too often. When used for appropriate products, however, it can be clever, as in these ads for Tabu lingerie (See Figure 11-24) and for Moss Optical (See Figure 11-25).

If an ad makes you feel something—anything—you are more likely to be persuaded by it. The best way to create ads that have emo-

Figure 11-19
Ad Campaign, "Melt Together/Feel Me"
Agency: Bartle Bogle Hegarty (BBH), London, England
Client: Häagen Dazs

Our ice cream will

melt

*relatively quickly, which is
a sign that we
never use additives. Blended*

together

*from the purest ingredients,
Häagen-Dazs is
the finest eating experience.*

Dedicated to Pleasure.

Our customers

feel

*Häagen-Dazs
is unique.*

Between you and

me

*there are no secrets to it.
only the world's best ingredients.*

Dedicated to Pleasure.

Figure 11-20
Ads, "Cool Down"
Agency: Arian, Lowe, Travis & Gusick Advertising, Chicago, IL.
Creative director: Gary Gusick
Art director: Mike Fornwald
Writers: Gary Gusick, Mike Fornwald
Client: EverFresh Juice Co.

We decided to target women for the Cool Down product. After all, 62% of all people who exercise three times a week or more are female. We retained the services of Nicole Hollander, creator of the "Silvia" nationally syndicated cartoon strip, to help with the executions. The ads are designed to poke gentle, gender fun on behalf of women and to demonstrate to women that Cool Down understands them. It worked.

Daryl Travis, President, Arian, Lowe, Travis & Gusick

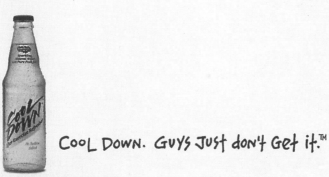

Figure 11-21
Ad, Hush Puppies
Agency: Fallon McElligott,
Minneapolis, MN
Art director: Bob Barrie
Writer: Jarl Olsen
Photographer: Rick Dublin
Client: Hush Puppies Shoes

Figure 11-22
Ad Campaign, 1989-1990
Agency: Mullen, Wenhan, MA
Art directors: Brian Fandetti, John Doyle
Writer: Paul Silverman
Photographers: "Turbulence" (stock), Harry DeZitter
("Waterfront Living")
By permission of The Timberland Company

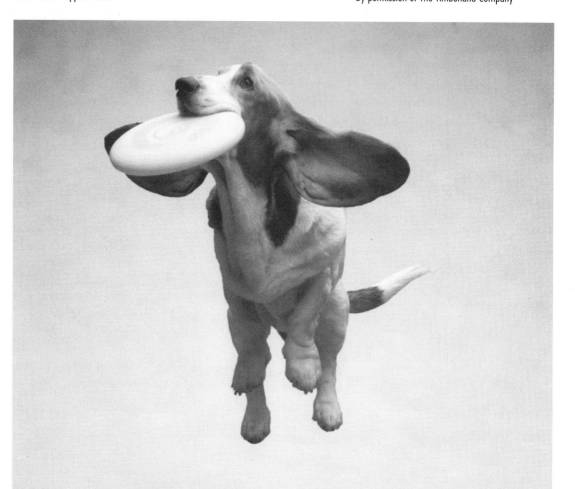

Springy Hush Puppies.

When you walk, raised areas on the bottoms of our Bounce® shoes compress and cushion. As they spring back,
they propel you forward. The result is a line of men's and women's shoes which actually makes walking easier.
Another giant leap for Hush Puppies. For the retailer nearest you, dial 1-800-6-HUSH PUP.

For those who accept turbulence as a fact of life.

Although Timberland gear gives you a great look in the flattering sunlight of a calm day at sea, its true worth shines through when the sky blackens and the water opens its jaws to feast on anything afloat. We build our clothing and footwear to meet the needs of people whose serious love of the sea exposes them to all its moods. People who will not or cannot cling to land until turbulence no longer threatens and the coast is clear. For these individuals, shelter is made of three things. Their boat, their skill, their Timberland gear.

Boots, shoes, clothing, wind, water, earth and sky.

Some people have a different idea of waterfront living.

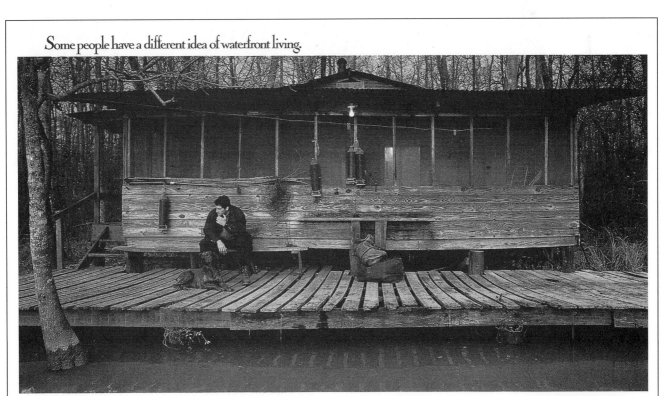

You'll find Timberland jackets, boots and duffels in use on the most civilized lakefront and river properties in the land. But to see our gear tested to its true limits, you might want to visit the more primitive types of real estate. Remote backwaters. Impenetrable marshes. Inlets even Rand McNally can't find.

Here you'll find a certain kind of waterfront dweller. An individualist who has two good reasons to abandon the comforts of civilization. One, his passion for adventure. Two, his trust in Timberland gear.

Boots, shoes, clothing, wind, water, earth and sky.

Figure 11-23 a & b
Ad Campaign, "Guinea Pig"
and "Cage", 1985
Agency: Leonard Monahan
Saabye, Providence, RI
Art director: Debbie Lucke
Writer: David Lubars
Illustrator: Kathy Toelke
Photographer: John Holt
Client: Volunteer Services
for Animals
(Continued on next page)

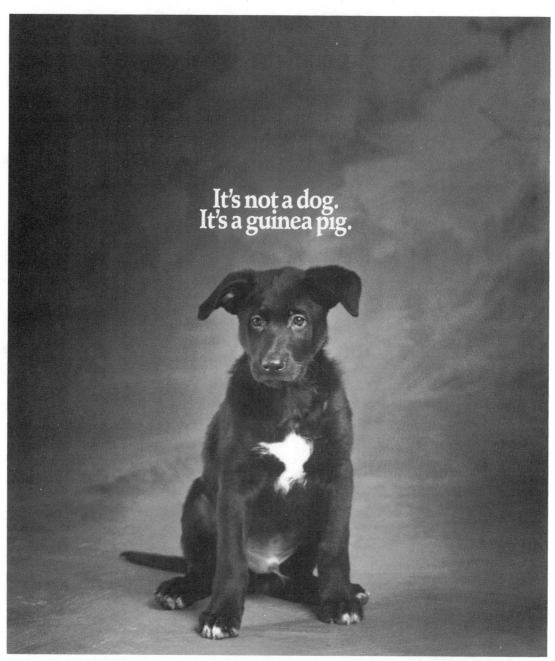

It's not a dog.
It's a guinea pig.

There is a thriving black market in this country. A dreadful, despicable black market.

A black market where lost and stolen pets are sold to laboratories for experimentation.

And while it's true that Rhode Island has passed legislation that makes selling pound animals for experimentation illegal here, it doesn't mean your pet is safe. Because it's a fact that thieves steal pets and smuggle them into states where selling animals for experimentation is legal.

What can you do?

Well, for your own dog, there are three things. One, don't let him run loose in the neighborhood. Keep him on a leash. Two, when you're not home, don't leave him alone in the backyard. And three, if you don't have ID tags, a license or a tattoo on him, get them immediately.

But there's something else you can do. You can join Volunteer Services for Animals.

We're a private, non-profit organization whose sole purpose is to improve the treatment and environment of animals in our state.

We also help municipalities provide humane services which they couldn't otherwise afford. For example, we have lost and found, adoption, veterinary care, population control, pet therapy and education programs.

So please call us at 273-0358.

And help our animal operation prevent animal operations.

VOLUNTEER SERVICES ▓ ANIMALS
401 Broadway, Providence, Rhode Island 02909

The average cage in the city animal shelter isn't much bigger than this ad.

And that's not the worst of it.

Because after spending five days in a cage like this, many times animals are killed.

And the tragedy is, our city shelters don't have to, or want to, operate like that. Because it's only out of a lack of money, people and space that they're forced to.

At Volunteer Services for Animals, we're working to correct this situation. We're a private, non-profit organization whose sole purpose is to improve the treatment and environment of animals in our state.

But we can't do it all alone. We need people who will help us make shelters better places for animals. We also need people who will participate in fund-raising events. Help find new homes for unclaimed animals. Educate pet owners about animal needs. And, most of all, bring love to the animals.

It really boils down to this. Lost and stray animals in Rhode Island are captured and stuck in cages as if they were criminals.

And the only crime they're really guilty of is being homeless. Call 273-0358 to help.

VOLUNTEER SERVICES for ANIMALS
401 Broadway, Providence, Rhode Island 02909

Figure 11-23c (continued)
Ad, "Oven," 1985
Agency: Leonard Monahan
Saabye, Providence, RI
Art directors: Debbie Lucke,
Brian McPeak
Writer: David Lubars
Photographer: John Holt
Illustrator: Kathy Toelke
Client: Volunteer Services
for Animals

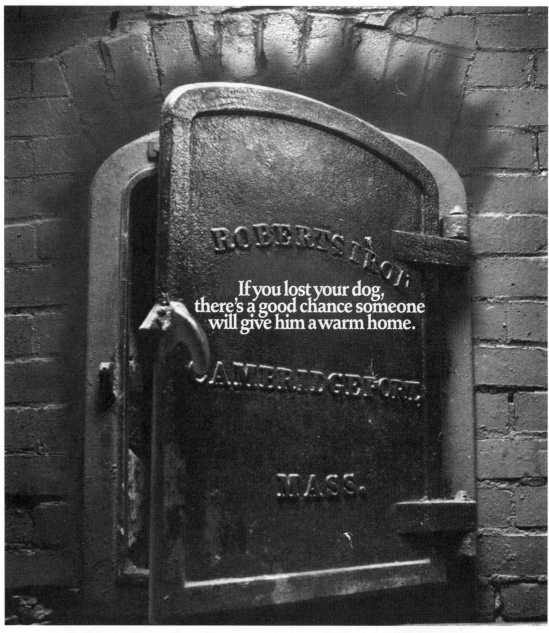

If you lost your dog,
there's a good chance someone
will give him a warm home.

What if you had a dog. And what if he wandered away from home and got lost. And what if he was picked up by the city shelter and stuck into a cage.

And what if, what if after five days you still hadn't found him.

You know what would happen? He might be killed. And then cremated in an oven like this. Or buried in the city dump.

Just think how you'd feel. And think how much worse you'd feel knowing city shelters don't have to, or want to, operate like that. Because it's only out of a lack of money, people, and space that they're forced to.

At Volunteer Services for Animals, we're working with Rhode Island munic-ipal shelters to correct this situation.

We're a private, non-profit organiza-tion whose sole purpose is to improve the treatment and environment of animals in our state.

We also help municipalities provide humane services which they couldn't otherwise afford. For example, we have lost and found, adoption, veterinary care, population control, pet therapy and edu-cation programs.

But we can't do it all alone. We need your help.

We're looking for volunteers who will help us reunite lost pets with their owners. Find new homes for unclaimed animals. Educate pet owners about ani-mal needs. Participate in fundraising events. Help with shelter chores. And, most of all, bring love to the animals.

Look at it this way.

Last year in one Rhode Island city alone, thousands and thousands of lost and stray animals were destroyed. So call us at 273-0358.

Before the subject of unclaimed pets becomes a dead issue.

VOLUNTEER SERVICES for ANIMALS
401 Broadway, Providence, Rhode Island 02909

Fig. 11-24 Posters,
Tabu Lingerie, 1992
Agency:
The Richards Group, Dallas, TX
Art Director: Jeff Hopfer
Writer: Todd Tilford
Photographer: Richard Reens
Client: Tabu Lingerie

ACTUALLY, THERE IS ONE
KNOWN CURE FOR SNORING.

TABU
LINGERIE

Warning: People don't like ads.
People don't trust ads.
People don't remember ads.
How do we make sure
this one will be different?

Why are we advertising?
To generate awareness for Tabu
by making customers feel more
comfortable about buying
sexy lingerie.

REMEMBER, MEDICAL EXPERTS
RECOMMEND INCREASING YOUR HEARTRATE
AT LEAST THREE TIMES A WEEK.

TABU
LINGERIE

Who are we talking to?
Men who buy lingerie for a wife
or girlfriend, and women who
buy lingerie for themselves (to
please the men in their lives).

What do they currently think?
"I'm a little uncomfortable
about buying sexy lingerie;
lingerie is very intimate
and private."

What would we like
them to think?
"This is a friendly, uninhibited
store. I wouldn't be embar-
rassed to ask for anything."

What is the single most persua-
sive idea we can convey?
Tabu makes buying lingerie fun.

JUST FOR THE RECORD, BASEBALL
ISN'T AMERICA'S FAVORITE PASTIME.

TABU
LINGERIE

Why should they believe it?
Because we're honest
about why people buy it.

Are there any
creative guidelines?
Sexy and intelligent.
Not sexist and crude.

The Richards Group

If Our Glasses Got Any Sexier, They'd Steam Up All By Themselves.

Figure 11-25
Ad, 1991
Agency: Carmichael Lynch, Minneapolis, MN
Creative: Kari Casey
Client: Moss Optical
Courtesy of Moss Optical

Keep it simple. The product is the hero.

Kevin P. Moss, Partner, Moss Optical
Kari Casey, Carmichael Lynch

tional appeal is to think of the most human reactions to events or situations. The approach to this type of creative thinking is very similar to the approach most comedians take. They illuminate the little things in life we take for granted and show us the inherent humor in our own behavior. They draw upon human experience—life's little dreams and comedies. This is true in advertising as well. If your concept is believable, then it may make the viewer think "That is really true—that happens to me!" Or, "Wow, I would love for that to happen to me." Or even, "I would hate for that to happen to me."

Creative Approaches

Great ads can be truly memorable. How do award-winning art directors come up with all those great visuals? First and foremost, the visual expresses the concept. Second, if you do not rely on a photograph or illustration of the product or service as the main visual, you have a world of visuals from which to choose. Here are some approaches to think about. They are not suitable for every concept, but when they are, they can yield exciting results.

- Borrow from language, try visual puns, similes, metaphors, and analogies. (If you use puns, use only one pun in your entire portfolio.) (See Figures 11-26 through 11-28 and Colorplate 32).
- Ask yourself: "What if...?" What if a tree grew upside down? What if a cow barked? The "what if" question is a classic creative exercise that helps prompt creative thinking (See Figures 11-29 and 11-30).
- Reverse things and statements. Look at something in a mirror. Turn a mouth upside down. Reverse a popular phrase (See Figures 11-31 through 11-33).
- Do the unexpected. Use an unusual

1st posting

Figure 11-26
Poster, NYNEX
Agency: Chiat/Day, New York, NY
Creative director: Dick Sittig
Art director: Dave Cook
Writer: Dion Hughes
Client: NYNEX Yellow Pages
Courtesy of NYNEX

2nd posting

3rd posting

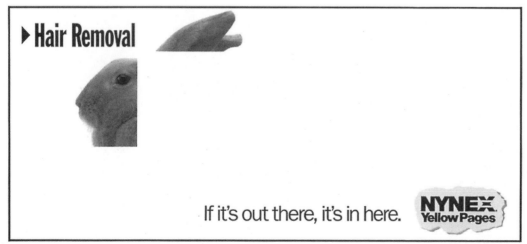

Figure 11-27
"Pretzel Ad," December 1990
Agency: Leonard Monahan
Lubars & Kelly, Providence, RI
Creative director: David Lubars
Art director: Micheal Kadin
Writer: David Lubars
Photographer: Paul Clancy
Client: Orlando Pardo, PC

Figure 11-28
Ad campaign, "Lampshade,"
"Slinky," "Rope"
Agency: Weiss, Whitten,
Stagliano Inc., New York, NY
Creative directors: Marty Weiss,
Nat Whitten
Art director: Ellen Steinberg
Writers: Ernest Lupinacci,
Paula Dombrow, David Statman
Photographer: Guzman
Client: Apriori

Look at it this way. Your back is the center of your whole body.

That's why when your back gets all twisted up, you seem to hurt all over. If you have chronic back problems, give me a call at (213) 749-6438 and we'll arrange an appointment.

Chiropractic is a proven, altogether safe technique. Which is why many insurance plans now cover it.

I think that after you see me, you'll feel a lot better than you did before.

Orlando Pardo D.C.
DOCTOR OF CHIROPRACTIC

The creators of Apriori clothing
take pride in the fact that other companies
have been turned on by their designs.

Figure 11-29
Ad, "Tank Ad"
Agency:
Goodby, Berlin & Silverstein,
San Francisco, CA
Creative directors: Jeff
Goodby, Rich Silverstein
Art director/associate cre-
ative director: Steve Stone
Writers: Steve Simpson,
Steve Stone
Photographer: Dan Escobar
Client:
Norwegian Cruise Line

Figure 11-30
Poster, "Cow," 1993
Agency: Stein Robaire Helm,
Los Angeles, CA
Art director: Laura Sweet
Copy: Clay Williams
Client: Roland Corporation

*The hardest part about shooting
the ad was standing around in a
cold, wet pasture until the cow
actually said "Woof."*

*Actually, this is a stock pho-
tograph that required a signifi-
cant amount of retouching. The
cow had dirt all over, and we
added a bunch of spots.*

Clay Williams,
Stein Robaire Helm

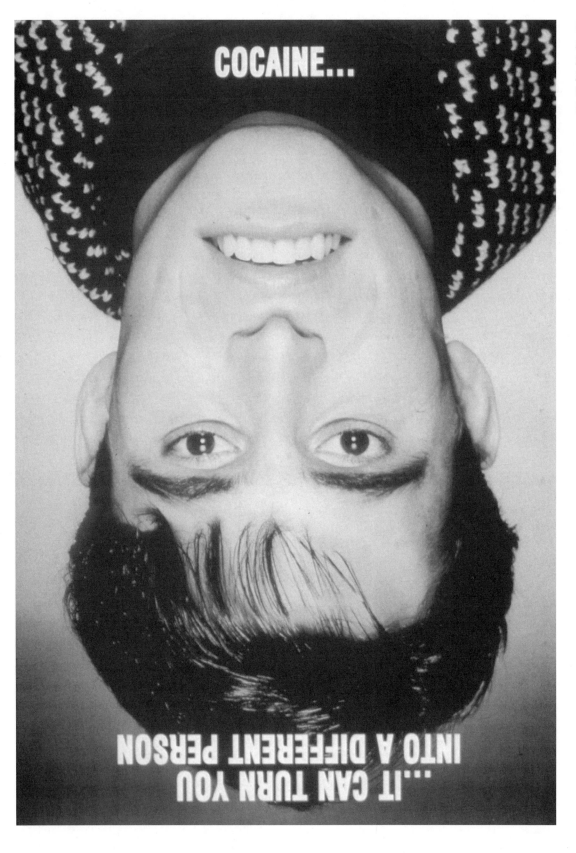

Figure 11-31
Ad, 1992
Agency: Fortis Fortis &
Associates, Chicago, IL
Client: Partnership for a
Drug Free America

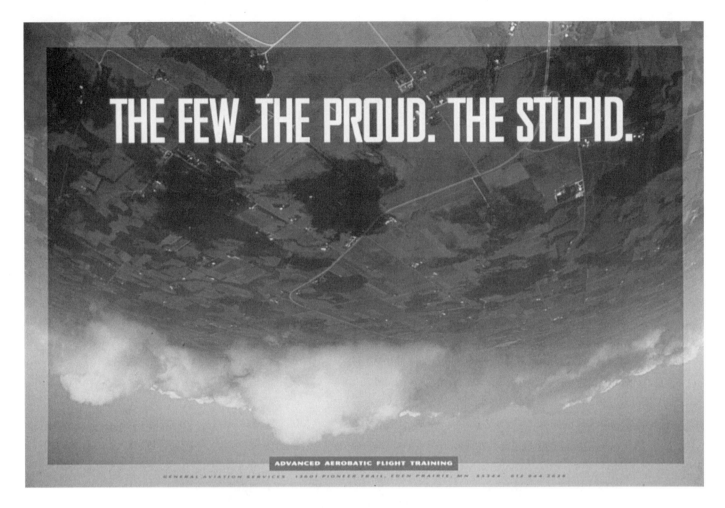

THE FEW. THE PROUD. THE STUPID.

ADVANCED AEROBATIC FLIGHT TRAINING

GENERAL AVIATION SERVICES 13601 PIONEER TRAIL, EDEN PRAIRIE, MN 55344 612 944 3628

Figure 11-32
Ad, "The Few"
Agency: Hunt Murray,
Minneapolis, MN
Art directors: Mike Murray,
Mike Fetrow
Writer: Doug Adams
Client: General Aviation Services

visual or one that is unrelated to the product or service (See Figures 11-34 and 11-35).

- Merge things. Bring two different things, images, or objects together to make a new one. Merge a tennis ball and a croissant. Merge a fish and a carrot (See Figure 11-36 and Colorplate 33).
- Change the scale of things. Make something that is usually small, very big and vice versa. Emphasize the size of something by the way you design the page, or compare the size of things to make a point (See Figure 11-37).
- Use a new or strange point of view. See something from an unusual or unexpected angle (See Colorplate 34 and Figure 11-38).
- Compare things (*not* products—like Coke and Pepsi), like a man to a mouse; or compare your luck to that of another (See Figures 11-39 through 11-41).

Stimulation

Most agencies want to hire people who take fresh approaches. How do you make sure your work is innovative? First you have to know what has been done (the history of advertising and graphic design) and what is currently being done. Then you will know what is old, new, and retro (a look back).

You probably know the saying that there is nothing new under the sun. If you believe that, the only thing to do is recycle. Take something from the past and make it new. For example, if you look at experimental type design in the '90s, it is reminiscent of Dadaist type design from the early 20th century. Now some advertising agencies and graphic designers are using visuals from the '50s because there is a whole generation out there who is not familiar with them.

Take cues from the other arts, such as dance, music, fashion, painting, film, and literature, and create visual responses. Similarly,

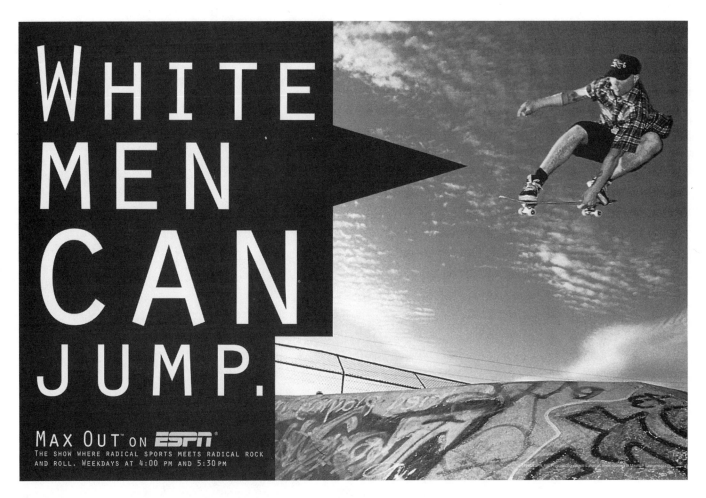

Figure 11-33
Ad
Agency: Weiden & Kennedy, Philadelphia, PA
Creative directors: Larry Frey, Stacy Wall
Art director: Paul Renner
Writer: Stacy Wall
Photograph by Sean Dolinsky courtesy of *Thrasher Magazine*
Client: ESPN

Figure 11-34
Ad, 1991
Agency: Franklin Stoorza, San Diego, CA
Art director: John Vitro
Writer: Bob Kerstetter
Illustrator: Mark Fredrickson
Client: Thermoscan

Figure 11-35
Ad, 1991
Agency: Follis, DeVito Verdi,
New York, NY
Art directors/writers:
Sal DeVito, Tom Gianfagna,
Rob Carducci
Photographers: Cailor/Resnick
Client: Daffy's

*We wanted our Thanksgiving
Day ad to stand out from all the
others, so we did something
different—we did one with an
idea.*

Julie Rosenberg,
Account Executive,
Folis DeVito Verdi

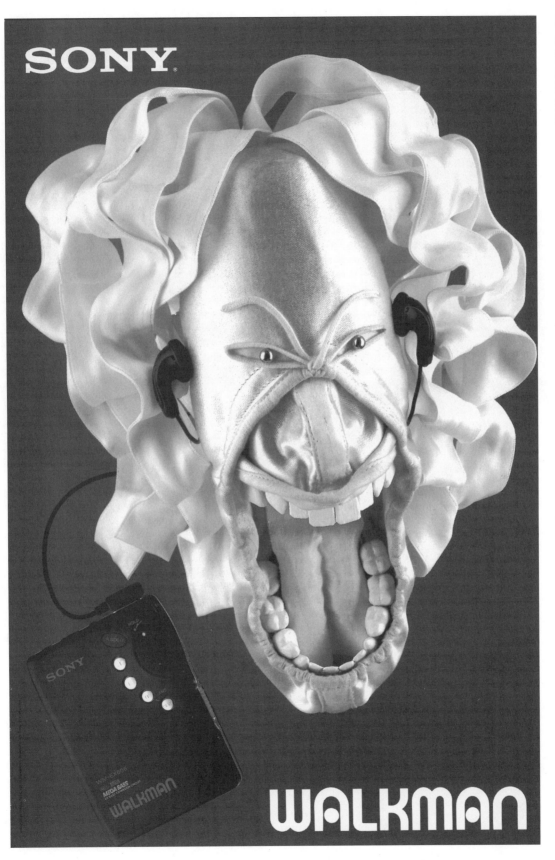

Figure 11-36
Ad Campaign
(continued next page)
Agency: Bartle Bogle
Hegarty (BBH),
London, England
Client: Sony Walkman

Figure 11-36 Continued

politics, world events, and social change can prompt visual ideas.

Be eclectic. Gather material and inspiration from various sources and bring them together. Examine other cultures and draw inspiration from diverse styles, imagery, and compositional structures. Go to the movies, look at magazines, listen to comedians, read humorists' works, watch music videos, look at all graphic design, observe human behavior. Be a critical observer, listener, and reader. Being well-read, well-educated in many subjects, observant, and in tune with the spirit of the time will enhance your creative abilities.

Figure 11-37
Ad, "The best part. The stuff. The double stuff..."
Agency: Pagano Schenck & Kay, Providence, RI
Creative director: Woody Kay
Art director: Robert Hamilton
Writer: Bob Shiffrar
Photography: © Francine Zaslow, Boston, MA
Client: Adweek's Marketing Computers

Adweek's Marketing Computers *magazine may not have the largest high-tech audience, but it does reach the best part of the audience, which, in effect, is the concept behind these ads. By merging the ad copy with "the best part" of each visual, the concept is doubly reinforced. The photography and typography were created in a very straightforward way, to help support the concept without distracting from it.*

Woody Kay, Executive VP/Creative Director

Some calls are more important than others, so get an answering machine. BT

Figure 11-38
Ad, "Screaming Baby," 1992
Agency: Simons Palmer Denton Clemmow & Johnson, London, England
Art director: Andy McKay
Writer: Tony Barry
Illustrator: Graham Storey
Client: BT

The illustration was commissioned as black-and-white artwork. It was executed in pen and ink and was one inch across, then blown up to achieve a ragged finish. The colors were specified later.

Andy McKay, Art Director, Simons Palmer Denton Clemmow & Johnson

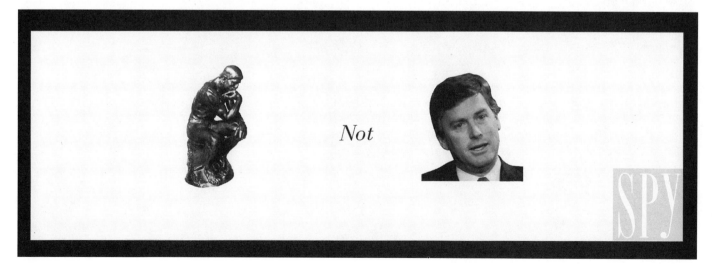

Figure 11-39
Poster campaign, *Spy* magazine
Agency: J. Walter Thompson, New York, NY
Art director: Michael DePirro
Writer: Christina McKnight
Client: *Spy* magazine

You Wouldn't Keep Something This Poisonous Around The House.

Or Would You?

Gladiola, lily of the valley, and dozens of other common plants are poisonous.
Remember to keep them away from young children. For a complete list, call your poison control center.

Minneapolis
Children's
Medical Center

© 1992 MCMC Staple photo by Tom McHugh/Allstock. a LifeSpan ® member.

Figure 11-40
Poster/Ad, 1992
Agency: Martin/Williams, Minneapolis, MN
Creative director: Lyle Wedemeyer
Art director: Sally Wagner
Writer: Tom Leydon
Photographer: Kent Severson
Client: Minneapolis Children's Medical Center

This ad and poster, one of three in a campaign, lets parents know about everyday items that are dangerous to children. The posters were distributed to doctors to hang in their offices.

In each ad (the others feature a walker and a balloon), the image on the left parallels the image on the right in shape to make the message clear. For example, in this ad the snake's mouth and flower open to create a similar image. The straightforward copy supports the image.

The poster uses a heliograph instead of a halftone to make the images look grittier and more frightening. Also, because the poster was printed on less expensive, uncoated stock, the heliograph, which actually is a line image reproduced better than a halftone would have.

Sally Wagner, Art Director, Martin/Williams

Bear Trap

Man Trap

YOU'RE A LOT LUCKIER THAN YOU THINK.

MYSTIC LAKE CASINO

1993

1850

YOU'RE A LOT LUCKIER THAN YOU THINK.

MYSTIC LAKE CASINO

Mates Once In Its Life.

Mates Two Or Three Times.

YOU'RE A LOT LUCKIER THAN YOU THINK.

MYSTIC LAKE CASINO

Figure 11-41
Ad campaign, "Man Trap," "Toilet Paper," "Mates"
Agency: Hunt Murray, Minneapolis, MN
Art director: Mike Fetrow
Writer: Doug Adkins

COPY EXERCISES

Exercise 11-1
Creative Writing Exercise—
An Autobiography

1. In essay form, write your autobiography (no more than one page). It may start at any point in your life. Establish an angle—emphasize one benefit of your life.

2. Condense the essence of the essay into one paragraph.

3. Write one line (not a title) that captures the essence of the autobiography.

Exercise 11-2
Creative Writing Exercise—
A "How-to" Essay

1. Write an essay about "How to lose someone at a party."

2. The opening line should hint at the purpose of the essay.

3. The middle of the essay should be the turning point for the reader—now he or she should know how to get rid of an annoying person at a party.

4. As you wrap it up, the essay should still hold your reader's attention.

5. The last line should be strong and almost carry the spirit of your message on its own.

Exercise 11-3
A Humorous Story

1. Write about something funny that happened to you.

2. Write for five minutes without stopping. Do not worry about spelling or grammar.

DESIGN EXERCISES

Exercise 11-4
A Redo

1. Find a bad ad.
2. Analyze the design concept (or lack of one).
3. Rethink it and redesign it.

Exercise 11-5
Recognizing Differences

1. Find ten different examples of layouts. Diagram the layouts.
2. Find five ads with examples of different types of visuals, for example: illustration, photography, cartoon, diagram, montage, typography, etc.

CONCEPT EXERCISES

Exercise 11-6
Analyzing Ads

1. Find a few good ads.
2. Identify the concept in each one; determine how the visual and copy express the concept.

Exercise 11-7
Product Research

1. Choose a product or service.
2. Research it.
3. Brainstorm strategies for selling it.

Exercise 11-8
The Creative Team

1. Choose the role of art director or copywriter. With a partner, create an ad for the client of your choice in a limited amount of time (for example, one hour).
2. Exchange the roles of art director and copywriter.

Comments

When the product, service, or client's logo is the main visual in an ad, the potential consumer immediately is alerted to the fact that they are being sold something. That kind of visual might as well read, "I'm an ad—do not bother to look at me." Learning not to depend upon the product as the visual is an important early lesson. (Thanks, Bob Mitchell, for teaching it to me.)

PROJECTS

Presentation

Most instructors do not mind when ads are presented as roughs. If you are interested in using ads in your portfolio, they should be presented as tight comprehensives—simulating finished, printed pieces as closely as possible. Photostats, color copies, computer-generated type and dry transfers are recommended. Your comp should be mounted on foam core without a border or on a black board with a 2" border. The format of your ad, whether it is a single page or a spread, should be determined by your concept. Save your thumbnail sketches; most art directors like to see them as examples of your creative process.

Project 11-1
The Search for a Creative Visual

Step I
1. Choose a client.
2. Do research. Find out everything you can about your client's product or service. Survey people—ask them what they think of it.
3. Determine the benefit or your client's product or service. For example, if your product is cookies, is your client's product sweetened with sugar or fruit juice? If it is sweetened with fruit juice, then the benefit for the consumer is that they will be eating a healthier cookie.
4. Determine the audience for your client's product.
5. Write a claim for your product.

Step II
1. Create an ad for your client's product or service.
2. Do not use the product, service, or logo as the main visual.
3. Brainstorm. Write down everything you can think of that is related to your client. Think of analogies, metaphors, and similes.
4. Think of situations where the product or service might be used.
5. Create at least ten sketches.

Step III
1. Refine the best sketches and create two roughs.
2. Remember: The main visual cannot be a photograph or illustration of the product or service.
3. You may show the product, service, or logo in the sign-off.

Step IV
1. Create a comp.

Comments

So often we see ads that have rather commonplace visuals. An ad for a cake mix shows a cake. An ad for pain reliever shows someone with a headache—nothing interesting or unpredictable. However, if the visual is unusual, perhaps even completely unrelated to the product, then we might notice the ad. After all, you will not sell anyone anything unless you get their attention first.

Project 11-2
Get Wild

Step I

1. Choose a product, for example, a pain reliever.

2. Do research. Find out everything you can about your client's product or service. Try the product or service (if possible).

3. Determine the audience.

4. Determine the benefit. Will your client's product or service make the consumer more attractive, healthier, richer, or offer some other benefit?

5. Write the benefit down on an index card.

6. Write a claim.

Step II

1. Create an ad; once again, do not use the product, service, or logo as the main visual.

2. This time you must use an unusual or extraordinary visual—a visual that is uncommon or unexpected.

3. Produce ten sketches with at least three possible visuals. **Creative approach:** If your product is a headache remedy, try thinking of visuals that symbolize headaches, like a monster, or try thinking of ludicrous headache remedies, such as using a guillotine.

Step III

1. Create a rough.

2. You may use a visual of the product or logo in the sign-off.

Step IV

1. Create a comp.

Comments

If a product or service has a USP, that is something solid the creative team can promote. Although most products do not have a USP, advertisers sometimes come up with a claim to make about their product simply to pre-empt the competition. Sometimes, an advertiser can take a unique disadvantage and turn it to their advantage, for example, the famous campaign for the Volkswagen Beetle that claimed, "Its ugly but it gets you there."

Project 11-3
The Unique Selling Point (USP)

Step I
1. Choose a client whose product or service has a unique selling point (USP).
2. Research it and its competition.
3. Tout the USP as the benefit.
4. Write a claim.

Step II
1. Create an ad for your client's product or service based on the USP.
2. Produce ten sketches.

Step III
1. Refine the sketches. Create two roughs.
2. Remember: always establish a visual hierarchy.

Step IV
1. Create a comp.

Comments

This assignment pushes you to think of alternative layout solutions. Most students are quite happy with their first layout and do not explore other possibilities.

Project 11-4
Varying the Layout

1. Take an ad that you have already created and lay it out five very different ways.

Comments

A campaign demonstrates your ability to create a flexible idea and run with it. It also demonstrates your ability to be consistent with strategy, concept, design, writing, and style.

Project 11-5

An Ad Campaign

Step I

1. Choose your best ad.

2. Determine whether you think the design concept can be expanded into a campaign? Can you think of two other ads that communicate a benefit? As stated earlier, a student campaign consists of three ads that share a common goal or strategy. The campaign shares a common spirit, style, claim, and usually, very similar layout.

3. Write a claim for all three ads.

Step II

1. Produce twenty sketches for the campaign.

2. Remember: the layouts should be similar.

Step III

1. Create two sets of roughs for the campaign.

Step IV

1. Create a comp for each ad in the campaign.

Comments

Preparing a verbal presentation teaches you to use everyday, informal language. You might be tempted to write trite phrases such as, "introducing the most amazing..." or "take the taste test..."; but you would probably realize they sound like sales pitches if you say them aloud. Sound, movement, and time are the advantages of television over print. Make the most of demonstration, music, sound effects, close-ups, cuts, and every other wonderful thing television offers. Television should be entertaining, funny, dramatic, bittersweet; think of a TV ad as a mini-movie. You may want to create a print ad and outdoor board to coordinate with your television commercial.

Project 11-6

Creating a Storyboard for a Television Commercial

Step I

1. Choose an inexpensive product.

2. Create a verbal presentation that will convince an audience your product has a benefit. Make sure it is entertaining.

3. Make sure your presentation does not sound like a sales pitch. (You may want to videotape the presentation.)

4. Use strong opening and closing lines.

Step II

1. Create a storyboard for your presentation consisting of four to six frames.

2. The frames should describe the key actions or visuals in the commercial.

3. The frames should be in proportion to a TV screen.

4. Under each frame, describe the action seen on the video and audio being heard.

5. Create a rough.

Step IV

1. Create a comp.

Chapter 12
The Portfolio

Objectives

- to understand the purpose of a portfolio
- to be able to compile a graphic design or advertising portfolio
- to be able to create a self-promotional piece

A **portfolio** is a body of work. It is used in the graphic design and advertising professions as the measure of one's professional ability. Whether you got A's or B's in your design courses does not matter nearly as much as the work that ultimately goes into your portfolio.

A portfolio consists of anywhere from twelve to twenty pieces of exceptional work. Some of the pieces should be related, for example, a poster, brochure, and invitation for the same event. These pieces, which are called companion pieces, demonstrate your ability to formulate a design concept for several applications.

If you want to specialize in an area of graphic design, such as packaging or information graphics, the work in your portfolio should reflect that area of interest. If all areas of graphic design interest you, your portfolio should include a range of projects that reflect your ability to solve different types of design problems.

There are four key components to a good portfolio:

1. Twelve to twenty professionally executed pieces
2. A book of working sketches
3. A résumé
4. A knock-out presentation

While a portfolio may contain anywhere from twelve to twenty pieces, fewer is better as long as they are excellent. If you do not get a potential employer's attention with your first twelve pieces, the last few probably will not get attention. Quality counts far more than quantity. Do not put a piece in your portfolio unless it is good and well-executed. You may be remembered by your weakest piece rather than by your best.

Begin your portfolio with your best work and end it with your next-to-best work; or begin it with your next-to-best work and end it with your best. Put a very strong piece in the middle (to maintain interest as someone flips through the work). Also, include a binder of working sketches you made while searching for the creative design solutions in your portfolio. These sketches demonstrate your ability to work through a concept and generate more than one solution to a problem.

Design a résumé you can send to potential employers and leave behind after an interview. It should be well-designed (after all, you are looking for a job as a designer), neat, and legible. You may choose to reflect your style or spirit in the design of the résumé. You also may want to create a self-promotional piece—something that will demonstrate your abilities, illustrate your work, and highlight your creativity.

Your work should be presented in a neat, clean, consistent manner. There are three basic types of portfolio presentation cases. One has plastic sheets or pages to slide your work into; another is an attaché-like case, and the other is a clam shell box. If you choose the one with plastic pages, make sure the plastic is clean, not torn or scratched, and secure all work inside the plastic (you do not want it sliding around). If you choose an attaché-like case or clam shell box, all the pieces should be mounted on the same size and color boards, which should fit easily and neatly into the case. Include a ringless binder of working sketches and a résumé. It is a good idea to have two portfolios. If you need to leave one at a studio or agency, you still have one on hand for another job prospect.

The Advertising Portfolio

Most student portfolios consist of three-to-five campaigns, along with three-to-five individual ads. You need a minimum of twelve ads in total. A campaign that is part of a student portfolio usually consists of three ads, each with an individual concept that share a common theme. A campaign demonstrates your ability to create a flexible theme and concept, sustain it through a series of ads, and run with it in a creative direction. You should include a storyboard for a television commercial that is linked to a print campaign. The rule for organizing an ad portfolio is the same as for graphic design—best ad first and next-to-best ad last or the other way around. Place a strong one in the middle. Advertising portfolios are presented the same way as graphic design portfolios, except ads are usually mounted on foam core without a border, or they can be mounted on black board with a 2" border. Again, include a ringless binder of working sketches and a résumé in the pocket of either presentation case. An alternative for an advertising portfolio is to use a ringless binder as the main portfolio.

Depending on the nature of the agency or studio you want to work for, you may need to include a couple of good graphic design pieces in your portfolio to demonstrate your design abilities. Some agencies require their creatives to know graphic design as well as advertising.

Advice from Three Graphic Design Professors

When I asked my esteemed colleagues to prepare a statement addressing the question, "What do you think makes a portfolio good?" they answered as a group, "Twelve great pieces." When asked again, they insisted, "Twelve great pieces." They are right; however, they finally offered more advice.

Portfolio: Your Talent In a Bottle by Alan Robbins

The problem most students have is assuming the portfolio presents their work. It does not. That is not enough. It has to compress your work. It has to hold an essence, like a bottle of perfume.

Therefore, you cannot just mount your twelve best pieces and hope for the best. You have to deal with your portfolio as though it were your most important work to date. Make it capture the essence of your talent.

That means redoing pieces that are not up to snuff, combining pieces that look lonely, giving yourself new assignments that draw out your creativity, reshooting pieces that are out of focus, refocusing in general. You are trying to make the portfolio explode with your individuality.

If there is something you can do that is not in the book, put it in. If some things are mediocre, fix them, change them, or junk them. Pretend that you are making the portfolio for a great grandchild you will never meet, and this is all they will ever know of your art. Let it stand by itself and charm, delight ,or challenge. If it does not compress your talent, then it is just a bag of stuff, easily forgotten.

Tips on the Most Important Things for A Portfolio by Martin Holloway

Consider the presentation a project in itself. The presentation should have:
- consistent board color and size
- a logical sequence
- immaculate and great craft—edges, backs, corners

Cover basics in portfolio content—logos, folder, posters, covers, editorial, corporate visual identity, packaging, etc. Show your personal strengths and interests—your book should show *individuality.*

Show *several* ideas for a problem in rough form—ideas, ideas, ideas. Show that you can have more than one good idea for a problem.

Show sketching skills—this is especially important now in the computer age. Pencil and paper are for idea generation. Computers are for developing an idea, pushing it, and creating multiple variations.

Pay particular attention to type, especially now that you can show real type in comp form generated by the computer (a real improvement). Think of type as the visual equivalent of the sound of the voice. Some messages should shout, some whisper, some be expressed with passion, some as a footnote. Sounds of the voice can add great richness and express layers of meaning about the same subject—type should do the same.

Make your résumé a design problem—excellent typographically! Make it clear, easy to read, with good visual hierarchy.

Have more good pieces than you may use in one presentation so you can tailor the presentation to a particular interview. For example, have an extra ad campaign, package, or logo to accommodate a potential employer's business specialization.

Learn as much as you can about a potential employer's design clients so you can speak intelligently to them.

Do a special piece for a particularly important interview.

Make the presentation beautiful but do not let it overwhelm the work.

Show a variety of mock-up techniques—thumbnails, full-size roughs, rough dummies, marker comps, super comps (tight comps) using computer-generated type and images, stats, halftones, line conversions, INTs, color keys, color tag, color copies, photocopies, montage, simulated embossing, colored pencil, magic markers, etc.

For conversation with prospective employers, be knowledgeable about the field, production, and designers. Be able to speak with interest and enthusiasm about your profession.

Never apologize for your work.

Suggestions

When creating and crafting a self-promo, consider the following suggestions:

- distinctive paper and envelope
- handmade, interesting bindings and clasps
- unusual materials
- experimenting with folds
- unusual sizes and shapes
- moving parts
- distinctive packaging

Always leave something behind after an interview—a résumé at least, or a promotional piece, something with your work on it.

Learn to explain what you did and did not do for each piece (for a complex piece, elements on a page or surface may in themselves be impressive solutions to problems—maps, spot illustrations, graphic devices). Do not assume a reviewer will know what you did (some people may use clip art, some may create the elements themselves). Learn to be concise in these explanations.

Know how much salary you want (or will settle for), instead of appearing befuddled by the question.

A Quality Portfolio by Rose Gonnella

A great portfolio displays a range of qualities—quality use of type, quality compositions, quality ideas, quality presentation, quality organization. Now to understand quality, see the contents of Professor Landa's book. (I still hold to the great twelve-piece theory.)

Self-Promotionals

In addition to sending a résumé to, or leaving a résumé with, a prospective employer, some students send or leave self-promotionals. A self-promo usually is a small version of your best work—a mini-portfolio—consisting of about five pieces. It is a creative, inventive piece that showcases your talent, sort of a self-advertisement. It is usually too expensive and time consuming to make a self-promo for every prospective employer; use them wisely.

A self-promo should always include your name and phone number. Like your portfolio, a self-promo represents you, your talent, intelligence, and abilities. Do not create anything that will be annoying to a prospective employer. For example, do not make something difficult to open or have glitter or confetti fall out all over someone. It must be well-thought out and well-crafted.

Sample Portfolios

Here are two sample portfolios, one for graphic design and one for advertising, created by students at Kean College of New Jersey.

Figures 12-1 through 12-16
Portfolio by
Karin M. Hoffmann

Figure 12-1
Art Faculty Exhibition
Announcement

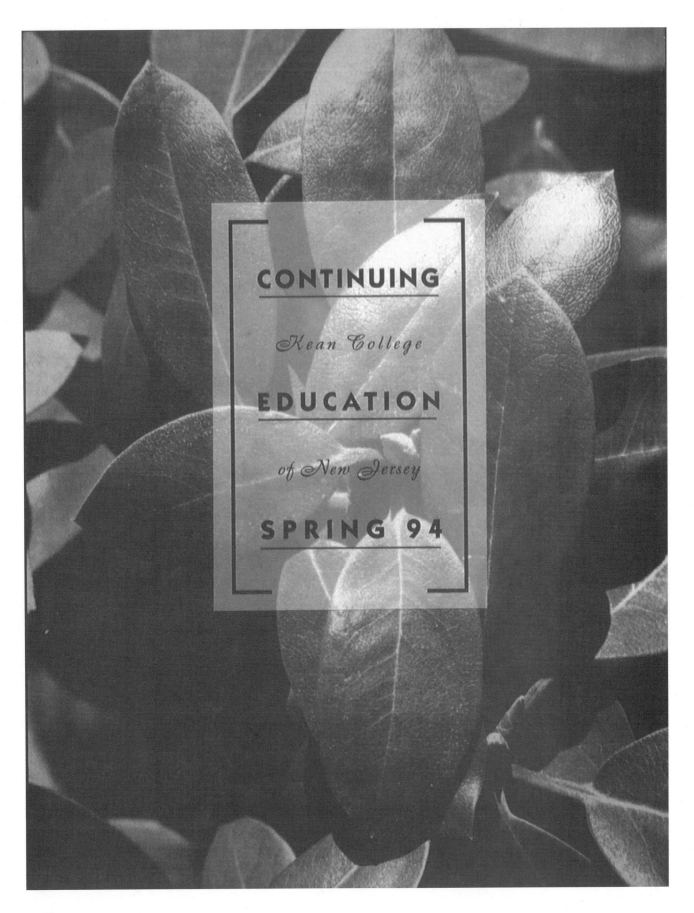

CONTINUING

Kean College

EDUCATION

of New Jersey

SPRING 94

Figure 12-2
Continuing Education Spring 1994 Bulletin

Figure 12-3
Roughs for Continuing Education Spring 1994 Bulletin

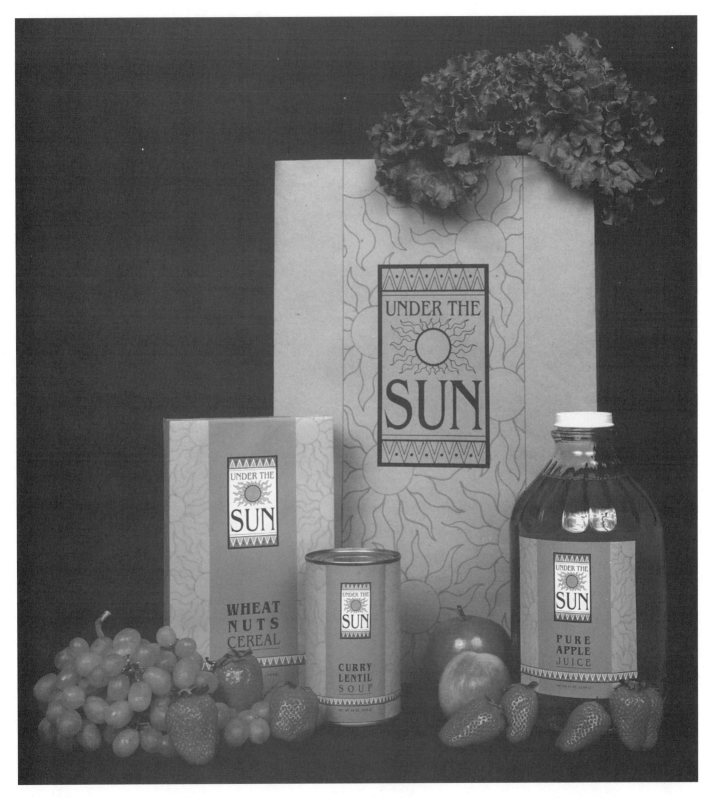

Figure 12-4
Under The Sun Visual Identity
Photographed by Tony Velez

May 15, 1993

Samantha Walsh
President
Under The Sun
926 Richard Street
Freehold, NJ 07728

Dear Ms. Walsh:

Enclosed please find a comprehensive layout of the stationery that we have
designed for your store, Under The Sun. We hope that you will find it
attractive, appropriate, and functional.

Since your stationery package consists of a letterhead, an envelope, and a
business card, one of our immediate goals was to create a design that could
be applied consistently on each item. This will help to produce a feeling of
unity among the pieces, and will add to the overall strength of your corporate
identity. The logo that you have selected is illustrative in its appearance, and
thus, should be treated as a small work of art. Therefore, we have decided to
present it on the stationery in as straightforward a manner as possible. It is
large enough to be easily viewed, but not so large as to be overwhelming. In
addition, your address is set in smaller type and placed at a slight distance
away from the logo itself, in order to give the art more visual importance.

In order to set the design of the letterhead to its fullest advantage, we have
several recommendations to make about the form of business letter you
should use. We suggest that you use a block format. The strong vertical line
created by the left side of the block will help to keep the page neat, and will
complement the vertical space created by the logo and your address. In
addition, we also propose that you begin with the date on a line level with the
top edge of your logo. Last, we suggest that you leave a left margin of 2
inches in order to give the design room to breathe. As for your envelope, we
have designed it so that you may place the address in the standard position,
as is required by postal regulations.

We hope that you enjoy using your new stationery. If you have any questions,
please let us know. Thank you.

Very Truly Yours,

Karin M. Hoffmann
Chameleon Design Group

Samantha Walsh
President
Under The Sun
926 Richard Street
Freehold, NJ 07728

Figure 12-5
Under The Sun Stationery

Figure 12-6
Sketches for Under The Sun

Figure 12-7
Martha Marchena Poster

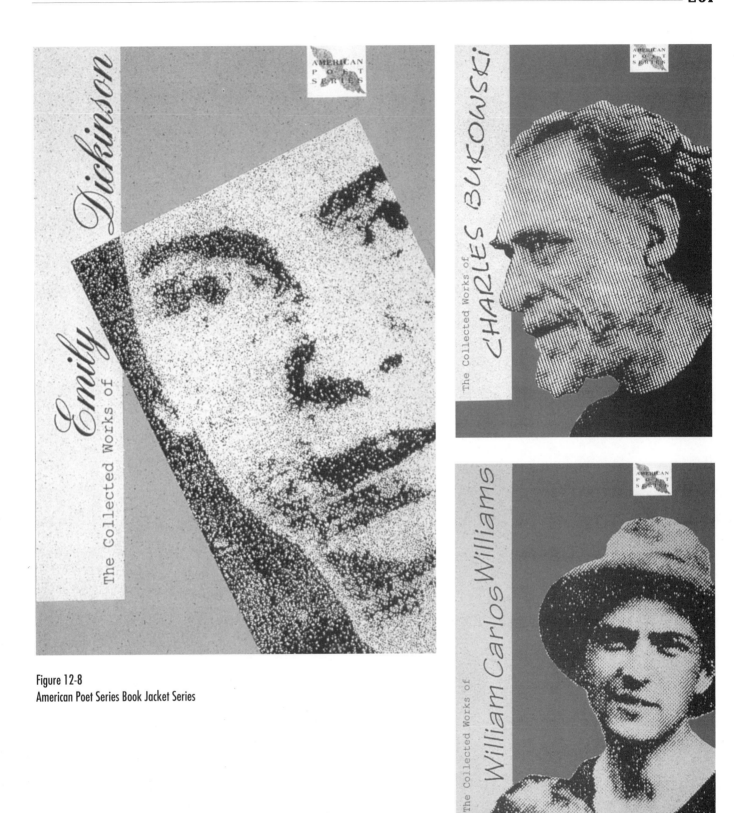

Figure 12-8
American Poet Series Book Jacket Series

Figure 12-9
Sketches for American Poet Series Logo

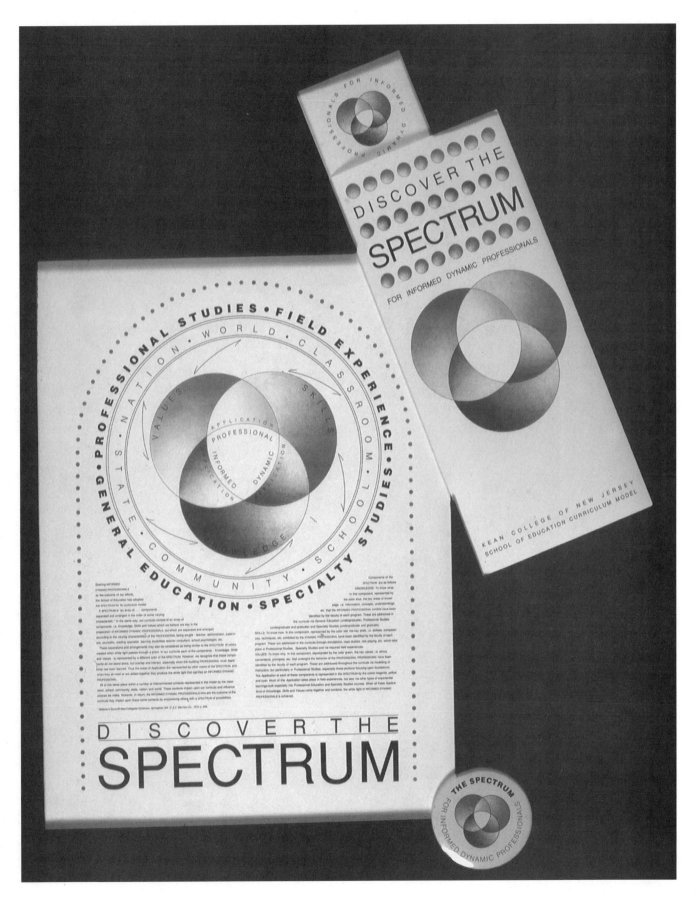

Figure 12-10
Spectrum Poster and Collateral Materials

Figure 12-11
Fine Arts Department
Poster Button

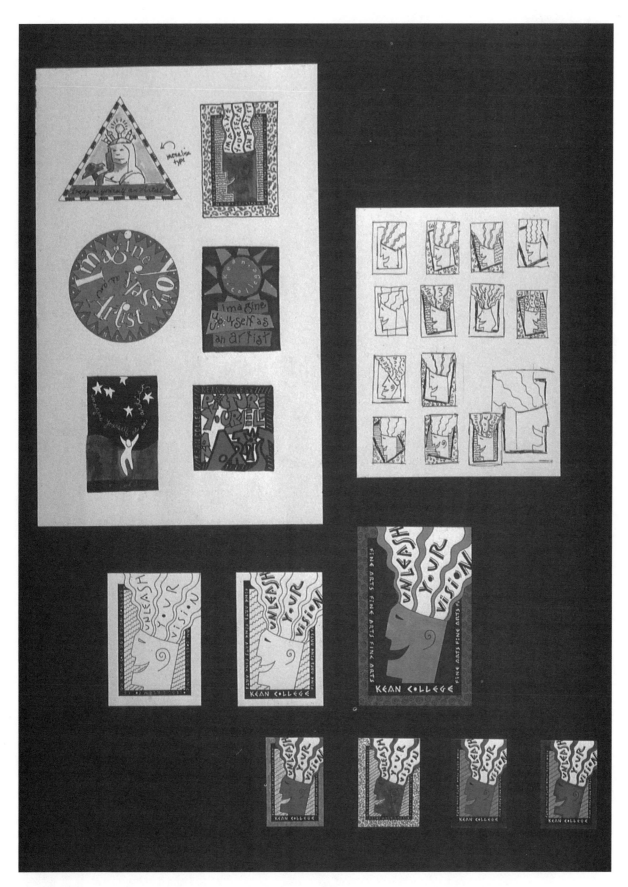

Figure 12-12
Sketches for Fine Arts DepartmentButton

Figure 12-13
1993 Book

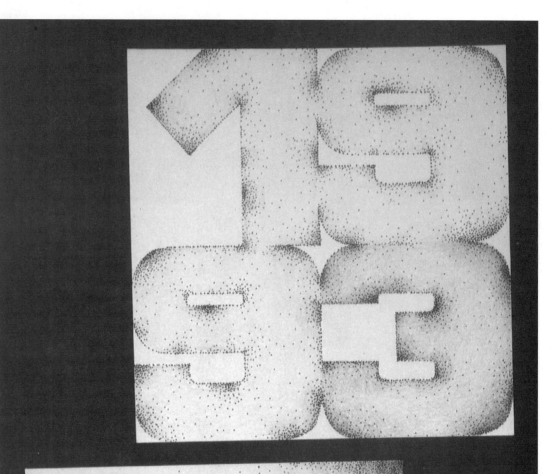

*A*h, here at last! After nearly a year of love and skillful nurturing, the *1993 Delaware Valley blush wines* are ready and eagerly awaiting the loosening of their corks at the fourteenth annual Bacchus Club Wine Tasting Fest. And judging from the blushing bottles, this promises to be the best year ever!

*S*o bring a friend and this invitation to share an evening of wine, cheese and good company! This year's tasting will be held on October 2 at 8:00 pm, at the Lambertville Station, 11 Bridge Street, Lambertville, NJ 08530. Please call the restaurant at (609) 397-4400 for directions.

Figure 12-14
Sketches for 1993 Appointment Calendar

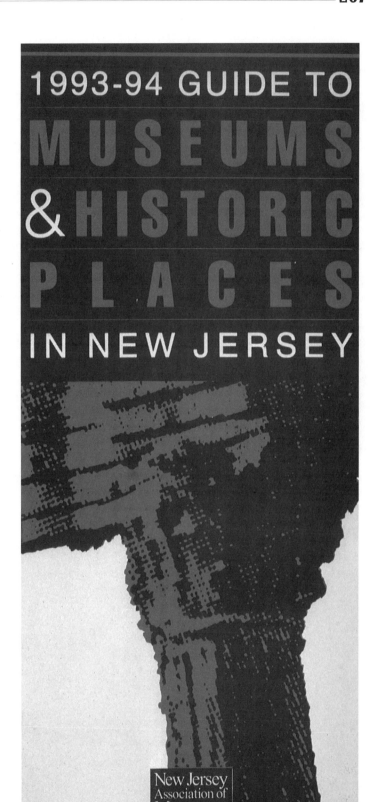

Figure 12-15
1993-94 Guide to Museums and Historic Places in New Jersey

Figure 12-16
Logo Book

KARIN M HOFFMANN / GRAPHIC DESIGNER
personal logo

AMERICAN POET SERIES
a collection of american poetry

UNDER THE SUN
a natural foods store

PAPER MOON
a vintage clothing boutique

MORRIS COUNTY PARK COMMISSION

SOUTH ORANGE / MAPLEWOOD ADULT SCHOOL

Figures 12-17 through 12-22
Portfolio by Tony Ciccolella

Figure 12-17
Morris Museum Invitation
Photography: Dave Witthuhn

The Department of
Communications and Theatre

The Kean College Theatre Series Presents

TO BE YOUNG, GIFTED AND BLACK

A portrait of Lorraine Hansberry
in her own words

adapted by Robert Nemiroff

Directed by
Ernest W. Wiggins

Scenic and Lighting Design
Nadine Charlsen

Costume and Make-up Design
John C. Rager

Choreography
Monica McNeil and Monica Jenkins

Sound Design
Gig Casci

Sound Adaptation
Ernest W. Wiggins and Todd-Dowdy Sloan

THE CAST (In Alphabetical Order)

Harold Boyd
Michael Echols
Michele Gadsen
Kim Henry
Christie Jensen
Kevin Labadessa
Monica Jenkins-Jones
Monica McNeil
Samson Ogalo
Lynada Staggers
Taunya Turner

Understudies
Larry Fowler
Ottamease Jenkins
Todd-Dowdy Sloan
Lynada Staggers

Drums
John Daly

Gospel Singers
Kim Henry
Ottamease Jenkins
Pricilla Sapp

ACT ONE

1930-1959

ACT TWO

1960-1965

What happens to a dream deferred?
Does it dry up
Like a raisin in the sun?
Does it stink like rotten meat?
Or crust and sugar over-
Like a syrupy sweet?

Maybe it just sags
Like a heavy load.

OR DOES IT EXPLODE?
Langston Hughes

ABOUT THE PLAY AND LORRAINE HANSBERRY

"Never before, in the entire history of the American theatre, had so much of the truth of black people's lives been seen on the stage That marvelous laugh. That marvelous face. She was my sister and my comrade . . . on the same side of the barricades, listening to the accumulating thunder of the hooves of horses and the treads of tanks."

So wrote James Baldwin of Lorraine Hansberry and her first play, A RAISIN IN THE SUN, which made her at 29, the youngest American, the first woman and the only African-American playwright ever to win the New York Drama Critics' Circle Award for the Best Play of the Year (1959). A RAISIN IN THE SUN was produced and published in some thirty countries and made into an award-winning film. Five years later, while her second play, THE SIGN IN SIDNEY BRUSTEIN'S WINDOW, was running on Broadway, Miss Hansberry died of cancer at the age of 34. Her posthumous play LES BLANCS was presented on Broadway in 1970 starring James Earl Jones and Cameron Mitchell.

TO BE YOUNG GIFTED AND BLACK is the story of Lorraine Hansberry, told in her own words. It begins with a gallery of the characters she created and a speech she delivered shortly before the opening of A RAISIN IN THE SUN.

And from there it moves back and forth in time – from earliest childhood in Chicago to memories of her first trip South and the images of slavery it stirred in her; from school days and the race riot at Englewood High to the year at the University of Wisconsin when she first encountered the plays of Sean O'Casey, the great Irish writer whose work so profoundly influenced her own; from the years of creation and triumph in New York to the search (in Act Two) for meaning and relevancy and ever-deepening involvement in "the movement" that followed success. (Her last book, written in the hospital for the Student Non-violent Coordinating Committee-S.N.C.C., was called THE MOVEMENT.)

Boldly contemporary in form, the play was woven together from letters, diaries, notebooks and portions of her plays by Robert Nemiroff, her husband and literary executor. The form is free-flowing but chronological, with scenes and memories merging into each other without sharp divisions. No single member of the company plays Miss Hansberry; rather all in turn portray her, her characters and the people who most affected her.

On the death of Lorraine Hansberry in 1965, Martin Luther King observed: "Her commitment of spirit . . . her creative ability and her profound grasp of the deep social issues confronting the world today will remain an inspiration to generations yet unborn.

For those who wish a wider acquaintance with Lorraine Hansberry, *To Be Young, Gifted and Black*, the book on which the play was based, has been published by Prentice-Hall and, in paperback Signet Books. The play itself is published by Samuel French, Inc. Her other works include: *A Raisin In The Sun* and *The Sign In Sidney Brustein's Window* (Samuel French, Inc.) *The Movement* (Simon and Schuster), and *Les Blancs*.

A full-length cast album of *To Be Young, Gifted And Black* is available from Caedmon Records, as is the spoken-word album, *Lorraine Hansberry: On Her Art And The Black Experience.*

Figure 12-18
To Be Young, Gifted and Black Playbill

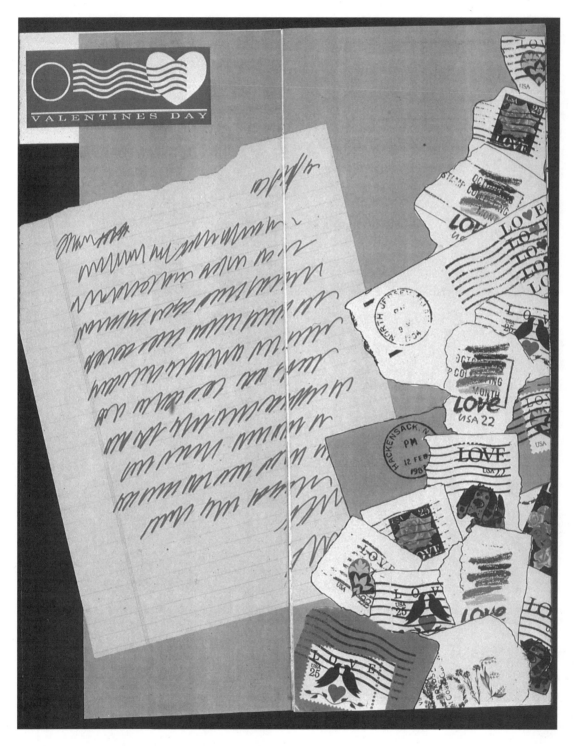

Figure 12-19
American Holiday Book

Figure 12-20
Music Magazine Spreads

Figure 12-21
Keane College 92-93
Performing Arts Brochure

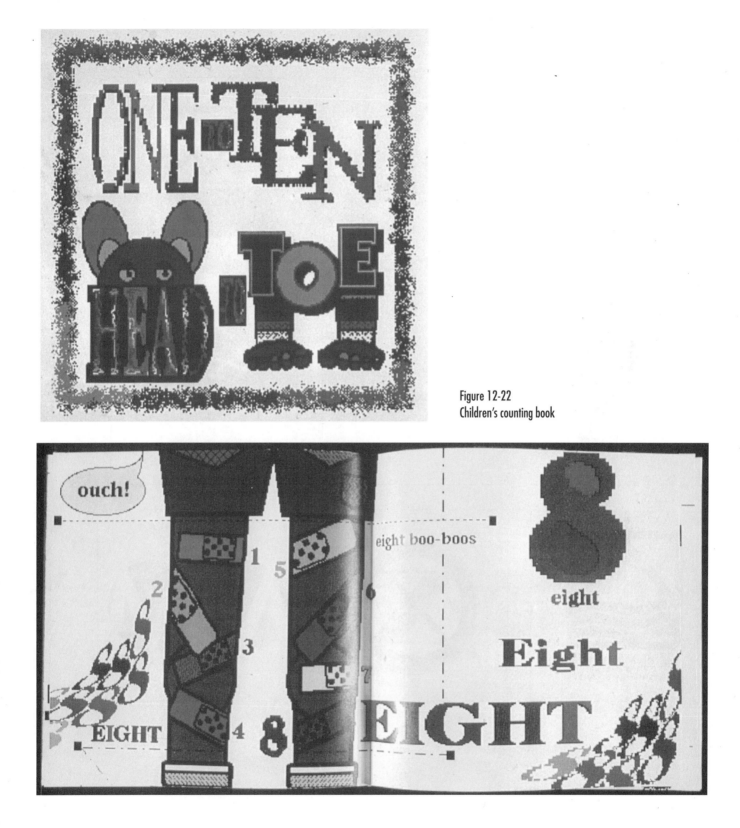

Figure 12-22
Children's counting book

Figure 12-23
Logos

Figure 12-27
"I Communicate Visually"
t-shirt and button

Portfolio Requirements:

- 10-15 great pieces impeccably mounted and contained in a professional case
- a designed resume
- Thumbnail sketches (demonstrates your ability to think visually and conceptually) contained in a ringless binder (bound book of acetate sheets)
- self-promotional piece
- a back-up portfolio (second portfolio of color copies) you may have to leave one somewhere or, heaven forbid, you may lose one
- sample to leave behind with resume
- *Optional:* a ringless binder with extra pieces of work or a book demonstrating a second skill (e.g., if your primary book is graphic design, your second book might be ads)
- *Optional:* computer disk of design work (which repeats contents of portfolio case)

Contents of Portfolios

General Graphic Design Portfolio

- logos - approximately 3
- stationery
- symbols, pictograms
- poster(s)
- folded brochure (featuring typographic and layout design)
- book jackets/CD album covers
- packaging/shopping bags
- visual identity
- annual report, catalog, or other multi-page piece
- editorial design: magazine spread, newspaper, book pages
- promotional design: coordinated pieces including poster, ads, brochure, invitation, direct mail
- ads
- invitations
- calendar

Presentation: mounted on black board with 2" border

Advertising Portfolio

- four campaigns (consisting of three ads each)
- two one-shot ads
or
- five campaigns
or
- three campaigns
- three one-shots

Presentation options:

- mounted flush on foam core, full or half size
- mounted with 2" black border, full or half size

Figure 12-25
AIGA Invitation
Marty Anderson Design
Washington D.C.

Appendix A
Graphic Design Materials, Tools, and Processes

Objectives
▌ to become familiar with the tools, equipment, paper, films, drawing tools, adhesives, and processes used to create graphic design
▌ to become familiar with key production terms

Years ago you could have solved graphic design problems with traditional hand tools, like a T-square and a ruling pen. Now, newer technology, like the computer, has changed everything. Some designers design everything on the computer — they never touch pencil to paper. Other designers still create their thumbnail sketches with markers, pencils, and paper, and use the computer for comps and production. And, there are still some designers who do almost everything by hand, using the computer as a typesetter only.

Almost anything that can be done by hand can be created on the computer. You must learn to use a computer — especially since technology will be moving ahead at a very fast rate in the near future. But, of course, you also still need to learn about some traditional tools and materials.

Tools and Equipment

Computer Hardware

Computers: There are basically two systems: the Apple Macintosh and the IBM (and IBM-compatible computers made by different manufacturers, referred to as PCs). The Power Macintosh now can be made IBM-compatible. Most designers use Macintosh because of its graphical user interface which is picture-oriented, although the Windows GUI for IBM and compatible machines is now similar.

Keyboard: The main input device which connects to the computer, similar in looks to a typewriter keyboard.

Monitor: Hardware that displays information, text and visuals on a screen in full color or grayscale.

Mouse: A hand-sized input device, used in addition to the keyboard, which connects to the computer with a cable.

Printers: Hardware that allows you to produce a hard copy, type, and visuals on paper, of what appears on the computer screen.

Scanners: Hardware: used in conjunction with software, that allows you to scan a visual or document onto the screen.

Computer Software

Draw and Paint: A two-dimensional graphics program used to create images with line, shapes, colors, textures, and type, for example, Macromedia Freehand, Adobe Illustrator, Pixel Paint and Fractal Design Painter.

Page layout: A graphics program used to create a layout (arrangement) of type and graphic elements; used in the creation of brochures, newsletters, annual reports, and editorial design, for example, QuarkXPress and Adobe Page-Maker.

Image-Processing: A graphics program that is primarily used to import photographs (through a scanner) for retouching, editing, and adding special effects such as mosaic patterns, textures, and distortions, for example, Adobe Photoshop, QuarkXPosure, and Ofoto2.

Multimedia: Creates dynamic, interactive presentations; combines text, graphics, animation, sound and video, for example, Macromedia Director, Passport Producer Pro, and Adobe Premier.

Equipment

Art-o-graph: This projection camera projects a temporary image oN any surface, like paper or board, which you can trace. It can enlarge and reduce images.

Copiers: This camera creates inexpensive copies in black and white or color. Most copiers can enlarge and reduce images. Copiers have become essential tools for the creation of comps. (Students should experiment with copiers.)

Luc-o-graph or **lucy:** This projection camera projects a temporary image on a transparent surface, like tracing paper. It can enlarge and reduce images.

Photostat or **stat camera:** This camera enlarges and reduces images, shoots line art, screens halftones, makes reversals, and uses special effects screens. It uses photographic paper and chemicals.

Hand tools

Cutting Tools: Single-edged razor blades or X-acto knives are used for cutting in conjunction with T-squares and triangles. The most commonly used X-acto knife blade is the #11.

Ruler: A straight edge used for measuring and drawing. Stainless steel rulers are best with point, pica, and inch measurements.

Triangle: A tool used in conjunction with a T-square and drawing or cutting tool; used to rule or cut straight vertical lines or angles. Triangles are available in plastic and metal at different degrees; the most often used triangle is the 30˚60˚90˚ or 45˚90˚. Metal triangles are best for cutting—they will not get nicked.

T-square: A tool used in conjunction with a drawing tool or cutting tool; used to rule or cut straight horizontal lines. Metal T-squares without incised measurements are preferable over ones with numbers. The incised measurements can interfere with ruling and cutting. Metal T-squares will not nick, while wood T-squares will get nicked and possibly warp.

Papers and Films

There are two categories of paper the designer uses: printing paper and artist's paper.

Printing paper is the paper a designer chooses for the printed piece. Choosing the right paper for a design is crucial. Different papers take ink differently. The ink prints better and runs less on some than on others. Paper can affect the legibility of type, the texture, tone, and personality of a piece. There are different paper finishes: antique, eggshell, vellum, and machine finish. Papers can be coated or uncoated; uncoated paper can be coated after printing to improve the finish and increase the smoothness. Printing paper is available in different weights, measured in pounds per ream (500 sheets). Several factors should be considered when choosing paper—color, brightness, weight, smoothness (surface), and opacity. Paper companies provide samples for designers.

Paper comes in different grades, which means that it is usually used for different purposes.

Book: general use, especially for books

Bond: usually used for stationery and business forms

Coated: paper that has been coated for a smoother or glossier finish, usually used for higher quality pieces

Copier: used primarily for copier machines

Cover: heavier weight coated and text papers used as covers for reports or brochures

Laser: used for laser computer printers

Newsprint: primarily used for newspapers

Offset: similar to coated and uncoated book paper with added sizing

Recycled: paper that has been recycled, usually bond paper

Text: papers available in many colors and textures, usually used for brochures, announcements, and promotional pieces

Artist's paper: The paper available to artists for inking, drawing, and making comps. Artist's paper comes in various textures, weights, and

finishes and is available in single sheets, rolls, and pads. Hot pressed paper has a smooth texture or surface; cold-press paper has a rough texture or surface. The quality of paper is determined by the rag content, which refers to the amount of cotton or linen fibers in a paper. Papers of 100 percent rag content are the highest quality and most expensive. Papers with a combination of ingredients, such as wood pulp, rag, and chemicals are less expensive and of a lower quality.

Acetate: Used as a drawing surface and protective surface. Acetate is available in different thicknesses (weights) and in different finishes: clear, frosted (matte), and prefixed.

Boards: There are three basic types of boards: illustration, mat and museum, and foam core. **Illustration board** is used for layouts, drawing, mechanicals, and inking. It comes in two categories: hot press (smooth surface) and cold press (rough surface). It is available in different qualities (grades), surfaces, and sizes. **Mat and museum board** is used for mounting and matting work and is available in various colors, grades, and surfaces. Most design students choose black, gray, or white mats. Museum board is usually acid free. Note: Cold press boards should never be used for mounting or mechanicals. **Foam core** is a lightweight board used for mounting; it is available in various thicknesses, sizes and in black and white. (Most ads are mounted on foam core.)

Colored film: Colored acetate with adhesive backing is available in a variety of colors. It is used in the preparation of comps and mock-ups.

Colored paper: Paper with color on one side is available in a variety of colors, qualities, and brands.

Cover stock: A heavier weight paper used to cover mechanicals (flap), which can also be used for comps.

Ledger bond: Smooth, opaque paper used for inking, drawing, comps, and to cover mechanicals (cover stock then goes over the ledger bond), available in a few different weights.

Masking film (amberlith or rubylith): A clear film coated on one side with a thin litho film, usually amber or ruby colored. It is used in the preparation of color separations and mechanicals. It is adhered to a board, the colored film is cut and then stripped off exposing the area to receive color—to be printed.

Screen or Texture Sheets: Acetate sheets with a line pattern or texture which comes with an adhesive backing. Used for comps and mechanicals; on mechanicals, the line patterns are used as tone.

Tracing paper: Nearly transparent paper used for tracing or drawing. Available in pads and rolls, and in various qualities. It is great for thumbnail sketches, layouts, flaps (covers), slip-sheets, and color indications on mechanicals.

Visualizer or marker paper: Less transparent than tracing paper; used for drawing with pencil, marker, and pen; available in pads and in various qualities. It is great for roughs, comps, layouts, and color indications on mechanicals.

Vellum: Heavy, high-quality tracing paper used for layouts and inking.

Drawing Tools

Markers: Tools used for sketching and comps. They are available with various nibs (tips): pointed, regular, flexible, and broad, which create different width marks. Markers contain pigments or dyes in a liquid. Different liquids, water, or solvents are used. Water-based markers are safest. Ethyl alcohol based markers, which are now used most frequently by designers, are the least harmful of the solvent based markers, but should be used in a well-ventilated room. Other solvent-based markers are more hazardous to your health and should always be used in well-ventilated rooms. You should experiment with markers and papers to see which brands and types work best together.

Pencils: Tools used for sketching, ruling guidelines, and drawing which are available in a wide range of cores that yield different types of marks. There are synthetic graphite pencils, charcoal pencils, chalk pencils, colored pencils, metallic pencils, and plastic pencils. Synthetic graphite pencils come in varying degrees of softness and hardness; for example, a pencil marked 6H is very hard and makes a light mark, and a pencil marked 6B is very soft and makes a dark mark. Charcoal pencils are generally darker than, and blacker than, synthetic graphite pencils. Colored pencils come in a great many

colors, qualities, and brands. Mechanical pencils are available with interchangeable leads that come in various hardnesses and thicknesses. Most pencils can be sharpened with single-edged razor blades or sharpeners.

Ruling pen: A pen which temporarily holds ink or thin paint. Primarily used for preparing line art for mechanicals; it is very difficult to use and requires a great deal of practice. When used well, it creates very clean lines.

Technical pens: Tools used for drawing and ruling. They have ink cartridges and are available with different nibs which yield different line widths.

Adhesives

Glue sticks: Non-toxic glue used as an adhesive. Although not considered a professional material, it is a safe adhesive.

Rubber cement: The most commonly used semi-permanent adhesive, available in jars and cans. Elements that have been adhered with rubber cement can be dissolved with rubber cement thinner, removed, repositioned and re-adhered. Excess can be removed with a rubber cement pickup. Two-coat cement, a mixture of three parts rubber cement and one part thinner, is best; both surfaces are cemented. The consistency of rubber cement is important; it should not be thick. Rubber cement is available in cans and a mixture (of rubber cement and thinner) can be kept in a jar with a brush attachment, which is sold separately. Rubber cement thinner is available in cans, but should be transferred, as needed, to a thinner dispenser which is sold separately. **Note:** Although rubber cement and thinner are commonly used, they should be used in a well-ventilated room.

Spray can adhesive: similar to one-coat cement and used for large areas. This adhesive can be messy. **Note**: This product **must** be used in a well-ventilated room or spray booth.

Tapes: Used for adhering. Drafting tape is used to adhere overlays on mechanical boards, and to tape your board or paper to a drawing table or surface. It comes in various widths and colors and can usually be removed without damaging board surfaces. White and black tapes are used to adhere cover stock to boards and to create mat presentations.

Wax: A commonly used semi-permanent adhesive. Wax is heated and applied to paper with a hand-held electric waxer, or paper is fed through a large electric waxer. It can be lifted and repositioned without solvents. **Note:** Wax is safe unless it is heated to the point where it smokes.

Note: There are several books about health hazards related to art materials and the proper use, handling and storage of materials. It is strongly recommended that you read one of them (as listed in the bibliography, pp. 291-294).

Processes

Color Key: A 3M corporation product used to make transparent overlays; available in a variety of colors. It requires a processing kit, chemicals, and Color Key papers; usually requires preliminary photostats.

Copies: Images made on copy machines in black and white, single colors, or full color.

I'N'T: A 3M corporation image and transfer product used for custom transfer type, images or graphics. It requires a processing kit, chemicals, and I'N'T papers; usually requires preliminary photostats.

Laser prints: Images generated by a computer and printed on a laser printer at various DPI (dots per inch)—300, 600, or 1200.

Photostats or stats: Good quality images produced on a photostat camera.

Transfer type: Display and text type, available in various sizes, faces, and colors, that can be transferred from wax sheets to almost any surface.

Production

Preparing art for printing can be done on the computer or by hand. Here are some basic terms related to production.

Bleed: Color or art that runs off the edge or edges of a page.

Color separation: The mechanical process where colors that are not continuous tone are separated in preparation for printing.

Continuous tone: Art that contains a range of values (grays), like a photograph or a wash drawing.

Halftone: Continuous tone art that has been screened in preparation for printing.

Line art: Art, such as type or black and white drawings, that contains no grays.

Overlay: Vellum, acetate, or film that is placed over a mechanical and taped down; used to prepare art for printing.

Pantone Matching System (PMS): A standardized system of numerically coded color mixtures used in printing.

Process colors: Cyan, magenta, yellow, plus black; the colors used in four-color process printing.

Screen: A film made with diagonal cross-hatched lines, varying from 55 to 160 lines per linear inch; it is used to convert continuous tone art into a dot pattern.

Silhouetting: When the edges of an image are silhouetted, the background is cut away. This is done either by hand with a blade or masking film, or with an image-processing program on the computer.

Appendix B
Glossary

Accents: supporting or secondary focal points.

Advertisement: a design that is intended to inform, persuade, provoke, or motivate us.

Art director: the person in an advertising agency responsible for ideation and the art and design decisions.

Ascender: the part of lowercase letters, b, d, f, h, k, l, and t, that rises above the x-height.

Asymmetry: the arrangement of dissimilar or unequal elements of equal weight on a page.

Alignment: visual connections made between and among elements, shapes, and objects when their edges or axes line up with one another.

Atmospheric perspective: the illusion of depth or distance is created by reducing value contrasts, color intensity, and detail in order to imply the hazy effect of atmosphere on forms as they recede.

Balance: an equal distribution of weight.

Baseline: defines the bottom of capital letters and of lowercase letters (excluding descenders).

Benefit: something in an advertisement that promises improvement.

Body copy: the text, the narrative that further explains the advertising concept and may provide more information; also called text type.

Calligraphy: letters drawn by hand with the strokes of a drawing instrument—literally "beautiful writing."

Campaign: a series of advertisements which share a common strategy, concept, design, spirit, style, and claim.

Capitals: the larger set of letters, also called uppercase.

Character: a letterform, number, punctuation mark, or any single unit in a font.

Claim: the verbal message that is associated with a product or service and is used in a campaign of ads for that product or service; also called end line, tagline, or slogan.

Collage: the cutting and pasting of different bits of materials onto a two-dimensional surface.

Comp or Comprehensive: a detailed representation of a design.

Copywriter: the person in an advertising agency responsible for ideation and writing.

Correspondence: when an element, like color, direction, value, shape, or texture is repeated or when a style is established; for example, a linear style and a visual connection or correspondence among the elements may be established.

Craft: the physical handling and use of materials.

Creative director: the person in an advertising agency with the ultimate creative control over art direction and copy; usually the supervisor of the creative team(s).

Creative team: in an advertising agency, an art director and copywriter.

Critique: an assessment or evaluation of work.

Cropping: cutting an element so the entire element is not seen.

Descender: the part of lowercase letters, g,j,p,q, and y, that falls below the baseline.

Design: the arrangement of parts into a coherent whole.

Design concept: the creative solution to the design problem. The concept is expressed through the combination and arrangement of visual and verbal materials.

Direct mail: an advertisement sent directly through the mail to the consumer.

Display type: type usually used as headings; type over 12 points in size.

Editorial design: the design of publications, such as magazines, newspapers, books, and newsletters.

Emphasis: the idea that some things are more important than other things and that important things should stand out and be noticed.

Flow: elements arranged in a design so the viewer's eyes are lead from one element to another, through the design. Also called movement.

Focal point: the part of a design that is most emphasized.

Formal elements: fundamental elements of two-dimensional design: line, shape, color, value, texture, and format.

Format: whatever substrate you start out with in graphic design, like a business card, book jacket, or poster.

Graphic design: the application of art and communication skills to the needs of business and industry; the visual/verbal expression of an idea.

Graphic Standards Manual: a guide for the use of the visual identity system detailing the use of the logo, colors, and other graphics and imagery.

Grid: a layout device used to achieve unity; a subdivision of a format into fixed horizontal and vertical divisions, columns, margins, and spaces, that establishes a framework for the organization of space, type, and visuals in a design.

Headline: (the line) the main verbal message in an advertisement (although it literally refers to lines that appear at the head of the page).

High contrast: a wide of range of values.

Hue: the name of a color, that is, red or green, blue or yellow.

Illusion of spatial depth: the appearance of three-dimensional space on a two-dimensional surface.

Impasto: the buildup of paint on the surface of a board or canvas.

Information design: informs and identifies; includes logos, identity systems, symbols, pictograms, charts, diagrams, maps, and signage.

Kitsch: art that has popular (not critical) appeal.

Layout: the arrangement of type and visuals on a format or page.

Leading: in metal type, strips of lead of varying thickness (measured in points) used to increase space between the lines; line spacing or interline spacing.

Letterform: the particular style and form of each individual letter of the alphabet.

Lettering: letters that are custom designed and executed by conventional drawing or by digital means.

Letterspacing: the space between letters.

Line: a mark made by a tool as it is drawn across a surface.

Line direction: describes a line's relationship to the page.

Line quality: refers to how a line is drawn.

Line spacing: leading; or interline spacing: the distance between two lines of type measured vertically from baseline to baseline.

Line type: (line attributes) refers to the way a line moves from its beginning to its end.

Linear: a predominant use of line to describe shapes or when line is used as a way to unify a design.

Logo: an identifying mark for a product, service, or organization; also called a trademark.

Logotype: an identifying mark where the name is spelled out in unique typography.

Low contrast: a narrow range of values.

Lowercase: the smaller set of letters. The name is derived from the days of metal typesetting when these letters were stored in the lower case.

Mock-up: a facsimile of a printed three-dimensional design piece.

Objectives statement: a clear, succinct description of design objectives which summarizes the key messages that will be expressed in the design; for example, facts or information, desired personality or image, and position in the market.

Package: encloses a product.

Parity products: products that are equivalent in value.

Perspective: a schematic way of translating three-dimensional space onto the two-dimensional surface. This is based on the idea that diagonals moving toward a point on the horizon, called the vanishing point, will imitate the recession of space into the distance and create the illusion of spatial depth.

Pictogram: a simple picture representing an object or person.

Picture plane: the blank, flat surface of a page.

Portfolio: a body of work used by the graphic design profession as the measure of one's professional ability.

Poster: a two-dimensional single-page format used to display information, data, schedules, or offerings, and to promote people, causes, places, products, companies, services, groups, or organizations.

Presentation: the manner in which comps are presented to a client or in a portfolio.

Print advertisements: type of advertisement—newspapers, magazines, direct mail, posters, outdoor boards—as opposed to television and radio advertisements.

Promotional design: is meant to promote sales or to persuade. It includes advertisements, packaging, point of purchase display, brochures, sales promotions, posters, book jackets, and CD covers.

Rhythm: a pattern that is created by repeating or varying elements, with consideration to the space between them, and by establishing a sense of movement from one element to another.

Roughs: sketches which are larger and more refined than thumbnail sketches and show the basic elements in a design.

Sans serif: letterform design without serifs.

Saturation: the brightness or dullness of a color; also called intensity and chroma.

Scale: the size of one shape or thing in relation to another.

Serifs: ending strokes of characters.

Shape: the general outline of something.

Sign-off: the product or service's logo; a photograph or illustration of the product, or both, in a print advertisement.

Stationery: consists of a letterhead, envelope, and business card.

Storyboard: illustrates and narrates key frames of the television advertising concept.

Strategy: the goals and objectives behind a design solution; how the graphic design fits into the larger marketing, promotion or communication plan.

Style: the quality that makes something distinctive.

Symbol: a sign or a simple, elemental visual, that stands for or represents another thing.

Symmetry: the balanced arrangement of similar or identical elements so that they are evenly distributed on either side of an imaginary vertical axis, like a mirror image.

Tactile texture: real texture that can be felt.

Text type: set type used for text, usually in sizes ranging from 5 points to 14 points.

Texture: the tactile quality of a surface or the representation of such a surface quality.

Thumbnail sketches: preliminary, small, quick, rough designs or drawing of ideas.

Trompe-l'oeil: literally, "to fool the eye"; a visual effect on a two-dimensional surface where one is in doubt as to whether the thing depicted is real or a representation.

Type alignment: the style or arrangement of setting text type, for example, flush left/ragged right.

Typeface: the design of a single set of letterforms, numerals, and signs unified by consistent visual properties. These properties create the essential character which remains recognizable even if the face is modified by design.

Type family: several font designs contributing a range of style variations based upon a single typeface design. Most type families include at least a light, medium, and bold weight, each with its italic.

Type font: a complete set of letterforms, numerals, and signs, in a particular face and style, that is required for written communication. In metal type, every available size of this set of characters is a separate font of type.

Type style: the modifications in a typeface which create design variety while retaining the essential visual character of the face. These include variations in weight (light, medium, bold), width (condensed, regular, extended), and angle (Roman or upright, and italic), as well as elaborations on the basic form (outline, shaded, decorated).

Typography: letterforms produced by mechanical means, usually computer. It is by far the most common means of using letterforms for visual communication.

Unique Selling Point: something special about a brand that the competition does not have; also called the Unique Selling Advantage.

Unity: when all the elements in a design look as though they belong together; an integrated whole. Also called completion or composition.

Uppercase: the larger set of letters or capitals. The name is derived from the days of metal typesetting when these letters were stored in the upper case.

Value: the range of lightness or darkness of a color, that is, a light red or a dark red.

Visual: the image in a graphic design or ad, which may be a photograph, illustration, graphics, typography, or a combination thereof.

Visual hierarchy: arranging elements according to emphasis.

Visual identity: a master plan that coordinates every aspect of graphic design material; also called corporate identity.

Visual texture: the illusion of texture or the impression of texture created with line, value, and/or color.

Visual weight: the illusion of physical weight on a two-dimensional surface.

Volume: on a two-dimensional surface, the illusion of a form with mass and weight.

Word spacing: the space between words.

x-height: the height of a lowercase letter excluding ascenders and descenders.

Appendix C
Bibliography

Arnheim, Rudolf. <u>Art and Visual Perception</u>. Berkeley: University of California Press, 1974.

_____. <u>The Power of the Center: A Study of Composition in the Visual Arts</u>. Berkeley: University of California Press, 1982.

Barthel, Diane. <u>Putting on Appearances: Gender and Advertising</u>. Philadelphia, Pennsylvania: Temple University Press, 1988.

Beaumont, Michael. <u>Type: Design, Color, Character & Use</u>. Cincinnati, Ohio: North Light Books, 1987.

Berryman, Gregg. <u>Notes On Graphic Design and Visual Communications</u>. Los Altos, California: William Kaufmann, Inc., 1979.

Brady, Philip. <u>Using Type Right</u>. Cincinnati, Ohio: North Light Books, 1988.

Bruno, Michael H., ed. <u>Pocket Pal: A Graphic Arts Production Handbook</u>. Memphis, TN: International Paper, 1988.

Cardamone, Tom. <u>Advertising Agency and Studio Skills</u>. New York: Watson-Guptill Publications, 1981.

Carter, Rob. <u>American Typography Today</u>. New York: Van Nostrand Reinhold, 1989.

Carter, Rob; Ben Day; and Philip B. Meggs, <u>Typographic Design: Form and Communication</u>. New York: Van Nostrand Reinhold, 1985.

Craig, James. <u>Basic Typography: A Design Manual</u>. New York: Watson Guptill Publications, 1990.

_____. <u>Designing With Type</u>. New York: Watson-Guptill Publications, 1992.

Dooley, Michael. "Kicking Up A Little Dust." <u>Print</u>, September, 1992.

Elam, Kimberly. <u>Expressive Typography: The Word As Image</u>. New York: Van Nostrand Reinhold, 1990.

Frederick, Diane. "Direct Mail: Up & Running." <u>Art Direction</u>, June, 1992.

Friedman, Mildred, et al. <u>Graphic Design In America: A Visual History</u>. Minneapolis, MN: Walker Art Center and New York: Harry N. Abrams, 1989.

Gill, Bob. <u>Forget All the Rules You Ever Learned about Graphic Design Including The Ones In This Book</u>. New York: Watson-Guptill Publications, 1981.

Glaser, Milton. <u>Milton Glaser: Graphic Design</u>. Woodstock, New York: Overlook Press, 1973.

Greiman, April. <u>Hybrid Technology: The Fusion of Technology and Graphic Design</u>. New York: Watson-Guptill, Publications, 1990.

Haley, Allan. <u>Photo Typography</u>. New York: Scribner's Sons, 1980.

Heller, Steven. <u>Graphic Design: New York</u>. Rockport, Massachusetts: Allworth Press, 1993.

Heller, Steven and Gail Anderson. <u>Graphic Wit: The Art of Humor In Design</u>. New York: Watson-Guptill Publications, 1991.

Heller, Steven and Seymour Chwast. <u>Graphic Style</u>. New York: Harry N. Abrams, Inc., 1988.

Hinrichs, Kit. <u>Typewise</u>. Cincinnati, Ohio: North Light Books, 1990.

Hofmann, Armin. <u>Graphic Design Manual</u>. New York: Van Nostrand Reinhold, 1965.

Holland, D.K.; Michael Bierut; and William Drenttel. <u>Graphic Design: America</u>. New York: Rockport Publishers, Inc. and Allworth Press, 1993.

Hurlburt, Allen. <u>The Design Concept</u>. New York: Watson-Guptill, 1981.

_____. <u>The Grid</u>. New York: Van Nostrand Reinhold, 1978.

_____. <u>Layout: The Design of the Printed Page</u>. New York: Watson-Guptill Publications, 1977.

Labuz, Ronald. <u>Contemporary Graphic Design</u>. New York: Van Nostrand Reinhold, 1991.

Landa, Robin. <u>An Introduction to Design</u>. Englewood Cliffs, New Jersey: Prentice-Hall, Inc., 1983.

_____. <u>Visual Solutions</u>. New York: Simon & Schuster, 1986.

Levenson, Bob. <u>Bill Bernbach's Book</u>. New York: Vintage Books, a division of Random House, 1987.

Livingston, Alan and Isabella. Graphic Design and Designers. New York: Thames and Hudson, Inc., 1992.

Lyons, John. Guts: Advertising From the Inside Out. New York: AMACON, 1989.

Marquand, Ed. Roughs, Comps, and Mock-ups. New York: Art Direction Book Company, 1985.

Meggs, Philip B. A History of Graphic Design. New York: Van Nostrand Reinhold, 1983.

_____. Type and Image: The Language of Graphic Design. New York: Van Nostrand Reinhold, 1989.

Minick, Scott and Jiao Ping. Chinese Graphic Design In The Twentieth Century. New York: Van Nostrand Reinhold, 1990.

Ogilvy, David. Confessions of an Advertising Man. New York: Crown, 1985.

_____. Ogilvy on Advertising. New York: Crown, 1983.

Paetro, Maxine. How to Put York Book Together and Get A Job in Advertising. Chicago: Illinois: The Copy Workshop, 1990.

Pearlstein, Steven. "Adman Tom McElligott." Inc. July, 1986.

Perfect, Christopher and Jeremy Austen. The Complete Typographer. Englewood Cliffs, New Jersey: Prentice-Hall, 1992.

Remington, Roger and Barbara J. Hodik. Nine Pioneers in American Graphic Design. Cambridge, Massachusetts: The MIT Press, 1989.

Richardson, Margaret. "Best Selling Design: Book Jackets and Covers: Three Case Studies." U&lc, Vol 20, Number 2, Summer/Fall, 1993.

Rossol, Monona. The Artist's Complete Health and Safety Guide. New York: Allworth Press, 1990.

Scher, Paula. The Graphic Design Portfolio. New York: Watson-Guptill, 1992.

Snyder, Gertrude and Alan Peckolick. Herb Lubalin. New York: American Showcase, 1985.

Spencer, Herbert, ed. The Liberated Page. San Francisco, California: Bedford Press, 1987.

Swann, Alan. Designed Right! Cincinnati, Ohio: North Light Books, 1990.

Wilde, Richard. <u>Problems:Solutions</u>. New York: Van Nostrand Reinhold Company, 1986.

Wong, Wucius and Benjamin Wong. <u>Visual Design on the Computer</u>. New York: Design Books, 1994.

Wrede, Stuart. <u>The Modern Poster</u>. Boston, MA: Little, Brown and Company, 1988.

Annuals

Coyne, Patrick, ed. <u>Communication Arts Advertising Annual #33</u>. Paolo Alto, CA: Coyne & Blanchard, Inc., 1992.

Coyne, Patrick, ed. <u>Communication Arts Advertising Annual #34</u>. Paolo Alto, CA: Coyne & Blanchard, Inc., 1993.

Fox, Martin, ed. <u>Print's Regional Design Annual/1992</u>. Rockville, Maryland: RC Publications, 1992.

Heller, Steven; Martin Fox; Anne Ghory-Goodman; and Ellen Lupton. <u>Graphic Design USA: 12</u>. New York: American Institute of Graphic Arts, 1991.

Pederson, Martin B., ed. <u>Graphis Design: 92</u>. Zurich: Graphis Press, 1992.

Warlick, Mary, ed. <u>Advertising's Ten Best of the Decade 1980-1990</u>. New York: The One Club for Art & Copy, Inc., 1990.

_____. <u>The One Show</u>, Volume 13. New York: The One Club for Art & Copy, 1991.

_____. <u>The One Show</u>, Volume 14. New York: The One Club for Art & Copy, Inc., 1992.

Appendix D
Endnotes

Chapter 5

1. Michael Dooley, "Kicking Up A Little Dust." <u>Print,</u> September 1992, p. 49.

Chapter 7

1. April Greiman, <u>Hybrid Imagery</u>. New York: Watson-Guptill Publications, 1990, p. 122.

Chapter 11

1. Pearlstein, Steven, "Adman Tom McElligott." *Inc.*, July, 1986, p. 36.

2. Hughes, Mike, in Warlick, Mary, ed., <u>Advertising's Ten Best of the Decade 1980-1990</u>. New York: The One Club for Art & Copy, Inc., 1990, p. 5.

3. Lyons, John, <u>Guts</u>. New York: AMACON, 1989, p. 124.

4. Barthel, Diane, <u>Putting On Appearances</u>. Philadelphia, PA: Temple University Press, 1988, pp. 39-56.

5. Angotti, Anthony, in Warlick, Mary, ed., <u>Advertising's Ten Best of the Decade 1980-1990</u>. New York: The One Club for Art & Copy, Inc., 1990, p. 8.

6. Hurlburt, Allen, <u>The Design Concept</u>. New York: Watson-Guptill Publications, 1981, pp. 48-65.

Index

Colophon

Graphic Design Solutions was designed and produced electronically on a Power Macintosh 8100/80 in QuarkXPress 3.31 by Stillwater Studio, Stillwater, NY. The text was set in 10/12 Adobe Garamond. The display face is Adobe Bodega Sans.

Prepress was done electronically by Jay's Publishers Services Inc., Rockland, MA. Images were scanned in high-resolution on an ECRM flatbed scanner and stored at Jay's. Low-resolution files were sent on SyQuest cartridges to Stillwater Studio for placement on the pages. After 300 dpi page proof review and corrections, the low-res files were replaced by the hi-res scans via automatic picture replacement. Negatives were then run out on an Agfa-Select Set 7000 image setter. The publisher and author reviewed booked dyluxes as well as photoprints of the art program.

The color signature also was designed and produced electronically by Stillwater Studio. Art scans were done by Chroma Graphics Pte Ltd., Singapore on a Crossfield Magnascan 363 scanner and then merged electronically with the text in QuarkXPress. Negatives were produced on Chroma's Agfa-Select Set Avantra 25 image-setter. The publisher and author reviewed full color press proofs.

The cover was designed by Denise M. Anderson of David Morris Design Associates, Nicole Reamer and Robin Landa. The electronic mechanical was created by Nicole Reamer in QuarkXPress on a Macintosh Centris 650. Films were produced by The Color Shop, Mechanicville, NY, on a Scitex Dolev 200.

The text was printed sheet-fed and bound by Quebecor Printing, Kingsport, TN. The stock was 50# Restorecote which is a 50% recycled sheet including 10% post-consumer content.

The color insert was printed sheet-fed, in four colors by Syracuse Litho, Syracuse, NY, on 80# Sterling Litho Gloss.

The cover was printed sheet-fed, in four colors with spot film lamination by Phoenix Color Corp, Hagerstown, MD on 10 point Carolina.